Modern European Sculpture
1918-1945

Unknown Beings and Other Realities

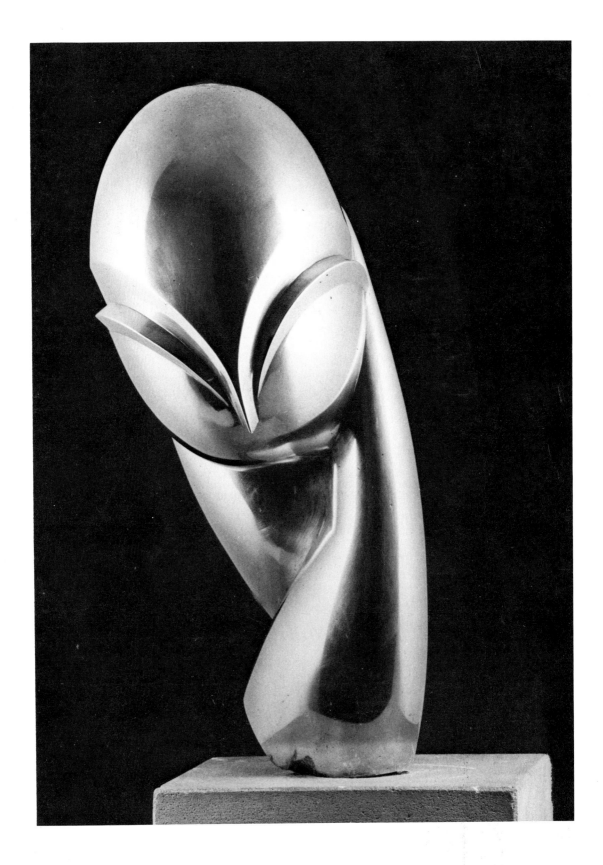

Modern European Sculpture 1918-1945

Unknown Beings and Other Realities

Albert E. Elsen

George Braziller, Inc.
New York
in association with the
Albright-Knox Art Gallery
Buffalo, New York

For Sidney Geist

This publication was prepared in conjunction with the exhibition of the same name organized by Dr. Steven A. Nash for the Albright-Knox Art Gallery, Buffalo, New York.

Albright-Knox Art Gallery, Buffalo, New York May 12 – June 24, 1979
The Minneapolis Institute of Arts, Minneapolis, Minnesota
July 22 – September 2, 1979
San Francisco Museum of Modern Art, San Francisco, California
October 5 – November 18, 1979

This exhibition is made possible in part through grants from

Henry Moore Foundation
Cameron Baird Foundation
Members' Council of the Albright-Knox Art Gallery
New York State Council on the Arts

Library of Congress Cataloging in Publication Data

Elsen, Albert Edward, 1927–
 Modern European Sculpture 1918–1945
 Unknown Beings and Other Realities

1. Sculpture, European. 2. Sculpture, Modern—
20th century — Europe. 3. Avant-garde (Aesthetics)—
Europe. I. Title
NB458.E45 735'.29 78–27519
ISBN 0–8076–0920–X
ISBN 0–8076–0921–8 pbk.

Cover ill.: Alberto Giacometti. *Invisible Object (Hands Holding the Void)*, 1934, cast 1935. Bronze, 60⅜ × 12¾ × 11″. Collection Albright-Knox Art Gallery, Buffalo, New York. Edmund Hayes Fund.

Frontispiece: Constantin Brancusi, *Mlle. Pogany II*, 1920. Polished bronze, 17¼ × 7″. Collection Albright-Knox Art Gallery, Buffalo, New York. Charlotte A Watson Fund.

Contents

Foreword

A few years ago, Albert Elsen organized an especially informative and well-received exhibition entitled *Pioneers of Modern Sculpture* which was mounted in the summer of 1973 at the Hayward Gallery in London under the aegis of the Arts Council of Great Britain. The exhibition explored far-reaching influences on traditional sculptural activity and transformations in imaging the human body at the turn of the century in the hands of such great modern sculptors as Rodin, Maillol and Matisse. When Professor Elsen suggested two years ago that we might be interested in a show designed to be a sequel to that one exploring an especially rich area virtually ignored in the recent annals of major exhibition work in this country, we were delighted to join forces with him and the results hopefully rectify in part the unfortunate absence of critical attention to areas of art history that this exhibition addresses. They are essentially the effects of war, social disaster, and swift technological change on artistic creativity in cataclysmic times when previously assumed understanding and usage of content and form in art were no longer serviceable to the best creative minds.

We are especially indebted to Albert Elsen for his insight and inspiration in organizing this exhibition. Working closely with him, Steven A. Nash, Chief Curator at the Gallery, labored tirelessly and, at times, seemingly against all odds to bring this viewing opportunity to our public. Samuel Sachs, Director of The Minneapolis Institute of Arts, and Henry Hopkins, Director of the San Francisco Museum of Modern Art, shared my enthusiasm from the start. The number of difficult loan requests fulfilled warrants special recognition of the role of individual lenders and institutions in shows such as this one.

Finally, important individual, foundation, corporate and public agency support enabled the exhibition to take place and we are greatly indebted to them. They are the Cameron Baird Foundation; the Members' Council of the Albright-Knox Art Gallery; the Henry Moore Foundation; and the New York State Council on the Arts.

ROBERT T. BUCK, JR.
Director
Albright-Knox Art Gallery

Acknowledgments

The research for this book was made possible by a Senior Fellowship from the National Endowment for the Humanities. The book and the idea for the exhibition would never have been realized without the support of the Albright-Knox Art Gallery, its Director, Robert T. Buck, Jr., and particularly the efforts of Chief Curator Steven A. Nash. The public is still largely unaware of what an exhibition such as this demands of museum curators in terms of being responsible for asking for loans of fragile and irreplaceable works, tracking down the location of sculptures that have changed hands and may not be in the literature, and finding equivalents for pieces committed to other exhibitions. Given the problems presented by a show of interwar sculpture, which is not strongly represented in American museums, the resourcefulness and tenacity of Dr. Nash and his staff are credits to the profession. It is an honor to collaborate with a museum that for so many years has shown such distinction in originating important exhibitions.

For the historical and cultural background of the period, I was both informed and influenced in my outlook by many authors, but principally by the following: Malcolm Bradbury and James McFarlane, who edited an important anthology, *Modernism*; Paul Fussell, *The Great War and Modern Memory*; Peter Gay, *Weimar Culture: The Outsider as Insider*; Irving Howe and others in *The Idea of the Modern*; H. Stuart Hughes, *The Obstructed Path*; Raymond J. Sontag, *A Broken World, 1919–1939*; and Stephen Spender, *The Struggle of the Modern*. Special thanks for bibliographic suggestions go to my distinguished colleague and Emeritus Professor of History at Stanford University, Gordon Wright.

In recent years a number of excellent monographs and articles have appeared on the major and minor sculptors working in the period and from which I have liberally drawn. They include Sidney Geist's brilliant books on Brancusi and Edith Balas's important articles on this artist; Reinhold Hohl's outstanding book and catalogue on Giacometti; Werner Spies's valuable study of Picasso's sculpture; Josephine Withers's important book on Julio Gonzalez and thoughtful essays on this artist by Leo Steinberg and Hilton Kramer; the richly informative and highly readable studies on Henry Moore by John Russell and David Sylvester; Jacques Lipchitz's own reminiscences on his life and art, intelligently encouraged and recorded by Deborah Stott and then edited by H.H. Arnason; Karin von Maur's important little book on Oskar Schlemmer; the

writings of John Elderfield and Werner Schmalenbach on Kurt Schwitters. The excellence of these monographic sources have encouraged the thematic approach in this book. Also of great help for this period were Jack Burnham's *Beyond Modern Sculpture*, which remains an imaginative and informative study of relationships between the history of modern science and modern sculpture, and William Rubin's *Dada and Surrealist Art*, still the finest integrated history of painting and sculpture for these movements. (This book inspired the question of what happens when we look at sculptors and sculpture without the labels of movements named after what were predominantly developments in literature and painting.) A personal model for the author was the late Robert Goldwater's brilliant short essay, *Space and The Dream*, which dealt with the intentions and themes of painters and sculptors in this period and generally treated artists on a par with poets by crediting them with having something to say.

A scholar can be helpless without the patient assistance of librarians, and I must credit our head librarian, Alex Ross, Margie Agramonte and the rest of the staff of the Stanford University Art Library for that necessary support without loss of humor. My indispensable partner in this undertaking was Patricia M. Elsen. Her tough-minded professional criticism and editing gave shape, sense and intelligibility where they were most needed. It is out of professional admiration and personal affection that I dedicate this work to Sidney Geist.

<div align="right">

ALBERT E. ELSEN
Stanford, 1979

</div>

Preface

Not since the survey *Sculpture of the Twentieth Century*, organized by Andrew Ritchie of the Museum of Modern Art in 1952, has any exhibition dealt in depth with the rich and complex development of European sculpture between the two World Wars, and no exhibition or publication, to my knowledge, has ever been devoted specifically to this time period and topic. A comprehensive examination therefore is long overdue, for the period encompasses truly a "golden age" of modern sculpture, in which innovative artists in several countries rebounded from the cultural and spiritual devastation of World War I and provided inspiring answers to such difficult artistic questions as "Where do we go after Cubism?", "How can sculpture reflect new modern realities?" and "What are the alternatives to the human body as a canon of form and beauty?" The present exhibition, originally conceived by Professor Albert Elsen and co-developed with him during two years of research and organization, as well as the book that accompanies it, are meant as explorations of the diverse sculptural ideas that arose in Europe in response to these circumstances.

A total of thirty-five artists are represented by roughly sixty works. The contents of the exhibition, while highly selective, are intended to provide a broad picture of the major creative forces at work during the era, and in only a few cases—as for example with Georges Vantongerloo, Joan Miró and Vladimir Tatlin—were artists of central importance omitted due to the impossibility of securing representative works for a traveling exhibition. In a number of instances two or more works by a single artist are included, but the attempt has also been made to balance the representation of well-known figures with work by important sculptors such as Kobro, Stenberg and Taeuber-Arp rarely seen in this country. It is felt that one of the exhibition's major contributions is the resulting opportunity for direct comparison between, for example, works by Brancusi and sculpture of similar puristic spirit by Arp and Hepworth, or the early Constructivist inventions of Stenberg, Rodchenko and Malevich and later Constructivist-inspired works by Pevsner and Calder, or the poignant reactions to war that Gonzalez, Picasso and Laurens expressed in their *Head of the Montserrat Crying II, Man with a Sheep* and *The Farewell*.

There are many problems attendant to organizing an exhibition such as this one, not the least of which are the astronomical costs of packing, shipping and insuring sculpture. These budgetary pressures made it imperative to draw as heavily as possible upon American collections, but conversely, the work of certain artists important to the history of European interwar sculpture is scarce in this country; even when locatable, there remains the problem that considerations of fragility and the irreversibility of damage to sculpture often make the securing of loans for a traveling exhibition difficult, if not impossible. For example, virtually all of Picasso's sculpture of the interwar period is tied up at this time in the artist's estate; to my knowledge, only one

Vantongerloo sculpture is in public hands in this country; and very few of Gonzalez's crucially important welded works or of the few known sculptures by the Russian avant-garde have entered collections in the United States. Almost all of Marini's and Manzù's pre-World War II production remains in Europe. Moholy-Nagy's seminal kinetic sculpture, the *Light-Space Modulator*, is in the Busch-Reisinger Museum but, somewhat typically of abstract sculpture of the period that drew upon new "technological" materials and means of construction, this work has not survived well and is now deemed too fragile to travel. The same can be said for most of the early works by Gabo now in America and also many of Calder's early constructions. In order to offset some of these difficulties, the decision was made to include a number of reconstructions and posthumous casts of lost or unavailable works. These are exhibited for their educational value and without any implied position on the part of the organizers on the questions of accuracy or justifiability they sometimes raise.

The organizational difficulties briefly outlined here make it all the more pleasurable to acknowledge those individuals who have made the exhibition possible through their cooperation and support, most notably the lenders for their generosity in allowing works in their care to travel and Albert Elsen for his untiring dedication to the project and his constant willingness to offer help and advice. It was a pleasure to work with the directors, Samuel Sachs and Henry Hopkins, and the curatorial staffs of the Minneapolis Institute of Arts and the San Francisco Museum of Modern Art, who are participating in the tour, and also with George Braziller, president of George Braziller, Inc., who skillfully guided the catalogue through publication. Many individuals helped with the gathering of photographs but special debts of gratitude are owed to Dr. Josephine Withers of the University of Maryland, Dr. Karin von Maur of the Staatsgalerie Stuttgart, Sidney Geist, Ann Cook of the Marlborough Gallery, New York, Lori Ciancaglini of M. Knoedler & Co., Nina Gabo, Dr. Louise Averill Svendsen of the Guggenheim Museum, Alan Bowness, Professor at the Courtauld Institute, and Henry Moore.

The task of editing and preparing the catalogue manuscript for publication fell into the extremely capable hands of Karen Lee Spaulding, the Gallery's Editor of Publications. Katy Kline, a former colleague at the Gallery, also provided valuable assistance with manuscript editing, while Annette Masling, Librarian at the Gallery's Art Reference Library, and Carol Nash assisted in the preparation of the catalogue bibliography. Kate Maynor and Carleen Ryan, students of mine in the Museum Studies course at the State University of New York at Buffalo, worked diligently on the compilation of several artist biographies and bibliographies. My secretary Angela Tomei typed much of the catalogue material, and special thanks are also due to Jane Nitterauer, the Gallery's Registrar, for coordinating the many loans and the shipping and insurance details, to Building Superintendent John Kushner and his able staff for their assistance in installing the exhibition, and to our Director, Robert T. Buck, Jr., for supporting the project through a number of troubled moments. Last but far from least, my very deep gratitude goes to the foundations and groups who provided financial support.

STEVEN A. NASH
Chief Curator
Albright-Knox Art Gallery

Introduction

This book was written to accompany the exhibition organized by the Albright-Knox Art Gallery in 1979. Both the exhibition and the book are sequels to the *Pioneers of Modern Sculpture* show and catalogue, produced in 1973 by the Arts Council of Great Britain. In the revised version of the Arts Council catalogue, titled *The Origins of Modern Sculpture: Pioneers and Premises,* the focus was still upon the new assumptions and ideas by which sculptors reacted against tradition and established the beginning of modern sculpture before 1918. The problems facing the artists, the influences on them, and the nature of the art during the period between the two world wars have suggested a somewhat different thematic approach for this book.

In *Origins of Modern Sculpture* the argument was made that the first revolution was largely one of form, undermining, thereby, the traditional and moral imperative of imitating nature in sculpture. There were also important developments in content, such as the search for a reality behind appearances and the enfranchisement of objects as subject for sculpture. Another important legacy for post World War I sculpture was the scope and depth of questioning itself. Tempered by the war and built upon the implications of the earlier revolution, interwar European modern sculpture was, arguably, even more innovative in its content, while achieving a stricter unity between content and form. Interwar sculpture knew unprecedented explorations of the self, the world and art, which led to fruitful formal audacities.

Despite a number of outstanding monographs on major sculptors and the Dada and Surrealist movements, we have missed overviews of this great period in modern sculpture. This exhibition and book are attempts to stimulate thought in this regard. What is here offered is an interpretive study, not the last words on the subject but some of the first.

At the outset of this study, the author's broad questions were: what was the impact of war and revolution on sculpture of the time; just how revolutionary was modern sculpture and what really happened to tradition; what were the aspirations, international in scope, of sculptors if we look at them free from the labels of movements; what happened to the figure and what were sculptors' intentions for abstraction; and was there a separatist movement to find what was exclusive to sculpture as opposed to painting, as formalists have claimed? In studying the artists and their work, it became apparent that the questions with which they struggled enriched the field of inquiry and gave drama to interwar sculpture.

Gabo put the question most frequently asked by sculptors after 1918 thusly: "After Cubism levelled Art to a 'conglomeration of ruins,' we had a dilemma to resolve, whether to go further on the way to destruction or to search for a new basis for the foundation of a new art?" Schlemmer searched older art for a "canon" that would inspire an image of the human figure appropriate to the postwar modern age. Hepworth searched for an "other order" by which to image the figure in a personal way. Arp sought a humane vision of man in har-

mony with nature. Brancusi wondered, "How do you get away from heavily loaded sculpture and create winged liberated beings?" Max Bill sought the answer to how sculpture could make his fellow man feel at home with science. Gonzalez wondered how sculpture could counteract an "overly mechanized society."

All the artists asked what was truth; what was reality. Gabo asked himself how sculpture could aid in the comprehension of the universe, and Calder speculated on how the systems of the universe could be made the basis of sculpture. Many sculptors searched for the means of making space more integral to sculpture and even be its subject. The Constructivists sought alternatives to inspiration and feeling as the basis of art. They and others, such as Arp, questioned whether individuality was still defensible in the new postwar era. The problem of the sculptor's relationship to society vexed most of the artists. Bellmer asked how the artist should act in a "scandalous world." Schwitters and Arp wanted ways to free man from fear and chaos. Lipchitz and Picasso sought to make sculpture more responsive to their processes of thought, to be thought's medium. The measure of importance in art is often supplied by the magnitude of the problems with which the artist was confronted. By such a standard and the artists' responses, this was a major period for modern sculpture.

Given the questions on which this study is based and the limitations of space and time, it is vulnerable to the criticisms that more was not done to integrate the sculptures "into the flow of events," that the relation of sculpture to painting and the other arts was insufficiently dealt with, and that certain sculptures were omitted. So be it, and perhaps this study will contribute to such future integrations. There are several occasions in the text where sculpture referred to was made either slightly before or after the dates of the title, which should alert the reader that the period 1918 – 1945 is not hard and fast. The Russian Constructivists are dealt with as a group, but there is no attempt to add glue to the existing labels of movements such as Dada and Surrealism. To what extent a certain artist is or is not a Surrealist is left to seminarians and dissertation writers. Many of the artists discussed were primarily painters, and one in particular, Otto Freundlich, did only two large sculptures in the interwar period to my knowledge. Their inclusion is justified on the grounds that this study is about modern sculpture, no matter who made it. Neither in the book nor exhibition have "Surrealist objects" been included. We agree with William Rubin that those who made these objects were not engaged in an "essentially sculptural activity."

The period this book is concerned with is bounded by two events that today do not have for those born since 1945 the apocalyptic associations they held for people who lived through one or both world wars. These events did much to shape the attitudes of the artists involved with them and who survived. The cultural historian, H. Stuart Hughes, argues, however, that in the case of France, 1929 constituted the end of a great intellectual tradition begun in the last century that was followed by a movement extending into the sixties. The situation of modern sculptors working simultaneously in different countries is arguably different from that of writers and other intellectuals working in one, and a comparable break in sculpture during the Depression, even in France, is not apparent. Modernism came later to sculpture than to painting and literature. Its beginnings, while recognizing the pioneering efforts of Rodin and Degas, occur roughly between 1909 and 1917.

The case for the isolation of the period 1918 – 1945 also rests in part upon the accidents of birth and the personalities of the artists who gave this time span its identity in sculpture. To the company of major artists active in sculpture before 1914 and who continued in the postwar era, such as Barlach, Maillol, Matisse, Brancusi, Picasso, Archipenko, Lipchitz and Epstein, were added during the First World War, Laurens, Tatlin, Arp, Vantongerloo and Gabo. After 1918, all of the foregoing were joined by a constellation of exceptionally gifted artists who either began as sculptors or turned from painting to sculpture. They included Schlemmer, Schwitters, Bellmer, Pevsner, Giacometti, Gonzalez, Ernst, Moore, Hepworth, Nicholson, Manzù, Marini and Calder. (Calder is included be-

cause his signature art is unthinkable without European sources, and he frequently lived, worked and exhibited in Paris during the thirties.) With all respect to the many fine European sculptors who came to prominence after 1945, the glories of post-World War II European sculpture have come in large measure from the later efforts of Picasso, Giacometti, Moore, Hepworth, Arp, Pevsner and Miró. For all of the artists named, there is little question but that their assumptions, styles, ways of making sculpture, even their themes, depend upon the pre-1945 period.

If one could select a single sculpture and prophetic statement made before World War I that sets the stage for much of the most important achievements of interwar sculpture, one could not do better than to choose Duchamp-Villon's marvelous plaster *The Horse* of 1914 (fig. 1), and the sculptor's own words that help us to fathom his intention: "The sole purpose of the arts is neither description nor imitation, but the creation of unknown beings from elements which are always present but not apparent." Duchamp-Villon foresaw correctly the turning away from the imitation of nature in sculpture and a new form of poetic metaphor. If he had lived beyond 1917, Duchamp-Villon might have recognized his "unknown beings" in Arp's *Concrétions*, Lipchitz's *Figure* of 1926 – 30, Picasso's *Woman in a Garden*, Gonzalez's *Cactus Man*, Giacometti's *Hands Holding the Void*, and Henry Moore's reclining figures of the late thirties. It was Brancusi, however, in his carved wooden sculptures begun during the first war, who independently introduced "unknown" or imaginative figural beings in this period.

The "Other Realities" of the book's title comes from the impact of modern science on the thinking of sculptors, as well as from the earlier reaction of artists against positivism. The sculptors believed they had the license to image worlds within worlds either by means of the human figure or abstraction. This is the first major period in western sculpture in which man was neither the measure of all things nor central to all important sculpture. When we immerse ourselves in the period, it becomes clear that for most sculptors abstraction was about something, other than itself, namely, the artist's vision of a reality other than the visible world. A literal, materialist, or purely formalist art constituted a distinctly minority objective, if indeed it existed at all.

What gives a period its identity are shared and contradictory values. Their identification has been one of the objects of this study. In terms of the artists' intentions and their works, the most distinctive characteristic of modern European sculpture between 1918 and 1945 appears to have been the incentive to unify rather than polarize, to fuse and connect rather than discriminate differences. A wounded humanity was offered a healing vision of wholeness in sculpture. Emerging from war and revolutions, new and old countries were offered what artists believed were models of constructive acts. Self-expression cohabited with the ideal of anonymous service to society. What made possible in sculpture the previously unimaginable, the "unknown beings," new unities, "other" orders and realities, were abstraction and the poetry of the new sculptural metaphor that compacted imagery without regard to probability.

Stanford, 1979

1. The Figure in Interwar Modern Sculpture

By 1918, in figural sculpture the traditional "canon" of the human form had been discredited for many of the most thoughtful and venturesome sculptors. In all periods and styles of European sculpture before the twentieth century, the norm had been to show, either by schema or as descriptively as possible, the *external* appearance of the human body; this is what here is meant by the "canon." Traditionally, expression in figural sculpture derived from the sculptor's illustration of the subject's thoughts and feelings by means of facial and gesticular articulation. The identity of the figure came not only from its title, but often from the use of costume and objects that were attributes or symbols. From the Renaissance the proportions and order, or composition, of sculpture were basically generated by the living human form or its ideal, which in the latter case meant that the artist engaged in a selective imitation of nature. The model's deficiencies could be corrected by recourse to approved artistic models of beauty from such paradigmatic periods as classical Greece. An artist's personal values concerning the human figure could be manifest in his style as well as in what he caused the figure to do.

Traditionally, sculptors had the role of vivifying heroes and heroines from history, the Bible, and other literary sources. Sculpture brought the dead to life in even more palpable form than painting. It served to edify society by presenting in the figure appropriate models of physical, intellectual and spiritual culture. Since antiquity, with its commemorative portraits of victorious athletes and the portrait bust, sculpture was a form of immortality for its subject. Whether in public places, chapels or the home, sculpture reminded the living of the past and the dead. For the great and not so great, sculpture was an irrevocable passport to the future.

Before 1918, it was the pioneers of modern sculpture who questioned the canon of the body's external appearance as the basis for their art. With the partial figure, Rodin rejected the demand for anatomical wholeness and proposed that sculptural completeness was more important than conventional finish. Celebration of the flesh and anatomical exactitude were disdained by Degas and Matisse, who found expression in the whole arrangement of their figures. Brancusi stripped away what seemed the body's outer layers to reveal a purified form that came closer to the Platonic ideals of academicians and their pronouncements on the essential than they could have dreamed of. Duchamp-Villon redesigned the figure to make it more formally taut and efficient, believing that concision was the basis of a modern esthetic. Epstein and Gaudier found sources for the figure in tribal art, hoping to

1. Raymond Duchamp-Villon, *The Horse*, 1914.

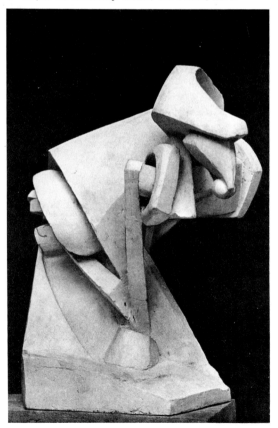

restore sculpture's lost power of expression. Following the initiative of Picasso and Braque in Cubist painting, Lipchitz and Laurens developed Cubist sculpture, in which invention replaced imitation; and the precedent of evoking the body by indirection, through clues or equivalents, had begun. The syntax of the body was upset by Laurens, and Lipchitz destroyed the separation between the figure and the object it held (fig. 2). The very separateness of the living body from the space around it was broken when Boccioni, Archipenko and Lipchitz brought space within the figure's customary limits. In 1917, Gabo made stereometric cellular busts and torsos which honeycombed the body with space. Except for Rodin and Degas, all of these sculptors had given up working directly from the model, preferring to assert mind over matter, which meant working from their imagination in developing a personal body image.

The consequence of this formal revolution was to strip the human form in sculpture of the culture of nudity, literary or historical identity and rhetoric — to remove its familiar appearance as well as its purposes. The "canon" had become meaningless, inhibiting to new ideals of creation and irrelevant to the expression and style required of a new century.

Alongside the revolutionaries, however, reformers such as Nadelman, Maillol and Barlach wanted to impose their own thought and style on the figure, while continuing to observe the canon. All shared with the revolutionaries a desire to simplify the figure, to cleanse it of technical virtuosity and congested rhetoric. Maillol (fig. 3) and Nadelman sought to continue the tradition of beauty on their own terms, and Barlach wanted to revive the spiritual power of medieval German sculpture to express the trials of the human spirit. There were no more striking sociological polarities in interwar figural sculpture than Nadelman's urban dandies and Venuses from the circus that he made in America and Barlach's restless, suffering peasant types. Maillol did not waver in his dedication to remaking basically the same sculpture of full, sensual and placid beauty that would bring peace and joy to those who contemplated his art.

In Italy, between the wars, two young

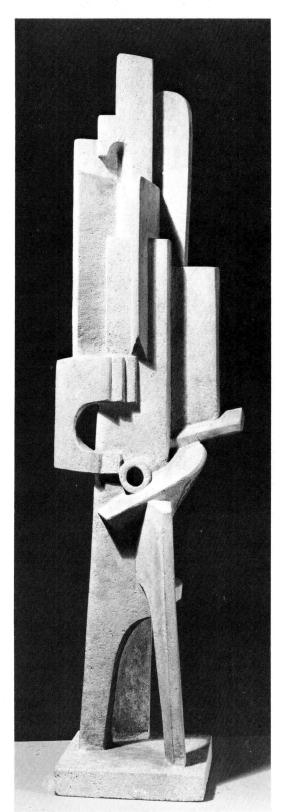

2. Jacques Lipchitz, *Man with a Guitar*, 1915.

sculptors stand out who succeeded heroically in finding their identities as sculptors working from the human form in manners opposed to the crushing forces of tradition. Both were aware of the revolutions in figural art taking place in Paris, for example, but chose to go back to the living model. Etruscan art, rather than that of the Greeks and Romans, helped to reinforce Marini's challenge to the facile virtuosity and mannered figural art that afflicted Italian sculpture after Boccioni (fig. 4). With Marini, Manzù represents part of the conservative spectrum of modern sculpture, which admittedly deserves more attention than is here given.

With the breakdown of traditional figural art and the emergence of abstraction in painting and sculpture by 1918, it is a fair question to ask why the new postwar generation did not cease completely to employ the figure in sculpture. Nothing so symbolized the hated tradition against which interwar artists rebelled than the nude in art. The very word became an epithet. It had come to symbolize middle class taste stifling art school tuition, and mindless artists who covered intellectual poverty with technical virtuosity. After the "canon" for figural sculpture was discredited, many artists were faced with an historically unprecedented situation: the imperative of *reinventing* figural sculpture. The choice of sculptors hereafter discussed in connection with the figure was made on the basis of their awareness of this challenge and their acceptance of it.

Schlemmer's Search for a New Figural Canon

After World War I, Oskar Schlemmer's efforts as a painter, sculptor and choreographer followed the tradition of the artist seeking to show Man's hope for the good life. Unlike Lehmbrück, he could not come to terms with the war, in which he had been seriously wounded, by imaging its tragedies. Like many other postwar artists, Schlemmer saw the need for an art that would help society counteract the catastrophe of the war and the bloody revolutions in Germany by directing attention to the future's promise. With the medieval guild system as a model, Schlemmer and his colleagues at the Bauhaus sought to coordinate

3. Aristide Maillol, *Torso of the "Ile de France,"* 1921, [cat. no. 38].

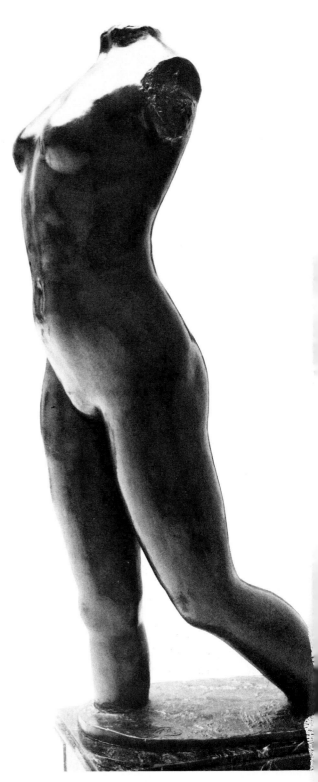

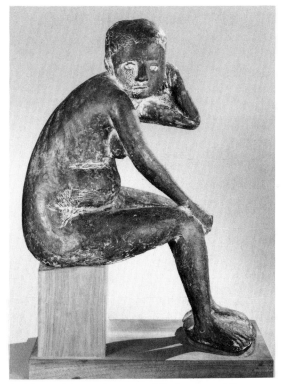

4. Marino Marinî, *Susanna*, 1943. [cat. no. 41]

5. Oskar Schlemmer, *Abstract Figure*, 1921, cast executed 1962. [cat. no. 56]

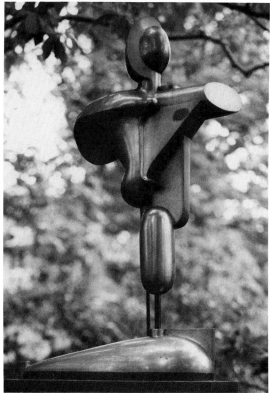

the arts and make them socially responsible rather than at the service of the artist's ego. The Bauhaus faculty in 1923 privately viewed itself as a "cathedral of socialism." Unity was their sacred concept for a society where so many believed God was dead. If men could love, respect and work harmoniously with one another, they could rebuild the world without the help of a deity. In the absence of a monistic tradition, could the artist create an image to inspire such a faith? What should be the sculpture's subject? In 1923, Schlemmer wrote:

> ... in the irreligious world of today, the arts concerned with great themes — as monumental painting and sculpture are — stand particularly forsaken. The foundations which once supported those arts — national conscience, ethics, religion, have been shaken or have crumbled. The new ideas are in the throes of birth—disputed, unrecognized. Nevertheless, there is one great theme remaining which is ancient and yet eternally new, a subject for artists of all times—Man, the human figure . . . the measure of all things[1]

To image Man rather than men, Schlemmer emulated the search for a canon in the manner of Vitruvius, Leonardo and Dürer. Schlemmer's early reliefs, intended to harmonize the figure, sculpture and architecture, and his *Abstract Figure* (fig. 5) show his drive to a willful style which rejected the "illusionism" of the submission of sculpture to nature's appearances. These works assert that, after learning its laws, human intelligence could "master" nature and give society an imaginative model of the ideal modern Man. Schlemmer and French academicians before him called such a normative conception the "type," which represented in Schlemmer's case not physical perfection so much as mastery of emotions and avoidance of excess. By the precision of its form, Schlemmer's normative freestanding figure implies that Man should move confidently, boldly in any space, for he is the measure of all things. It also asserts the potential for a unity between man and himself, other men, his newly engineered environment, measured or infinite space, and the cosmos. The paradigmatic figures of Leonardo and Dürer were set in circles, which may or may not have symbolized the relation of the perfect human being to God. Whether by conscious design or coincidence, Schlemmer's *Abstract Figure* has a head that from one side seems to be embedded in a halo-like sphere.

Schlemmer's figure showed nature redeemed by geometry, man transformed by art and intelligence. As it did for the Belgian sculptor Vantongerloo and Polish artist Kobro, mathematics represented for Schlemmer an artistic tool, a trigger for his imagination that provided him with poetic form rather than a codifiable system such as that of the Greeks or Egyptians. Geometry gave Schlemmer his art of simple forms, the body in art purified of eclecticism or vestiges of past styles.

Abstract Figure confirms that its maker was heir to the pioneers' premise that the spirit or logic of a sculpture, not the laws of anatomy, would determine the number, shape and arrangement of its parts. Schlemmer had looked hard at the work of Archipenko, which was very popular in Germany in the twenties, and at the Cubists. Whether in relief or in the round, his forms recognized no separation between inside and outside, for space was a partner, not an adjunct to sculpture. In this attitude he announces the interwar preoccupation with and celebration of the marriage of form and space. Schlemmer's drawings of the early twenties and his later wire sculptures, which go far to dematerialize the human form, anticipate the later tubular and wire sculptures of Picasso and Calder.

Schlemmer's art has too often been read as machine-inspired and its maker's talents and complex personality have been underestimated. Like his sculpture in the round, the artist is himself full of surprises, as full of contrasts as the convex-concave, stacked and fused, sensuous and flat forms that interweave his structures. Looking at *Grotesque* (fig. 6) against *Abstract Figure* or seeing Schlemmer's *Triadic Ballet* figures and the artist himself as a clown on stage confirms the polarization of his mentality between the sublime and the ridiculous, the rational and the irrational.[2] Schlemmer, the metaphysician, inspires Schlemmer the technician. Yet, Schlemmer distrusted the machine as much as abstraction. He wanted his art to "unhinge" material reality, and he came to look upon his creations as mythical beings. As so often happened to modern sculptors who aspired to replace discredited religious art with one of their own devising, Schlemmer found no supporting cult. This may have been one reason why the theater and dance appealed to him and other sculptors like Gabo and Pevsner, Picasso and Arp, and later Calder.

The fact that Schlemmer made relatively few sculptures may have been because he felt that they did not sufficiently convey the unity of form and spirit or fuse with life. He shared the Bauhaus dream of total art. His dancers donned costumes like those of *Abstract Figure*, who was a kind of "dancer-man." Notice how in the old photographs of the plaster original of this sculpture, seen with artificial lighting, the vertical rod that supports the figure above its base is invisible, and the form, which could turn, seems to float in light and space, just as did the dancers. Schlemmer's theatrical gifts have been recognized and his sculpture again appreciated only recently. Like Elie Nadelman in America, he was an idealistic artist, a perfectionist, who could not transform himself and his art when the times betrayed his hopes.

Bellmer and the Pygmalion Dream[3]

The Pygmalion dream helped to create two Western traditions of figural art in the round. The most important and visible one in art history books and museums is that of the "fine art" of figural sculpture in stone and bronze. The second, a sub-tradition, was that of automata, that goes back to the Egyptians and reaches its peak of ingenuity and technical brilliance in the eighteenth century in the work of men such as Vaucanson, whose mechanical duck could make the appropriate noises and both ingest and excrete actual food. The clockmaker Jacquet-Droz made a mechanical android in the form of a boy who could write, and almost two centuries before Tinguely's "meta-matics" made abstract drawings, this same inventor, assisted by Leschot, a "mechanicien," made an automaton that could draw four subjects.[4] These automated figures were considered mechanical wonders or objects of curiosity that are assignable to the history of mechanics rather than what in the eighteenth century came to be considered "fine" art. There is a rich literary tradition in which the imaginations of writers since antiquity conceived golems, homunculi or marvelous androids that baffled and destroyed

young men and women who fell in love with them. E.T.A. Hoffmann's Olympia and Viller de l'Isle Adam's Halady (made by an inventor named Edison) epitomized the "soulless humans" and were reincarnations of Pygmalion's Galatea, providing their lovers with longed-for passive partners obedient to every amorous whim. The use of the most sophisticated mechanics to create robots exemplified a confidence that man could master his environment through technology. What unites the traditions of "fine art" and automata is the Promethean urge to rival the gods by exploring the secrets of life and recreating it.

Since at least the time of Dürer, artists employed wooden mannequins as aids in the study of postures and movement. These articulated dummies were helpful in assisting artists to calculate the possible in art, and always the intention was for the artist to conceal his source by making the resulting painted or carved figure seem to be of flesh and blood. It is in the twentieth century that the automated source becomes perceptible in the finished work: De Chirico's paintings of mannequins that parody the actions of human lovers, Léger's evolution of robot-like figures in his paintings and film, *Ballet Méchanique*, Elie Nadelman's humanoid sculptures derived from dolls (so eloquently discussed by Lincoln Kirstein),[5] the making of marionettes by Jean Arp and Sophie Taeuber-Arp, and in Russia by Alexandra Exter, and the Surrealists' employment of fashion mannequins with other found objects. All occurred when "the canon" based on the imitation of nature was overthrown and artists were pulverizing the categories of drawing and sculpture, art and non-art. The obsession with style and manifestation of artifice recommended inspiration in automata.

It is probable that Duchamp-Villon's *Seated Woman* of 1914 derived directly from a studio mannequin of polished wood, while after the war Schlemmer's canonical *Abstract Figure* was inspired not only by the study of dance costumes, but also by dolls and puppets. His *Triadic Ballet* (so named for its three acts and three characters in three differently colored costumes) involved sham robots (fig. 7). Schlemmer costumed his dancers in the form of geometrized metallic figures, perhaps to

overcome the stigma of the "soulless humans" attached to automata. There is no doubt that Schlemmer saw the 1916 German film *Homunculus,* in which a chemist makes a human being from a retort with the aid of an assistant, who befriends the tragic creature. (That the chemist's assistant was named Rodin was hardly a coincidence.)[6] In a 1923 manifesto for the Bauhaus, Schlemmer wrote, "Man, self-conscious and perfect being, surpassed in accuracy by every puppet, awaits results from the chemist's retort until the formula for 'spirit' is found as well."[7]

It is in the audacious dolls of Hans Bellmer, between 1933 and 1938, that there is a culmination of the fusion of automata and sculpture.[8] In his life are found all the ingredients of the Weimar Republic drama of a gifted son rebelling against the tyrannical father and his culture. His childhood fantasies of magic power were encouraged by his mother, whom he adored. In adolescence he felt him-

6. Oskar Schlemmer, *Grotesque*, 1923.

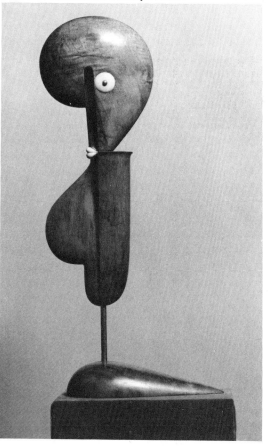

self tormented by young girls. His career led from the engineering training imposed by his father into middle class respectability in the advertising profession and finally to giving up all that was "useful" and respectable in favor of the "useless" and "scandalous." Overlooked by historians of automata and German social history, Bellmer's emergence in 1933 as a gifted erotic artist marks a coincidence of personal and cultural crises. Boredom with respectability and commercial routine combined with hatred of his engineer father and his father's hero, Adolf Hitler, contributed to the making of Bellmer's first doll, after seeing Max Reinhardt's production of *The Tales of Hoffmann.* She was patterned after his adolescent cousin, Ursula, with whom he was infatuated. This first *poupée* contained a "crystal" within the womb which was revealed when the viewer (voyeur) touched one of the doll's breasts. The crystal revealed in turn several images or "panoramas," including one of a sinking ship and another of a handkerchief covered with an adolescent girl's spittle. The doll was demountable, and Bellmer photographed it disassembled in a variety of sexually and sadistically provocative ways, which in real life could have been achieved only through murder[9] (fig. 8). Figural sculptures inspired by murderous fantasies had been made a few years earlier by Lipchitz and Giacometti, and yet no sculpture of the interwar period so frankly reveals the aggressive candor with which modern artists sought to break through society's sexual inhibitions as does Bellmer's. As a child and when an adult, Bellmer saw himself as the "magus of the prohibited." His training as an engineer made him a technician of the improbable, ironically subverting German optimism concerning technology and the machine and putting it at the service of researching what he rightly termed the "anatomy of desire."

Bellmer's earlier contacts with the German Dadaists, Grosz and Dix, who warned that the artist must always be a "savage critic of society," came to fruition years later. It is too often forgotten that under the "repressive" middle class morality of the Weimar Republic and the early Nazi years there flourished a subculture dedicated to the perverse and sadistic, which

Bellmer could have witnessed first hand in Berlin and have read about and seen in German films, including *The Metropolis,* which vividly dramatized the themes of making and loving robots and filial defiance of the father. That Bellmer created his dolls while living in Berlin until 1938 constituted one of the most dramatic acts of defiance against Nazism in modern art and exemplified his culture's dual attraction to mysticism and cruelty.

In 1936, a second doll was conceived and executed which allowed greater rearrangement of feminine anatomy. It was inspired by the example of ball-jointed dolls attributed to the School of Dürer in the Berlin Kaiser Friedrich Museum. This work, cast in aluminum only in 1965, consisted of two pelvises attached by a ball joint that permitted manipulation (fig. 9). The double pelvises heightened the mobility of his sexual fantasy. Bellmer had observed that from close up details of the body evoked analogies with other anatomical parts, so that an inverted pelvic area atop the stomach could resemble breasts. (In at least one photograph,

7. Oskar Schlemmer, *Glass Dance,* from Schlemmer's *Triadic Ballet,* 1929.

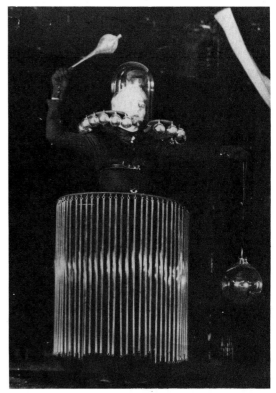

it is apparent Bellmer had added a head to the upper part of the second doll.) Bellmer discovered new "realities" of personal body imagery through meditations on and permutations of the sculptures, and he became convinced that "an object that is identical with itself is without reality." "Amorous anatomy," he found, differed from "physical anatomy," and "the human being's immoral drives are motor forces of the finest kind that impel him to something exceptional."

The Machine Gunneress in a State of Grace (fig. 10), made in 1937 and known as the *Düsseldorf Vampire*, was a sexual mechanism that metaphorically thumbed its nose at the machine in the service of utility and science. Like a telescope or machine gun, the sculpture's wooden frame was moveable into various positions, aiming its irreverent message at the artist's assorted enemies.[10]

In his study of the Weimar Republic, historian Peter Gay writes of the German intellectuals' hunger for "wholeness."[11] Bellmer represents those courageous individuals who wished

to go further than Freud and Jung in examining human drives in order to understand the darkness or most unexplained sides of their nature.

As a sculptor, Bellmer's audacity was not in giving art a new esthetic; for there is no distinction between his craftsmanship and that of Swiss doll makers. There is an almost "academic" realism to the formation of the parts of the figure. His daring lay in violating the body's syntactical structure and carrying thematically the partial figure into areas undreamed of by Rodin. His brilliant technical facility and seeming indifference to esthetics appealed to the Surrealists, who joyfully published his photographs of the doll in *Minotaure* in 1934 with the title, "*Poupée, Variations on the Assembling of an Articulated Minor.*" The Paris Surrealist writers and painters in the thirties had been working with mannequins and other found objects to establish what they called "the crisis of the object" and, thereby, to throw knowledge of the body into question by imaging it in terms of love and hate. Bellmer's brutalized mannequins, thus, found welcome

8. Hans Bellmer, *La Poupée*, 1934.

9. Hans Bellmer, *La Poupée*, 1936, cast executed 1965. [cat. no. 8]

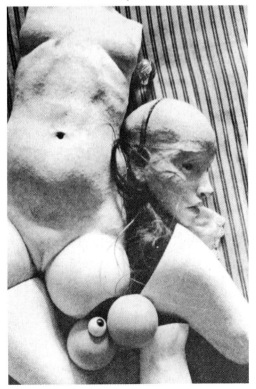

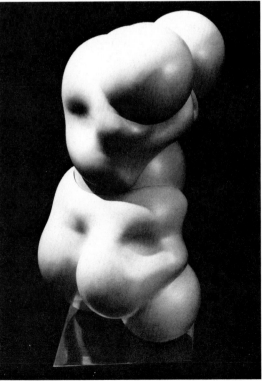

in the Surrealists' war on the stultification and hypocrisy of bourgeois morality and documentation of the inner life.

Spiritually, Bellmer's private cult figure belongs with the pneumatic looking automatons fashioned by Nadelman, who disdained working directly from the model in favor of types found in dolls or in photographs of the depersonalized women in circuses and chorus lines. Overlapping in time and closer in sexual inspiration are Gaston Lachaise's erotic partial figures, whose passionate proportions and anatomical contractions were modeled into personal fertility goddesses.[11a] These modern cultless idols replace images of Venus and the Virgin, which had become clichés of figural mastery in the hands of nineteenth century artists like Gérôme. In fact, Lachaise's objective was the modernizing of Venus, not as a subject for religious and public veneration, but rather for understanding the self and the celebration of life.

The aggressions of candor committed by Bellmer, Lachaise and others were against classical humanistic values of moderation and dignity and such norms as a "healthy," natural, beautiful body in art. Perpetuation of a discredited figural narcissicism patterned after Renaissance ideals would have been hypocritical, if not unthinkable, for these artists. Woman as a sex object or fetish figure, reshaped, reproportioned, turned inside out, mechanized, brutalized, mindless and soulless was the cost of an art that probed the unexplored recesses of intimate body imagery. The personalization of sculpture in their hands demanded the dehumanizing of the opposite sex in art, but what they created were always recognizable as fictions. Bellmer's wife helped him make the first doll, and Lachaise passionately loved his sympathetic wife all of his life. Art afforded them the realization of sexual excess and the adventure of trespassing cultural posted areas. Ironically, it is recent sculpture, the life casts of Segal, Kienholz, Hanson and de Andrea that cause us to look again at Bellmer and recognize that his sculptures are not "documents" of sexual research. The overwhelming nature of their subject interferes with the cognition of any formal values, which is consistent with the artist's intent, but which obscures his high artistic consciousness.

The Simple and Indirect Figures of Brancusi

During the years of the First World War, Brancusi was like a scientist, seemingly oblivious to the cataclysm at the front and working productively in his Paris studio on the implications of inventions he had begun to make in 1907. Since he was a Rumanian, he did not have his work interrupted for military service; and he had developed the distinctive modes of his art and most of his motifs by 1918. Thereafter, while adding a few new subjects, mostly animals and women who inspired portraits, he devoted himself to refining and resolving ideas begun before the end of the war.

Brancusi was a model of the quiet revolutionary who reacted against yet respected tradition, partly for the discipline it gave him in carrying out his rebellion. His hope was for an art that would impart spiritual joy as well as esthetic pleasure. His vision of a modern art led him to simplify, purify and unify. He thereby gave his fellow man a comforting and uplifting view of life, not an incentive to die in emulation of the stone heroes that had tenure in cemeteries and public spaces. Rather than dividing men by artistic appeals to the fatherland, Brancusi created an art that could not be typed as coming from a given country. He sought to image the *essential* in nature or "the true sense of things," evoking the reality that lay behind surface appearance yet was apprehensible by thought and intuition, through a style that looked as if it belonged to the twentieth century.

Brancusi posed the crucial question of what sculpture could do without. His dramatic answers meant the uncomplicating of a tradition that had in his view become "overloaded" by virtuoso feats of replicating appearances. Rodin had earlier answered the same question with the partial figure, showing that a complete work of art need not presuppose the whole figure. In his own series of torsos, beginning in 1909 and extending into the twenties, Brancusi amplified Rodin's ideas, reiterating that the claims of form overrode those of resemblance. His *Torso of a Young Man*, 1916 (fig.

11), and *Torso of a Young Girl II*, 1922, gave the motif greater formal self-sufficiency, and the purification of their forms led to a poetic ambiguity. He had found that the simpler the form, the more that could be said, for as Sidney Geist has observed, the second version of a girl's torso "suggests a precariously balanced container — the womb."[12] Brancusi had led sculpture into a world of what interwar artists liked to refer to as "primal" or "elementary" forms of an organic nature which lent themselves to associations or new unities between species or between the body and its own organs. One of the most obvious examples of the provocative simplicity of Brancusi's purified forms was the *Princess*, the bust of a woman that was withdrawn from the Salon des Indépendants in Paris in 1920 as being too phallic. Thus, Brancusi went beyond even Rodin in breaking with the public's expectations both of probability, or correspondence of the image to its source, and propriety.

The new sculpture he proposed was an art of simple forms that he could complicate and uncomplicate, that verged on but seldom became totally abstract. He broke with classical beauty and tradition by introducing indivisible forms that, even when conjoining two or more anatomical parts, as in *Flying Turtle*, did not lend themselves to parsing. Essential to these developments was the indivisible or continuous single surface. This textureless surface, when brought to high polish, induced light, space, and the immediate environment into the sculpture. Despite using marble and bronze and retaining the monolith in his sculpture, he reduced the sense of great weight, mass and gravity. He detested salon and cemetery socles and invented the sculptural base, whose utility was such that it could serve in a supporting role, as a sculpture in its own right or as furniture in the studio.[13]

Brancusi's legacy to younger interwar sculptors was both a new formal awareness and awareness of new form, resulting from the imposition of a relentless intellectual self-discipline. His high finished bronzes and marbles helped establish a new "machine" esthetic, although there is no evidence that machines inspired the sculptor. That he did his own carving and personally finished his bronzes interested those who, like Henry

10. Hans Bellmer, *The Machine Gunneress in a State of Grace*, 1937.

11. Constantin Brancusi, *Torso of a Young Man*, 1916 (?).

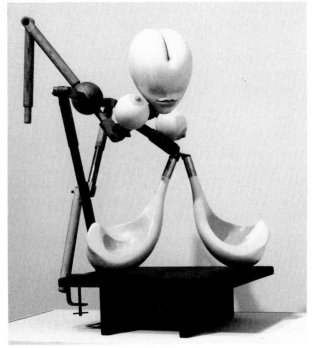

Moore, desired to rehabilitate the do-it-yourself, truth-to-the-medium tradition. Brancusi was one of the pioneering modern sculptors who acknowledged African art as part of world sculpture; along with Rumanian folk art, these primitive sources did much to remove Brancusi's inhibitions with regard both to foregoing the imitation of nature and turning to carving. One of the fruitful paradoxes in Brancusi was his ability to synthesize "primitive" craft and decorative abstraction with a twentieth century machine age esthetic.

Brancusi's subjects were for the most part traditional, inspired by contacts in his personal life, but also drawn from literature and myth, as well as the art of his contemporaries. He carved his first *Torso* directly from a model, but *Maiastra* was inspired by the "Golden Bird" of a Rumanian myth; *The Kiss* came from his unrequited love for a woman; and the *Sleeping Muse* series came out of Rodin. The sculpture united self-expression (Brancusi admitted he was *The Cock*) and exploration of the world and its hidden realities. It was in the carved wood sculptures that we see the more cryptic side of Brancusi's fantasy, which produced his "unknown beings," *Prodigal Son* (perhaps a self-portrait), *Chimera*, *The Sorceress*, *Adam and Eve* and *King of Kings* (fig. 12). The work in stone and bronze still permits us to recognize the motif in nature from which the form was abstracted. Except for *Torso of a Young Man*, he liberated his wooden beings from anatomical laws. In them he made an imaginative leap beyond substitution and amputation, avoiding the obvious geometrizing of body parts while maintaining their sequence if not number, as was often Archipenko's style. Unlike the latter, Brancusi offers us no projection principle by which to calculate how he arrived at these forms. African art offered him extreme examples of the figure's simplification or schematization and, stylistically, the precedent for the strong accenting of each part; but no tribe would recognize *The Sorceress's* hooded head being trailed by cylindrical breasts.[14] While his wooden feminine figures proclaim their sex, the male personages, *Prodigal Son*, *Adam* and *King of Kings*, are not comparably endowed. (The sex of *Torso of a Young Man* resides in its overall configuration which replaces the missing genitals.)

One of Brancusi's most ambitious and frustrating sculptures to complete was *King of Kings*. The seriousness of his intent and the personal importance of its enigmatic character are beyond question. It was originally conceived in the early thirties for installation in a "Temple of Meditation" the Maharajah of Indore proposed to build in 1933. The original title was *Spirit of Buddha*, but it was later changed, presumably after the artist found the temple would not be built. *King of Kings*, according to Geist, is an allusion to Genghis Khan.[15] The staggering polarity of associations in the two titles makes the sculpture's reading and conjecture about its meaning for the artist all the more intriguing. Interpreting the sculpture, Geist notes its reprise of some of Brancusi's favorite forms and motifs in wood and goes on to say, "Though the two upper elements have the appearance of a head and a flame-like crown, Brancusi may have attempted a version of a Tibetan *Ch'orten* [a Buddhist architectural structure] which symbolizes in ascending order: earth, water, fire, air, ether." After citing the reference of the title to Genghis Khan, Geist sees the head as having a "forbidding character." (Without the allusion to Genghis Khan, would the head still seem forbidding?) Edith Balas cites its origins:

> Rather than assembling actual separate components in the studio, he carved from one piece of wood an object whose formal elements were assembled in the artist's mind. So the lower element of *King of Kings* has a strong formal empathy with Rumanian folk objects such as chair backs and a screw of a mill part which could be found in Brancusi's studio; its central part resembles Oltenian porch pillars; its "neck" resembles a mug; its head a folk mask; and it is crowned by what seems to be the upper portion of a funerary pillar.[16]

In Duchamp-Villon's terms, *King of Kings* was an "unknown being" made from elements "always present" for the artist, but "not apparent" to us. The modern and creative aspect lies in Brancusi's having achieved a figure by indirection. It is only the upper parts that, when isolated, suggest anatomical alternatives to their location in the whole. Some of these carved motifs had previous histories with vary-

ing associations and uses. Such inconstancy is characteristic of modern art in general, as are the importance of context for the significance of a motif and the changeability of the artist's own interpretation. It is, therefore, only from the vertical alignment of the disjunctive elements that one gains a sense of a figural or spiritual presence, benign or threatening, in *King of Kings*. [17]

Jean Arp: Extracting New Form from Man

The fifty months the world was at war, starting in 1914, did much to shape the thought and art of Jean Arp, who never saw the battlefield. Born in Alsace-Lorraine in 1887, he escaped conscription by both the French and German armies, in one case feigning insanity, to flee to Zurich, where he worked from 1915 until 1921 as a member of the Dadaist group in that city. He destroyed almost all of his art from before 1915, as if choosing to be reborn in a neutral country, where his work had begun anew thanks to his meetings with his future wife, the artist Sophie Taeuber-Arp, and Dadaist friends, notably Hugo Ball and Richard Huelsenbeck. [18] The latter recalled Arp telling him in Zurich that "he wanted to produce something entirely new, a form of abstraction expressing our time and our feelings about it." [19] In the war years and in the thirties, Arp wanted an art to combat "confusion, unrest, nonsense, insanity and frenzy [that] dominate the world." [20] For Arp, by comparison with the "radiance of the universe," man had made himself "degenerate, tragic and ugly," largely through vanity and the notion that "Man was the measure of all things." Not needed, in Arp's view, was an art that continued to put men on a pedestal, celebrating him as had been done "in the museums," by an egocentric artist who proudly signed his name to his work.

To comprehend why Arp's sculpture in the round done between 1930 and 1945 must be termed "figuresque" rather than "figural," it helps to know what he intended as well as what he rejected. Beginning with his reliefs in 1915, Arp sought "to inject into the vain and bestial world and its retinue, the machine, something peaceful and vegetative." [21] "Naiveté and fun" were to "triumph in the world." Arp and Sophie Taeuber determined to create an art

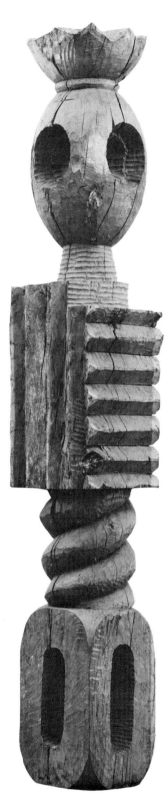

12. Constantin Brancusi, *King of Kings*, 1920.

that would "simplify, beautify and transform life" and would lead man to "the spiritual, the real." Arp wrote about his years in Zurich:

I wanted to find another order, another value for man in nature. He was no longer to be the measure of all things, no longer to reduce everything to his own measure, but on the contrary, all things and man were to be like nature, without measure. I wanted to create new appearances, extract new forms from man.[22]

The search for this "other" order took Arp and Sophie Taeuber to an "elementary" or "concrete" art that aims

. . . to transform the world, . . . to make existence more bearable. It aims to save man from the most dangerous folly: vanity it aims to identify him with nature. Reason uproots man and causes him to lead a tragic existence. Concrete art is an elemental, natural, healthy art, which causes the stars of peace and love and poetry to grow in the head and heart the works of concrete art should not be signed by their creators. . . . these sculptures, these objects, should remain anonymous in the great studio of nature artists should work in community like the artists of the middle ages.[23]

Arp's way of reuniting man with nature, of extracting new forms from man to, in effect, create new beings, was expressed in the injunction, "The artist must let his work create itself directly."[24] This meant that the artist became a medium in what Arp thought was nature's way of creation rather than an imitator of nature.

Art is a fruit that grows in man, like a fruit on a plant, or a child in its mother's womb. . . . I love nature, but not its substitutes. Naturalist, illusionist art is a substitute for nature.[25]

In the absence of an actual model, Arp was the first sculptor to build an art on automatism, the spontaneous release of promptings from his intuition, which he would usually make into drawings and from which templates would be made for carpenters to cut his reliefs. He thereby completed the impersonality of the act and avoided any chance of "miracles of the hand." How he made his sculptures in the round after 1930 is not clear, as they were not susceptible to the kind of blueprint arrangement of the reliefs. His preferred medium was plaster, which, when wet, could be shaped either by hand or by molds, and then, when dry, could be filed and sanded to the smoothness he desired. While he may have begun a form spontaneously in a few hours, the labor period for his "spiritual fruit" took longer.

"One work often requires months, years. I work until enough of my life has flowed into its body."[26] From his own account it appears that Arp thought abstractly and not in terms of specific themes:

A small fragment of one of my plastic works presenting a curve or a contrast that moves me, is often the germ of a new work. I intensify the curve or the contrast, and this determines new forms Each of these bodies has a spiritual content, but only on completion of the work do I interpret this content and give it a name. In this way my works have received names such as "Black cloud-arrow and white points," "Plant escutcheon,"[27]

Arp's style was developed in his earliest reliefs. *Torso*, a relief made in 1925 (fig. 13), if rotated 180 degrees in space would almost describe Arp's sculpture in the round of 1931, also called *Torso* (fig. 14). It was a style, often referred to as biomorphic, characterized by continuous curvature; so that even when presumably several parts are compacted into the sculpture, as in *Torso* or *Great Pip*, what results is a unitary form, one that is indivisible, because it has a homogeneous surface. Unlike the single and unitary forms of Brancusi, those of Arp seem to contract and expand. Brancusi's

13. Jean Arp, *Torso*, 1925.

conceptions seem concentric or subtractive, honed to an irreducible core by a carver, working in the round. Arp was closer to a modeler; his forms are expansive and his beings pulsate rather than hold their breath. Even more than Brancusi, Arp found the partial figure crucial to the spiritual as well as formal alliance of man with nature. Arp acknowledged his indebtedness in his sculpture, *Automatic, Homage to Rodin*, of 1938, which presents a partial figure-like form that turns back on itself, recalling Rodin's women who fold in on themselves, as if listening to an inner voice.[28] The partial figure allowed Arp to eliminate troublesome extremities while permitting him to extract new forms from the human figure and subconsciously join them with shapes animal and vegetal. The most poetic and dramatic series of "unknown beings" in which the human is fused with nature are the *Concrétions* (fig. 15), created in the early thirties. His own account of them explains why the term figuresque is more appropriate than figural:

> Suddenly, my need for interpretation vanished, and the body, the form, the supremely perfected work became everything to me. In 1930 I went back to the activity which the Germans so eloquently called *Hauerei* (hewing). I engaged in sculpture and modeled in plaster. The first products were two torsos. Then came the "Concretions." Concretion signifies the natural process of condensation, hardening, coagulating, thickening, growing together . . . Concretion designates solidification, the mass of the stone, the plant, the animal, the man.[29]

The *Concrétions* were Arp's answer to museum art, the way to take man off his pedestal and restore him to humility and nature. "Concretion is something that has grown. I wanted my work to find its humble, anonymous place in the woods, the mountains, in nature."[30] Lacking a base, front and back, top or bottom, the *Concrétions* were placed directly on the ground in various orientations; they were, in fact, invertible. To give his form greater affinity with nature, he avoided a fixed perspective.

Not only was Arp searching for perfection when he turned to sculpture in the round but also a new beauty, one uncorrupted by "Art." Paradoxically, and like the academician, Arp believed that each age must rediscover beauty and look freshly at the past.[31] Arp thought of

his sculptures as emerging from "cosmic spheres"; poetical rather than archaeological are his probes for a primal beauty. His *Pre-Adamic "Torso"* (fig. 16) whimsically advances the thought of human life before the first man and beauty's corruption by sin. Classical antiquity was very much part of Arp's consciousness, especially the hybrids of myth that join human beings with imaginary beings such as Sirens and Sphinxes, after which he named sculptures in 1942. Arp made fun of the classical nymphs of academic sculpture, mimicking them even as a child. Venus on a pedestal embodied all that he disliked in bourgeois culture, but he produced her equivalent: Flora became *Growth* (fig. 17), a reclining Venus became *Form Shaped by a Human Hand* and *Concrétions*, and Terpsichore became the ebullient *Torso* of 1931. There was a loss of the classical face, but not grace. Arp never escaped his culture, but sought to cleanse it.

Arp's personal culture included serious interest in pre-Socratic philosophy, such world views and evolutionary theories as those of Empedocles and his "whole-natured forms."[32] Some have seen Arp's art as regressive, even

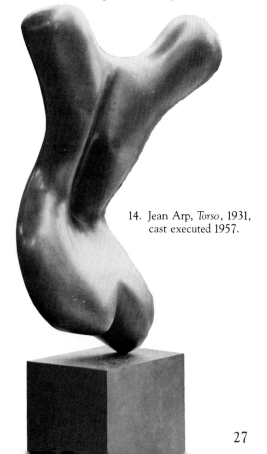

14. Jean Arp, *Torso*, 1931, cast executed 1957.

illustrating early evolutionary theories and favoring sub-human types. Rather than illustrative, Arp's figuresque sculpture is a parable about the present, how even in modern times beauty and the unity of all life persist but have been veiled from us by reason and science. It is through the artist's intuition, his poetic sculptural metaphor, that the vision of nature's wholeness is manifested.

Although he had been touched by the physical beauty of classical Greek statuary, Arp inverted Greek hubris by showing the human in terms of nature, in happy symbiosis with other living forms. His gentle hybrids are without menace or tension (*Kaspar* is Arp's delightful gnome), nor are they vacant shells, sculptural balloons with all meaning on the surface, as recent formalists would picture them. As Arp put it, "each of these bodies has a spiritual content."

In opposition to the specialists who analyzed, classified and dissected, Arp offered a model of synthesis that overleaped hierarchies and boundaries. His utopia was in the mind, based on love and respect rather than political or social systems, science and technology. Rather than the engineer, the poet was the model, for he alone was capable of imaging a humane and healing wholeness.

Jacques Lipchitz: The Humanizing Of Cubism

From the end of the First World War to the end of the Second, the course of the figure in the work of Lipchitz ran from Pierrot to Prometheus, from the once unconventional Cubist motif of the clown to an art of "themes and ideas," involving heroes of myth and the Bible. This evolution came about as the sculptor sought a more humanistic art and an intensification of formal language that would convey strong personal feelings and thoughts about life. He restored to modern sculpture the expressiveness of gestures, purposeful action and narrative that had been absent since Rodin's death in 1917.

Beginning in 1915, Cubism had meant for Lipchitz, "the means of re-examining the nature of sculpture as an art of three dimensions, space, mass, plane and directions . . . a means of stating the nature of sculptural form in its simple essence and asserting the work of the sculpture as an identity in itself rather than as an imitation of anything else."[33] He also spoke of Cubism's "dissolution of distinctions" between the figure and objects, which was crucial for the emergence of his metaphoric and metamorphic images. At first, Cubism was liberating as an alternative to "realism" and for the study of abstract relationships between shapes. By the mid-twenties, it had become for the artist confining in its "iron rule of syntactical cubist discipline."[34]

Pierrot Escapes, of 1927, (fig. 18) is an ironical and witty self-portrait of the artist. The

15. Jean Arp, *Concrétion Humaine Sans Coupe*, 1933. [cat. no. 3]

16. Jean Arp, *Pre-Adamic Torso*, 1938.

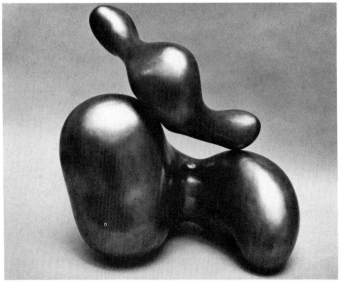

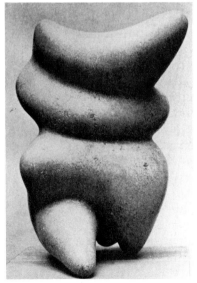

irony is that he saw himself as escaping from Cubism, which ten years earlier had seemed his liberation as an artist. By 1925, however, Cubism seemed to have too many "taboos, regulations and restrictions," from which he wanted to free himself in order to "introduce space and light into sculpture" and make it "as quickly as my inspiration came and my imagination dictated."[35] *Pierrot Escapes* is one of his "transparents," which rank among the artist's most fruitful discoveries. They transformed for him the conditions of making sculpture and placed new demands on the techniques of bronze casting. They were first made from cardboard (not unlike Picasso's cardboard models for his sheet metal *Guitar* of 1912), and then transferred to wax. The thinness of the elements posed special casting problems that Lipchitz worked out with a skilled foundryman. As he often used wire, the "transparents" provided the artist with ways of "drawing in space," gave him freestanding reliefs, and preserved the freshness of a sketch. Pierrot's "prison" wittily recalls the Cubist "grid," which rhymes with the ladder by which he will escape. The formal discipline given to Lipchitz by Cubism was necessary for control in the more passionate art he was to develop. In this sense Cubism was both jailor and liberator. The seven-pointed, star-like figure becomes Pierrot, and the buttons on his clown suit are replaced by two holes. To the face are given ganglia-like features, in a transferral that would have been appreciated by Picasso, Giacometti, Gonzalez and others who saw and admired this and other "transparents" when they were exhibited and reproduced in the second half of the twenties.

Between 1926 and 1932 are clustered a series of heroic large sculptures that grew from Lipchitz's feelings of the need for a new "impetus" to give his art a more "human base" and imaginative content: *Figure*, 1926 – 30, *Joie de Vivre*, 1927, *Couple*, 1929, *Mother and Child*, 1930, *The Harpists*, 1930, *Return of the Prodigal Son*, 1931, and *Song of the Vowels*, 1931 – 32. The "transparents" were important to these more open-form sculptures because, as the artist put it, the space became the "ethereal soul" of the form.[36] As the figure regained mass and movement, there was an increased fullness of

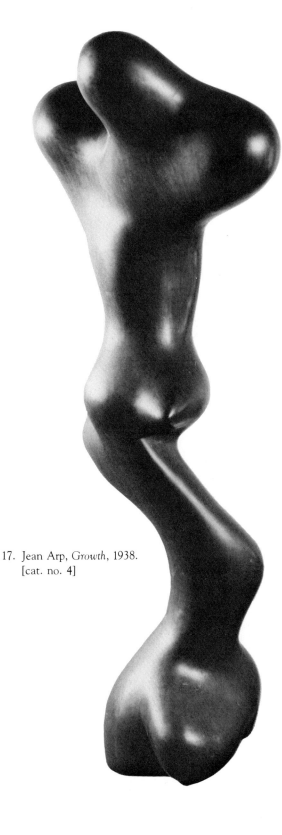

17. Jean Arp, *Growth*, 1938.
[cat. no. 4]

meaning and poetic allusion. All of his sculptures, consciously or not, derived "from something in [his] life, a desire, or a dream."[37]

Perhaps Lipchitz's greatest sculpture is *Figure* (fig. 19), on which he worked for four years. It exemplifies his preoccupation at the time with getting space to flow freely around and through the form. It is also an example of how ideas, going back to 1915, on "massive, material frontality and aerial openness," germinated in his mind and art to culminate in a stunning configuration that transcends its sources.[38] *Figure* began as a maquette or model of 1921, in which a small group of figures was mounted on a column of intersecting diamond shapes. In 1926, Lipchitz saw rocks balancing on one another off the Brittany coast at Ploumanach, a resort town. The sculpture bearing that name is a freestanding oval relief in which was embedded a reclining figure, inspired by figures on the beach, the whole balancing on a crescent base. The synthesis of the maquette and *Ploumanach* next came about as the result of a commission for a garden sculpture in 1926. It had been Lipchitz's dream to carry out a monumental outdoor piece. This was the first occasion he conceived such a large work from a small model. Somewhat in the manner of Brancusi's *King of Kings,* he drew upon his earlier ideas, and the diamond and crescent bases became the intersecting chain forms of *Figure* and were surmounted by the oval of *Ploumanach.* Two cylindrical eyes replaced the reclining figure in the latter, but the feminine reference remained. Lipchitz incised a "familiar sexual symbol" into one of the links, giving the work its gender. He later acknowledged the "hypnotic power" and "a rather frightening personality" of his *Figure,* whose coming into being was neither totally foreseen nor its meaning completely fathomable to its creator. (Lipchitz's client rejected the work for her garden.)

Figure is one of the most potent images of the internal life of the body in modern sculpture. Its frontality and immobility suggest the artist's interest in tribal art and the totemic. Unlike African sculpture, which does not depict feeling, however, *Figure* is rigidified by tension, evoked by the intersecting links joined to the same base and leading to the concave oval

18. Jacques Lipchitz, *Pierrot Escapes,* 1926.

head with its "staring eyes." The work may have indirectly exteriorized the sculptor's own frequent psychological crises during the sculpture's formation, when he despaired for his family and his finances and questioned the purpose of his life and art.

The other and optimistic side of Lipchitz was expressed in the 1927 *Joie de Vivre,* (fig. 20) a second large size outdoor sculpture that was commissioned by the Viscomte Charles de Noailles, in which he showed "a dancing figure with a large guitar." This monumental version of a transparent was intended to be seen turning in space. (Lipchitz tried a motorized base and rejected it.) He saw it as the culmination of his specifically Cubist work, the solution to joining masses and space. The movement of the figure, new to Cubism, and its fusion with an object prepared the way for the return of figural action to his art and more poetic alliances of the figure with objects and animals, as in *The Harpists* and *Song of the Vowels.*

Lipchitz's sculptures of the late twenties re-

veal an interest, shared with his friends in the Paris art world, in the new discoveries of psychology. Despite his criticism of the Surrealists for their unbridled Freudian adventures, his sculptures show that he had opened his art to free associations.[39] Often two or more disparate motifs or experiences were later cited by the artist as occasioning causes for a sculpture. His imagination could be set off by a form seen in a cloud (which is the title of a 1929 sculpture), vague feelings of love and hate toward his mother (*Mother and Child*), or joy and despair. The large and small works from the period 1926 – 32 may be his richest imagery in probing life's ambivalence. Friendship with Picasso and access to his art of violent new formulations of the body may have encouraged Lipchitz's development beyond Cubism. Picasso certainly supplied an immediate and compelling example of emotional and psychological candor. Lipchitz was a happily married and optimistic man, who, nevertheless, poured into sculpture that for which psychiatrists probe: self-doubt, destructive inclinations and tragic and exalted states of being. Lipchitz was attentive to his own moods and unfathomable sensations, like those of spiritual "thirst," expressed in *Return of the Prodigal Son*; and he exposed himself to tough self-interrogation, questioning for example whether there was such a thing as Jewish art and whether sculpture could respond to Fascism.

The equivocal nature of Lipchitz's imagery preserves the authentic, ambivalent psychological source. *The Couple* (fig. 21) is plausible as copulating lovers and as an anguished cry of some "strange beast." By suspending "thought and control," Lipchitz discovered what he felt was something "magical" in the act of creation; and the forming and finishing of the sculpture from its maquettes made him feel that something had been "wrung out" of him.[40] The gesture of embrace was Lipchitz's most equivocal expression, enacting love and forgiveness (*Prodigal Son*) and unity with a musical instrument (*The Harpists* and *Song of the Vowels*), but also brutal tearing (*Mother and Child*, 1931) or murder (*Strangulation*, 1933). Lipchitz relates this gesture to the recurrence of what he calls "encounters" in his art, chance

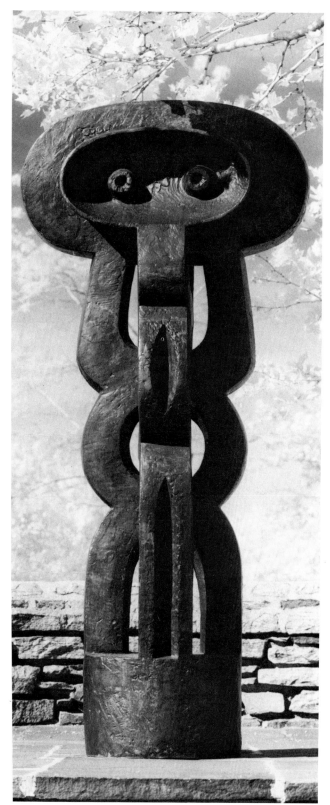

19. Jacques Lipchitz, *Figure*, 1926–30.

31

meetings, not just with persons from life and myth, but with his second self and with his materials, incidents that are revelations produced by nature and by accidents in the studio.

During the thirties, the sculptor gravitated more and more to nature without working from a model, and he developed in his figures a sense of bursting strength. Beginning in maquettes, notably *Leda* of 1929, *Jacob and the Angel,* and *Prometheus,* both of 1931, Lipchitz began to christen his sculptures with titles from myth and the Old Testament. Prometheus symbolized the agonies of the intellectuals during the rise of Fascism, specifically in the 1931 maquette in which the reclining figure writhes under torment.[41] When depicted strangling the "Vulture," he personified science and then Republican Democracy fighting Fascism. Perhaps drawing on memories of his training at the École des Beaux-Arts, where sculpture's mission was seen as the voice of human hopes and fears, and in the absence of contemporary heroes, Lipchitz celebrated Prometheus, who defied the gods to act for man and who was also a legendary model for the artist as a person and as a professional.

Picasso: Rediscovering the Figure

Between 1928 and 1944, Picasso made a large number of figure sculptures that were modeled, carved, assembled and cast from objects. Most of these works were done in 1928, 1930 to 35, 1943, and 1944. Much attention has been focused on the constructed works in metal of 1928 and 1930, largely because of their influence on Gonzalez and the interest of modern sculptors in welding. The other works, notably the modeled sculpture, have received relatively little recognition but show another important aspect of Picasso's genius. While Picasso did not subscribe to the old view of man as the measure of all things, the human figure reigned in his imagination. Picasso had no fixed theory, technique or style. (He called upon God, "who has no style," to go bail for him against charges of inconsistency.)[42] Nor did Picasso have what might be called a philosophy of man which he illustrated in his art. When he talked about man, it was in terms of how the human form could be signified in art, not human nature. Picasso's artwork reflects the continual process of rediscovering

the human form, which led to a brilliant series of unknown beings, often made from elements already present in his studio but not apparent to others as suitable for sculpture. He was obsessed with showing what man could be—not intellectually, but in form. The figure sculptures are Picasso's "fruit," in Arp's term, not made to resemble the living model but given their own identity while reflecting their creator's mind.

With few exceptions, his figures do not represent or commemorate anyone but themselves. Nor are they vehicles for the calculated illustration of abstract concepts in the manner of traditional personifications of nature and society's collective values. Many of these figures, such as *Man With a Sheep,* undoubtedly had strong personal associations, but Picasso preferred having the works change in meaning with time, context, and the experience brought to them by the beholder. Picasso detested rules he did not make, and in 1935 he told his friend Christian Zervos, "Art is not the application of a canon of beauty but what the instinct and the brain can conceive beyond any canon."[43] It was having rules and norms in figure sculpture to react against that inspired him to place a small head on a large body, and

20. Jacques Lipchitz, *Joie de Vivre*, 1927.

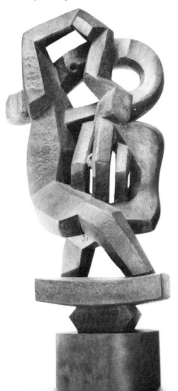

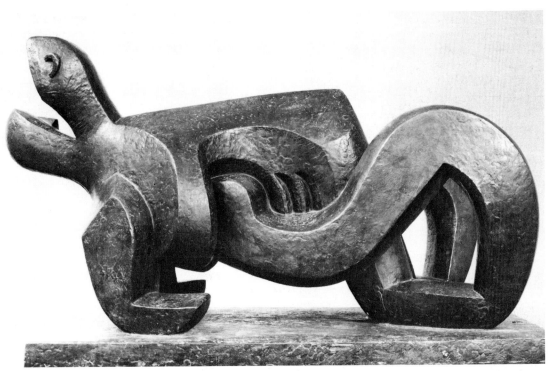

21. Jacques Lipchitz, *The Couple (The Cry)*, 1928–29. [cat. no. 37]

the reverse, in what he called "*rapports de grand écart*."[44] No more than he could repeat a figure, did he want the viewer to be able to take anything for granted, Picasso complained that counting on the traditional "syntax" of the body in older sculpture caused people to equate it with truth.

Some of his most impressive and influential sculptures were never actually made, but appeared in his 1927 and 1929 drawings for outdoor monuments, or what Spies calls, "potential sculpture."[45] Only a small bronze maquette, *Figure of a Woman*, of 1928, (fig. 22) distilled into three dimensions his visionary hybrid human forms. Picasso stuns by tearing nature apart and recombining the body into an impossible "syntax" or anatomy, one lacking any consistant projection principle. He had opened his art to spontaneous free association. *Figure of a Woman* has her ancestry not only in Picasso's paintings of violent body imagery after 1925, but also in the hallucinatory, transmuted figures of Miró and Masson that drew from subconscious memory. Masson had made a single plaster sculpture, *Metamorphosis*, in 1927, that was probably known to Picasso,

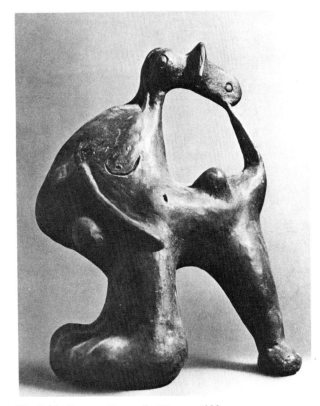

22. Pablo Picasso, *Figure of a Woman*, 1928.

33

and which Carolyn Lanchner describes as "an animal-mineral-vegetable being in the process of devouring itself," and which was intended as an image of "perpetual metamorphosis."[46] The modern metamorphic image, starting with Duchamp-Villon's *Horse* and represented by the sculptures of Picasso and Masson, does not present us with both the unaltered and altered entities, as in traditional metamorphosis, but rather with the last or latest state of the being after it has undergone an irrational transforming process in the artist's imagination. The "original" form of the human and animal are in our mind when we confront the sculpture. Lipchitz's *The Couple*, on the other hand, is a reversible image in the sense that it can be seen either as two joined lovers or as a turtle-like animal, but not both at the same time. Picasso also used the reversible image, as in his *Head of a Bull*, 1943, made from a bicycle seat and handlebars, as part of his view of objects as old metaphors and his art as their rehabilitation. His 1928 modeled *Figure of a Woman* was not a reversible image nor one that shows us the actual process of changing states. Along with her sisters in drawing and painting, this sculpture did appear "monstrous" to many of the artist's contemporaries, but they were the fruit of his amorality. Their creation may have been sexually aggressive acts on his part but were not intended to declaim against the "evils" of woman.

Picasso's small figures of 1931, carved from thin sticks of wood, reportedly frame molding, suggest paraphrases of erect and even seated pre-classical figures, their thin proportions occasioning comparison with certain early Etruscan sculptures, which in Picasso's mind may in turn have been suggested by the proportions of the material. One of these carved sculptures, titled simply *Couple*, seems a paraphrase of Brancusi's *Kiss*, as it shows two seated figures embracing and presumably copulating.[47]

Though carved or whittled, the wood sculptures started from Picasso's finding scrap wood in the studio. In 1946, Picasso said of his relationship to found objects: "What I have to do is to utilize as best I can the ideas which objects suggest to me, connect, fuse and color in my way the shadows they cast within me, illumine them from the inside."[48] *Figure* of

1935 (fig. 23) is a roping together of wood such as would have been used for painting stretchers, a long-handled metal ladle, and a pair of garden rakes to produce a configuration whose fork-legged, open-armed stance evokes memories of Bernini's *Longinus*. No one was more aware than Picasso that man makes objects as extensions of himself, which, in turn, he saw as metaphors of parts of the body. In his art, objects could make man.

In his life-size *Woman in a Long Dress*, 1943, Picasso mixes his modes so that the found objects of a dressmaker's mannequin and a wooden arm from Polynesia, given to the artist by a friend, are augmented by a modeled arm and head. This is an example of an unknown being having a specific personality, a case of what Picasso called a more or less "convincing lie." As Breton observed, Picasso did not engage in voluntary labors of improvement, and the modeling is a hasty but brilliant evocation of a Parisian type with her hair tightly pulled up into a topknot. She recalls Parisian concierges who wore turtleneck sweaters in winter. Photographs of the sculpture show that at one time Picasso added a smock and put a plastic palette in her left hand, reminders of how he never accepted a sculpture as "finished" and believed that occasionally it is a good thing for art not to be shown respect.[49]

That an exhibition of Picasso's sculpture from just the thirties, for example, looks as if it were a group show is due in part to the diversity of his figures made from plaster casts of objects. It is the textures as much as the shapes of the objects that make them inspiring metaphors for the artist. Two brilliant sculptures stand out in this series, *Woman With Leaves* and *Woman* (figs. 24 and 25), both of 1933. The former was made from casting actual leaves, a cover for a small box, and corrugated paper which Picasso analogized with the columnar folds of an archaic Greek robe, such as one sees on Kore of the sixth century. The head of *Woman* was also cast from a cardboard box.[50] With wet plaster he modeled the eyes *below* the nose. The eyes are downcast, out of modesty, for below, her twin bell-breasts ride exposed over her dress, cast from crumpled paper. The configuration of the agitated folds of the paper dress, supported by an exposed foot from which the

figure seems to be pushing off, evokes the image of the woman swaying in a dream-like dance. If *Woman With Leaves* is Picasso's equivalent for Flora, *Woman* (with bells) is Terpsichore. These cast sculptures are reversible images, exemplary of Picasso's aim of "fooling the mind and not the eye." He wants to reveal their sources and what his mind made of them and also to aid us in our rediscovery of nature.

Three modeled figures of the early thirties, *Reclining Woman*, 1931, the pirouetting *Woman* (fig. 26) of 1932 and *Woman with a Vase*, 1933, demonstrate Picasso's paradoxical relation to traditional figural sculpture.[51] The past was always in his mind; it was something to depart from, but also to continue meaningfully on his own terms. *Reclining Woman* is Picasso's reworking of the classical odalisque, the recumbent beauty pose. The attenuated proportions of the figure derive from Picasso's use of clay in rolls, which may also have inspired the brilliant device of showing the buttocks of the woman, who lies on her back, on the front of the figure. This relocating of features was part of his continuing interest in showing simultaneously the most sexually attractive portions of the body in violation of anatomical laws. In a small group of brilliant dancing and running figures, Picasso, as had Lipchitz, restores physical movement, gesture, and the depiction of feeling to modern figure sculpture, that had gravitated to immobility and the expressionless subject. The proportional disparities of the dancing *Woman* were Picasso's *rapport de grand écart*. This sculpture, that seems to give a worm's eye view of the figure, may have come from his subconscious memory. His fascination with huge, swollen legs goes back to childhood experiences of seeing a seated woman's enormous legs under a table.

Woman with a Vase was almost seven feet tall and cast in concrete, the material Picasso hoped to use for the seaside monuments in his paintings of the late twenties. Where his smaller modeled figures gave themselves to the abandon of the dance, she, who stands solemnly extending a vase (or is it a lamp?), is inscrutable, recalling archaic hieratic statues. In several paintings and drawings of the thirties, Picasso shows a woman, arm extended,

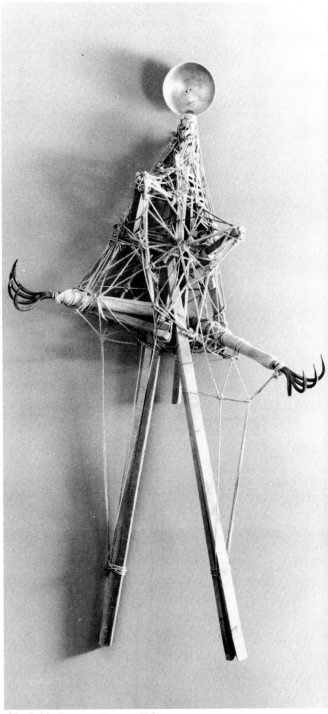

23. Pablo Picasso, *Figure*, 1935.

holding a lamp, at times as a witness to violent and tragic acts, which culminate in the death and destruction depicted in *Guernica*. His mistress, Marie-Thérèse Walter, is often associated with the woman holding the lamp. She was the inspiration for many sculptures of heads, and she may have inspired this work with its fulsome form, as it was done during the bloom of their liaison. There may be some corroboration of Picasso's deep personal attachment to the *Woman with a Vase* in that a smaller version or model for the large one that broke apart stands today by his grave at Vauvenargues.[52]

In his Cubist paintings and sculptures, it was Picasso perhaps more than any other single artist who before 1918 did the most to undermine the tradition of western figure sculpture. It was not Picasso's habit to turn his back on any option, including those tradition had to offer as a negative incentive.[53] His sculptures in the interwar period convince that in developing alternatives to Cubism, he revitalized the figural tradition. The great *Suite Vollard* etchings made in 1933 show his love affair with tradition and the joy he experienced with sculpture in those years. Picasso is the naked and bearded sculptor in his studio, contemplating, working from and loving the model. In style and theme the depicted sculptures, many of which relate to those inspired by Marie-Thérèse, collapse distinctions between ancient past and present. When Picasso made the classically drawn live model contemplating his "furniture" figure, he was, in effect, telling us that all of his sculptures confront what does exist with what can exist: it is the artist's right to add to reality.

Julio Gonzalez: Breathing New Life Into the Figure

In the iron sculpture of Julio Gonzalez between 1929 and 1938, the figure lost its separability from space and gained a new expression of its internal life without loss of dignity. At fifty, Gonzalez found himself as an artist, and in 1931 wrote about his objectives for his new open form sculpture:

> The real problem to be solved here is not only to wish to make an harmonious work, of a fine and perfectly balanced whole—No! But to get this by the marriage of material and space, by the union of real forms with

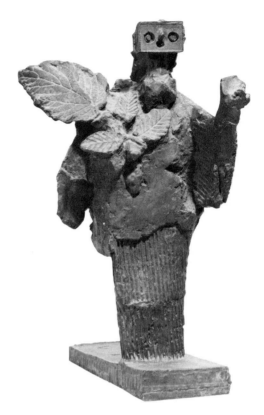

24. Pablo Picasso, *Woman with Leaves*, 1934.

imagined forms, obtained or suggested by established points, or by perforations, and according to the natural law of love, to mingle and make them inseparable one from another, as are the body and the spirit.[54]

That Gonzalez fixes on a specific artistic problem was the result of being from 1928 to 1931, close to Picasso, who did much to cause his friend to focus talents previously dissipated and then to surpass himself. Gonzalez's pride in his craft, that allowed him to make jewelry to support himself, explains the search for a "fine and perfectly balanced whole." Marrying material and space was a conceptual problem he had been introduced to by Picasso, who helped the younger artist resolve the practical means of so doing by welding and forging. It was a marriage aspired to by Lipchitz earlier in his transparents begun in the mid-twenties, when he had spoken of the space in his forms as their "ethereal spirit." Giacometti, Calder and another Spaniard, Pablo Gargallo, to whom Gonzalez was to give technical assistance, had also opened their thought and form to space. The "real forms" of the statement above refer to such details as eyes, teeth, hair or hip joints,

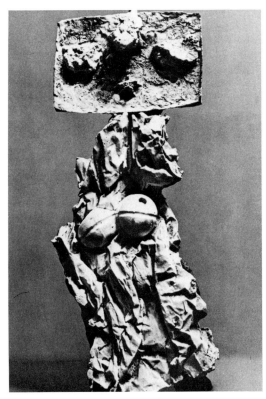

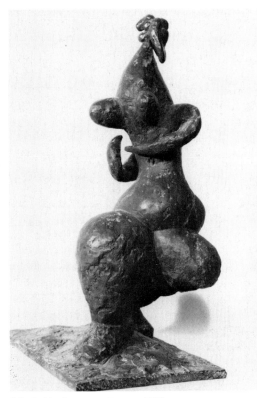

25. Pablo Picasso, *Woman*, 1933.

26. Pablo Picasso, *Woman*, 1932.

that Gonzalez used, in the manner of Picasso, to connect his form with its human inspiration — to give it authenticity. The "imagined forms" were space and perhaps those metallic shapes by which he vectored imagined stresses or movements within the body.[55]

Both in Cubism and in the 1930 *Figure of a Woman*, made from iron rods and a shoemaker's last, Picasso had shown Gonzalez that the artist need not construct a figure by a predictable projection principle based on imitating the body's external contour. The lesson included the fact that respect for the human body need not demand its "realistic imitation," and that the artist could also signify both the artist's and subject's felt experience of the body. In his sensitive but undistinguished sculpture made before 1914, Gonzalez had modeled gently embracing figures, but by 1930, he had found the way for a more meaningful and mystic coupling, that of the body and spirit, which was so important to his reverence for nature. From the modeling of anonymous models, Gonzalez moved to the creation of unknown beings: "The sympathetic defor-

mities of material forms, of color, of light; the perforation, the absence of compact planes, give the work a mysterious, fantastic, indeed, diabolical aspect."[56]

Looking at (and through) the numerous filiform works of the early thirties and those sculptures between 1935 and 1938 in which he returns to compact volumes, it is apparent that he was taking off from his earlier modeled sculpture by "breathing new life" into traditional poses, to which he added simple and somewhat semaphoric movements. When it came to "transposing the forms of nature" into his iron art, unlike Gargallo and Archipenko, Gonzalez did not schematize or literally skeletalize anatomy to augment the sculpture's readability. As an example, Gonzalez did not cut out space in the shape of a missing limb or organ nor did he consistently observe all of the flexible joints of the human skeleton. His imaginative morphology required a new physiology. *The Dancer with a Palette*, *The Woman Combing Her Hair* (fig. 27), and *The Woman with a Basket* are convincing as imagery and are specific entities, mysterious as they may be,

because Gonzalez did not yield to anatomical paraphrase. That his personages repeatedly show their own logic of form and being is a tribute to the consistency of the sculptor's poetic intensity.

The term "metamorphic" has often been applied to these open form figures of the thirties, but that of "reversible image" is more appropriate, because we do not see the depiction of changing states. When Gonzalez uses a found object, a nut or bolt, a palette or sickle, as with Picasso, it is because of its structural equivalence to some aspect of the human form and possibly its expressiveness. *Grande Faucille* (fig. 28) may have derived from memories of a Spanish peasant, and the sickle becomes the sign of the head as well as occupation of the subject.

As Leo Steinberg and Josephine Withers have observed, Gonzalez's figures have pride of self. They also bound with enthusiasm, bend with sorrow, stretch in anger, or quietly effect a toilette. Never larger than life and mostly smaller, Gonzalez's figures are not commanding presences nor assertive toward the viewer. The achievement of these qualities was the way Gonzalez solved his problem of making iron "cease to be a murderer." His delicate use of iron is also antimechanistic in its consistently human associations and its esthetic that often accommodated rusted surfaces. Despite the strenuous and sometimes violent methods required to bend iron to his thought, Gonzalez was the paradigm of the artist with "peaceful hands."

Not only did Gonzalez have the audacity to depart from likeness, but he had the good sense to make sure he had a return ticket. His forged *Torso* (fig. 29) of 1936 is one of the most beautiful and expressive partial figures in modern sculpture. The serenity of the relaxed stance of the lower torso coexists with the ragged, hence harsh, silhouette. As the form is open in many places, Gonzalez achieved compact volume without a sense of mass. Gonzalez could model with his hammer as well as his fingers. The 1934 – 1935 *Grand profil de paysanne* has all the firmness and subtlety of surface of his best modeled forms twenty years before.

Gonzalez's respect for and commitment to nature, which made abstraction unthinkable,

was matched by a feeling for tradition, especially in fine craftsmanship and a human-centered viewpoint. He made palpable form in space, as tradition said a sculpture should do, but he also made palpable space in form. The inventiveness and formal power of his welded and forged iron figures with their poetic imagery were extremely influential for post-World War II artists. He had shown not just that iron could be made into art, but that it could become imagination's medium. One could attain marvelous levitation of form and make sculpture free of the appearance of mass and weight, while giving fresh life to the figure. A whole new area of configurations, sensations, perceptions and beings had been opened up by the loving spirit of this most modest of artists, who had done little more than ten years of his best creative work when he died in 1942.

Giacometti: Figures Seen in the Mind's Eye

When Giacometti's teacher, the sculptor Emile Bourdelle, saw his pupil's invented images made in the mid-twenties, he told the young Swiss artist: "One makes things like that for one's self, at home, but one doesn't show them."[57] It was Giacometti's contribution to modern interwar sculpture not to suppress but to release images without concern for their suitability for art and, thereby, to ignore and contradict Bourdelle's distinction by showing in public what he made in private. Unquestionably, Surrealism and the contemporary examples of Picasso and Lipchitz in Paris were deinhibiting influences, giving him the cutting edge by which to penetrate consciousness and enter into a world of enigmatic, erotic and aggressive fantasies. This, in turn, meant suspending the critical impulse or unifying it with creative drive. The quality of his sculpture recommends the latter.

Giacometti personifies that characteristic of modern sculpture in which the artist, to be faithful to the unique qualities of personal experience, transforms the conditions of making sculpture. Another fruitful quality — and his dilemma — was how to reconcile his personal vision and understanding of reality with the art world's ideas about truth in art and reality. From youth, this son of the gifted Swiss painter and early abstractionist, Augusto Giacometti, could not bring himself to accept the artistic

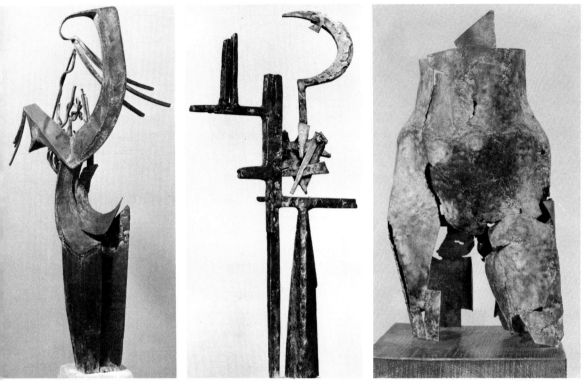

27. Julio Gonzalez, *Woman Combing her Hair*, 1936.

28. Julio Gonzalez, *Grande Faucille*, 1936–37.

29. Julio Gonzalez, *Torso*, c. 1936.

conventions by which the artist was supposed to confront nature. Giacometti came to art in the postwar years when there were powerful precedents for contradicting conformity and incentives to be rebellious and independent. (Bourdelle seems to have been a tolerant teacher in this respect during the four years Giacometti worked with him.) It was not only that Giacometti early recognized his own way of seeing things, but that he was steadfastly and morally honest to his vision.

Between 1925 and 1935, Giacometti abandoned the problem of making sculpture the "double" of the model and instead chose to work at first from memory and then from "invented works in [his] mind."[58] Not until *Hands Holding the Void* of 1935, did he attempt a full freestanding figure. For nine years his imaginative models for the body were based upon the partial figure. This meant that the sculptural "ensemble" did not depend upon resemblance to the entire human form. In certain respects, his figural inventions telescope parts of sculpture's history, as, along with free associations, they drew from such diverse

sources as African tribal objects, spoons having human legs (fig. 30), Cycladic heads that were almost featureless and the geometric shapes associated with Cubism. It was Cubism that released him conceptually from working directly from the model in favor of working from memory. According to the artist, his objects and sign-like personages from 1925 to 1930 were entirely conceived in the mind and then executed exactly and usually rapidly. This may account for their predominant frontality. What was modern about this activity was Giacometti's acceptance of the initial creative moment of vision without prejudice and his indifference to questions of decorum. After a few small but massive cubic configurations, *Torso*, 1925, *Cubist Composition, Man*, 1926, and *Personnages*, 1926 – 1927, his conceptions tended to flatten out and become shallower, while admitting more space within their borders. Giacometti wrote:

This gave me some part of my vision of reality, but I still lacked a sense of the whole, a structure, also a sharpness that I saw, a kind of skeleton in space Figures were never for me a compact mass but like a transparent construction.[59]

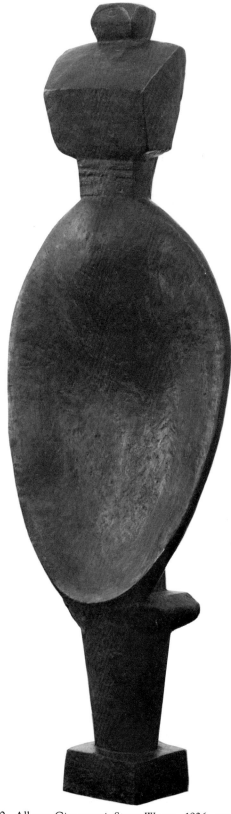

It is apparent that these conceptions necessitated exact articulation, and the imperative of being faithful to the quality of his imagined beings was his charter of freedom. Their "truth" came from their having been realized in his mind, and he carried them out because he felt the force of their strangeness. *Man* (fig. 31) and *Reclining Woman Who Dreams*, both of 1929, show an interesting skeletalizing or open form structure. In *Man*, the figure loses not only its customary external form becoming a sign, but also its ability to stand by itself. Giacometti's configuration is locked into a grid mounted on twin supports, the antithesis of Leonardo da Vinci's famous drawing of the Vitruvian, ideally proportioned man inscribed within a circle and square but capable of vigorous and free movement. Aside from saying he rejected any illusion of movement, Giacometti left no notes about the figure's significance. It seems safe to speculate that he was not constructing an abstract ideal of perfection, but rather saying something personal. Was he, for example, evoking the antithesis of Lipchitz's *Pierrot Escapes* by showing his own imprisonment in Cubism? On another level it is interesting to compare Giacometti's human grid of 1929 with Picasso's rope-bound *Figure* of 1935 (see fig. 23), for in both a ladle served for the head and the overall structure constructs, if not imprisons, the being. Picasso was not usually given to complete pre-visualization, and the richness and strangeness of his imagery developed during the performance of making what started out as the spark of an idea. The speed of Picasso's arrival at the final image was crucial to preserving the fugitive, unlike Giacometti's process, where rapid execution resulted from having worked out the total design in advance.

It was in themes of male and female personages that one can follow not only the skeletalizing and pointedness of which the artist wrote, but also his devices for staging his private dramas, the frame, cage and horizontal set, which culminate in *The Palace at 4 A.M.* of 1933.[60] His coupling of male and female becomes progressively hostile to the point of murderous confrontation in *Man and Woman* of 1929 and climaxes in *Suspended Ball* of 1930 – 1931 (fig. 32), which was the delight of

30. Alberto Giacometti, *Spoon Woman*, 1926, cast executed 1954. [cat. no. 21]

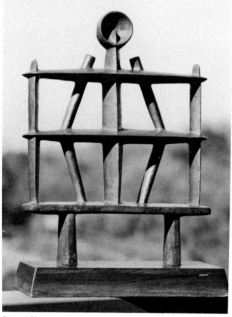

31. Alberto Giacometti, *Man (Apollo)*, 1929.
 [cat. no. 23]

32. Alberto Giacometti, *Suspended Ball*, 1930–31.

the Surrealists. (Giacometti may have been inspired by Picasso's drawings of fantastic anatomies made of bone and object-like forms which were vertically stacked or propped against one another.) The cage of iron rods, which, in turn, may have been suggested by Picasso's 1928 *Constructions*, allowed him to suspend the plaster sphere, segmented just where it would ride along the upturned crescent below it when swung. The beholder cannot resist moving the ball, thereby setting up the provocative sexual situation admired by the Surrealists and solving Giacometti's personal problem with movement in sculpture. "Such movement I only wanted if real and effective. I also wanted to give the sensation of provoking it."[61] In the early thirties, the artist was preoccupied with the idea of "several objects which move in relation to one another."[62] This led him to more provocative situations that may have been of a cryptic confessional nature. These sculptures also remind us that Giacometti was the first artist to use the partial figure or figural part in situations where threatened or actual mutilation was the theme. His *Cage* of 1931 is filled with randomly disposed forms that evoke clavicles and detached sexual organs. *Hand Caught by a Finger*, 1932, instigates gruesome associations with

mechanical mutilation. *Drive to the Eye* of the same year is a menace to the optical organ that obsessed him. These last two sculptures are like icons of an artist's nightmare. Giacometti's solution to the self-expressed problem of finding a way to show things that were "clear and violent" ended in "a woman strangled, her throat cut" (fig. 33). As with Degas's *Woman in a Tub*, which for its time was a disenchanting image of the theme of feminine toilette, we are to look down on the sculpture of the fantastic corpse, which the artist, it appears, actually set on the floor. In form, Cubism made sculpture continuous inside and out, and Giacometti took the next step, which was to exteriorize imaginatively the inside of the body.

Hands Holding the Void or *Invisible Object* (fig. 34) was Giacometti's last invented figure. It culminates his attempts to achieve a synthesis of life and "abstract" sculptural form. All evidence of its making by hand has been polished away, as in ancient idols. Hohl traces the formal source and morbidity of the work to Oceanic art, the head to a protective mask developed by the French for warfare. Giacometti also synthesized the cool impersonality and fine finish of mannequin figures, with which he had been working commercially, with recollections of frontal and hieratic

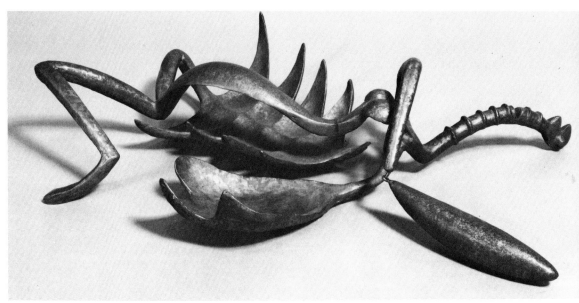

33. Alberto Giacometti, *Woman with her Throat Cut*, 1932, cast executed 1949.

Egyptian art, that he had admired since a student trip to Florence in 1920. The earlier cage idea has been transformed into a framing chair, against which the figure seems both to stand and sit. Adding to this enigmatic posture, he placed a plinth in front of the legs, enforcing its immobility. The motif of the empty space between the hands and the original title, which in French has a punning relationship to "Now the Void," are conjectured by Hohl to be the artist's rejection of Surrealism's obsession with mysteries of the object; or possibly it was also intended to suggest "the seed of a new life." Written about exclusively in terms of its enigmatic nature, *Invisible Object* is also a beautiful sculpture; its finely honed surfaces and the elegant curving planes of its back, the dialogue between the tapering body and the rigid frame, and the decided intervals between frame and figure are a joy to observe from any angle. The bird head attached to the seat of the frame in the earlier casts is of the same stylized mode as the figure, giving poetic as well as stylistic consistency. The woman's head has the prismatic hardness of the stylized skeleton heads (which he called Cubist Heads) of the time and which signify his reflections on death.

In 1935, Giacometti encountered a crisis of disbelief in his invented works and returned to working from the model to confront life freshly and, as a result, to try to reinvigorate his work. When he began, he wanted

> to make (quickly, I supposed; in passing) one or two studies from nature, just enough to understand the construction of a head, of a whole figure. . . . this study (I thought) should take a fortnight, and then I wanted to realize my compositions. I worked from the model through the day from 1935 to 1940. Nothing was like what I imagined it to be. A head (I soon left the figure aside, it was too much) became an object completely unknown and without dimensions.[63]

Once again, as when he was much younger and struggling to realize in art what he actually saw, Giacometti recognized the duality and paradox of making art from life. As before, he tried working from memory during the years 1940 to 1945.

> . . . to my terror the sculptures became smaller and smaller, they had a likeness only when they were small, yet their dimensions revolted me, and tirelessly I began again, only to end several months later at the same point. A large figure seemed to me false and a small one equally unbearable, and then often they became so tiny that with one touch of my knife they disappeared into dust. But head and figures seemed to me to have a bit of truth only when small.[64]

One of the major pieces to survive this period is *Woman with Chariot I* (fig. 35) in which a woman is shown, frontally erect, hands at her side, standing on a modeled block mounted on wheels, which the artist's historians relate to his recollections of a pharmacy wagon seen during his hospitalization in 1938.

Compared with *Invisible Object*, in which the figure is similarly immobilized on a sculptured base, it is apparent that Giacometti had rejected the stylized precision of his earlier conceptualized figure and was moving toward the type of tentative, hand-worked surface that, while insuring the central mass of the body, made its periphery elusive. Prophetic of much of his postwar work, *Woman with Chariot I* is the cross-fertilization of observation and memories of Egyptian art, the prosaic and the symbolic, art's limits and power.

Max Ernst's Figures of Fun

The figurative fantasies of Max Ernst, seen in his sculptures of 1935 and 1944, differ from those of Giacometti by not being as autobiographical nor as committed to the human form itself.[65] In addition, they are not linked with problems of understanding vision and reality. Just as Ernst did not have any commitment through training to traditions of making sculpture, so was the memory of the living human body not so central to his sculptural thought, as it was to Giacometti's. His imaginative personages, such as *Oedipus II* or *Lunar Asparagus* (figs. 36 and 37) seem to have come about fortuitously; accumulations of cast objects were stacked asymmetrically until the artist felt he had created a being. It appears that, consistent with the reactive nature of his imagination, Ernst sometimes baptized his figures with the names of mythical figures, but often, as in *Bird Head*, *Moon Mad*, or *Young Man with a Beating Heart*, the titles are simply amusing commentaries or associations. Rather than illustrate a myth or a fable, he developed, as in his paintings, an imaginative bestiary or race of improbable entities.

Ernst's coming to sculpture in 1934 coincided with a vacation and provided a change of pace from painting. With Giacometti in Maoloja, Switzerland, Ernst found some stream-worn, egg-shaped stones or natural readymades for his imagination. He incised and painted some abstract and imaginative figural designs on the stones. At the time, some of his "paintings," such as *Europe After the Rain* of 1933, done in oil on plaster, verged on relief because of the thickness of the medium. Ernst's history as an artist was one of indiffer-

34. Alberto Giacometti, *Invisible Object (Hands Holding the Void)*, 1934, cast executed 1935. [cat. no. 24]

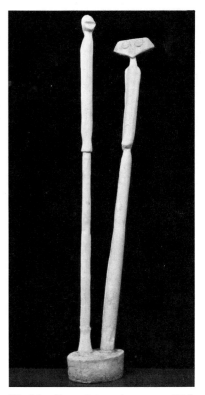

35. Alberto Giacometti,
 Woman with Chariot I,
 1942–43.

36. Max Ernst, *Oedipus II*, 1934,
 cast executed 1960. [cat. no. 17]

37. Max Ernst, *Lunar Asparagus*, 1935.

ence to preserving distinctiveness of artistic categories.

During the winter of 1934–1935, working in Paris and perhaps influenced by Picasso's example, Ernst made plaster casts of objects, such as plates, sand pails, bottles and cups, all having simple shapes and rarely exhibiting pronounced texture. A photograph of 1935 (fig. 38) shows a table in Ernst's studio on which are piled what Bosquet called "unachieved sculptures."[66] Ernst literally assembled a kind of arsenal or repertoire of parts, from which he then assembled his configurations, such as *Oedipus*. One might see this practice as a mimicking of machine-age, standardized parts. (He had used hat molds in 1920 for a Dada show.) By themselves, the repertorial elements are not expressive. Ernst's configurations were not tied to anatomical probability, nor did their textures, as in Picasso's case, dictate or suggest a costume. His method of joining and titling was additive, a piling up of parts until his personage had achieved a distinct character and expressiveness.

The smooth quasi-geometric surfaces of Ernst's sculptures are like those of Giacometti's figures, *The Woman Who Walks* and *Invisible Object*, and give his ambiguous subjects formal certitude. Ernst shared his colleague's distaste for geometric abstraction, on the one hand, and fascination with non-European art and its forceful presences, on the other. Ernst's instinct was to animate and to analogize. Rather than a romantic revival of primitivism, Ernst seems to have sought in sculpture ironic or amusing commentary on a variety of subjects: Freudianizing of myth, as in *Oedipus II*, sentimental love and eroticism in *Young Man with a Beating Heart* and *Young Woman in the Form of a Flower*, and chess and Duchampian puns in *The King Playing with the Queen*.

Primitive and psychotic art and the work of Giacometti and Picasso gave Ernst the precedents to shape sculpture into images of the symbolic intensity he required. He was not an amateur student of comparative mythology nor a dedicated social interpreter of his time. (He was intellectually aware, but deeply involved in his own experiences.) Since his Dada days, he had been convinced that modern society,

38. Incomplete sculptures, Max Ernst's studio, Paris, 1935.

which paid homage to science, needed the corrective of the imaginative act, gratuitous in terms of society's practical needs, but vital to counterbalance the objectivity of the technician. He accepted that man was no longer the measure of all things and seems to tell us that by things man can be recreated if not measured. His *Hat Makes the Man* of 1920 set the tone and direction of his thought. There is wit and wisdom in his recycling of found parts. *An Anxious Friend* (fig. 39), for example, is neither a mythic nor metaphoric figure, as Ernst's historians like to describe his work. His fictive pair are shown in a comic situation, back to back, straining to find one another, a situation incomprehensible in the sculpture of another period. *Woman Bird,* once described as being like a Surrealist Veronica Handkerchief, is also somewhat comic, for the large face registers something akin to surprise at the apparition that seems to be on her brow if not her mind.[67] Ernst's personages often register open-mouthed emotion, as in *Young Man with Beating Heart,* and their asymmetry, unlike that of ancient or medieval monsters, does not evoke menace but rather their individuality. Primitive terseness and the wit of caricature are coupled with a twentieth century sophistication and an uninhibited attitude toward sex (not the exclusive prerogative of Surrealism) in Ernst's *Young Woman in the Form of a Flower*, which is a sculptural pun on a female sexual organ. It is part of Ernst's comic comparative anatomy. It has also been argued that his focus on poetic imagery is sometimes at the expense of his sculptural sense, but he does not sacrifice rhythm and formal rhyme for a laugh.

Ernst exemplifies the modern sculptor who creates rather than interprets the modern experience. He is the self-cultivated man who makes from an experience of world art and his time intuited images that are meant to bring art into new areas. His art is not retrospective, but an attempt to collapse time, to fuse elements of the past with his present, in unexpected ways, relying upon wit and improvisation. If the old myths were spent forces and no longer the carriers of society's goals or hopes, they could still be mocked and be used to make parodies of life. Ernst is, however, a creator rather than critic. He sets up situations or predicaments for his subjects that try our learning and wit. In an ironic way, Ernst helped restore to sculpture psychological expression: pathos, feeling, and humor. He did it through the device of creating imaginative surrogate human beings, who simply express states of mind or feeling, which are easily translatable into mundane experiences. The root of Ernst's poetry is his under-

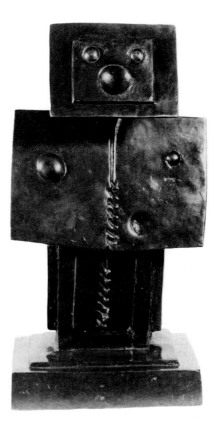

39. Max Ernst, *An Anxious Friend*, 1944. [cat. no. 18]

45

standing of human nature; his strategy is not to appear to concern himself with it.

The Tough and Tender Figures of Henry Moore

There is no more distinctive sculptor than Henry Moore. His work is readily identifiable anywhere in the world today. Consider the paradox, however: there may have been no more original sculptor than Moore, and yet no other major sculptor has admittedly drawn upon so many sources in his lifetime to achieve that originality. The authority for this last statement is the artist himself, for it has always been one of his qualities to acknowledge his sources.[68] His art is a lesson in the nature of creativity. In the words of Arthur Koestler:

> The creative act is not an act of creation in the sense of the Old Testament. It does not create something out of nothing; it uncovers, selects, re-shuffles, combines, synthesizes already existing facts, ideas, faculties, skills. The more familiar the parts, the more striking the new whole.[69]

Moore is an example of the artist who chooses his models from the past and present, the better to confront his experience of life and nature. From the beginnings of his formal training, after 1918, Moore was committed to the figure and life drawing. One of his first

40. Henry Moore, *Composition*, 1931.

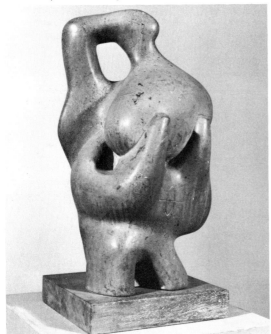

carved sculptures, however, was a 1923 copy from memory of a bust of the Virgin by the Italian Renaissance sculptor Rosselli in the Victoria and Albert Museum in London. All through the twenties Moore tried speaking the language of sculpture in foreign tongues, pronouncing the figure, if you will, first in Italian and then moving to a stylized Esperanto language such as Dobson and Gill were employing in England. From this stylization, he gravitated to "primitive" simpler forms, encouraged by the example of Epstein's defiance of the critics and the Western museum traditions of beauty and of Gaudier-Brzeska, whose excitement at rediscovering sculpture and its power had always touched him. Gaudier helped him think in terms of "planes" and to equate sculpture's power with that of mountains. From these sources and especially Brancusi, Roger Fry and African tribal art, Moore became shape and form conscious, learning that imitative art was inimical to the exercise of imagination and the realization of sculpture's potential expressive and esthetic power. Even before he had seen a photograph of the pre-Columbian Chacmool figure in 1928, Moore was committed to showing the human figure motionless in vertical, seated or reclining postures. He criticized conventional sculpture in England during the twenties for its sentimentality, fussiness over detail and ambiguity about its identity as sculpture. The toughness he saw in Mexican carving seemed a strong antidote, and Moore made heads and figures in a way which suggests he wanted to know what it felt like to work in the manner of pre-Columbian artists as opposed to those of the Renaissance.

From the first it is clear that Moore felt affinities with the most mundane, prosaic themes, a mother and child, a head, a standing woman. He recognized by the end of the twenties that stylization or primitivizing were superficial statements or empty rhetoric and that what was in him to express about sculpture and humanity would come through *formal invention.*

Moore's evolution during the thirties is neither fine-grained nor linear in a single direction.[70] Its diverse formal interests predict the post-World War II history of his work.

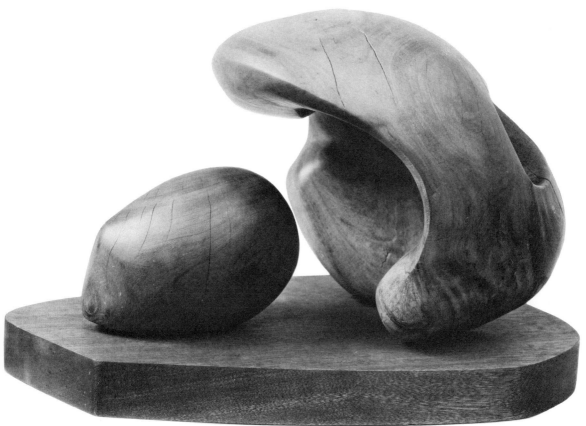

41. Henry Moore, *Two Forms*, 1934.

Moore never wished to lock himself into a single formal idea, such as the reclining figure, but sought to keep his art open to chance encounters with objects as well as the human form. In the early thirties, for example, he wrestled with the temptations of abstraction, even using flat surfaces, without total loss of human reference. This fruitful experience helped him find other ways of breaking with anatomical syntax. In the late twenties he had moved gradually beyond stylization of the figure by drastic reproportioning of the body, but he had not yet arrived at reinventing the human form, for he was still constrained by probability and legibility. The sculptor once indicated to the author that *Composition* of 1931 (fig. 40) was a conceptual breakthrough. Related to the mother and child theme, it had two shapes, the smaller gourd shape seeming to be cradled by the larger. Both forms, however, were joined at the top by an anatomically impossible form. Moore owned at that time a 1930 periodical, *Documents,* in which the works of Picasso were reproduced, and it is likely that the latter's 1928 modeled *Figure of a Woman* gave the British sculptor a crucial

shove into the uncharted land of the anatomically impossible but formally desirable. Moore did not set up permanent residence in this new territory, however, for he returned to his patient inquiries into the reshaping and reproportioning of the body, providing new formal continuity and stronger rhythms for his upright, half-length and reclining figures. It is in the period 1931 – 1934 that Moore's figural art comes closest to that of Arp in the sensuous ambiguity and flow of the form. The year 1934 was an important year in Moore's development, as he moved to a series of horizontal situations or confrontations between abstract shapes. These multi-part pieces suggested that he had absorbed the basic concept of the table-top format from Arp's *Bell and Navels* and *Figures, One Large and Two Small* of 1931 and his more biomorphic *Head with Annoying Objects.* Moore had not previously worked with the problem of composing separated forms, and in retrospect this experience was fertile ground for his post-World War II multi-part pieces and monumental compositions. The best known interwar composition to come out of these explorations of divided forms was the 1934 *Two*

42. Henry Moore, *Four Piece Composition*, 1934.

Forms (fig. 41) in the Museum of Modern Art, which of all in the series comes closest to the feeling of the maternity imagery: there is a parent form, both breast and pelvis-like, from which has issued, one imagines, the smaller form, now in the process of assuming its own identity. By circling the composition, one gains a narrative effect; and the offspring appears in differing relationships to the larger shape. Seen through the hole of the parent, the smaller form appears to be still embedded within. It is a poetic discourse on birth, and is a fitting accompaniment to Arp's views on art as a fruit.

In 1934, Moore's multi-piece compositions (fig. 42) included those in which the shapes and their relationships evoke a reclining figure. Moore acknowledges the impact on his thought at the time of Picasso's drawings for abstract and bone-like compositions in the late twenties and early thirties. They fostered his experience of breaking up the continuity of the body and drilling through its outer shell to derive forms from bone, all of which allowed space to circulate through as well as around the forms. Moore possessed the body in a more deeply felt, intimate and imaginative way. It is possible that Picasso had helped Moore break through a certain reserve, a sense of decorum about approaching the body, invading its privacy, not in the aggressive, even sadistic way of Giacometti's *Woman with Her Throat Cut*, but with tact, sensual satisfaction and wonder. It seems, however, that Moore did not have an idea of how to pursue these discoveries and inventions, for from 1936 through 1938, he rehabilitated monolithic sculpture of a single form (see fig. 150), reverting to more explicit maternal themes and applying to the surface

cryptic incisions or small eyes that confirm the human but do not add to the largeness of form he was seeking.

From 1936 until the outbreak of the war, Moore seems to have narrowed his focus and worked more consistently in series around the central theme of the reclining figure. In the wood and stone figures, space takes up residence where the upper torso is expected and, less surprisingly, between the legs, which are in relaxed postures found in Western art since the Renaissance. The most venturesome inventions were made in small lead figures of 1938 and 1939. Greater liberties were taken with the head simultaneously with the opening of the whole form to space. He had, one might say, liquified his external sources, forgotten about contemporary issues involving the abstract and figural, and let his inspirations flood less self-consciously into the work. He alternated the closed, full and sensuous form of the body with

43. Henry Moore, *Stringed Figure*, 1937.

44. Henry Moore, *Reclining Figure*, 1939.

fantasies involving bone and tissue forms, in some of which the body is figuratively strung out, held in tension by circular discs which gather to them tubular anatomical inventions. From 1937 to 1939, Moore was also artistically conjugating his response to stringed mathematical models seen in the Kensington Science Museum (fig. 43). The startling lead *Reclining Figure* of late 1939,[71] first acquired by Onslow-Ford, seems an attempt to incorporate the attenuated effect of the stringed works into metal. For an academically trained student such as Moore, the bone structure was supposed to be inviolable. *Reclining Figure* of 1939 helped establish for Moore that sculptural anatomy could supplant actual anatomy in the service of the artist's imagination.

The climactic sculpture of Henry Moore's pre-World War II art was his largest work until then, the wooden *Reclining Figure* of 1939, now in the Detroit Institute of Arts (fig. 44). Ideas embodied in previous sculptures were brought together with his thinking about the requirements of truly monumental sculpture and its relationship to the out-of-doors, specifically to landscape. Years later, Moore recalled that he had put small heads on the sculptures of this earlier time to give the body a more monumental appearance and not out of a desire to minimize the human aspect of his subject. In formal terms, one of Moore's richest interwar sculptures, *Reclining Figure*, conjoins perfectly all of his major concerns: his search for silhouettes that would carry from a distance, the idea of form built around inner space, his study of the relationship of shapes and spaces separated by distance, the harmonizing of flat and curved forms, the achievement of fluid continuity and most importantly, evocations of the tough and the tender. Moore had found that "primitive" art lacked the possibilities for a play or range of feeling and simultaneous formal hardness. This he was now able to achieve, while sustaining our awareness of the character of his medium, using its grain, rough and smooth textures and color for surfaces that departed from flesh but evoked the body's exterior. The being he has added to reality has a more humane quality than have pre-Columbian idols and a mystery suggested by the figure's form rather than cult associations.

Understandably, Henry Moore's reclining figures of the thirties and thereafter have been interpreted as romantic symbols of nature, the eternal woman or mother, "primal" beings, or as Jungian archetypes. The implication behind these various interpretations is that Moore wanted a generic type of figure to illustrate a general ideal of the human: the mother of all mothers, and so forth. None of these assertions

has ever been supported by the artist in his published statements from the period or in discussion with the author. What stamps Moore's themes as modern and particularly as being of the interwar period is his resolve, beginning with the twenties and continuing to the present, to create imaginative beings that have *specific* identities that he cannot predict or thereafter explain verbally. Just as did Arp and Picasso, Moore determined to work *like* nature, to let his creations take on their own personalities as they took on form and, in effect, took over from the artist. Thus, he wrote in 1937: "Each particular carving I make takes on in my mind a human or occasionally animal character and personality, and this personality controls its design and formal qualities, and makes me satisfied or dissatisfied with the work as it develops."[72]

In Moore's working method he may have only a vague idea, usually in a drawing, of what the figure will look like and what its character will be. He looks forward to the way the form comes to life, develops according to its own logic and rules, and seems to encourage or stay his chisel. Reason or critical judgment is not abandoned, but is at the service of imagination. Moore seems to have had in mind in the most general terms the goal of producing mysterious beings that, in turn, would impart his enthusiasm for the human form, life itself, and their capacity to inspire art. They were not intended as romantic evocations of images for lost cults. Until the Northampton *Madonna* of 1943, they were formed by his culture without cult intentions.

Rare is the discussion of the characteristics of Moore's women in his art of the thirties. We gain a sense of his early norm of women from drawings of the twenties and thirties, done from life. The figure is never svelte, but solidly built, full, firm, and of varying but often broad proportions. She is related to Picasso's classical nudes of the early twenties, both in form and self-contemplative passivity. Neither in the life drawings nor imaginative sketches does Moore show the slightest interest in strenuous bodily movement until the coal mining drawings done during World War II. Unlike Rodin and Degas, Moore did not see sculpture's purpose as seeking new truths from new gestures or positions never before fixed in art. His satisfaction with the reclining pose freed him from decision making and allowed him to concentrate on formal adventures.

No matter what liberties he took in invading the body's solidity or in eliminating or fusing parts, Moore maintained great respect toward the figure. He always honors and never humiliates his feminine subjects. They are sensual but not flagrantly or even coyly erotic. The Mediterranean pride of body that Moore had seen in the Parthenon sculptures in the British Museum meant more to him thematically than he would credit until after World War II. His women sustain a quiet majesty, an aloofness and serenity no matter how distorted their proportions. Although they cannot be visualized as changing pose, they often have a formal springiness (especially in metal); they bound off tapered points in contact with the base or swell upwards from solid thighs. Never do these carriers of health and optimism sag, slump or lie inertly. Moore's model of what sculpture should be, his desire for forms which seem larger than the block that once held them and for fashioned surfaces giving the impression of alternating between hard and soft, stretched and relaxed, derived from healthy and strong living bodies.

Moore did not go as far as Arp in interpreting the human being in terms of nature. His thought was so woman-centered that this was not possible. Many observers see the very late reclining figures of the thirties, such as that owned by the Detroit Institute of Arts, as beginning to incorporate landscape elements. Whether Moore had this in mind at the time is hard to say; there is no evidence from his statements of the period. He photographed his works against the gently rolling landscape, but this could also be explained by his long-held desire to have the work out-of-doors, as he conceived his sculptures as being surrounded by air in nature. Moore's primary concern was not in consciously incorporating landscape elements but more likely in domesticating the fantastic, in developing a new logic, and artistic logic, for the human figure that would look at home in nature, not unlike Arp's goal with his *Concrétions*.[73] It is after World War II that Moore seems to draw more self-consciously

from memories of natural motifs, such as large rocks and cliffs.

Barbara Hepworth: Landscape in the Figure

In the period between 1925 and 1945, Barbara Hepworth's distinctiveness as a sculptor emerges from the ways by which she enacted the vanguard ethos of "only unify." Her whole life in art and impulse in sculpture was to capture "the fundamental and ideal unity of man with nature." This process began in the second half of the twenties in motifs of birds and partial figures, made susceptible not so much to stylization but to her search for an accord with her materials and craft. She let the varieties of wood growth and stone structure and texture determine the formal problems of each sculpture. Part of her early incentive was negative: to react against conservative traditions she had been taught in the Royal College of Art. In this enterprise Gaudier and Epstein (especially his *Doves*) were of help by their precedent of direct carving and simplification of form in passive subjects. She was not so susceptible to as wide a range of older sources as was her friend Henry Moore, and primitive art touched her own work much more lightly. She was not so disposed as Moore to combat between the tough and tender, and her work does not have his dynamic synthesis of Pre-Columbian and Mediterranean figural art.

In *Pierced Form* of 1931 (fig. 45) and *Head* of 1930, Hepworth felt she had won a new freedom by which "the conception [was] born free of the block." She had found a way to "break down the accepted order and rebuild and make [her] own order." This meant finding "a new way of composing forms other than by the accepted order of human anatomy or by [her] poetic demands from the material."[74]

A second great unification she sought was to achieve accord with certain aspects of modern art, notably the examples of audacity in imposing "other" orders in art that she saw firsthand in the work of Mondrian, Brancusi and Arp during visits to Paris around 1930.

All three were models of strongly different and personal ways by which to achieve an "ideal unity between man and nature." Mondrian was a model of undeviating strength, integrity and courage for her, and she saw in his

45. Barbara Hepworth, *Pierced Form*, 1931.

work a crucial moral premise: "the artist's intrinsic right to assume entire responsibility for the development of his art." From visiting Brancusi and his studio, she derived a strong sense of "eternity mixed with stone and stone dust," as well as a clear approach to material, and the recognition that his sculpture represented an "integrated personality." As important for Hepworth as Mondrian's moral basis for art was the liberation Brancusi offered from the sense that northern European sculpture was fettered by a tradition of the "gravity of monuments to the dead." The special revelation she thus obtained from Brancusi was that sculpture "belonged to the living" and that the "joy of spontaneous, active and elemental forms of sculpture," its still beauty, met "contemporary needs" and affirmed "continuity of life."

Most unexpected for Hepworth was her encounter in 1930 with Arp's art, which freed her from previous inhibitions about material, such as letting the "block" influence the conception. It was through Arp that she later felt she could find fresh and personal ways to unite the figure with the landscape.

These revelations had also been shared with Ben Nicholson, whom Hepworth was to marry. His painting, drawing and reliefs helped

46. Barbara Hepworth, *Two Segments and a Sphere*, 1935-36.

to draw Hepworth to abstraction as a means of finding her own poetic order. They showed her the possibilities of geometric motifs as the source for a "new and very great beauty," and, beginning in 1934, she purified her shapes of "naturalism," but did not always eliminate human reference. Her study of "relationships in space and tensions between forms" were part of a quest to "discover some absolute essence in sculptural terms giving the quality of human relationships."

Like those of Henry Moore (but less like Nicholson's reliefs), Hepworth's geometric forms were abstractions from human sources and situations—male and female, mother and child, and all three. The disposition of her geometric duos and trios on a plinth (the "displacement of forms in space"), like Moore's *Two Forms*, was calculated to establish a sense of mutuality between the forms. Her format recalls Arp's *Bell and Navels* rather than Picasso's drawings of dispersed figural parts, to which Moore was more susceptible. Her humanism and a predilection for the sensual abetted by a love of the modeling action of light on curved surfaces took the expected hard edge and coldness away from her spheres, conoids and prismatic or crystalline shapes (*Two Forms with Sphere*, 1934 and *Discs in Echelon*, 1935). *Two Segments and Sphere* of 1935 – 1936 (fig. 46) argues that she had looked hard at Giacometti's *Suspended Ball*, and while accepting his conjunction of sharp and round,

avoided its aggressive sexuality. The balance of "stacked" shapes was a prelude to later "nesting" forms (*Nesting Stones*, 1937) having maternal evocations.

Ironically, it was the coming of the war in 1939, and the move to Cornwall, that helped to integrate her personality and art into her greatest sculptural achievements, the evocation of the *landscape within the figure*. She had the formal experience and ingredients to respond artistically to the impact of the Cornish landscape. Her work with the partial figure in the late twenties had helped establish in her mind the minimal reference sculpture required to signify the human and had paved the way for the abstracting of the body into geometric forms. In 1931, in *Pierced Form*, she had penetrated through the stone, not to indicate the customary, naturalistic interval between body and arm, but as part of her search for a freer assembly of form. Only seven or eight years later, with the addition of color in 1938, did she find new ways to enlarge this discovery and evoke the "withinness" of sculpture and to make darkness tangible, which was the matrix for her empathetic responses to nature in southwest England. (Consider *Oval Sculpture* of 1943, *Wood and Strings*, 1944, *Wave*, 1944, *Landscape Sculpture*, 1944, *Convolute*, 1944, *Elegy*, 1945 [fig. 47] and *Pendour*, 1947 [fig. 48]). The experience with geometric abstraction gave her formal terseness, clarity and rhythm by which to encode experiences of incoming and receding tides, the simultaneous plunging of sight toward a distant horizon at sea and awareness of stone bedded deep in the earth, lying on the sand and sensing the sea, the calligraphy made by waves on stone and sand, the circling patterns of birds, and the double spirals of the coastal coves of Pendour and Zennor, the "withinness" of form in a great bay, and feeling a form within herself when sheltered near some great rocks. "I used colour and strings in many of the carvings of this time. The colour in the concavities plunged me into the depth of water, caves or shadows deeper than the carved concavities themselves." Hepworth had seen the stringed mathematical models of scientists and the stringed sculptures of Gabo as well as Moore. By contrast with these precedents, her use of strings in such

elegant, simple forms as *Wave* humanized geometry or made intimate what for Gabo had been cosmic. Unlike Moore, who gave them up, she found the strings to be not just contrasts within the form but ties to *life* situations. "The strings were the tension I felt between myself and the sea, the wind or the hills."

The diversity of her art made in the early Cornwall years was built on these experiences and reflected "the ever changing forms and contours embodying my own response to a given position in that landscape." Rather than as a spectator looking at a sculptural object in a landscape or seeing nature devoid of human presence, Hepworth made *herself* the figure in the landscape. She audaciously inverted the relationship, so that works such as *Elegy* and *Pendour* become the landscape within the figure. Just as Arp and Moore, she helped revolutionize sculpture's image of man's relation to nature by showing man in terms of nature. While she was to live a long and productive life and her work continued unbroken from the war years, Hepworth never made more beautiful, richly evocative or inspired sculpture than works such as *Wave, Elegy* and *Pendour.*

During World War II Gabo was with Barbara Hepworth and other artists in Cornwall, and she seems to have shared her friend's convictions about the true relationship of the artist

47. Barbara Hepworth, *Elegy*, 1945. [cat. no. 30]

and society. In the late thirties, as a result of contact with architects, she shared an interest in the fusion of the arts united in one great common purpose. By 1938, she felt this hope "eluding them," due perhaps to imminent war and the breakup of the Hampstead group. "It seemed as though the worse the international scene became the more determined and passionate became my desire to find a full expression of the ideas which had generated before the war broke out." It is apparent from her own reflections written in 1952 on the earlier period that she felt tested by world war as to her function as an artist. Even when not carving, her drawings show a persistent meditation on abstract form. She said of these endeavors, "I do not think this preoccupation with abstract forms was escapism. I see it as a consolidation of faith in living values, and a completely logical way of expressing the intrinsic 'will to life' as opposed to the extrinsic disaster of the world war." Unlike sculptors who had been captured by the Constructivist ideal of a utopian union of art with technology and apolitical ideology and who felt disillusioned even before as well as after the war, Hepworth's consistent evolution and optimism partly stemmed from *not* attaching her hopes to engineering and the machine, but to *creation* itself in the most archaic medium of all.

Summary

The persistence, in fact, flowering of the figure in modern interwar sculpture resulted from a constellation of ideas emanating from important new assumptions which deinhibited sculptors from transforming the figural tradition. Man was no longer the measure of all things, as he was before 1900. The sculptor felt free from the constraints of imitation, selective or otherwise, with which to treat the body. The classical esthetic of beauty, which affirmed the nobility and perfectibility of Man, had been discredited, as world art replaced the hegemony of the art of classical Greece and the Renaissance.

To these negative freedoms were added the positive premises that the sculptor could add to reality by creating new and unknown beings that did not require verifiability. The unexplainable was accepted, and the sculptor shared with the viewer the possibilities of in-

48. Barbara Hepworth, *Pendour*, 1947.

terpretation. Arp's concept that art was the artist's "fruit" and should not be made to look like anything else, but allowed its own form and identity, implied that the sculptor should emulate nature. Creation was seen as a natural, instinctive procedure. The biological process appealed to many figural sculptors, just as mathematics and engineering became paradigms for abstract sculptors. Creation born of instinct and free association, undeterred by past decorum but still submitted to critical judgment, allowed sculptors to portray the impact of contemporary life on their imaginations. The sculptor was encouraged by psychology and painting to exteriorize his inner life, and there was an unprecedented candor of expression. Free of the limits of logic and likeness, sculptors could make their work more poetic, employing metaphors that effected impossible unions. Unify, connect, and fuse were widely held imperatives which led to surprising conjunctions between the human and the world of nature and objects. Simply put, things and nature could become the measure of man. The human could be evoked by indirection. Arp's new ecological vision upset centuries of discriminating differences between man and the world.

Society was offered new visions of wholeness in which Man was at home in the new world of technology and nature. Conversely, Hepworth showed nature could live within her. Opening the figure to space gave Lipchitz and Gonzalez a new means by which to celebrate the spirit, while for Moore it proclaimed the continued mystery of the figure. Gone was the edifying function of sculpture, to be replaced by imagery that made no judgments, that told us what it felt like to live in this period, and that proclaimed there was an anatomy of desire and that murder and joy could issue from the same heart. Myth could be mocked, mimicked or modified. Artists respected its history of universal significance but recognized the imperative of recasting myth in a modern idiom even at the expense of transforming its older meanings. André Breton had called for the creation of a modern myth, but there was no collective myth subscribed to by all sculptors. Free to find "other order" for the human form, sculptors found new rhythms and couplings of space and shape. Old media could support new diction, as Moore proved. Picasso alone invented a whole new sign language for the body, thereby conceptually blowing open the minds of other artists to the previously unimaginable. The Pygmalion dream did not die. Picasso and others strove for a reality more real than what had previously been thought of as real; poetry was truth. For reasons of the self, as well as social need, sculptors reconfirmed this importance of a human presence.

54

2. Portraits and the Evocative Head

With few exceptions, the portrait was marginal for major sculptors who began their work before 1914 and continued into the interwar period. For abstract sculptors, such as the Constructivists, a likeness of a single individual was out of the question. The portrait carried with it the connotations of "realism" and concessions to a client, which for many artists would have compromised their integrity and style. The challenge to create, to reinvent sculpture, seemed to have disqualified interpretation of a specific human face for the new sculpture. Yet, within this period a number of fine portraits of genuine quality and daring were made by modern sculptors. In some instances portraiture was done out of economic necessity; in others it was a matter of friendship with the sitter; and in still others it was because portraits offered challenging artistic problems.

After the death of Rodin, it was Jacob Epstein who carried on the tradition of the modeled psychological portrait done directly from life. Epstein had once visited Rodin and knew his work well and even portrayed some of the artist's subjects, such as Bernard Shaw. Epstein's approach was basically that of Rodin. To begin, there was the preliminary reconnaissance in the round of the sitter's head with the aim of exactitude in construction of its form through precise observation of proportions and formation of the features. The character was allowed to emerge slowly as the features were interpreted, along with a growing sense of what the subject was like. (". . . by the natural process of observation the mental . . . characteristics of the sitter impose themselves on the clay.")[1] Epstein had a keen eye for how changes of expression altered the relationship of all the features. Like Rodin, Epstein sought to construct a form that defied disintegration, to be "light proof" no matter the viewpoint or illumination by which it was seen. In works such as the portrait of *Joseph Conrad* (fig. 49), done before he fell into the habit of stylizing certain features, such as the eyes and mouth,

Epstein's portraits have a force and conviction, a balance between form and character. Indeed, his more spontaneous and even unfinished works, the mask of his wife of 1916 and the incomplete portrait of Haile Selassie, have held up better in terms of quality and balance than his finished works. His compulsion to make his subjects bigger than life and the frequent loss of overall effect at the expense of detail and exaggerated features, such as the eyes, weaken many of his portraits. Before and during the interwar period, however, Epstein symbolized the embattled, rugged modernist, drawing strength from adversity, while also obtaining commissions to portray many of England's most famous men. He was a modernist in his refusal to let the sitter impress his own conception of himself upon him. In turn, his own vitality, warmth, compassion and probing nature asserted themselves and "coloured his outlook."

Self-taught, and his art formed in Bergamo and Milan, away from the major centers of revolutionary modern sculpture, Manzù's portraits of the thirties reflect a gentle and sincere commemoration of his family or of women with whom he felt at ease.[2] Rosso seems to have been his principle paradigm, in both temperament and a predilection for images of quiet reverie. Absent an artistic atmosphere of audacity and viable options for treating the head, Manzù committed himself to working directly from his sitter. Whether the portrait was just a head without a neck, a bust, or a full length nude version, there is no trace of an interest in status or conformity to a norm of national pride, as in Roman portraits. After the earliest heads, one does not have the sense of the subject self-consciously posing for eternity. He early showed a penchant for inclining the head, selecting the pose either to conform to the relaxed mood of the subject or as a characteristic or habitual mode of bearing, as in the portrait of *Signora Vitali*, 1938 – 1939. Manzù's discretion requires he never intrude

his presence between us and the subject of our contemplation or on our thoughts about the delicate formation of the head and face. He did not insist upon a vigorous style and, like Rodin, appears to have found himself by submitting to the form and character of the model. Manzù was particularly effective in treating adolescent subjects, capturing the subtleties of the delicate and elusive formation of the emerging mature features. Perhaps his most moving portrait is *Bust of a Girl at a Window* (fig. 50), simple, unaffected and wistful, the natural beauty complemented by the subtlety of the colors of the unpatinated bronze.

Marino Marini, who was academically trained, had spent more time in Paris after World War I than Manzù and had a greater awareness of what was happening in modern sculpture.[3] His portraits down to 1945 reflect more decisions about how not to work. Like Manzù, he chose consciously not to impose his feelings or a decided style upon the sitter. His artistic models were late Etruscan; and yet it was not only the use of terra cotta, that he had seen in the Etruscan museum in Florence, that touched him but also the compelling ancient commitment to likeness. He felt that the way to a personal and modern sculpture had to be found by going back to nature. Thus, far from engaging in a stylistic revival or feeling, overwhelmed by the glories of the past, as did his compatriot Arturo Martini, Marini found in Etruscan art the incentive and warrant to commit certain faces in his life to what he called "the silence of sculpture."

While escaping from the war in Switzerland and presumably to support himself, Marini did a brilliant series of painted terra cotta portraits of acquaintances and a bronze of fellow sculptor Germaine Richier. The portraits of Manuel and Ulrich Gasser show a decidedly modern emphasis upon the asymmetry of the face and individual features. The artist resisted stylistic clichés, not only in forming the features but in working the broad planes of the face: cutting, scraping, etching, and mashing in a seemingly undeliberated fashion to totalize the man before him, all within a firm, compact oval or cube. The polychromy is not for descriptive accuracy, but augments the overall

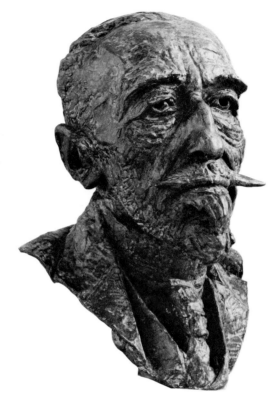

49. Jacob Epstein, *Joseph Conrad*, 1924–25.

intuited quality of the face. In *Portrait of the Artist* of 1942 (fig. 51), it is apparent that the scarring of the plaster with a knife has several motives. It defeats any vanity or narcissism and tightens the sense of concentrated thought, while plowing furrows of shadow into the broadly treated surface of the plaster.

For Marini, as for Manzù, the styleless conjuring of a silent human presence in sculpture by means of a candid portrait was to effect a bridge with one's own time — not the past. Their modernity was in candor, an unwillingness to flatter, and a distrust of facility while exploiting inventive textures that added to the indefinable individuality of the sitter.

After 1918, Matisse did only four heads, three of which were done from a model named Henriette at two year intervals, beginning in 1925.[4] This series recalls that of Jeanette, made before the First World War, in that the changes made after the first reconnaissance of the subject's head were the result of the sculptor taking possession of the model by means of his imagination and the "distillation of his sensation" in time. Rather than develop the series in the direction of greater resemblance and revelation

of character, as did Rodin, Matisse, in fact, gave the woman a new *persona,* one that accorded with his view of expression. The modern portrait, which was largely developed by Matisse before 1914, put the artist's intelligence under a new stress; rather than observing the character and emotions of the subject from the outside, the artist had to look inward and wrestle with the form until it conveyed the feelings that the subject induced in the artist. Self-expression was also conditioned by the formal claims of the evolving image, the expressiveness of the whole arrangement. With this in mind, one can understand the changes Matisse made in the very formation of the woman's features and overall shape of the head. *Henriette II* (fig. 52) is more mask-like or depersonalized than her predecessor. It was as if Matisse were purifying and regularizing the form with a view to achieving a more monumental statement. The largeness of form he sought meant minimalizing facial irregularities and broadening the planes, so that the major areas of the whole could be more easily read against one another. The effect of the second head is one of inward serenity, a greater fullness and perfection of form that receives the light more evenly. *Henriette III* (fig. 53) is an example of Matisse working from smooth to rough, remaking what had seemed perfection, moving from his feminine to masculine mode, pronouncing the head in a different voice. The

serenity has been amplified and abetted by the closing of the eyes. The eyes also display etching, as if he had not made up his mind whether he wanted them open or closed. With a knife, he has cut away areas of the chin, giving a blockier profile that accords with the new modeled cubical base. Greater inflection of the planes about the mouth and projection of the brows give the head a more assertive, less passive look, the whole gaining a stronger impression of being constructed. The whole rhythm of the piece has changed, due to more accents, and Matisse has restored surface incident as a counterpoint to the overall symmetry of form.

Perhaps two years later, in 1930 or 1931, after a trip to Tahiti, Matisse made his head titled *Tiaré* (fig. 54), after a native flower. All other heads were inspired by living models, and this, his only evocative head, recalls at once his admiration for the beauty of flowers and of women. (Matisse owned a Gauguin painting of a Polynesian woman with a gardenia behind her ear.) It is also as close as Matisse would come to Arp and Brancusi, and except for two small torsos of 1929, it is the most purified of his forms (and the one that sees the human in terms of nature). The white marble version, carved by his son Jean in 1934, extends the reference to the white gardenia. The marble's radiance and fruitful shapes temper the more chilling formality of *Henriette II,* while also imparting that quality of

50. Giacomo Manzù, *Bust of a Girl at a Window,* 1943. 51. Marino Marini, *Portrait of the Artist,* 1942.

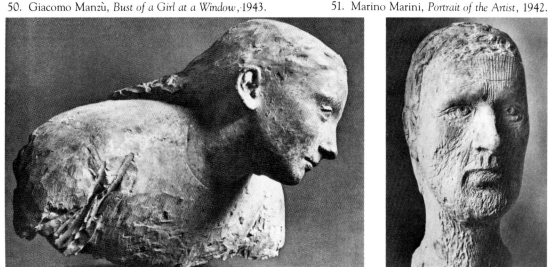

52. Henri Matisse, *Henriette II*, 1927. [cat. no. 43]

53. Henri Matisse, *Henriette III*, 1929.

feminine elegance Matisse admired. *Tiaré* is a symbol of the man and his art; for its gesture, intended to give us pleasure, is open, yet secretive. The form is irrational in its syntheses, calculated in its refinement, eccentric and concentric in movement, and somehow always revolving about its fertile center like the artist, who once said, "I am only interested in myself."

Throughout his life, Lipchitz had a continuing interest in portraiture. When he did a small series of portraits between 1920 and 1922, he was, in a sense, picking up an interest in objective portraiture that had earlier manifested itself in 1911 and 1912. One of these early portraits had drawn the praise of Rodin when it was exhibited in the 1912 Salon des Beaux-Arts. "Like all the young sculptors, at this period I was making portrait busts in a simplified manner with the blank eyes and the broad generalization of classical sculpture."[5] Lipchitz felt that a common source in Greek and medieval sculpture was what caused people to find a resemblance between his work and that of Despiau, even though he himself claimed not to have seen it.

Economics accounted in part for Lipchitz's

acceptance of some portrait commissions, such as that for Coco Chanel in 1921, but the rest were of friends who interested him. Done simultaneously with severe prismatic Cubist figures, the return to portraiture may also have reflected his uneasiness about how abstract his work had become and about its remoteness from more obvious human attributes. These portraits predict the transformation of his Cubism into a more sensuous form of sculpture later in the decade. It is possible that they also reflect a kind of personal repentance or counter-modern reaction within the artist, a condition common to many artists in the post-World War I period, when there was a revival of museum art and a rehabilitation of objectivity, classical values and the figure.

Two of the best portraits Lipchitz did in this period are those of Gertrude Stein (fig. 55) and Jean Cocteau. Although coolly objective and related to the 1912 heads, they reflect the intervening experience of Cubism, as they are firmer in design and surer in the handling of planes. Lipchitz had learned to achieve a largeness of effect, notably in the hair, and to clarify the cranial and facial structure without loss of resemblance. The Stein portrait (which

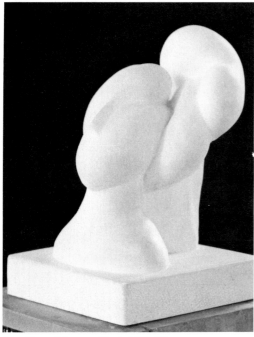

54. Henri Matisse, *Tiaré*, 1930 (?).

55. Jacques Lipchitz, *Portrait of Gertrude Stein*, 1920.

he referred to as "a massive inscrutable Buddha") had those qualities of idealism and repose Lipchitz saw in classical sculpture, whereas the head of Cocteau preserves the intensity and tension that attracted him to the young poet. Lipchitz believed that the omission of eyes in the Stein head would impart "an impression of shadowed introspection" to this self-confident woman. Both of these heads have a sense of strong characterization and inspired, taut form lacking in that of Chanel, which the artist himself felt "had a little too much of an official or commissioned portrait." These differences, due to the artist's greater self-consciousness with a wealthy, though friendly client, reflect how modern artists had departed from the conventions of commissioned portraits that had inspired artists such as Rodin to surpassing effort. Artists such as Lipchitz usually needed intimacy with the subject to be inspired, to be candid, and to take license with resemblance—in effect to create a double portrait, that of the subject and themselves. Lipchitz remembered that he was ill at ease portraying women, as he could not bring himself to flatter. He felt much happier about his 1938 portraits of the aging Gertrude Stein,

where he felt he was freer to interpret the "tired and rather tragic old woman." (Even here artistic and feminine vanity clashed, and Stein preferred a study that made her more lady-like.)

Important exceptions to the modern rule of intimacy between artist and subject as a requisite for an inspired portrait are Lipchitz's 1942 portrayals of Marsden Hartley, with whom he had only a slight acquaintance. Newly arrived in New York and in need of funds, Lipchitz thought that by doing portraits of Americans he could supplement his income. The portrait of Hartley asleep shows how important it is to know the background of a work of art, for in the studio the painter showed Lipchitz the pose of an old man on a bench he had just seen.[6] So "graphic" was the re-enactment that Lipchitz decided to make it the basis of a sculpture. It was a daring decision, a rare pose in the history of male portraits and especially intriguing for that of an artist, but it was also one that relieved the sculptor of having to plumb the character of his new acquaintance. The portrait of Hartley awake does not impress as a character study but rather as the sculptor's vigorous response to an already expressive face. In

59

the later Stein and Hartley portraits, he was able to restore to the portrait a sense of the mobility of the flesh; the portrait derives character and its rich texture from the filing and cutting of the clay or plaster and the addition of touches of clay to attract highlights. By the end of the interwar period, Lipchitz, like Rodin before him, wanted to continue a tradition of portraiture that committed the likeness and character of the subject to eternity as strong works of art rather than neutral effigies.

Calder's contribution to modern portrait art was to elevate caricature to the level of serious sculpture. (Daumier's famous caricatural studies were made in preparation for drawings.) While in Paris in 1926, Calder made his first full-length portrait, that of Josephine Baker (fig. 56), completely out of wire. He had been working with and expressing himself in wire since childhood and claimed he thought best in this material. Many of his heads and even some of the full-length portraits, first exhibited at the Weyhe Gallery in 1928, were designed to hang so that they would move, anticipating the mobiles of the early thirties.[7]

Limning his subjects in wire, Calder had to think of ways for his line to be continuous. Because of their curvature in depth and feature-forming inflections, these see-through sculptures seemed to enclose volumes and to cast marvelous shadows that added to the richness and complexity of the forms. Calder's inventiveness in evoking textures by crimping the wire, doubling it back and winding it about itself rivaled that of Picasso at the time. In *The Hostess,* a single curving wire line conjures an abundant torso and pair of legs atop high heeled shoes with an economy of effort Picasso may have admired. The artist's resourcefulness can be seen in his refusal to submit to clichés in forming eyes, for example.

Entirely on his own, Calder solved many of the problems that challenged figural sculptors such as Matisse, Picasso, Lipchitz, and Gonzalez: how to incorporate space into sculpture and how to make the form interesting from all points of view. Gonzalez and Lipchitz were to realize their dream of drawing in space with bronze and iron, but Calder was to precede them with his work in wire.

The drama of Giacometti's involvement with portraits is not in the struggle to extract the subject's character, but rather in the resolution of dualities: balancing the effect of artistic wholeness between the head and its details; deciding the conflict between the memory of art and the actual appearance of the model; and finding a style that was strong but not one that would call attention to itself because of the lifelike nature of the subject. This struggle to resolve contraries, which began in Giacometti's art from 1919 to 1925 and then continued from 1935 until his death, is brilliantly chronicled and interpreted in Reinhold Hohl's 1971 book on the artist. If there is a precedent for Giacometti's efforts to remake sculpture according to his personal perceptions, it is in the art of Medardo Rosso, whose work does not seem to have had an influence on Giacometti. Many years before Giacometti, Rosso deliberately tried to suppress knowledge of the face in favor of showing how it appeared to him or how he remembered it at a given moment, under specific lighting conditions and acted upon by a particular setting.[8]

The early portraits of Giacometti, like those done throughout his life, are of his parents, brothers, or close friends and were not made under any compulsion to flatter; the features of his subjects are expressionless. The young sculptor was precocious in his touch, which gave the surfaces of his portraits of his mother and a boyhood friend a compensating animation. As if distrusting his gift, he gravitated to stylized portraits, influenced strongly by Egyptian art he had seen on a trip to Italy in 1920; there is a frontal fixity in the blank-eyed heads that followed. Stylization allowed him to dispense with the agonizing study of details he experienced working in Bourdelle's studio. The firmly volumed, mask-like heads still maintain residual likeness. Even when Giacometti began creating figures out of his imagination, he continued an interest in the portrait. In 1927 he made a third portrait of his father (fig. 57), in which he flattened the front of a rude, block-like head in order to incise roughly, almost like a graffito, the bearded features of his father. He had collapsed the frontal prospect of the head, denying the literal projection of the features. It may have been, as Hohl suggests, that Giacometti was

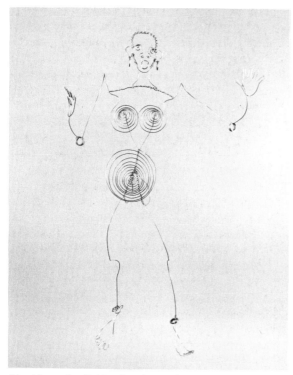

56. Alexander Calder, *Josephine Baker*, 1927–29.

57. Alberto Giacometti, *Portrait of the Artist's Father*, 1927. [cat. no. 22]

formulating his observation that "reality seen from a distance is perceived as a whole."[9] It appears he started by simply incising three slits in the tapered, oval plaster surface to indicate eyes and the mouth, but then for some reason felt compelled to etch the plaster into fuller resemblance. Torn by conflicting notions of what was true for art and life, Giacometti then moved into his imaginative heads until 1935, when he returned to working from the model; and, not surprisingly, as he returned to resemblance, it was in an Egyptianizing mode, as in *Head of Isabel*, 1936.

Dissatisfaction with Surrealism and its methodology, coupled with the need to replenish his imagination and to come again to grips with understanding reality brought Giacometti back to working with a live model in 1935. His account of the difficulties he had in fathoming the model and his realization that "heads and figures only seemed at all true when miniscule," has already been quoted. (See Ch. I, fn. 64, p.42). Thus began Giacometti's agonizing struggle and, for him, exciting personal adventure in bringing sculpture closer to his actual perception, stripped of all previous assumptions and artistic conventions for its rendering. The more he studied a face, the more it eluded him. In 1933, he had written, "No human face is as strange to me as a countenance which, the more one looks at it closes itself off and escapes by the steps of unknown stairways."[10] Where previous sculpture had presupposed an ideal, even intimate distance of six feet or an arm's length between the artist and his sitter, Giacometti came to portray his subjects as he saw them: frontally and from a greater distance. Psychological intimacy with his subjects had never interested Giacometti, and the portrait became a crucial means by which to use sculpture in his search for the understanding of reality — under what conditions and how we see our fellow human beings.

The Evocative Head

The evocative head in modern sculpture differs from the portrait, even in its most stylized manifestations, and from the traditional imaginary head, such as Rodin made for architectural decoration. It is not derived from a sitter nor does it serve a conventional symbolic pur-

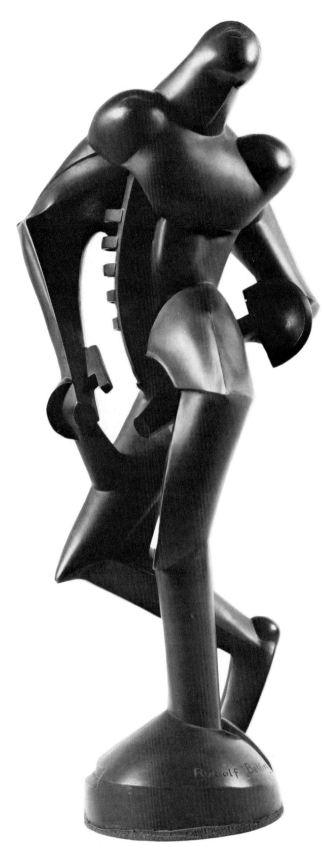

58. Rudolf Belling, *Organic Form*, 1921. [cat. no. 6]

pose or as applied architectural decoration. The evocative sculptural form signifies or is an idea of the head. The head may be realized by indirection, such as through signs in a certain context. In themselves, the signs may not be what one normally associates with the motif. The sculptor's purpose is not to make the beholder play hide and seek nor to provide a screen onto which one projects missing features. Evocative heads are unknown beings, having their own specific identity for the artist. As the fruit of the artist's fantasy, they permit him to continue a human presence in art. The literature and artists themselves say little on this subject. Lacking contrary testimony, one can speculate that this motif appealed to certain interwar sculptors who made figural unknown beings, because it afforded still another way of transforming tradition. The head could be liberated from likeness and; fittingly, as the locus of creativity, it became the subject of fantasies on its internal life. Cubism had helped to open the solid form of the head to space, and after 1918, it was more open to irrational speculation and inexplicable association.

In modern sculpture the evocative head probably has its beginnings in the 1906–1907 carvings of André Derain, and thereafter it is found in the work of Epstein, Gaudier, Modigliani, Brancusi, Archipenko and others.[11] Just as in the pre-1914 period, tribal, pre-Classical and early medieval art continued to present artists with models which have not only human presence, but also mystery. Just as compelling for some sculptors was the challenge to create a head that had the look of the machine age.

In the twenties, both within the Weimar Republic and abroad, Rudolf Belling's sculpture rivaled in the public view that of Archipenko as a symbol of modernism.[12] More than any other German sculptor, Belling also seems to reflect the changing character and the contradictions of the Weimar Republic from its violent beginnings and affinities with Expressionism to its stabilization, prosperity and taste for cool rationality. The popularity of Belling's art was largely due to what we see in retrospect as really an *applied* modernism. After his most abstract work, *Three Sounds* of 1918, which was

a reworking in inspiration and style of Archipenko's earlier sculpture *Dancers*, Belling moved to the mechanizing of the human form coincidentally with his culture's obsession with engineering as the means of rebuilding Germany. Belling's *Organic Form* of 1921 (fig. 58) showed a striding robot, or more exactly, the human form made to look like a mechanized figure. Although self-taught, Belling had a strong academic streak which caused him to make sculptures that were like demonstrations of rules formulated from what in more venturesome artists had been intuitive. (In this he was like colleagues in the Bauhaus, many of whom domesticated their own pioneering art.) For our purposes in this section, Belling's *Sculpture 23* (fig. 59) exemplifies what might best be called a contrived evocative head, the result of a kind of rational problem solving. Unlike that of Schlemmer, Belling's work does not challenge the viewer for long because he has not really disturbed the number or sequence of the features. Belling, in effect, domesticated Cubism and Constructivism, adopting the obvious qualities associated with these movements and creating a paraphrase of the human head. *Sculpture 23* had the look of mass production. Learning from Cubism, he showed simultaneously the inside and outside of the form, which was also a connecting link with architecture. In fact, that same year Belling designed a domical gas station for the Olex Company, which is a takeoff from *Sculpture 23*.[13] Understandably, his work was in demand from industrialists and manufacturers to modernize their image. The saving grace of this example of substitution rather than invention is the right eye of *Sculpture 23*. Unlike the round, ball bearing, wide-open left eye, the right eye is closed as if in a wink, seeming to reassure us that we, like the artist, should not take the robot too seriously.

Belling's best head may be that of 1925 (fig. 60), called either *Head* or *Madonna*, reportedly all that remains from a mother and child sculpture. The serenity of the image reflects the calmer atmosphere in Germany after the postwar years, and also suggests in art as in politics, the time for revolutionary experimentation was over.[14] *Madonna* must have been a consolation to those who worried about

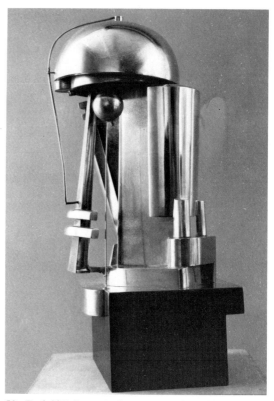

59. Rudolf Belling, *Sculpture 23*, 1923.

60. Rudolf Belling, *Head (Fragment of a Group: Madonna and Child)*, 1925. [cat. no. 7]

whether there could be a compromise between human and machine-age beauty. Having previously designed mannequins for window displays, Belling here flirted with a slickness, a high fashion chic, in a paraphrase of a Classical or Renaissance Venus head. (In this work he is the German Elie Nadelman.) The composed, impenetrable being also satisfied artists and critics interested in the New Objectivity. Belling's cleverness and skill won him several portrait commissions of important Weimar Republic figures. Their stylized, matter-of-fact, and literally hollow-eyed expressionlessness suited the taste of the time and represented a counter-modern movement within modernism itself.

The difference between talent and genius stands between Belling and Picasso.[15] The latter's three evocative heads, made with Gonzalez's help out of scrap metal in 1928 and 1931, were generated by an original vision. Far from resulting purely from chance encounters with found objects, as had Picasso's later *Bull's Head* of 1943, these three heads were first realized in drawings and in *thought*. They constitute in theme, form and material Picasso's achievement of the unimaginable in sculpture. Nor are these works *totally reversible* images, as was *Bull's Head*, wherein one could see the source and what it inspired. In the heads, no total alternative image is evoked by focusing on the object origins of the parts. Picasso wanted unknown beings with their own logic or magic and, therefore, painted two of the heads to give them greater consistency of context. Nor do these three heads enforce the view, at times stated by Picasso, that he always started with something seen around him. Two of them, in fact, originated in drawings.

The 1928 *Head* (fig. 61) coincides with that of the artist in the 1928 painting *Painter and Model* in the Museum of Modern Art. The sexual identity of the small metal head is intentionally ambiguous. Such is the provocative power of the piece that it can be interpreted as a triple image of the same head or a double portrait of a man and a woman embracing: there are two conjoined profiles and a frontal view, the latter encouraged by the circular ring, with the colors evoking the idea of a light and dark nature. The multiple image is an idea

61. Pablo Picasso, *Head*, 1928.

Picasso was to develop thereafter and throughout his art.

More ambitious in scale but not more potent as images are *Head of a Woman* (fig. 62) and *Head* (fig. 63), both of 1931. When shown facing one another, they take on personalities and engage in a ludicrous dialogue. Their respective faces serve as sounding board and trumpet for an emphatic exchange. The woman responds to the male's pompous, booming challenge with her tiny, clothes-pin mouth. The male is descended from the masked clowns on the right side of Picasso's two paintings of *Three Musicians* of 1921. Between the broadly spaced, bored holes of the eyes in the sculpture, a sharp metal shape has claimed tenure as nose and presides over a heavily soldered moustache. "Factual" details such as these and the pitch forks, which substitute for shapes in his paintings of 1929 and are used as signs for the woman's hair, were not lost upon Gonzalez, who sought the same whimsical credibility for his evocative heads. Gonzalez assisted on the work, and we know that Picasso instructed him to obtain a colander for the woman's head. Picasso not only plundered

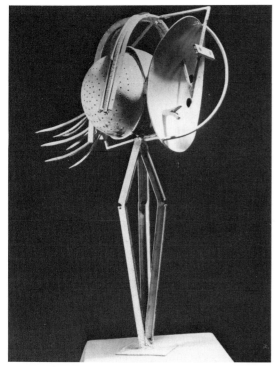

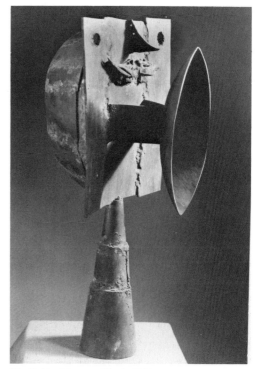

62. Pablo Picasso, *Head of a Woman*, 1931.

63. Pablo Picasso, *Head*, 1931.

junkyards but also his own art, notably certain paintings of monumental fantastic heads of 1929 and *Constructions in Wire,* to achieve the shape for the woman's nose, to which he soldered the double, perforated plaque for the eyes.

In sum, Picasso's assembled and partly improvised works in metal are the antithesis of dead pan "machine-age" art. They reflect his preference for the humble discards that he found high in physiognomic value and potential for expressing his wit. With these brilliant constructions, Picasso helped launch the modern tradition of welded sculpture, and he could have devoted the rest of his life to developing the rich ideas in them. It was not his way to open a new door and slam another, for in sculpture he next went back to carving and modeling, exchanging puns and sleights-of-hand for more traditional ways of creating imaginative "souvenirs" of human beings in life.

Picasso's group of heads modeled in the round and in relief made at Boisgeloup in 1932 rank as one of the great series of variations on a theme in the history of sculpture. Initiated by the passion for his new mistress, Marie-

Thérèse Walter, only one of the heads may be called portrait-like in the traditional sense. When Picasso fell in love with a woman, as he himself put it, he tore his art apart. Rather than work progressively toward a more essential and intimate characterization of the subject through successive reductions and structural clarifications, as did Matisse in the Jeanette series, Picasso seems not to have had his lover always in mind. One of the notable exceptions is the head in which he imposed masculine sexual parts upon the woman's face in a stunning image of copulation (fig. 64).[16] In Picasso's mind the head in general, not just the portrait, could be complete in itself, and he felt free to impart to it the expressiveness and, in the cited example, even the actions of the human body. When Picasso "tore" his art apart, he also reshaped, reproportioned and relocated facial features. Nose, cheeks, eyes, hair and neck became separate negotiable parts that could be stacked or fused in astonishing combinations. In one *Bust of a Woman* that most writers see as a torso, Picasso locates the conical nose atop twin, ball-like eyes that, in turn, nestle on the bosom-buttock-cheek

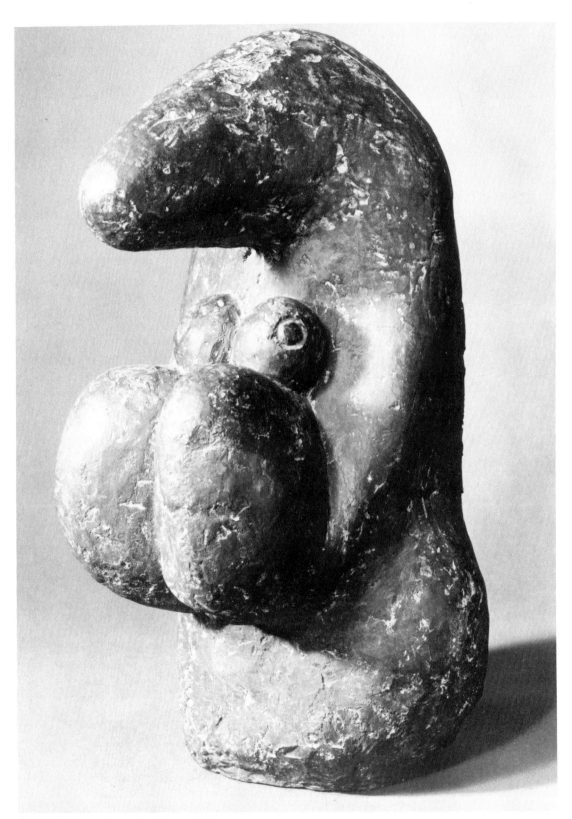

64. Pablo Picasso, *Bust of a Woman*, 1932.

forms below. For Picasso, when the Renaissance type of nose became the norm in western art, "reality went to the devil." To know Picasso is to realize that it is not paradoxical that these fantastic heads were his way of discovering reality, reality more real than real, which he claimed was not indebted to Surrealism.

Consider Picasso's comment to a friend that art need not look like what it represents, as with the printed word "man." To Brassaï and Françoise Gilot, he pointed out how three circles could evoke a face as powerfully as the letters in the noun, "face." Where Rodin spent a lifetime studying the expressions of which the faces of his living subjects were capable, Picasso spent years discovering how faces could be evoked, how imagination could become artistic fact. All man-made objects and even pebbles and other forms from nature had a physiognomic potential for Picasso. As with his figure sculptures assembled from readymade elements or found objects, Picasso's heads show us the human in terms of the world, as well as the reverse.

One of the greatest sculptures in modern art is Picasso's *Death's Head* (fig. 65) made in 1943 (or possibly 1944). As Rubin and Steinberg have shown, Picasso was preoccupied with the prediction made years before by Max Jacob that he would die in the year this sculpture was made.[17] The creation of the sculpture was the artist's way of confronting and possessing death itself. Picasso's artistic achievement was to encompass contradictory feelings of fear and joy and to say the unsayable, to stretch the mind beyond the comfortable boundaries of understanding. Picasso's triumph was to show life in the head of death. It is not a medical school object intended for exact study but rather a being contrived by widely spread, graffito-like eyes, a surface that fuses memories of flesh and bone pulled tight, and a jaw that does not hang open slackly but is set in taut resignation or even defiance. The sculpture may have been begun in paper torn and burned with a cigarette, while he sat with Dora Maar in a Paris café, recalling Breton's observation about Picasso making perishable art because he did not have the presumption of materials.[18] The final head, however, cast in bronze during the

worst moments of the Occupation when metal was not available for artists, makes eternal Picasso's challenge to the notion of death's finality as symbolized by the living skull.

Gonzalez's interest in the head dates from his early modeled portraits, done before the First World War. These early heads show women withdrawn into their own thoughts, a self-absorbed or introverted quality which continues later in the several evocative heads Gonzalez made out of iron in the thirties. Even the masks of the late twenties do not seem to look out on the world. Like the *Sleeping Muse* of Brancusi, Gonzalez's more representational but neckless heads balance on their sides, as if in their own dream world. Brancusi's work, tribal masks, the fanciful faces of Gargallo and the imaginative heads of Picasso formed an immediate and accessible "tradition" within and against which Gonzalez could work. In the early thirties, when his figural pieces were filiform, the imaginative heads were often fashioned from flat, inflected and perforated planes with little regard for equivalents of all the features and their normal sequence. As Withers points out, one of Gonzalez's feats was to achieve some of these masks out of a single sheet of iron, handled as if it were paper.[19] (Picasso's Cubist pasted paper works had suggested carved stones to Gonzalez; and he used solder instead of glue to join his planes.) The remoteness of some configurations from those of a head suggest the sculptor's temporary

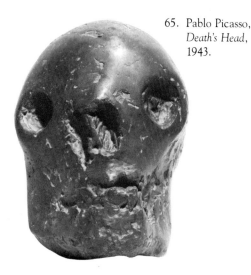

65. Pablo Picasso, *Death's Head*, 1943.

attraction to abstraction around 1930. It seems probable, however, that Gonzalez never wanted to lose contact with the human and backed off from the limits of the new sign language Picasso had encouraged him to develop from his own. Taking the idea from the tripod bases of Picasso's painted metal heads, Gonzalez at times mounted his configurations on metal supports to elevate them while asserting sculptural and thematic self-sufficiency: the artist's self-aware identification of the head as the locus of activity. There is a greater range of expression in the later heads than in their modeled predecessors.

Although Withers sees humor and occasionally a menacing feature in the heads, such works as *Head Called "The Tunnel"* (fig. 66), *The Cagoulard* and *Head* of 1935 (fig. 67) at the Museum of Modern Art can also be thought of as having qualities of the diabolical that the sculptor saw in his own work. *The Tunnel* is one of his most challenging sculptures thematically and formally, for it does not immediately convey the head, even by indirection, as do the ovoid or crescent configurations and featural clues of the beautifully formed silver heads of 1933. This work reflects Gonzalez's ability to free himself from a repertoire of shapes or signs, such as those he used for hair. In the thirties he also turned to carving generalized heads in soft stone and bronze. Less revolutionary than the iron fantasies, the great iron and bronze head studies of *Head of the Montserrat Crying II* (fig. 68), for example, show that he was capable of forceful traditional expression, and their quality and sculptural power is impressive.

With his series of heads called *Plaques* of 1928, Giacometti stepped away from the problems of likeness and gave himself over entirely to inventing a new life for the head. Cubism had taught him to think in terms of planes and their artistic rather than featural logic. He had been moving toward flat, simply outlined surfaces in portraits of his parents and thinking how the head was complete in itself. The plaques became a fruitful new conclusion to this evolution, for they also predict the sculptured landscapes, the horizontal reliefs that follow. The concavities of *Observing Head* of 1928 (fig. 69), which suggest an eye and

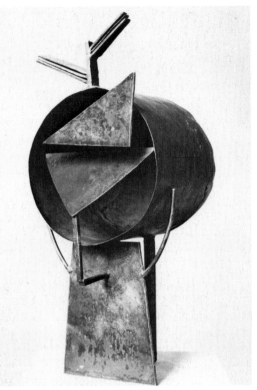

66. Julio Gonzalez, *Head called "The Tunnel,"* 1933–34.

nose of a profile head, relate to the hollows of his spoon women and look forward to the crater-like depressions of *No More Play* (see fig. 135). These thin, flat, rectangular shapes became a kind of imaginative projection screen, just as the cage forms established the context for three-dimensional fantasies, as is seen in the plaque called *Woman*. A rectangular shape, roughly the same as in *Observed Woman*, though reversed, becomes the field in which float a sphere and woman's lower torso and legs, cut at the knees. The purified shapes and single, continuous surface of *Observed Head* suggest it was influenced more by Brancusi than by Cycladic heads.

The asymmetrical *Skull* of 1934 converts the pliant surfaces of the plaque series into a hard, crystalline, planar mass, descendant from the featureless prismatic *Cube* of the same year. As Hohl points out, Giacometti's themes partly polarize between life and death, but as Giacometti stated, Freudian interpretations of thematic sources are not so important as how deeply the artist feels about his forms: "The

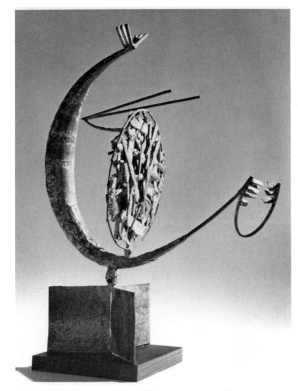

67. Julio Gonzalez, *Head*, 1935. [cat. no. 26]

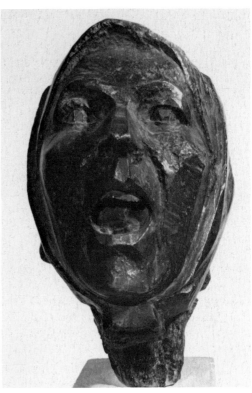

68. Julio Gonzalez, *Head of the Montserrat Crying II*, 1942. [cat. no. 28]

plastic quality of a work of art always depends on how strongly the artist was concerned by his subject; the power of the form always corresponds to the intensity of this concern."[20] Giacometti's conception of death is that it has a cold, hard, unblinking life of its own. The density of the head and its fathomless eye today evoke associations with the black holes into which burned-out stars compress themselves.

In the late twenties, Hepworth, like Moore, had made a few primitivized heads, at least one of which was titled "mask."[21] Her earliest works showed skill at traditional portraiture, but this mode became inimical to an artist rapidly becoming committed to a modern style that dealt more with essences than particulars. In 1932, Hepworth made her literal breakthrough of the monolith, by penetrating the stone of *Profile*. It is, in effect, a feminine bust, with the profile of a woman etched into the stone, a generalized amorphic shape in a Picassoid manner with a frontal eye. On the one hand, she was searching for new formal continuity, the "other" order she was to write of.

On the other hand, she wanted to retain more traditional evidence of a human presence. She and Moore were briefly intrigued with the conjunction of relief and full form, possibly because this mixing of modes went against convention and won them surprising formal contrasts. *Two Heads* of 1932 seems abstract from the back, with both forms joined together, while from the front they take on the appearance of a mother and child, with the more abstract shape evoking the head of an infant with still-to-be-formed features. Hepworth had looked with understanding and interest not only at the work of Arp and Brancusi but also at Epstein's *Mother and Child* of 1913, and her evolution after 1932 was probably encouraged by their purification of form which still retained human resonance. In the mid-thirties, Hepworth did a series of very beautiful sculptures variously titled, *Two Forms, Disks,* and *Forms in Echelon,* which often evoke paired heads. The calculated proximity of the shapes continues the traditon of showing human relationships in sculpture, but

on the artist's own terms, not depicting feeling and therefore not "confusing" different types of expression, psychological and artistic. By fusing mother and child in bust-length compositions, rounded off for artistic self-sufficiency, Hepworth, who had herself become the mother of triplets, could feel reassured that modern art was thematically capable of retaining a strong basis in human experience.

In the late twenties and early thirties, Moore's heads, like his figure sculptures, had a decidedly stylized look. Sometimes the stylization derived from a kind of primitivizing, as in his heads that seem to stem from a Mexican type, and at other times there is the suggestion that he had looked at Picasso.[22] Moore was always committed to a fixity of expression, avoiding any suggestions of the potential flexibility of the face, "motions of the mind" or the complexity of emotion. Thus, when he does achieve a genuinely imaginative reconstruction or evocation of the head (fig. 70), as in 1936, the Nicholson-like, geometric relief surface of the face retains the earlier quality of unblinking stare. The etched and indented surfaces of his most cryptic heads, such as those done in 1937, make them resemble a geometricized lunar landscape or a Giacometti table relief.[23] There is no sense of any interior life, no compelling character or formal logic in the surface scarification. These are among his least convincing works, for one has the impression, nurtured by Moore's own art as a whole, that

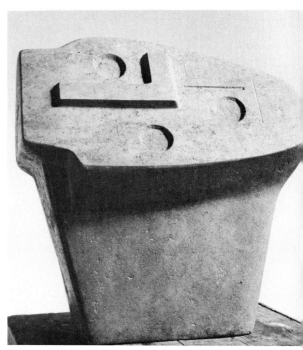

70. Henry Moore, *Carving*, 1936.

mystifying signs have been applied and do not generate from the inherent poetic mystery of a unified conception. The heads, although handsome, are superficially strange and lack the conviction and power of the figures. Of interest is Moore's attempt at geometric relief, two modes inimical to his beliefs. He compromises by backing the "face" in relief with a three-dimensional form; flat and round are conjoined to test the wisdom of breaking a rule.

It is when Moore comes to *The Helmet* sculpture of 1939 (fig. 71) that he achieves conviction, authority and genuine mystery in an evocative head. According to Alan Wilkinson, "The helmet idea may well have been suggested by two prehistoric implements or utensils which Moore copied in a 1937 sketchbook. In all probability the single hole at the back of the 'Helmet' derived from the holes which appear in each of the Greek bronzes."[24] From Surrealism and, more notably, Picasso, he had derived the premise that any object could initiate a sculpture. Possibly Moore had in mind Jacques Lipchitz's small helmet-like work of 1932 (fig. 72) that was part of his study of "interior or negative spaces." It predicts the

69. Alberto Giacometti, *Observing Head*, 1927–29.

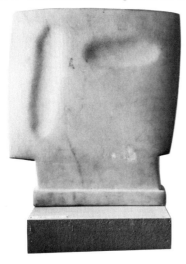

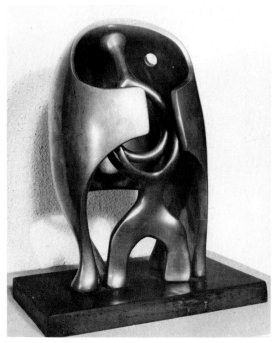

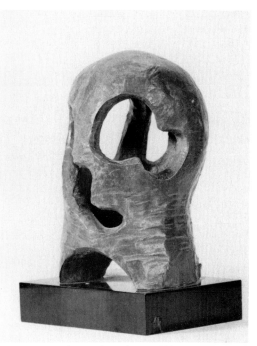

71. Henry Moore, *The Helmet*, 1939–40.

72. Jacques Lipchitz, *The Helmet*, 1932.

overall shape of Moore's work, but its ragged orifices, cut through the thick, bony shell, have a more overtly brutal aspect than Moore's form. Unlike the *Helmet,* in Lipchitz's sculpture one looks into darkness and sees only the shapes and light coming through other pierced openings. The lighter tone of the earlier transparents had given way to a brooding, aggressive form.

Drawings helped the transforming process, and one that preceded the *Helmet* sculpture has a nocturnal environment, shadowed and even sinister in character.[25] Given the date of the drawings, the lack of information on the circumstances in which they came about, and Moore's consistent grounding of major forms in personal experience, it is conceivable that they reflect the sculptor's response to the Spanish Civil War and the threat of world war. The paired motif descends from the nesting and maternal imagery of the thirties. The hole in the back of the helmet recalls that in the somewhat pelvic shape of *Two Forms* (see fig. 41) in the Museum of Modern Art, through which one can see the progeny of the parent. In the *Helmet,* however, the relation between the two forms oscillates between protection or

shelter and imprisonment, between two separate entities and a fantasy on the human head with its tough, external shell like a reliquary and its fragile, almost flowering interior. It is like the armored intelligence of an unknown being. Both forms are new and atypical of Moore's art at the time. They are important for postwar sculpture; the shell form will culminate in his monument to the Chicago project for the atomic bomb. While the war period brought forth the Shelter drawings, it may have interrupted further important development of exciting sculptural and thematic ideas emerging in the small bronzes of 1939. It was as if his imagination had a new impetus. He could have continued in small clay maquettes, but perhaps guilt dissuaded him?

3. The Other Realities of Abstract Sculpture

Russian Constructivism[1]

One of the most ambitious attempts by artists to fulfill humanity's hope for the good life resulted in the first pioneering movement of abstract sculpture and took place in Russia between about 1914 and 1922. This movement, known today as Constructivism, a term which came into use only in late 1921 and was then identified with utilitarian design, was based on an optimistic culture of materials, space and the structures that related them. It was a culture that stressed new unities on all levels of life and could generally be supported by both mystics and materialists, although they ultimately differed on the way the ideal should be achieved. After 1920, materialists such as Tatlin (fig. 73) and Rodchenko wanted a utilitarian art, based on the most advanced artistic ideas, eventually exchanging the studio for the factory, while Malevich and Gabo wanted a more spiritual and pure art made in the studio, which was equated with a research laboratory. Both groups wanted to give their fellow man an understanding of what it meant to live in a modern age.

Sculpture seems to have been at least quantitatively a relatively minor part of Russian revolutionary art, which was dominated by painting and literature. After 1920, graphic, industrial, stage and book design dominated the attention of artists, along with painting. After about 1922, Constructivist sculpture appears to have died out in Russia. There also seem to have been few prerevolutionary, trained, full-time sculptors, who are, so far, mentioned in the translated literature as having made sculpture acceptable to the revolutionaries in art and politics. Babichev was one, but his works do not seem to have been reproduced outside of Russia. Another was B.D. Korolev, who supposedly worked for Rodin in 1913, and whose Cubist monument to Bakunin was torn down after its unveiling in a Moscow festival in 1918.[2] Katarzyna Kobro was the best known professionally trained sculptor. Before 1914, Gabo was educated as an engineer and self-taught as a sculptor. His brother Pevsner was trained as a painter and turned to sculpture under Gabo's guidance. Tatlin and Rodchenko were painters who came to work in three dimensions to escape from the limitations of painting's flat surface. How many Constructivist sculptures have survived in Russia may become clear in the near future, but relatively few were brought out of that country by 1925, to exhibitions in Germany in 1922, and Paris in 1925, and the rest are known through old photographs in publications. It was from these sources, the publication of articles by Malevich and others, plus the departure from Russia of Gabo, Pevsner and Kobro, that Constructivism had an impact on European and American interwar art.

Russian Constructivism, as we now refer to an aggregate of movements, did much to shape our view of modernism. It arose among a number of artists as a result of a deeply felt need to evolve an art that more fully expressed their consciousness of revolutionary changes in the world that cut through not only all social strata but also activities in life from politics to poetry, science to stage design, and mathematics to music. (Constructivism was really formed before the Russian Revolution in October, 1917.) Their collective vision was that of a mobile rather than static world, one being constantly reshaped by science, machines, and political and social theory and which, after 1917, they saw as heading for a communist or socialist utopia. When achieved, this ideal would either eliminate the need for art or make every person an artist. Painters and sculptors did not see themselves as passive chroniclers of historical change, but as its prophets. Theirs was the challenge to give tangible and artistic form to the newly discovered rhythms and intuited relationships of the natural and man-made worlds. The artists were to articulate the discoveries that replaced the discredited hierarchies, premises and prejudices of the old order. Constructivism represented for most what

Stephen Spender has called "presentism," by which the artist considers the moment in which he lives to be a dividing line from the past from which to look to the future. In 1920, Gabo wrote in a manifesto, "We take the present day."[3] For artists born just before 1900, there was to be no attempt to fuse past and present, with the exception of certain spiritual and ideological aspects of the Russian artistic tradition, such as the admiration for medieval icons and peasant art. (Tatlin, for example, saw Russian medieval icons as stressing innate properties of materials, such as gold.) Rather than creating an art that merely reflected revolutionary changes in society, many of the artists believed at the outset that their art could itself help to effect revolutions in thought, perception and feeling. They felt they could substantially change the environment, by guiding architecture or even designing more efficient clothing, and that they could reconnect the inner life of the artist, that had been driven inwards by Tsarist society, with the ideas and events of the external modern world opened to Russia by the Revolution. It was to the visions and hopes of the masses rather than the wealthy that the Constructivists naively but sincerely believed they addressed themselves. They would show their countrymen that, just as for artists, there could be for all an accord between one's internal life and the soon to be industrialized society.

In the new Marxist society artists were particularly self-conscious about the public stereotype of their profession, the artist as an idle, self-indulgent, "day-dreaming romantic," and they determined to affirm the importance of creativity in the new society. (Gabo defended the title of artist, but Tatlin and the other Productivists renounced it for "technician.") The new role of the sculptor, like that of his colleagues in the other arts, was to be a model of modern constructive man. More than any style, this was the enduring meaning of Constructivism for artists such as Gabo and Pevsner. The implications of this adjective were that the artist was to accept challenges and engage energetically in problem solving: in short, to be a peaceful creator and model for society. The artist's special contribution was to give mankind an incentive to live. During and

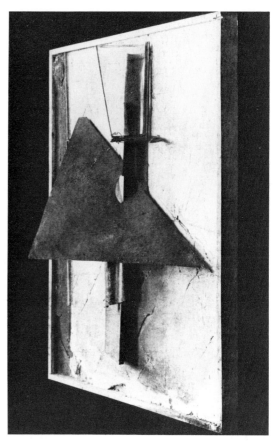

73. Vladimir Tatlin, *Construction*, 1914.

after the Russian Revolution, the engineer was held out to the artists as the paradigm of one who makes significant contributions to all. In their 1920 "Realistic Manifesto," Gabo and Pevsner wrote, "The plumb line in our hand, eyes as precise as a ruler, in a spirit taut as a compass . . . we construct our work as the universe its own, as the engineer constructs his bridges, as the mathematician his formula of the orbits." The artists saw twentieth century science moving from description to the analysis of nature in terms of structures, patterns and architecture, and this became a justification for their rejecting descriptive art. The artist-engineer was not encouraged to be a specialist, but to move from one medium to another as his researches dictated. The goal was a collectivity of creators, working in unison toward the common goals of knowledge and the good of the people.

Unlike the orgins of modern sculpture in France, Germany, England and Italy, there was

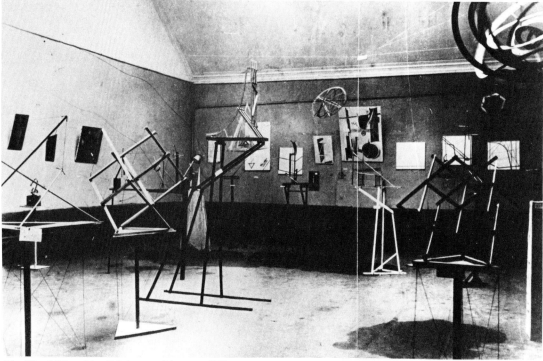

74. Third Obmokhu Exhibition, Moscow, 1921.

no strong conservative sculptural tradition in Russia to serve as a serious opposition to the Constructivists. The academicians had fled with the White Army in 1917. Rather than exhibiting new work in public salons crowded with hundreds of conventional figural sculptures, as in France, the Russians showed their latest creations in avant-garde exhibitions and in their studios (fig. 74). There were no art dealers, such as Vollard and Kahnweiler in Paris or Herwarth Walden in Germany, to introduce their work or create a sympathetic middle class clientele. (Tatlin gave a work to a sympathetic newspaper and either traded or gave his works to fellow artists. In one instance he sold a piece to the famous Moscow collector Shchukin.) The Constructivists believed that their art would gain state support in place of private patronage and that it would belong to the people. For a short time Russia led the world in museums of modern art, and some of the Constructivist sculpture purchased by the state may still survive in storage. During the Revolution and until about 1922, the government was generally sympathetic and saw to it that leading artists, such as Tatlin, Malevich, Rodchenko, Pevsner and others, held teach-

ing positions in new art schools. Otherwise, there were few funds to support sculptors. (When Tatlin and his two assistants went to Moscow to show their model of the Monument to the Third Communist International, they had barely enough money to live in an attic for a month.) Sculptors taught in nineteenth century Beaux-Arts stone structures and lived and worked in wooden buildings, using cardboard, urban scrap and kindling wood to model their dreams of iron, aluminum and glass constructions. Besides teaching, much of their time was involved with meetings or occasionally working on large propaganda displays commemorating the Revolution. Living in great privation amidst political strife, the artists, all through the years of 1917 – 1920, carried on intense ideological debates which, if recorded, have so far not been translated. Cut off from Europe by the war in 1914, and until 1917, the energetic interaction of writers, poets, composers and visual artists made life in Moscow and Leningrad just as rich and fruitful as that of prewar Paris and Munich.

From 1917 to 1922, the Constructivists hammered out a new modern art. All previous assumptions about sculpture's purpose, such as

the imitation of nature and celebration of the past, were stripped away; modeling and carving were rejected and bronze and marble were viewed as outmoded by the vanguard, if not the public and its political leaders. The celebration of neither individuals nor nations was to be sculpture's purpose in the new international communist age. Beauty, perfection and style were all associated with discarded social systems, ego gratification of the artist and capitalist exploitation of art. Style was to give way to honest disclosure of materials and technique. New to modern sculpture was resentment against subjectivity and individuality. Artists saw themselves as engaged in impersonal research into the inherent expressiveness of untried materials and the nature of space and in the search for structural systems by which to evoke a continuous reality that extended beyond sensory experience, the "non-objective world" that was to replace that of persons, places and things. Historically, the Constructivists were imaging what to earlier generations was not only unthinkable, but unimaginable. In turning away from man-centered art and the imitation of nature, the new abstraction or "realistic art," as Gabo called it, gravitated toward a vocabulary of roughly geometrical shapes, because they were constructs of the mind and in sculpture were "neutral" or free from previous psychological and artistic associations. Space was the exalted subject of energetic inquiry and often obscure rhetoric. No previous sculptural movement had been so space conscious or so determined to make it integral to and tangible in sculpture. Just as late nineteenth century painters had sought the inherent expressiveness of line and color, the Constructivists, beginning with Tatlin, absorbed themselves in a comparable study of materials, "real materials," as Tatlin referred to them, meaning vernacular as well as new machine-produced materials (fig. 75). Along with certain contemporary poets and musicians who investigated compositions based purely on sounds, the sculptors wanted the equivalent in materials that would express the new textures of life in a society moving into an industrial age. With the abandonment of the figure, there was no reason for sculpture to have a front or a back, and so it became com-

75. Kasimir Medunetsky, *Construction No. 557*, 1919. [cat. no. 44]

76. Alexander Rodchenko, *Suspended Composition*, 1920–21, reconstructed 1973. [cat. no. 54]

munized by Gabo and Rodchenko (fig. 76). Inspired by the new non-Euclidian geometry, they, like their colleagues, believed in doing away with fixed perspectives by which to create a sculpture. This new freedom to reflect on sculpture was equated with new possibilities of thinking about a world no longer tied to the old coordinate systems. In sum, just as their fellow creators in literature and music, the Constructivists sought revelations of their modern consciousness by means of the richness and strangeness of a new artistic language.

An apt characterization of Constructivist sculpture would be the paraphrase of Duchamp-Villon's dictum: "The sole purpose of the arts is neither description nor imitation, but the creation of unknown beings *and realities* from elements which are always present but not apparent." The sculptures themselves were a new class of objects, poetic and esthetic. They offered no resonance of the figure or organic life, but instead still inspired associations with scientific instruments or models

(Rodchenko and Gabo), machines and engineering structures (Medunetsky and the Stenberg brothers) and futuristic skyscrapers (Malevich and Gabo). *Invention* even more than creation was the key word. All of the analagous objects that inspired the sculptors are themselves modern inventions and differ from the tableware, food, musical instruments and objects of personal possession, like pipes, in Cubist assemblages having connotations of sociability. In a manner reminiscent of Boccioni's attitude towards his *Development of a Bottle in Space*, the Constructivists did not conceive their "objects" as being static, but rather as dynamic, incorporating "forces," and "rhythms" which made them "beings," as Gabo was to refer to his work.

The Constructivist ideal of a perfect unity of form and meaning depended upon total revelation of the sculpture's structure, resulting in a form of unprecedented openness and lightness. (It was the difference between Bartholdi's external sheet copper form of the *Statue of Liberty*

and Eiffel's internal armature for that colossal sculpture.) Nothing was to be hidden, and there was to be no distinction between inside or outside. Rodchenko constructed from kindling some cage-like structures (fig. 77) that conceivably were invertible.[4] From 1917 through 1922 the common goal was to free sculpture from its weight and achieve solidity without density while also asserting the material properties. These see-through structures were to depend upon massless construction made possible by engineering principles, such as "I" beam construction, and the use of new lightweight materials, such as plastic and aluminum. This last was in short supply, and Rodchenko used painted cardboard to simulate it. It appears from what evidence we have in old photographs that the Constructivists wanted industrial materials to be worked cold, hence joined by riveting or bolting.

The artistic inventiveness of Tatlin, Rodchenko, the Stenbergs and, above all, Gabo was in getting sculpture into space and space into sculpture. The traditional pedestal and base were optional and not always done away with entirely. On the one hand, Tatlin's *Corner-Reliefs* of 1915 depended for their removal from the wall and suspension in space on wires held in tension from the walls. Medunetsky's sculpture at Yale University (see fig. 75) springs upward from a conventional marble cube. The Stenbergs and Boris Ioganson braced their open form wooden "socles" with wires in tension. Rodchenko stabilized his free-standing works on flange-like plinths, but suspended his concentric oval structures like pendulums from the ceiling to underscore space as the form's nucleus. The Stenbergs and Rodchenko cantilevered their free-standing sculptures into space, relying upon the tensile strength of new metals, and launched their forms from narrow, scaffold-like supports. Gabo's use of glass and plastic gave him the continuous depth, light and movement of light he sought to encode his intuitions about space. Often overlooked is that Gabo proposed shadowless sculpture (fig. 78).

The structural system used by Tatlin and Puni in their reliefs came directly out of Cubism and its "architectonic" arrangements of elements, that ranged from an irregular grid to greater randomness, while maintaining some points of tangency between the motifs themselves and the exterior shape of the field. Rodchenko worked with both asymmetrical and symmetrical sculptures. Not since the Middle Ages had symmetry been as important as it was to Rodchenko, and in this respect he violated one more taboo of Western art since the Renaissance. His hanging concentric circle and oval constructions (see fig. 76) gave him a constancy of optical vibration and rhythm that seemed to him appropriate to the new age. The Stenbergs favored constructions that looked like engineering structures infinitely extensible into space (fig. 79). Sometimes they had strong diagonal thrusts, like probing girders. The way they were cut off at the highest point suggests the signs used by engineers to indicate indefinite extension. (The work of the Stenbergs and Constructivist stage designs seem prophetic of the braced structures of roller-coasters in American amusement parks.)

The famous photograph of the third Obmokhu exhibition in Moscow during 1921 (see fig. 74), that shows work by Rodchenko, Medunetsky and the Stenbergs, also reveals several "music-stand" wood and wire structures by Boris Ioganson in the left and right foregrounds. These "Constructions in Equilibrium" consist of three-dimensional open and rectilinear grids, set at about 45 degree angles.

77. Alexander Rodchenko, *Construction in Space*, 1919.

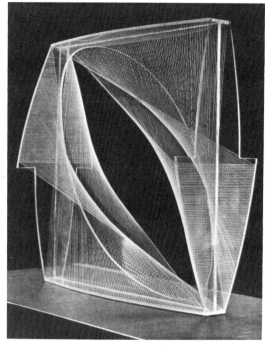

78. Naum Gabo, *Linear Construction No. 1, Variation*, 1942-43. [cat. no. 20]

They, too, seem capable of infinite extension. The structures are made of three L-shaped pieces rising from three different points on the same triangular plinth and are connected in space by three cross-pieces. The work is held together entirely by tension. The pedestal, also a structure in tension, continues its traditional function of getting the sculpture off the ground and into space. At the other extreme of the continuous tension concept (that Kenneth Snelson was to develop further in the sixties in his "tensegrity" series) was the compositional device of stacking, the piling up of simple geometric volumes, to which was occasionally added cantilevering, as in Malevich's models for architecture (fig. 80) and Vassily Ermilov's 1930 wooden model for an *Architectonic Construction* (fig. 81).[5] Rectilinearity was the predominant syntactical form for joining and the way in which space was often composed. This was the history of Gabo's work from 1917 until the thirties, from his stereometric analyses of the body to his paraphrases of imaginary architecture and scientific apparatuses. (It is not until the thirties that curvature, simple and compound, moves into the work of Gabo and Pevsner.) Overall, the tendency of the Con-

structivists was to move from the more inspired works of 1917 to greater regularity through simplifying and repeating shapes and rhythms.

Except for Tatlin, who enjoyed the varied "natural" textures of his found materials, the Constructivist taste was for the textureless and native color of industrial materials, which may account for why so many works in wood or cardboard were painted white. There was also agreement on eliminating any evidence of forming by the human hand, both to eliminate individuality from a communal art and to anticipate industrial fabrication on a large scale. As a consequence, there is no mention of or concern about quality, such as was associated with pre-1917 handmade art. Mental rather than manual gymnastics were the ideal. For the foregoing reasons, it was possible for Georgii Stenberg's sculptures to be reconstructed from measured drawings by his brother Vladimir in 1973.[6]

The Constructivists often referred to their modest-sized sculptures as "laboratory models," suggesting both objects resulting from research and projects for monumental structures. Presumably, then, the "models" miniaturized space and, if enlarged, would have had a space continuous with that of the viewer. According to Gabo, however, this was not true. Writing in 1962, he said, "In a Constructive sculpture, space is not a part of the universal space surrounding the object; it is a material by itself, a structural part of the object—so much so that it has the faculty of conveying a volume as does any other rigid material."[7] By contrast, Tatlin really meant it when he said that he was interested in "real materials in real space," and he seems to have carried his reaction against all forms of symbolism into a spatial literalism seen previously in Western art, for example, in the hyper-realistic, life-size sculptures of northern Italy in the sixteenth and seventeenth centuries that dealt with the Passion of Christ.[8]

One of Constructivism's paradoxes is that for sculpture not only was the figure renounced but also the type of empathetic seeing it induced. Yet, artists such as Rodchenko and Gabo wanted the beholder to read their forms as anything but static or neutral. They were to be visualized or intuited or even felt as

"dynamic forces," movement going in all directions and not just away from or toward the viewer. Treatises on line by Rodchenko and those on color and planes by painters such as Malevich were intended to prepare the masses to enter into the spirit of the work. Through this new sign language, abetted by published explanations, the masses were to feel an uplifting unity with an art that, in turn, articulated newly discovered realities.

The relation of Constructivism to Marxism was a temporary marriage of convenience and not a case of the latter inspiring the former. Tatlin's ideas had developed before he accepted Bolshevism in 1918. According to Gabo, most artists were politically neutral. No more than the Surrealists in France could the Constructivists make a convincing theoretical case to political leaders for the similarity of the artistic and dialectical methods. Because both·were against established orders and the political leaders were preoccupied with rebuilding the country, Lenin tolerated the revolutionaries in art. Perhaps recognizing their failure to win over the politicians, Tatlin and his fellow "Productivists" wrote in 1920, "The task of the Constructivist group is the communist expression of materialistic work."[9] "Communist" art became equatable with crafts. The politics that most engaged the artists were art politics, in which they were as ruthless toward each other as the professional politicians.

With a few exceptions, Constructivist artists were as naive or untutored about science and technology as about political theory. They were all affected by the general climate of new scientific ideas, but did not possess detailed knowledge and understanding of these areas. Constructivists had a simple faith that there could be a fruitful alliance with industry. Despite the rhetoric concerning scientific analysis and the studio as a laboratory, Constructivist art was still largely based on artistic intuition; in short, it was poetic and unscientific. Because of his technical training, Gabo did have first-hand acquaintance with engineering, and he applied some of this knowledge to his experience with Cubism. It might be argued, however, that Cubism helped make Gabo's engineering background relevant to sculpture, for it tended to reduce form to planes

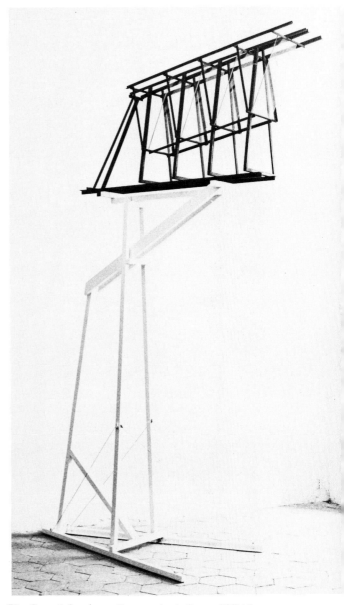

79. Georgii Stenberg, *Construction in Space: KPS 13*, 1919, reconstructed 1974. [cat. no. 58]

and invite a more systematic application of massless stereometric structures to sculpture of the human form. Gabo's 1917 constructions are, thus, an engineered Cubism.

Just as any movement which had several strong-minded members, Constructivism was filled with paradoxes and contradictions. The most obvious was the conflict between the

80. Kasimir Malevich, *Suprematist Architecton*, 1922.
[cat. no. 39]

more spiritually and purely art oriented, led by Malevich and Gabo, and the more materialistically inclined Productivists. On the one side there was the collective dream of "freedom from everything" and on the other the conscience of many about making art socially responsive, meeting the needs of the masses. Both groups detested the Western European ideal of the perfected esthetic object, sculpture as an object of esthetic contemplation, but their "laboratory models" turned out to be just that. Constructivist ceramics, designed for the people, found no popular acceptance but have become today capitalist collectors' items or reside in museums. The artists themselves realized by 1920 that with their sculpture the beholder was still on the outside looking at the inside and admiring the new beauty of a technologically oriented art. As Nakov has pointed out, what had been born spontaneously in the early years became codified and eventually academic after 1920 — and, one would add, not only in Russia, but in the Bauhaus in Germany and in American art schools influenced by Constructivism. After the explorer's drive came the academician's will to dogma. The Constructivists prided themselves on being rational and precise, but all ultimately worked from intuition, especially with regard to composition. Individuality was never eradicated. The early years of research by Tatlin and Malevich were characterized by secrecy, a jealous guarding of discoveries and insistence upon receiving credit for primacy of discovery. The cult of the individual was often just as strong among the new communists as among the hated capitalists.

Not the least of its paradoxes was the ideal of total freedom, for the Constructivists formulated as many prohibitions as imperatives, rivaling the Tsarist academicians they replaced.

The short but fruitful life of Russian Constructivist sculpture resulted from a phenomenon that might be characterized by the banality, "easy come, easy go." With the rare exception of, say, Gabo, those who made sculpture came from painting. They had no academic indoctrination in sculpture to overcome, no sensual addiction to materials and tools and no attachment to the great tradition of Western sculpture. They had no intellectual or emotional commitment to sustain a new history of sculpture. Young artists were exhorted to explore freely and work in more than one medium. Further, what was required to make the new constructive sculpture did not demand arduously acquired imitative skills or mastery of craft. "Models" could be quickly and rudely made from ideas largely worked out in abstract painting. Intellectually, making the sculpture was daring and difficult; technically, it was relatively easy. Given a common vocabulary of simple or primary forms, aptitudes for shaping did not count as much as those for joining. Artists such as Rodchenko came intermittently to sculpture to escape the limitations of painting. His scissors, saw, metal shears, compass and ruler applied to wood, cardboard, wire and tin made the sculptures happen. A paintbrush finished them off. And when it seemed that ideas about space could be better realized in painting, photo-montage, posters and stage sets, there was no hesitation in leaving sculpture. Ideas were negotiable in many media, and with the strong spirit of unity, many artists liked to work intermedially. Quite simply, the Constructivists found more new ways to start and end sculpture. They believed in perpetual evolution rather than eternal revolution, and this attitude affected movement between media. Gabo, Pevsner, after he left Russia, and Kobro stand out as the only Russian artists to build an entire art in sculpture on the foundation of Constructivism.

Oversimply put, Constructivist sculpture died in Russia because of Lenin's fear of golden toilets and the Communists' preference for Karl Marx's beard in plaster; in short, it was

irrelevant to the requirements and tastes of politicans and the needs of the people. The Constructivists had underestimated Russia's hunger for the patriotic and practical, as well as the sentimental. At all levels, their countrymen showed they did want an art with a cultural memory. The avant-garde in sculpture and painting had neither middle class backing nor the allegiance of most of the intelligentsia, nor had it made itself understood by the masses. The leaders in government placed developing the necessities of life, modern industrial production and nationalism before the lofty dreams of the artists. Trotsky pointed to

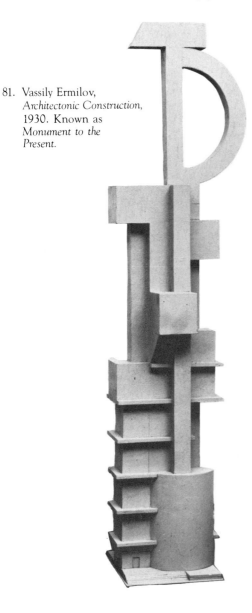

81. Vassily Ermilov, *Architectonic Construction,* 1930. Known as *Monument to the Present.*

Moscow's greater need for sewers than for Tatlin's *Monument to the Third Communist International* and urged the artists to hold their ideas in abeyance. Even those artists who converted to industrial design were handicapped by lack of technical know-how. Despite his formal sensibility, Tatlin just did not know how to make practical things. Although it was his most beautiful formal structure, his glider, *Letatlin,* made in 1930 (and supposedly taken from another's design), depended on ten times the power its pilot could generate himself to get off the ground. The people and their leaders wanted to celebrate their heroes in stone, just as did Tsarist and capitalist cultures. Lenin feared that if art was to be made for everyone, the result would be a demand for gold toilet seats. The art students who studied under the revolutionaries and were scarcely their juniors seem as a majority not to have converted to Constructivism. When the old academicians began to return, starting in 1921, they found the young avid to learn traditional techniques and how to be socially realistic painters and sculptors, as well as how to paint the landscapes, still lifes and portraits that were being called for by the public that could afford art. The final paradox was that the Constructivist ideal was to flourish in capitalist societies and in the hands of artists who saw it as a means of asserting their individuality.

The Radiant Spaces of Naum Gabo and Antoine Pevsner

The most distinguished sculptors of quality to emerge from Russian Constructivism were Naum Gabo and his brother, Antoine Pevsner. No previous sculptor was as broadly trained as Gabo in the sciences: mathematics, physics, chemistry and civil engineering. As a result of exposure in 1910 to the analytical teachings of Heinrich Wölfflin in Munich, Gabo may be the first sculptor to have been influenced by an art historian to come to his profession. He did not go through a formal artistic education but had been exposed to the most advanced ideas of the pre-1914 period. Cubism and the abstraction of Kandinsky, as well as his theoretical writings, had shown the young, philosophically minded Gabo that art need no longer be descriptive, hence dependent upon

the development of imitative skills; it was opening to more conceptual and analytical directions.

During the First World War and until he returned to Russia after the Revolution of 1917, Gabo worked in Copenhagen and Oslo, meditating on what he had learned in Munich and Paris. His few surviving wooden, celluloid and metal busts and torsos suggest that, having seen Archipenko's opening of sculpture to space, with his extreme stylization of the figure and use of new materials, Gabo set himself the problem of how to engineer the human form for sculpture. The planar constructions of Archipenko and the Cubists made relevant Gabo's training in stereometry and massless construction. His cellular constructions honeycombed the figure and brought light and space to its very core. The corner relief *Head of a Woman* of 1916 (fig. 82) recalls Archipenko and Laurens's use of this format, and the somewhat translucent celluloid introduced Gabo into a lifetime courtship of light. It was not until 1920, working with clear plastic, that Gabo produced his first shadowless sculpture. As shown by drawings of 1917, Gabo left the figure as his paradigm and moved to abstraction and his visions of a luminous world.

The years 1917–1920, when he was teaching in Russia, Gabo later referred to as the "oral years," because so much time was spent in group discussions and disputations on the new art and its goals. We have only a few drawings for sculpture from this time. The Realistic Manifesto of 1920 was a way of getting on the record the ideas which he had formed and championed with certain colleagues, such as his brother, Pevsner, then a painter, who was a co-signer.

The first part of the manifesto tells us where the brothers came from in their thought: until then no art adequately dealt with "the growth of human knowledge with its powerful penetration into the mysterious laws of the world begun in this century"; their art would respond to new forms of life and the pressure of a culture born of war and revolution, giving rise to the means for a new "Great Style." Cubism and Futurism were credited for bringing down tradition, but not building anew from sources in modern life and going beyond "optical impressions of the external world" and the anecdotal. The brothers called for activism, new deeds to meet modern needs, for an "art to be erected on the real laws of life." They claimed, "The realization of our perceptions of the world in the forms of space and time is the only aim of our pictorial and plastic art." (Years later, Gabo asserted that establishing space and time as the "backbone" of art was the manifesto's greatest contribution.) Still impressive is the ambition of these artists to image worlds within our world, to show that imagination was no longer tied to the external appearance of the visible world: in short, to realize the previously unimaginable. They had been touched by working "in an age when the scientific eye of man is looking through matter into a fascinating all embracing image of space" and where time is "the very essence of our consciousness."[10] The basic principles of the manifesto affirm that line (and by implication the edge in sculpture) was not to be descriptive but was to convey a sense of the direction of forces and rhythm. Space was to be achieved "by continuous depth," which, in turn, eliminated mass. Volume was to be freed from mass by such engineering devices as a T-beam or intersection of four planes, which could construct "the same volume as of four tons of mass." Finally, the brothers claimed that actual or kinetic rhythm, as well as "static" rhythm was now within the province of sculpture.

Gabo's cosmic consciousness and his idea of sculpture that actually moved had been anticipated by the Futurists, Giacomo Balla and Fortunato Depero, in their now lost 1915 Futurist *Reconstruction of the Universe*, which had been motorized. (Gabo could not have seen this piece.) The only time Gabo turned his mind to making a work that really moved, his solution was the polar opposite of the elaborate, multi-media contraption of the Futurists. In Jack Burnham's words:

Technically, the construction is utter simplicity, which accounts in part for its importance. At the base of the work a vibrating electrical motor is attached to a vertically erect length of flat spring steel weighted slightly on the upper end. In motion its outer form strangely resembles the mass defining contours of Brancusi's *Bird in Flight* (1919)—of which Gabo could have had no knowledge. In the same way as Duchamp's revolving glass construction, the *Kinetic*

Construction presents a virtual volume, a volume described by the speeding trajectories of an object. . . . the harmonic wave-form pattern which Gabo's construction creates is, in spirit, if not in physical principle, a visual echo of then recent theories of wave mechanics as the basis of matter. It announced . . . the essential immateriality of matter.[11]

Gabo seems always to have believed that the destiny of Constructivist sculpture was to move toward architecture, and much of his sculpture of the twenties was architectural in spirit. He both drew from its rational construction methods and also, in turn, sought to guide and influence architecture. Gabo felt *The Column* of 1923 (fig. 83) was the culmination of the mutuality which he sought. By the way the planes conjoined, it epitomized rectilinearity in the shaping of space. *Column* has rightly become an icon of Constructivism. That it was made in Germany, after Gabo had left Russia permanently, signified the sculptor's view that the art he visualized was wedded to neither politics or geography. *Column* has fared far better than the international style architecture it helped inspire, because it was not enlarged or betrayed by materials that could not preserve the purity of appearance and effect. As a model, it has been for most of its history in a museum, protected from the elements and human wear. Its durability also owes to its quality of thought and execution. *Column* helped announce a new sculptural esthetic of luminosity or reflectivity, physical lightness and elegance. It still retains a dignity, a paradoxical strangeness despite its transparency, precision and self-evident structure.

Gabo's projects of the twenties, his proposals for monuments based on scientific apparatuses, a design for the Palace of the Soviets, and the stage set for a ballet, *La Chatte*, indicate that despite his rejection of Productivism, he wanted his art to influence actively the look of a new society and that he still hoped to make more than "laboratory models."[12] When this hope faded in the thirties, his sculpture seems a projection of how the modern world impacted upon his imagination. He sought purely sculptural expressions of new rhythms, "other" sights or spaces, perhaps the exalted sensations of living in a world without limits. From correspondence with the artist, Jack Burnham persuasively ar-

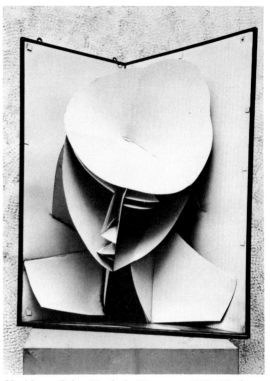

82. Naum Gabo, *Head of a Woman*, c. 1917–20 after a work of 1916.

gues that Gabo's work evolved from an imagery inspired by utilitarian appearances to the purely conceptual, reflecting Gabo's view of himself "as a soul taken by the technological spirit yet free of its functionalism."

Mediating between the rectilinear "Tower" series and the "Spheric" themes of the mid-thirties are those sculptures of the late twenties in which Gabo introduced torsion, giving the forms a different kind of energy. One of these was destined for a fountain in which the water would activate the turning of the sculpture. In the early thirties, Gabo carved a series of small spherical stone sculptures that have spiral motifs cut into them, conveying his continuing interest in "kinetic" effects. Mass had not been totally rejected, as the 1920 Manifesto had implied, and it is ironic that this most ancient of materials could serve the sophisticated, scientifically tinged interests of a Constructivist.

Gabo's "Spiral" themes of 1936 and after (fig. 84) represent an important leap of imagination, a totally new concept of space and artistic form, and, as Burnham has pointed

out, they come shortly after new and relevant developments in the science of topology. All angularities of form, all sense of metric space have been removed. "I enclose space in one continuous surface," was Gabo's comment on these sculptures, that curved back on themselves, either around an implied spatial core or a nuclear motif made from plastic or carved stone (fig. 85). In the latter case, the impression is that of a planet surrounded by its own light and space. By 1937, Gabo was ribbing these continuous curving planes with either etched radial lines or plastic cord, which seemed to radiate out from the center. Here the inspiration may have come from stringed mathematical models seen by Gabo in science museums. It was also at this time that Moore, Hepworth and Pevsner took up the same motif, each for differing and personal reasons, reminding us of the early interest of Constructivists such as Rodchenko and Tatlin in "linear" motifs as indicators of force. Gabo's lyrical structures with their double curvatures still present surprising prospects of optical patterns as his radiant webs are seen against one another (see fig. 78). It is this texturing of light and space that gives the visual interest to unswervingly symmetrical forms. By the outbreak of the war in 1939, Gabo had by and large established the ideas he was to elaborate after 1945.

Antoine Pevsner had been a painter, working out of Cubism and into abstract art. Under the revolutionary government he held a position of leadership in a Moscow art school from 1917 until around 1922, when he was discharged. In 1923, he emigrated to Paris and there was visited by Gabo, who was living in Berlin. Gabo encouraged his slightly older brother to take up sculpture. According to a third brother, Alexei Pevsner, Gabo provided motivation and instruction in craft, reputedly encouraging his brother to work from his own sculptures as exercises. That the brothers were already in ideological agreement is clear from

83. Naum Gabo, *Column*, 1923.

84

Pevsner's signature on the 1920 Manifesto authored by Gabo. Pevsner began with stereometric constructions of *Torso*, 1924–1926 (fig. 86), and *Portrait of Marcel Duchamp*, 1926 (fig. 87), following the pattern of his younger brother eight years before. *Torso* may have been one of the "exercises" encouraged upon Pevsner by Gabo, as it is a stereometric version of the stock studio hipshot pose of a nude made into a partial figure. Besides being finely crafted, it is an interesting and sometimes witty structural paraphrase of anatomy, taking into account the limited ways by which plastic could then be shaped. The body is made transparent and depersonalized, suggesting that Pevsner's *Portrait of Marcel Duchamp* may have been in homage to the artist, who in his painting, *The Bride,* of 1912, had broken the human form barrier, opening up the female form to reveal an interior that suggests a complicated arrangement of plumbing. The warm, brownish tones of the celluloid torso accord with those of Duchamp's smoothly textured "organs." Pevsner, by inverting the conical breasts, was picking up on the possibilities of optical illusions that he may have seen in Archipenko's work, where concave shapes substitute for convex.

Pevsner's *The Dancer* of 1927–1929 (fig. 88) is more abstract than his *Torso,* but the tapered base of the now symmetrical, diamond-shaped figure evokes the pose of a dancer. Not only has Pevsner moved closer to abstraction, but he has begun to work with symmetry, again as had his brother several years before. Using machine screws, he joined the thin brass sheets as well as the celluloid planes, a system new to sculpture but one he would later give up for welding. Whatever mysteries he found in the hieratic *Dancer* did not satisfy the artist, who in 1932 wrote about plural worlds, wanting to bring to light "the hidden forces of nature, . . . new rhythms of the great axes of construction and other orbits in the coordinate system of time and space." After ten years in which he made more abstract proposals for monuments

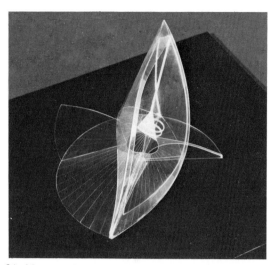

84. Naum Gabo, *Spiral Theme,* 1941.

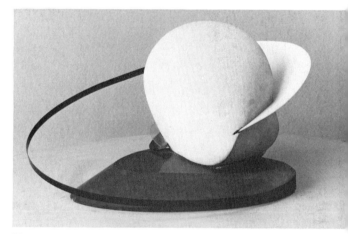

85. Naum Gabo, *Construction (Stone with Collar),* 1933. [cat. no. 19]

and reliefs, elsewhere discussed, Pevsner came about 1936 to his "developable surfaces." (The actual date is uncertain; it may have been earlier.) In Jack Burnham's words:

> . . . the developable surface—a singly-curved surface (a plane curved in only one direction) found in descriptive and differential geometry—became Pevsner's means for liberating the surfaces of his constructions from the limitations of Euclidian planes and edges. It mainly gave the artist both an extremely rich surface texture and a flexibility in joining straight-line edges to curved surfaces.[13]

As with Gabo's move to radiating lines, Pevsner's greater, and at times exclusive, reliance on brass rods to form his sculptures may

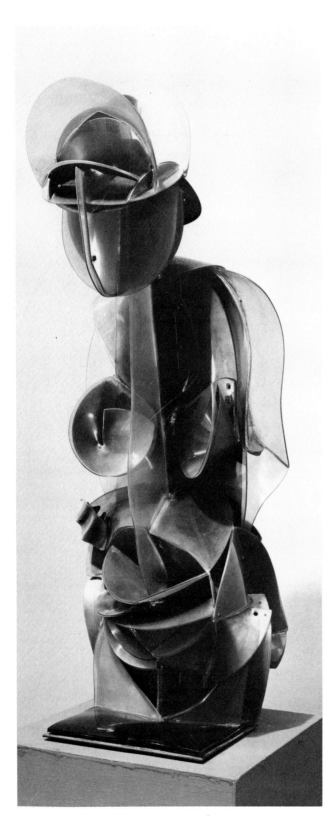

86. Antoine Pevsner, *Torso*, 1924–26.

have been inspired by scientific models, whose string and curving planar forms seem ancestral to both artists. It is interesting that to free themselves from the Euclidian aspects of their Cubist "crystalline" structures, both Lipchitz and Laurens moved in the late twenties into curving volumes that at times alternate with flat planes. Pevsner did not follow Gabo into shadowless sculpture or forms that curve upon themselves as if in their own spherical orbits. His spiralling sculpture, *Projection into Space* of 1938, seems a segmentation of a more complex, outwardly moving or open form. His overall configurations show more variety than Gabo's. As his conceptions became more complex, Pevsner reduced his constructional unit to a single rod, as in *Developable Column* of 1942 (fig. 89). In arrangements generated by intuition rather than the formulas used for mathematical models, these rods not only perform as straight lines or vectors, but they also spiral and, unlike Gabo's plastic rods, experience a gamut of lights and shadows. As an aggregate, they produce not only ribbed, curving planes but also the strong rhythms Pevsner had earlier written about. As we follow the route of the rods, we experience the work in time and space, and it is impossible to grasp from any prospect all of the configuration at once, to hold in mind all that is inside and outside or where the distinction lies. In successive views of his modestly sized works, Pevsner offers sequences of revelation and concealment. The configurations have a grace of movement rivaling that of the finest dancer and an élan that holds its own with the best architecture. Pevsner created for sculpture the rhythmic grace we still associate with dance, flight and the movement of the planets. His poetry was in finding a personal metaphor at once unique and yet bearing rich associations of different realities.

The Case of Katarzyna Kobro

The destruction of most of her work by the Nazis and the relative inaccessibility of the surviving sculptures in the Muzeum Sztuki in Lodz and denied Kobro inclusion by Western art historians in the history of modern sculpture. The exhibition of Polish Constructivism at the Albright-Knox Art Gallery and

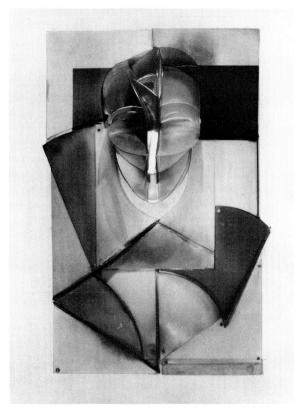

87. Antoine Pevsner, *Portrait of Marcel Duchamp,* 1926.

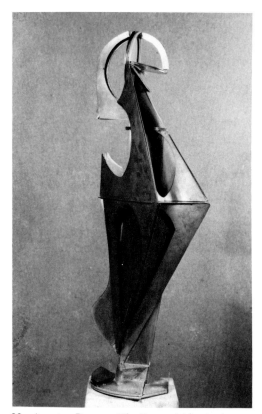

88. Antoine Pevsner, *The Dancer* (side view), 1927– 29.

the Museum of Modern Art in 1974, originated by the Lodz Museum, with its excellent catalogue, brought modest attention in America to her work.[14] That some of her pieces have been reconstructed from old photographs tells us of their basis in predictable systems, consistent with the Constructivist dream of creating an imitable and hence universal basis for art.

In 1917, at nineteen, she entered the Moscow School of Sculpture and Drawing in 1917, and three years later, when she left that school, which had become one of the Free State art schools, her work resembled that of her mentor, Tatlin, and exemplified his "culture of materials."[15] After her marriage to the theoretically inclined painter and designer Styzeminski in 1921, Kobro absorbed ideas from Suprematism during the period that they were working in Smolensk and were in contact with Malevich. In the early twenties, possibly inspired by Rodchenko, she made suspended sculptures, whose reconstructions elicit

memories of Malevich's paintings. One in particular recalls his inspiration from modern flying machines and is like a dirigible to which cubicular forms are held in tangency. Just as Gabo and Moholy-Nagy, Kobro was briefly interested in moving sculpture and the use of readymades, such as tools, in suspension, but she, too, became more interested in the optical movement in the eyes of the viewer than in the actual motion of the sculpture itself. In 1924, when she and her husband settled permanently in Poland, Kobro became a Polish citizen, and the couple were active in that country's avant-garde. From 1925, until she ceased making sculpture in 1933, her small-sized works, that are most admired today, were of an architectural nature and were generated by numerical systems, paradoxically derived not from new mathematics, but those of a medieval Italian mathematician, Leonardo of Pisa, who had helped introduce arabic numerals to Europe.[16] Kobro's most important contribution was her "Unist" sculpture, supposed

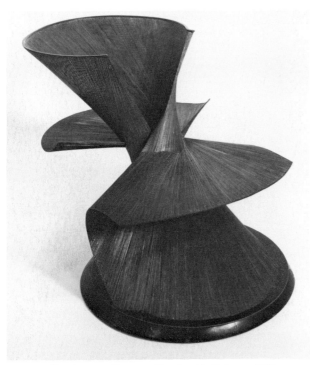

89. Antoine Pevsner, *Developable Column*, 1942.
[cat. no. 51]

to be truly open form and continuous with its environmental space, her way of uniting art and life (fig. 90). (The idea of sculpture's infinite extensibility into space had been briefly tried by the Stenbergs in 1921.)

Just as the figure was to lose its independence in the art of many avant-garde sculptors, Kobro believed sculpture itself should not be a discrete object solely for contemplation, as "luxury" art had been. With her husband she sought an art that "organizes life and its activities." There exists a photograph of her project "for a Functional Nursery School," in which she has glassed in one of her open-form sculptures, recalling the interior free-space or open plan designs of Mies and the International Style in architecture. Influenced by Malevich's architectural models, Styzeminski had himself worked with embedded cubicular forms in a project for a railway station in the twenties. Kobro's distinctive sculptures are those entirely constructed of flat and curved planes, rather than volumes, and which have two or more axes, usually at right angles to one another. As with the painting of her husband, which eliminated distinctions between figure

and ground, there was a calculated attempt to give the space the equivalent shape of the planes, so that both received equal emphasis and seemed interchangeable.

In a book co-authored with her husband and titled, *Composition of Space; Calculations of a Spatio-Temporal Rhythm*, written in 1931, Kobro set out her views:

> A unistic sculpture aims at the unity of the sculpture with the surrounding space, a spatial unity. . . . A work of sculpture, arising in space unlimited by any frontiers, should make up a unity with the infinity of space. Any closure of a sculpture, any opposition between it and the space, strips it of its organic character of the uniformity of a spatial phenomenon by breaking off their natural connection and isolating the sculpture. . . . The device which gives uniformity to a piece of sculpture without closing it up, is the spatio-temporal calculated rhythm. By rhythm we mean a regular sequence of spatial shapes. The rhythm of a unistic sculpture is a complex rhythm of spatial shapes and of colored planes. A regulation of their sequence consists in reducing the mutual relationships of the consecutive shapes to the common numerical formula. . . .A rhythm of shapes connected by a common numerical formula can grow in any direction. [17]

Kobro and the Polish avant-garde fell victim to a sense of a failed utopia in the thirties. The same forces that earlier replaced Constructivism in Russia, that other reality which consisted of the demand of the Communist Party for a new realism in art whose content mirrored the peasant and worker building the new state, eventually caused Kobro to cease working long before her death in 1955.

Moholy-Nagy, The Artist as Anonymous Agent[18]

Outside of Russia, the most ardent and lifelong Constructivist, both in spirit and action, was the Hungarian-born artist László Moholy-Nagy. Wounded in the war, he turned to art and eventually away from law. After the war, he came into contact with Russian Constructivism and the Dada movement in Berlin. He was taken with Berlin's "industrial landscape" and sought "equivalent structures" in his assemblages made from metal scrap found while walking through the city. (Schwitters's *Merz* pictures stimulated such scrounging.) Moholy-Nagy's *Nickel Construction* of 1921 (fig. 91) shows his "own version of machine technology," achieving "machine-like perfec-

90. Katarzyna Kobro, *Space Composition 5*, 1929–30. [cat. no. 31]

tion," while he seems to act as "an anonymous agent" by not signing the work.[19] This small construction encapsulates the "problems" with which the artist was to engage throughout his career: how to work with light, space and movement in previously unexplored ways by utilizing textureless, industrially processed materials in "neutral" geometric forms. The spiral won him a new articulation of space as well as a new means of inducing reflectivity, and it helped the artist to begin using the strip or ribbon form as a basis for future shapes. As other artists admired Euclidian shapes for reasons totally remote from their meaning to mathematicians, so Moholy-Nagy explored the properties of new materials for purely esthetic and expressive purposes, rather than the utilitarian ones that concerned engineers. When he later wrote that the artist was "not unpolitical" but was a politician "realizing ideas for the benefit of the community," he presumably meant that the look of postwar modern Europe should be influenced by self-effacing artists who understood the esthetic possibilities of the new technology. Moholy-Nagy straddled the conflicting views of Malevich and Tatlin by conducting pure research and by applying his discoveries to advertising displays, stage and movie sets, posters and book covers.

Moholy-Nagy was like many other Constructivists in that he came from painting and did not see sculpture as exclusively fulfilling his interests. Art and its "problems" flowed through categories. The problems of light, space and movement that he first encountered in painting were also worked on in film and photography as much as sculpture. Specifically, the possibilities of "transparency" and disembodied color or colored light drew him from the planar surface of painting into plastic planes separated in space.

Light-Space Modulator, the three-dimensional construction that brought together his many interests in diverse media, was the result of years of planning from 1922 until 1930 (fig. 92). It was intended as a sculpture, and as a kind of prop for the stage or film making. Alternating spotlights were projected on this four-foot high mechanized mobile made of plastic, chrome and perforated sheet metal. Despite careful choreographic planning of the "prop's" performance, when the artist saw the apparatus working for the first time in a small Berlin studio, he felt like "the sorcerer's apprentice: . . . the mobile was so startling in its coordinated motions and space articulations of light and shadow sequences that I almost believed in magic."[20] The whole was designed so that he could study "transparencies" made by light passing through plastic and perforated metal "in action," but he was surprised with the shadows cast by and reflections on the metal frame itself. He was disappointed that people did not grasp his "technical wit" and the future promise of his experiment.

The film made of his illuminated mechanized mobile helped pull Moholy-Nagy

91. László Moholy-Nagy, *Nickel Construction*, 1921.

92. László Moholy-Nagy, *Light-Space Modulator*, 1930.

away from sculpture. It was not until about 1940 that he returned to the making of a series of "light modulators" in sheet plastic (fig. 93). In the first works, he cut the cold plastic into flat, geometrically shaped planes and staggered them in distance from one another. Then he changed the process and began to heat the plastic to warp or mold it in order both to pick up highlights and to provide dynamic edges so that it appeared the artist was drawing with light. Occasionally, he added wires in shapes that complemented the curvatures of the plastic, achieving, thereby, what he referred to as "cells of space." The most impressive pieces, however, are those which are purely plastic, molded in free-swinging arabesques. When he tried to add wires or paint on the surfaces, there was often confusion of expression or trivializing of total effect. However interesting, his plastic sculptures have neither the overall au-

thority, clarity of thought and uncomplicated beauty of Gabo's work nor the elegance of Bill's use of the ribbon form. The legacy of Moholy-Nagy's teaching was to make his discoveries in art truly academic and eventually studio clichés, as we can see in the work of his own students, making it difficult to look freshly at the venturesome prototypes. Until the contemporary art world recovers from its fascination with bigness, the small plastic sculptures of Moholy-Nagy, like those of many other interwar artists, will not be appreciated either for their intrinsic beauty or historical importance.

Vantongerloo and the Incommensurable[21]

In the absence of a biography, we do not know to what extent Vantongerloo's war experiences, which included being wounded while fighting for Belgium, contributed to his

evolution into abstraction. His prewar painting and sculpture, judging by the little that is reproduced (by the artist himself) had to do with the figure seen in modes influenced by early twentieth century avant-garde thinking about simplifying and rationalizing the figure in sculpture. He literally abstracted the figure in works of 1917, reducing it to solid geometrical forms of a beautiful rectilinear and curvilinear configuration, in what he called "Spherical Constructions." From 1917 until 1919, he was in Holland and in contact with the De Stijl group headed by van Doesburg and Mondrian. Vantongerloo later stated that because of previously formed ideas, presumably about the function of abstraction to present mankind with a model of harmony to emulate in its goals for new social organization, he had affinities with the Dutch artists, but claimed independence from their influence. There is no question but that his earliest abstract sculptures, dating from 1919, have the look of De Stijl esthetics, which transcend any one medium: clean rectilinear clusterings of solid geometrical forms (fig. 94). In keeping with De Stijl ideals, he even made models for a bridge in Antwerp in the late twenties. He was to remain with right-angle geometry until the mid-thirties, cantilevering forms further into space, thinning out the solid forms and admitting more space, which fired his imagination, until he achieved a near equivalence of the two. Almost always, the sculptures were in materials not usually associated with machine esthetics, namely, wood, concrete and, occasionally, iron, for Vantongerloo resisted the obvious materialistic link with his time (or "technomania," as he called it). Beginning in the mid-thirties, he moved into thin wire sculpture with configurations that involuted or spiraled, or alternatively he used strips of soft metal twisted in space. These are his least impressive images and fare poorly when compared, on the one hand, with the wire sculpture of Calder and, on the other, with the ribbon structures of Max Bill.

Vantongerloo's importance to modern sculpture, particularly to the work of Max Bill, lies in his early (by 1919) use of mathematics as a tool to help enact his conceptions. Though only the latest in a long line of sculptors going

93. László Moholy-Nagy, *Dual Form with Chromium Rods*, 1946. [cat. no. 45]

back to antiquity to use mathematical systems, he was the first sculptor to be as explicit about his sources and to forego the figure entirely. He established the premise for sculpture that there was "no need to express art in terms of nature. It can perfectly well be expressed in terms of geometry and exact sciences."[22]

Vantongerloo's writings explain his motivation and view of his sculptures. Far from being prosaic, static objects, demonstrations of mathematical formulas, they were his way of encoding a sense of the sublime, embracing the infinite and evoking "the great mystery" or what he termed the "incommensurable." He wanted to transform matter into a "spiritual body: . . . We create a new entity out of the matter that constitutes the subject."[23] He invested his shaped materials with his reflections on realities other than those the eye took in and saw his sculpture as creating "a living unknown."

He sought to give us art which imparted the sense of having come into being by its own laws rather than by a reproduction of nature or the machine-made. By exploring "the laws of creation," Vantongerloo felt it was possible to bridge art and science. He hoped that his sculpture would have the effect of seeming to be what he termed "a new crystal," rather than the elaboration of some geometric system as

was used, for example, by the artists of the Gothic cathedrals. (In speaking of "a new crystal," Vantongerloo was referring to the fact that there are *seven* basic shapes of crystals in nature.) Geometry helped him achieve his esthetic goals, but the crucial ingredient in his formula was his own artistic intuition based on knowledge and experience with the world. In 1930, he wrote of his dream of a new era when art would be freed from various forms of past "servitude," such as that to political and social causes, an era in which the artist could be anonymous while working for the benefit of society. (He was reluctant to sell his work and for a while lived from pensions given by the Belgian government.) Perhaps his war experiences had confirmed his view, elaborated in that 1930 essay, that as an artist he should strive for an art of "universality," which would be a model of a utopia without politics or geographical boundaries, where reason would dominate and there would be only workers of the hand and spirit.

Max Bill and Finite Infinities[24]

In the same spirit of inquiry as the mathematician but governed by artistic logic, the Swiss sculptor Max Bill began in the thirties to give sensual form to his intuition and understanding of the art and science of "relationships between object to object, group to group and movement to movement." In the thirties, sculptors who worked with geometric abstraction faced the criticism from other artists whose art had a more sensual, even figural orientation, that they were anti-humanistic. Bill's purpose was humane, if not humanistic. He sought to help mankind "take cognizance of the world that surrounds us." He attempted to demystify geometry, just as sculptors, beginning in the Renaissance, domesticated the nude by exploring the wonders and beauty of the human body freely moving in space after centuries of concealment under clothing. Bill favored frank exposure of "pure forms" and giving properties to geometrical shapes to which the geometer would be indifferent. By using polished stone, brass and stainless steel, he gave cubes, tetrahedrons and segments of spheres sensuousness and lightness and, by reflectivity, color and texture from the environ-

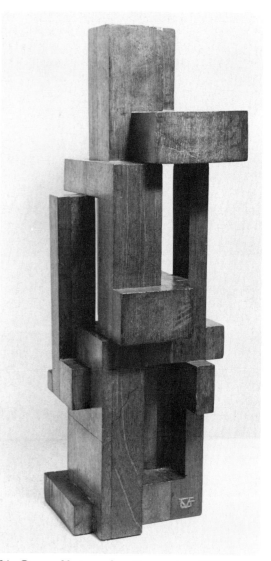

94. Georges Vantongerloo, *Construction of Volume Relations*, 1921.

ment. His linked tetrahedrons in *Construction of 30 Equal Elements* of 1938 – 1939, for example, is engineering freed from utilitarian function and open to optical and structural playfulness. Bill's *Construction with Suspended Cube* establishes a visual dialogue between solid and space, support and suspended form, which extends the Russian beginnings fifteen years earlier into areas of greater visual sophistication. The series *Construction from a Ring* (fig. 95) amazes with the variety achievable in symmetry, due in part to the Brancusian polished gilt-bronze surfaces which bring the external world into the sculpture with ironic distor-

92

tions. It is like a parable on the incorruptibility of mathematics and the subjectivity of sensory experience. Even earlier in the thirties Giacometti and Hepworth had sabotaged the convention that we were neutral to geometric forms, investing them with sexual feeling. Their use of geometric shapes was strongly conditioned by involvement as sculptors with the human figure. Lacking that commitment, Bill did not try to anthropomorphize geometry and instead let his imagination conceive of what for sculpture were astounding structures, structures that surprise in their convolution and thinness by being fashioned of granite.

Bill's most fruitful discovery or "system" is that of the *Endless Ribbon* (fig. 96), the continuous, single-sided surface that twists in space and is without start or finish. The "content" of these works, which he began in 1936, is the modern concept of a "finite infinity," which goes away from and returns to us. Bill claims to have evolved this form as a commission *before* he learned of Moebius's discovery in the 1890's: rotating a strip 180 degrees and joining its ends together. The *Ribbon* and *Cube* series all involve Bill's interest, like that of Gabo and Pevsner, in topology, the study of the most permanent properties of objects and those susceptible to distortion without negating such constants as continuity, edges, vertices. His interest in "elemental" or "primordial" forms and formal purity, notably in highly polished surfaces, recall the abstracted work of Brancusi, even to the use of such traditional materials as bronze (or brass) and stone. Bill was not interested in abstracting from nature but treated imagined realities. The clarity and precision of his form resulted in effects that contest normal perceptual experience. It is the element of uncertainty raised in the viewer's mind from such pieces as the *Endless Ribbon* that gives it poetry.

In 1949, Bill summed up the purpose and character of his art:

> Things have no apparent connection with mankind's daily needs—the mystery enveloping all mathematical problems; the inexplicability of space—space that can stagger us by beginning on one side and ending in a completely changed aspect on the other, which somehow manages to remain that selfsame side; the remoteness or nearness of infinity — infinity which may be found doubling back from the far horizon to present itself to us as immediately at hand; limitations without boundaries; disjunctive and disparate multiplicities constituting coherent and unified entities: identical shapes rendered wholly diverse by the merest inflection; fields of attraction that fluctuate in strength. . . . For though these evocations might seem only the phantasmagorical figments of the artist's inward vision they are, notwithstanding, the project of latent forces; forces that may be active or inert, in part revealed, inchoate or still unfathomed, which we are unconsciously at grips with every day of our lives. . . .[25]

"The least you can ask of a sculpture is that it move": Alexander Calder[26]

In spirit Calder was as venturesome as any artist of the time. Alone among American sculptors, he worked and exhibited in Europe consistently, holding his own with the intense competition, and for the high quality of his imagination he won more admiration from important European artists than any of his countrymen in the past. Calder resisted compartmentalizing as having made an American art or even as having made sculpture. Once, when asked if his art were not truly American, Calder replied, "I got the impulse for doing things my way in Paris, so I really can't say."[27] Calder's art was unthinkable without his early training as an engineer and his contacts with many of the most gifted artists in Europe during

95. Max Bill, *Construction from a Ring,* 1940–41.

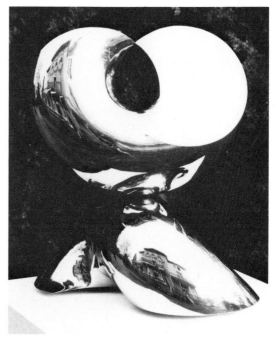

the thirties. It was in Paris that he first encountered modern art and the challenges that successfully tested his imagination and aptitude for both forming and structuring random as well as fixed relationships. Paris taught him that wit in art would be taken seriously and that he could be a complete artist working in many media.

Next to Henry Moore, Calder has suffered less from concern about influences than perhaps any other modern sculptor. So freely did Calder acknowledge important debts to fellow artists that their number seems to exclude any room for originality. Calder's gift was to begin where other artists left off and to draw new conclusions. In 1930, for example, he saw the possibilities of transforming the white wall in Mondrian's studio, covered with colored cardboard rectangles, into a sculpture "that could be made to oscillate in different directions at different amplitudes." During the visit, Mondrian may have pointed out that he had thought of the white as space. Two years earlier Miró had stunned the red-headed American in the orange suit by showing him collages such as *Spanish Dancer,* in which the most improbable materials became art. Calder was always tied to Arp and Miró by a shared wit

96. Max Bill, *Endless Ribbon,* 1935, executed in diorite 1965.

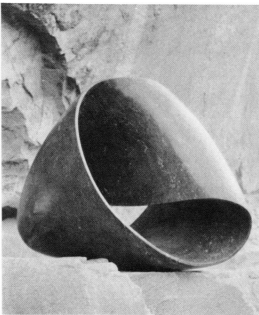

in art, and they gave him the models for making poetic worlds. Their biomorphic flat and brightly colored forms sired Calder's own. In the late twenties, Calder was also exposed to the cosmic consciousness of Kandinsky's *Circle* paintings, to the micro- and macroscopic fantasies of Klee, and to Pevsner's bold invasions of space. To all of these artists may be credited the source of Calder's statement, "The universe is real but you can't see it. You have to imagine it."[28]

The first serious study of Calder's early abstraction, Joan Marter's article, "Alexander Calder: Cosmic Imagery and the Use of Scientific Instruments," analyzes the paintings and early constructions of a universe that Calder made in late 1930, after the visit to Mondrian's studio.[29] She stresses that, at the time, Calder was aware of important scientific discoveries concerning the solar system which cast into doubt existing theories about its origin and nature. In addition, Calder had said, "A wooden globe gave me the idea of making a universe." He thus based some of his spherical constructions on eighteenth century scientific instruments used to model the universe. A parallel phenomenon occurred in 1911 when the physicist Ernest Rutherford used as his model for the atom, having a nuclear core orbited by electrons, the image of the universe proposed three hundred years earlier by Copernicus, Galileo and Newton.[30] Professor Harter further shows the importance of Calder's engineering training at Stevens Institute for the building of his imaginative models. She concludes that "Calder's training in mechanics and his fascination with astronomical instruments account for the cosmic imagery and the successful utilization of static and kinetic elements in the early 1930's." Certainly, these sources showed the way and in a manner we now understand far better, but the avant-garde artists with whom he came into contact inspired his will to move the heavens and earth in sculpture.

The adventurous spirit of modern sculptors such as Calder is summed up by the question, "Why not?" In 1930, Calder answered affirmatively the question, "Why not plastic forms in motion?" When he decided in that year to build an art which would show forms free from

the earth, volumes in motion that floated in space and were of different sizes and densities, he was in effect saying, why not use the "system of the universe" as "the underlying sense of form?"[31] His mobiles became worlds within worlds, spaces carved out within the surrounding space, poetic miniaturizations of imagined solar systems (fig. 97). The wires became "vectors" of force, velocity, energy and acceleration or orbital trajectories. He mechanized several mobiles, masking their power source, but came to resist the predictability of mechanical motion in favor of "accidents to regularity" provided by wind-driven sculptures. In the early thirties, he worked simultaneously in motorized and suspended wire sculptures, producing abstract configurations while also making figure drawings of the circus. Perhaps learning from his European friends, Calder did not close the door on fruitful options that continued to provide him with the joy necessary to inspire his work.

When he came to art, what he felt was missing were the motions of the world. At least in the thirties and forties, if not earlier, Calder seems to have looked upon his works as metaphors for the events of life and the physical world. In 1932, he wrote for the catalogue of the *Abstraction-Création* group that his works were "abstractions which resemble no living thing except by their manner of reacting." He seems not to have looked upon his abstractions as merely physical objects, for his references to his art involve equations with phenomena or events associated with life or action. He has wanted his works to represent more than just what they are. His stereometric discs or spheres, for example, were stand-ins for the earth and planets; "My purpose is to make something like a dog or flames, something that has a life of its own."[32] (See fig. 98)

In the process of building his art largely but not entirely on movement, Calder, in effect, reinvented sculpture and gave it a fresh start. Calder was as inventive as all of the Constructivists combined in getting sculpture into space and space into sculpture. Only Picasso can match his record. Except when he used a block of wood or stone to anchor a wire construction, as would Gonzalez with his iron filiform pieces, Calder dispensed with conventional bases. He

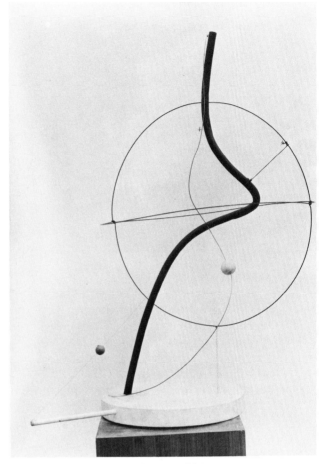

97. Alexander Calder, A *Universe*, 1934.

found surprising ways to spring his sculptures from the ground and walls and to suspend them even from themselves as well as ceilings. In both mobiles and stabiles, which rise from the ground, there is no separation of base and sculpture, most notably when stabiles were used to support mobiles, by point balance or suspension, not unlike the way bird cages are hung from stands. Like Giacometti, he developed a cage or frame concept, but he used his in more diversified ways, ranging from analogies to a picture frame to the spherical orbit of planets. Found objects were used as bases (*Gibraltar*) as well as in combination with geometrical shapes in his mobiles (*Circles*). Calder demonstrated with his first big mobiles, such as *The Forest is the Best Place*, that monumental sculpture could move and come down from a ceiling rather than rise out of the ground. No sculptor before or since has found

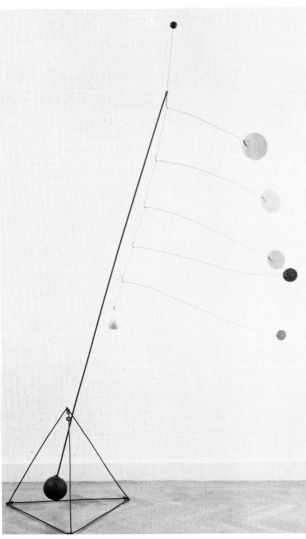

98. Alexander Calder, *Calderberry Bush*, 1932.

ties. A critical moment in Calder's development after he ventured into abstraction and elementary geometric forms came when he followed the example of Arp and Miró in making biomorphic shapes. Such was his genius that Calder could make compositions of geometric shapes whose overall structures made them seem like natural forms. By their moving relationships, he gave a new and unexpected expression to shapes the Constructivists and Neo-Plasticists had designated as neutral. Calder realized the dream of the artist working in many media, creating both a pure art and a useful art which was involved with the world outside the studio. Unlike the Constructivists in Russia, he did not choose sides for or against studio and laboratory art, but resolved the dilemma by doing both. Free from theories and dogma, his whole drive was to connect art with life, and he brought his art to theater and the dance, book illustrations and toys for children, fountains for public pleasure, posters, paintings, jewelry (given away) and even household objects (although with no thought of mass production). Unlike his Constructivist predecessors, when he came to design and fashion useful objects Calder knew how to make them work.

Otto Freundlich: "Constructor of Life"[33]

The last artist in this section, Otto Freundlich, was not the only remaining abstract sculptor in this period, and he made but two large-scale sculptures between the wars, as he was a painter. These two works, however, are remarkable and unfortunately little known in America. Because they were modeled masses and not constructed directly or indirectly from the scientific and technological sources used by the artists previously discussed, these two sculptures are closer in spirit to Arp, Lipchitz, Laurens and Picasso in the latter's modeled works.

On August 2, 1929, in a gallery on Rue Bonaparte in Paris, an *Exposition d'art abstrait* first showed Otto Freundlich's *Ascension* (fig. 100). This roughly six-foot high plaster abstract sculpture, one of the few made by the German-born painter who had come to Paris in 1909 and become friends with Picasso and his circle, was probably seen either at that exhibition or in its many reproductions in the

more ways to choreograph movement, including painted metal shapes hanging from wire catenary curves and water and mercury in two of the most imaginative fountains done in the first half of this century. Calder made the forces of nature partners in his sculpture when he found that electrical or hand power did not give him the variety and surprising elements he wanted from a sculpture that was to emulate natural movement.

In the stabiles that begin in 1937 with *The Whale* (fig. 99), Calder "carved space" and added to the Constructivist tradition of massless bolted sculpture a rich organic vocabulary which helped him to extend his private bestiary begun with his movable toys of the twen-

art magazines of the thirties by Henri Laurens, Jacques Lipchitz and Picasso. It is possible that all three artists were influenced by the powerful forms, strongly textured surfaces and stacked shapes. Laurens was just moving away from crystalline Cubism; in 1930 he began to texture more roughly his consistently sensual volumes. Lipchitz, at work on his transparents, was coming to terms with massive volumes and developing surface texture of mashed balls of clay that was similar to that of Freundlich, who had developed this style as early as 1912. Picasso's Boisgeloup series of heads inspired by Marie-Thérèse Walter, involve stacked, curved and spherical volumes rising from a tapered base that suggest the upward swelling in Freundlich's *Ascension*. Freundlich's configuration, repertoire of shapes and their relationships, as well as surface finish were his own, an astonishing performance by an abstract painter of flat, colored planes, whose paintings are only now beginning to be hung in museums around the world. Within his own art and dating back to 1912, Freundlich had established a precedent for the simple, massive ruggedness of *Ascension* in his sculpture, *Mask*, which could have been a self-portrait, judging by photographs of the artist.

In 1933, Freundlich made a second abstract sculpture, almost seven feet tall, titled *Composition*, in which he reduced the number of shapes, straightened their vertical arrangement, and simplified their relationships. Just as its predecessor, it remained in plaster during the artist's lifetime. Still today, these sculptures are unsettling in their power and challenge to gravity without being aggressive toward the beholder. They vigorously assert their identity as unknown beings, beings that are associated with masonry and natural stone, floral and human life. They do not have the elegant sensuality of Arp's *Growth* nor the sensual geometry of Hepworth, and yet the different views of *Ascension*, reveal a form which both parts and fuses, as if driven from within, burgeoning outward as well as upward. Freundlich fashioned in both works a family of shapes, unified by texture as well as mutual conjugation of each other's configuration.

These sculptures illustrate Freundlich's convictions that art based directly on the figure or

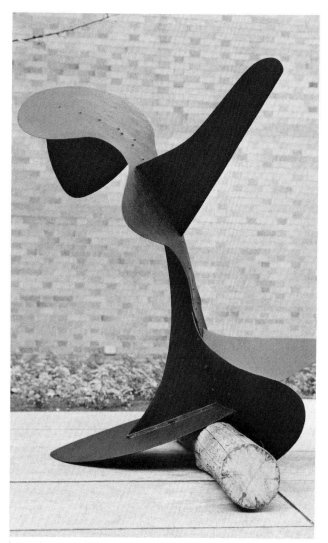

99. Alexander Calder, *Whale*, 1937.

objects would not meet the needs of the future. He sought a selfless art, one in which the artist opened himself to "pure forces," which he referred to as "social and universal," such as the coming of worldwide socialism. Freundlich sensed that humanity and art's future were in unity; art would be the prophet of the future if it could realize true creativity and signify transformations in the world. He believed that societies torn by war and exploitation had failed to find harmony through religious cults and that, as a "constructor of life," the artist's destiny was to connect mystically the living with a "great order of being" that he believed existed in the cosmos. *Ascension* may have been his attempt to invent and organize forms

and forces to show the difficult ascent of the human spirit. His 1933 sculpture was sometimes called *The New Man,* and from certain aspects it presents suggestions of a helmeted figure. Freundlich wanted art to challenge the imagination so that the viewer might share the artist's intuition about the mysteries of existence.

Summary: Art and Science as Friendly Faculties

Abstraction came into modern sculpture at the time of the First World War and the Russian Revolution, neither as escapism nor as pure formalism, but largely because sculptors, as well as painters, believed that modern science had opened for them the opportunity to create imaginative models of realities other than those the visible world afforded. Twentieth century science was founded on the view that there were worlds within worlds, underlying structures for all things, a view which Jacob Bronowski has pointed out in turn reflects the influence of architecture on scientific thought. Further encouraging sculptors to begin a new tradition was science's recognition of individual conceptions of reality rather than continuing to insist on absolutes. Modern physics had acknowledged the unattainability of an exact picture of the material world, whose structure was made permanently open to question. The scientific method that stressed analysis rather than description confirmed in sculptors, beginning with Vantongerloo, the idea that they should be creators and not "reproducers." Both scientists and sculptors worked by analogy to express the imagined. Gabo wrote in 1962, "I accept the image of the world which science is constructing . . . because it is a beautiful work of Art."[34] Comforting to sculptors was the belief that images were superior to words in presenting imagined worlds; where the scientist relied on symbols, the artist could actually image the reality of his consciousness. New developments in mathematics further inspired sculptors (who may not have understood Lobachevsky and Riemann) to take liberties with old-fashioned Euclidean geometry and even, in Kobro's case, with medieval numerical systems. None of the sculptors saw themselves as popularizers of modern science. As in fifteenth century Florence, when systematic perspective assumed an audience trained in gauging for business purposes, artists believed they could count on a more scientifically sophisticated audience to appreciate the source of their poetic imagery. Cubism and the work of Duchamp had introduced utilitarian objects from the material world into art as alternatives to the human figure. Similarly, abstract sculptors frequently looked for inspiration to scientific objects, such as mathematical models and laboratory apparatus. Space, light, things and forces rather than the human body formed the inspiration for abstract sculpture. In the thinking of the Constructivists, Vantongerloo, Bill and Calder, sculpture came to be the art and science of creating tangible forms and depicting their relationship to each other and to space. As did their counterparts in science, artists often displayed indifference to traditional categories or limitations on disciplines; and many worked in more than one medium or intermedially.

Abstraction between the wars was a joyful art, one marked by optimism, confidence and boldness. Sculpture seemed to have new and great purposes that, above all, were peaceful and dedicated not to the service of nations but of all people. The tradition of figure sculpture was linked with chauvinism, militarism, egotism and the glorification of the past. Abstraction seemed as universal as science (though it ended by being just as incomprehensible to the layman). As scientists constructed models of imagined inner-structures of nature on which to build new knowledge, so interwar artists honestly believed that their abstract art could serve as models for social harmony, providing humanity with a unique and tangible vision of what equilibrium in a modern world could *look like.* For some sculptors, it was exhilarating that their profession was again, at least conceptually, connected to science, architecture and society itself.

For various reasons interwar abstraction freely adopted impersonality in the making of sculpture. Like the published scientific article, it was analytic and did not reflect the processes of generation that led to the final result, unlike a Matisse sculpture that permits us to follow

the shaping and cutting of the clay through the making and remaking of the form. Quality was now determined by thought rather than manual formation of the material. Ambiguity, so vital to sustaining interest in the form, was to come from our perception rather than the sculpture's construction. Sculptors talked about making their art from its own laws; and their abstract geometric forms have the look of generating themselves, not unlike crystals in nature, rather than resulting from pressures of the hand and the friction of tools. Sculpture won what previously only architecture had known, the claim of beauty for forms that were non-figural and that were arranged in a certain order without regard to any apparent ulterior meaning. The new esthetic provided options other than the traditional harmonious relation of parts to each other and to the whole: single shapes or surfaces, symmetry, reflectivity of light and continuous depth or space. Shared with science was the esthetic of elegance: achieving maximal effect with minimal effort. In a curious way modern science gave interwar abstract sculpture the new power which Epstein had hoped tribal art would impart to sculpture of the prewar era.

100. Otto Freundlich, *Ascension,* 1929.

4. Interwar Relief Sculpture

The pioneers of modern relief sculpture had established by 1918 the new and basic premises that inspired many of the ideas of the most venturesome artists who worked in that medium.[1] It was in reliefs first developed by Picasso, Archipenko, and then Tatlin between 1912 and 1917 that sculpture began a new history, one augmented largely by painters who turned to this form of sculpture for various reasons, including the further development of ideas begun in painting. By the end of the First World War, architects such as the Austrian Josef Hoffman had pioneered in making abstract reliefs, and Picasso had established objects as appropriate motifs. More consistently than at any time in the past, reliefs were conceived as being independent of architecture and the socles of outdoor monuments and gravestones. This self-sufficiency was seen in Archipenko's works and later in Laurens's development of "corner" or self-supporting reliefs that could stand without support from the wall. As Duchamp-Villon had observed, modern artists often did not have an inspiring architectural model from whose style they could take inspiration for their own, and he counseled artists to design their own architecture. This attitude would change with movements such as De Stijl and the Bauhaus during and after the First World War.

The most fruitful revolution in reliefs came from Picasso and his Cubist still-lifes of 1912–1914, some of which now seem abstract but were titled with the names of musical instruments. Picasso established a new permissiveness in the ways and means of making reliefs, so that vernacular materials or those lacking art history were manipulated and joined through nailing and gluing to construct Cubist still-life compositions or objects. That traditional imitative skills and knowledge of sculptural craft were dispensable appealed to painters. As important as using materials lacking historical associations but relating to the present was Picasso's rigorous re-formation of the shapes of objects so that they lacked self-sufficiency, becoming dependent upon adjacent shapes and space. As Geist says, Cubist sculpture means showing simultaneously the inside and outside of a form. It was the spirit, character and esthetic requirements of the overall composition that determined the handling of the parts. Picasso sought to "fool the mind," not "the eye," and to assert the new reality of Cubism: artistic truth held parity with scientific truth.

Along with non-descriptive color and planes, Archipenko brought new industrial materials, such as metals and celluloid to reliefs whose style reflected Cubism. These reliefs also helped introduce the esthetic of reflectivity that developed in the interwar period. The Russian painter Vladimir Tatlin visited Picasso's studio in 1913, and there studied the Cubist works until Picasso, reportedly, threw him out for making copies. He realized latent possibilities in Cubism in his influential reliefs made between 1913 and 1917 (fig. 101). Briefly, Tatlin's contribution was to take Cubism into literal abstraction, to build an art on the material properties of the urban detritus culled from the streets of Moscow. In fact, asphalt was used as the back plane in some early compositions. After a few early reliefs emulating Picasso's still-life conceptions, Tatlin renounced any symbolic or representational reference, which he felt would have corrupted the new culture of materials he had discovered and believed would purify and revivify art in Russia. The fact that Tatlin never developed a way of organizing his reliefs that went beyond the principles of Cubist collage and assemblage, evolved in a capitalist environment, was either not recognized or was not considered detrimental to his aims, as Russia was cut off from Western Europe during the First World War. Nor was Tatlin steadfast in selecting materials with no personal or cultural reference, for by 1917, as Nakov points out, they had become somewhat autobiographical.[2] In addition to bringing metals into his reliefs, Tatlin took the Cubist idea of building the relief into the viewer's space a step further by suspend-

ing his "counter-relief" compositions by cables from the corners of exhibition rooms, a revolution limited to Russian art before 1922, as it turned out. Today we know these reliefs derived from Cubism only in old photographs, and it is hard to understand the excitement they caused. It is confirmed, however, by the aggressive rhetoric with which they were explained and defended by the artist and his friends, who were convinced that truth to materials was a vital counter to the elusive metaphysics of Malevich and the Suprematists.

Other options established by pioneering sculptors included the restoration of the practice of painting reliefs in a non-descriptive and non-illusionistic way, giving them greater formal certainty under different lighting conditions. In addition, for most sculptors, the relief that in the previous century was considered an outdoor art intended for public edification became an indoor object of speculation and, at times, intimate self-revelation.

Matisse and the Monumental Decorative Relief

In power of effect, no interwar relief surpassed that modeled and carved by Matisse of a woman's back in 1930 or 1931 (fig. 102). It was the culmination of a series of four reliefs on the same subject that may have been intended as a single serious decorative sculpture on a monumental scale.[3] *Back IV*, as it is referred to (the first work in the series, now lost, being referred to as *Back "0"*), represents the final distillation in relief of Matisse's thought and feeling on the subject. It has an outstanding clarity, a simplification rich in subtlety, and an interlocking of figure and field that is stamped with the authority of a great artist. From the rendering of a specific model in the first version, the final work emerges as that of an unknown feminine being, her identity transformed by the formal and expressive demands of the evolving image. It is doubtful, however, that Matisse saw her in generic or symbolic terms, as it was his habit, no matter how extreme his re-formation of the model, to think of a work in terms of the woman who inspired it.

Back IV consummates Matisse's empirical quest for a largeness of form in monumental sculpture by its dramatic and surprising resolution of the whole and its parts. He could not, for example, bring himself to eliminate the wom-

101. Vladimir Tatlin, *Counter Relief*, 1915, reconstructed 1966–70 by Martyn Chalk.

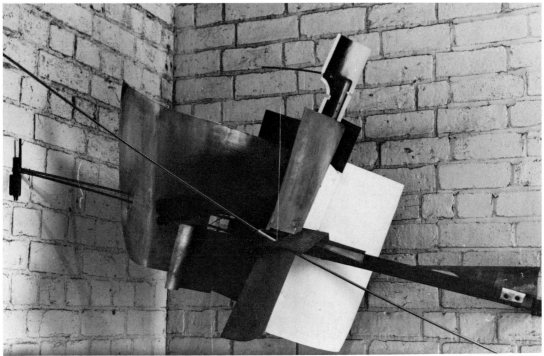

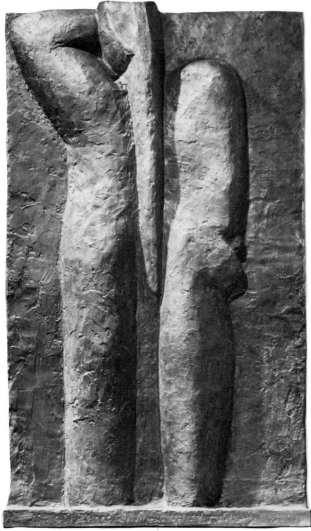

102. Henri Matisse, *Back IV*, 1930.

In addition, it was conditioned by the reproportioning of the volumes of the figure, as Matisse strove for logical mergence of anatomical parts. These formal preoccupations, including an overall uniformity of surface texture, did not distract the artist from his theme. Conventional beauty was disowned but not feminine elegance.

During Matisse's lifetime, the relief remained in plaster. It stood in his studio, at least for a while, near a plaster reduction of Michelangelo's *Bound Slave* he had purchased from the Louvre. In part, the relief was Matisse's response to the challenge of the great Renaissance artist. He showed that art's power of expression transcended that embodied in the strenuous movement of muscles and was based on the overall effect of the composition. Matisse may also have had in mind making a monumental relief (in white) that could hold up with the heroic life-size archaic figures of Ancient Greece, casts of which were also in his collection. Matisse never made a life-sized, freestanding figure, and a relief seemed congenial for this competition. Matisse's mode in this relief came closer to the Archaic than the Classical phases of Greek art because of the suppression of detail and increasing rigidity of the figure, as it became more upright, solid and coordinated with the shape of its field. In *Back IV*, far from attempting to start a new history for sculpture, Matisse should be seen as seeking to continue a tradition he venerated, one proclaiming the dignity of the nude.

Picasso's Reliefs: New Life for an Old Medium

In the thirties, Picasso did two different kinds of reliefs. Chronologically, the first kind were the assemblages, seven or eight framed or panel compositions of 1930–1932, in which he staged cryptic narratives and furthered his interest in fictive figures. A reprise of early Cubist still-life assemblages came in 1936–38. The second kind were modeled reliefs, in which he continued his variations on the theme of a head, begun in the 1932 Boisgeloup series inspired by Marie-Thérèse Walter.[4]

The assemblages seem superficially to continue aspects of the Cubist collage works begun before World War I, but now the reliefs have

an's right hand nor to adopt the cliché-ridden thinking typical of Archipenko's stylization at this time. The right hand, reduced almost to a sign, became coordinated in shape and direction with the upraised left arm, providing, thereby, the essential implied diagonal he needed to contrast with the vertical chording of the figure. The bold broadening of the back and its extraordinary fullness discourage the viewer from rotating the figure in his imagination in order to visualize what it looks like from the other side. The sense that the woman exists only through what is given in the relief is strengthened by the effect of the drawn edge of her body; it is not a contour that implies curvature into depth. There is no comparable line in Matisse's painting, since the contour of the figure was engendered by those which preceded it.

been changed by a uniform coating of sand, which gives them an overall context as well as texture — an atmospheric ambiance that, paradoxically, heightens their credibility. The relief of a boat in a harbor, done while he vacationed in the summer away from the pressures of the Paris art world in 1932, most resembles a child's play at the beach. It is as if Picasso was enjoying a childhood he never had when young because he had been too busy learning to draw like Raphael. The reliefs have a wide range of motifs. One is a cut-out profile self-portrait like those in the paintings of the twenties with a monstrous woman. Others are isolated improbable beings related to his creation of new anatomies in 1932. Still others are staged scenes in which the imprint of a leaf or an actual butterfly might mediate between two personages in confrontation or an amusing ghost form might flee a small house.[5] *Construction with Glove* (fig. 103) is the most widely reproduced in this series, although not the most interesting. In crowded conjunction, it displays an inflated glove and a cardboard shape, what William Rubin calls "a 'head' of contoured felt covered with 'hair' (ravelings from cloth) in a way that makes the whole work look like something washed up by the sea."[6] With one exception, Picasso seems to have used, as a convenience, the stretcher side of a small canvas as the receptacle for his cryptic situations. It is almost as if he were showing us the other side of his two-dimensional art: working with real objects in real space and light to extend his own image of reality and also creating narrative in scenes suggesting action whose origin and outcome are undetermined. On the one hand, he uses the most ephemeral material—grass, cardboard, leaves, sticks and cloth — to irritate his imagination and, on the other, he coats them with sand to fix the fugitive forever.

The modeled reliefs are not only conjugations of the human head in profile, but astounding inventions in making clay reliefs by inverting hollow and lump or concave-convex relationships (fig. 104). Some of the reliefs look like negative molds of a head, and we know Picasso wanted to short-cut the making of plaster casts, so that he, in effect, thought and modeled in the reverse of convention. He

103. Pablo Picasso, *Construction with a Glove*, 1930.

used clay in thin strips to outline a profile, eyes and hair, a kind of banding Schlemmer was using at about the same time in his Zwenkau mural.[7] When Picasso prepared the clay in long, thin rolls, he would then draw with them, pinching off an end to make an eyebrow or joining two together to outline the head.[8] No two reliefs have either the same formation of identical features or a repetition of surface texture. (Their resemblence to highly stylized early medieval Gallic coins has been remarked on.) The small, irregularly shaped reliefs, whose metal hooks for hanging on a wall are often visible, all manifest a vigor of working and robust engagement of light and shadow which clay prompted in Picasso. When he worked with bone and stone his thoughts shifted to stone age art, and he would etch features that sometimes, in a calculated way, he playfully wanted to be mistaken for prehistoric works.

Picasso synoptically recapitulated many aspects of the history of the relief, but he put his stamp on them all with his touch and facial types. The reliefs are still another reminder of the subtle persistence of tradition in the thinking of some of the best artists during the interwar period. For Picasso and Lipchitz it

104. Pablo Picasso, *Face of a Woman*, 1934.

coexisted with the present, something conjured during the process of working, not deliberately sought out or made the new basis for art. Picasso's culture differed from that of Calder, for example, in his extensive awareness of the history of art—not to imitate, but to draw inspiration from, to compete with, and thereby possess.

Manzù and His Model

Manzù's self-training gave him an unprejudiced approach to sculptural relief that led to one of the most unusual self-portraits in the history of sculpture, sometimes called *Self-Portrait with Model at Bergamo* (fig. 105). Manzù shows himself, wearing his customary hat, seated sideways to a surface upon which he is etching a contour line of the model. She herself stands with her back to us and sideways to the artist. One of the several enigmas of the relief is the relation of the artist to the model and to his drawing, for he can see neither his mark nor the profile it has generated. He appears to look at neither drawing nor model, but seems to be creating in a trance-like state. Manzù does show us the beauty of the woman's full back. The relief came out of a series of drawings and sculptural studies of the artist and

model, possibly inspired by those of Picasso that Manzù may have seen either in reproduction or on a trip to Paris in the thirties. During the war years, he continued his art with difficulty, and this relief poignantly recalls that steadfast dedication to the timeless subject of the artist working from a live model. It is as if Manzù were saying that no matter what happens in the world, the artist's commitment is to understanding art and life; art based on the study of a living human form will not betray him.

The complexity of the relief is surprising. Manzù did not bother to true the overall shape of his field, nor contain the model's silhouette within it, nor maintain a consistent back plane, nor establish a space into which the figures are then placed; the whole has the quality of a free-hand drawing. The model's form is, to all intents and purposes, in the round, that of the sculptor in half relief, and the artist's drawing incised. It seems he built his composition inductively and by intuition without regard for theory or the conventions of how reliefs should look. There is no self-consciousness about maintaining a consistent mode of rendering. In all, this is a stunning example of a modern artist working with a traditional medium and yet making sculpture thought's medium by shaping his style and reshaping sculptural tradition to accommodate what was closest to his mind and heart: drawing and modeling from life. Manzù did not think of the relief as architectural decoration, but rather as a self-sufficient and intimate projection of his obsessions. In recent surveys of modern sculpture, Manzù and Marini tend to be ignored or dismissed for engaging in a "revivalist" style or not coming to grips with topical issues of the Paris art world. To work without a self-conscious style is hardly *revivalist*, and Manzù may have been reassured by Picasso's example to be himself.

Arp's "Essential Picture" Reliefs

It was by means of his reliefs or "constructed pictures," as he called them, that Arp brought whimsical free association into modern sculpture even before the war was over. During the war years while he was in Zurich, Arp had told his friend Richard Huelsenbeck that he

105. Giacomo Manzù, *Self Portrait with Model at Bergamo*, 1942.

106. Jean Arp, *Torso, Navel, Head with Moustache,* 1930.

wanted to produce something entirely new, a "form of abstraction" that expressed "our time and feelings about it."[9] The Dadaists' spirit of playfulness gave him the courage to say what he wanted to say and allowed his intuitive art a chance. Their cultivation of absurdity was the Dadaists' reaction to the war headlines. It was not Arp's intention, however, to caricaturize or indict. In the midst of destruction, he sought to explore new worlds for art that had been unspoiled by human greed and stupidity. The postwar reliefs were the fruits of Arp's determination, even before 1915, to "be natural" rather than "faithful to nature"; and they are revelations that result from his "first experiments with free forms," in which he "looked for new constellations of form such as nature never stops producing." He "tried to make forms grow" and put his "trust in the example of seeds, stars, clouds, plants, animals, men, and finally in [his] innermost being."[10]

Arp credited his first wife, the gifted artist Sophie Taeuber, and her work in mixed media with encouraging him with his constructed pictures. The extent to which they were inspired by Cubist collage is not clear, but both artists probably saw it as the way to a new style and vision. For an artist drawn to nature, Cubism, which had developed a tight morphology and become more urban since its deri-

vation from landscapes, must have been too confining to his imagination. Rather than segmented objects, Arp wanted more self-sufficient shapes; and rather than the rigid, architectonic relational compositions of Cubism, he proposed a floating world of detached biomorphic forms randomly disposed in provocative situations. Where Cubism used rhyming to achieve stricter formal unity, Arp developed punning relationships between disparate shapes to evoke hidden or mysterious affinities. But Cubism must have touched him by its break with formal probability, and he may have realized its implications for release from thematic logic, as well.

During the war years, to uncomplicate his own art and thought, he had searched for elemental relationships and shapes free from fixed associations; he later recalled having formed his first "essential picture" from childrens' toy blocks.[11] For Arp, the "essential picture" embodied multiple unforeseen images. Instead of seeking to recreate low levels of biological life, as is often claimed, Arp's elementary shapes are at least partly unconscious reductions of or associations with sophisticated as well as simple motifs. *Birds in an Aquarium* of 1920, *Shirt Front and Fork* and *Egg Board* of 1922, the string relief of *Dancer,* 1923 – 1924, *Torso, Navel, Head With Moustache* of 1930 (fig. 106) and numerous other reliefs show how, to achieve a world of surprising congruities, Arp collapsed customary distinctions based on such physical properties as size, shape, color and texture. The unsteady scale of the reliefs permits Arp to range from the cosmic to the mundane, from stars to snowflakes. As with some of Schwitters's *Merz* constructions, those by Arp are potentially invertible. Titles came after the artistic fact, as Arp sought to fathom the sources of the images in himself, and they tell us more about how he read his work than what inspired it.

Arp came upon his reliefs unexpectedly from a desire to personalize painting and free it from tradition. As he put it, his discovery was "the result of wanting to approach painting from the other way round" and play with elemental forms. He likened his find to Columbus's discovery of America by mistake. Arp transformed the conditions of the relief before 1918,

by making the background plane optional or irregular, eliminating the middleground, and layering his flat, cut-out shapes without conformity to a rectilinear boundary. His major change after 1918 was to paint at times shapes on the background plane to contrast with those in relief, as in *Infinite Amphora*. The fertilizing paradoxes of his constructed images (fig. 107) lie in a contrast between impersonality of means — using a saw to eliminate evidence of the hand—and personalization of the image to render precisely the ambiguous. He was a perfectionist and demanded exactitude in the forming of his shapes and application of color. Monochromatic areas of nondescriptive color won him both surfacesness and infinite depth, while provocative contours induced a sense of modeling in the form. The modest scale of his reliefs was partly due to economics, as well as the intimacy of his vision. These "essential pictures" were intended to hang in home and studio as joyful private icons for those who shared his devotion to the perceptions available through the unconscious and the "laws of chance." Like his friend, Kurt Schwitters, Arp saw his reliefs as a way to lift humanity's burden of care and fear of chaos.

Schlemmer's Relief Murals[12]

Oskar Schlemmer's first sculptural attempts to create a healing art, one that reconciled art with architecture and man with his built environment, took the form of a series of nine individual reliefs begun in 1919, and culminated in his painted relief murals at the Weimar Bauhaus in 1925. From Cubism, Schlemmer derived his inspiration for the architectural composition of the figure and from Archipenko an interest in new materials, such as metals and plastic. The "Sculpto-Painting" of Archipenko helped persuade Schlemmer that his early reliefs were a logical continuation of his work in painting. The figural reliefs balance between stylization and a more genuine reconstitution of the figure, based on simple geometric forms. Appropriate to his intention of creating an idea of man, the figure was reduced to signs, usually elements of the figure in profile, as in *Relief H* of 1919. More than Archipenko's work after about 1915, Schlemmer's mannequin-like figures are unpredictable

107. Jean Arp, *Constellation of Leaves on Oval Form*, 1930. [cat. no. 2]

in their reincarnation. Schlemmer achieved an often witty conjunction of sensuous and astringent forms, while avoiding the impression of working from a system. Several of these early reliefs are variations on a theme: notably, complicating a basic image by painting and adding metallic and glass materials to "activate" the surface with strong textures and more staccato rhythms of light and dark. *Constructive Sculpture "R"* of 1919 (fig. 108) stands out for the imaginative vigor and formal rigor by which the figure is integrated with the field. Schlemmer's inventiveness takes the form of surprising shifts in the mannequin's silhouette, interrupted by compartment-like divisions. The changes are in altitude of relief as well as discontinuity of profile. Recourse to a partial figure eliminated troublesome limbs and encouraged greater terseness of design. In his diary of November 1919, Schlemmer called these reliefs part of "a larger plane, of a space surpassing their size, thus part of an imaginary desired architecture. The formal law of their surroundings is contained within them. In this context, they are tables of law."[13]

Schlemmer in 1922 took over the wood and metal workshop of the Bauhaus, where he availed himself of the resident craftsmen, such as Josef Hartwig, to develop new ideas for reliefs. In his diary in February 1922, we read, " 'The new series!' White plaster panels as a ground, hollowed out, heightened, pierced—

108. Oskar Schlemmer, *Constructive Sculpture "R,"* 1919, cast executed after 1959. [cat. no. 5]

then upon it and in it, glass, glass tubing, mirrors, coloured glass. . . . Wire of nickel, brass, copper, steel ribbon. Polished, modelled wood. Overall: real materials. Nothing from the machine, nothing abstract, always man."[14] Photographs of the workshop at this time indicate that the same figural relief could be realized in both the concave and convex versions, as part of Schlemmer's interest in optics that he had probably picked up from Archipenko's substitution of hollowed or protruding shapes in his earlier work (*Standing Woman* of 1920). To achieve this alternation, Schlemmer had reduced the feminine (androgynous?) form in an almost caricatural way to a succession of globular shapes (*Half Figure With Accentuated Forms*, 1923). His relief of *Plaster and Glass* of 1923 was of a frontal humanoid with a head like a glass bowl. The torso is cut away to reveal colored glass tubing that wittily implies a circulatory system or, as the artist put it in his diary, "a fulfilled glass culture." Today these reliefs of impossible figures appear caricatural rather than metaphysical, as the artist seems to have intended.

Schlemmer's most ambitious project involving reliefs was decorating the small and poorly lighted front entrance of the Bauhaus Workshop Building (fig. 109), designed by Henry van de Velde.[15] Schlemmer treated the reliefs as murals, and they were framed only by the edges of the walls and ceiling, from which they were built up in plaster and mortar. In keeping with the severely simple modern architecture and with his personal canon, the decoration was to be of exemplary masculine and feminine elementary figures, "primary types," as Karin von Maur calls them. The artist described his overall plan: "The elementary colours of the chromatic scale, the elementary forms of geometry (point, line, angle, rectangle, circle, elipse, golden section, the law of Pythagoras) — and the elementary plasticity of regular structures such as cubes, pyramids, spheres, cylinders and their interpretation."[16] Shown immobile, frontally and in profile, in raised relief, the figures recall Egyptian relief art, which the artist admired. The thematic program is not self-evident. The full implication for the artist of what he termed his two "temple guardian" male and female figures, flanking the

stairway, is not known, any more than is that of the three intersecting partial figures on the ceiling. Schlemmer must have counted on repeated exposure to it by sympathetic students and faculty, who knew his course on Man, begun in 1928. The strength of the overall design, the bold scale and disposition of the figures within their architectural fields can be appreciated only in photographs, for in 1930, under the orders of the new Nazi Bauhaus director, Schultze-Naumberg, they were destroyed as being "without artistic value" in one of the first acts of Nazi vandalism against art.

In 1930, Schlemmer fulfilled a private commission by providing the home of a Doctor Rabe in Zwenkau with an astonishing relief mural (see fig. 110). It is boldly adapted to the entire end wall of a large room. There is the wire seated figure of a man, that Schlemmer referred to as "Homo," who holds in his left hand a cut-out metallic silhouette of a woman seen from the back. At the far right is the gigantic profile of a woman, somewhat Picassoid in her classic profile, realized by a continuous band of metal, with the eye outlined in wire. Between the two is a geometrized cross, bisecting concentric circles, suggesting a star and contributing to the impression that the overall theme is that of creation or a private speculation on the nature of man. Writing to his friend, the artist Willi Baumeister, Schlemmer said:

> The metal figure assembly really appears superb in reality. . . . The wire sculpture, or better still "Metal composition" or figurative composition of different metallic wires is a triple one; the large figure carries a smaller one on its hand; on the right in relation to the first figure, is the metal profile of a face, over five meters high. The figures are detached from the wall by about eight centimeters, so that the changing light forms a series of interesting varied shadows (in the manner of a sun-dial).[17]

Because the artist had described himself as having a "mystical bent," the meaning of the two figures and the profiled head has been variously interpreted as Adam and Eve and the Creation, which would make the feminine profile head that of God, or as theosophical depictions of Spirit, Soul and Nature, or Body, Soul and Mind. The schematized astral symbol might have related to Schlemmer's insistence that man be viewed cosmically, rather than as

109. Oskar Schlemmer, Wall Reliefs in Workshop Building, Weimar Bauhaus, 1923.

an isolated being, a totality within himself and a part of the universe.[18] As seen in old photographs, the wire and band reliefs were in harmony with the tubular Bauhaus furniture of the room. In addition, Schlemmer had ingeniously staged his drama on a wall cut by two doors, while arrogating the natural side lighting to the service of modeling his forms in depth, realizing, thereby, Gropius's idea of a total building — a *Gesamtkunstwerk*.

Schwitters and the Merz Cathedral[19]

Kurt Schwitters established no new premises for reliefs, but drew his basic ideas for an entire art from Cubism and Picasso's collages and assemblages. A painter by training, he never displayed in his freestanding or relief sculptures and mixed media collages a strong aptitude for forming or even re-forming his materials. His gift was in joining things, in inducing totalities that were poetically and artistically greater than the sum of their parts. A singularly independent and complex figure, Schwitters not only mocked modern architecture and parodied Constructivist sculpture in his Dadaist "cult objects" (*Cathedral, Gallows of Lust,* and *Cult Pump),* but also twitted Dadaism itself. As he himself put it, he "passed for a Dadaist," but incurred the enmity of certain Dadaists who resented his unwillingness to commit his art to political ideologies.

What linked Schwitters, who was working in the twenties in Berlin and then Hanover, with Schlemmer, who was working first in

110. Oskar Schlemmer, *Wire Relief Mural* in home of
Dr. Rabe in Zwenkau, 1931.

Stuttgart and then Dessau, was the conviction
that art could have a beneficial influence on
the rebuilding of Europe, not by political ac-
tivism but by helping humanity to rise above
the mundane. Schlemmer formed his personal
canon of the ideal cosmic man, while Schwit-
ters makes us aware of urban man in his *absence*
by the things he has made but discarded. The
laws they admired were those to be discovered
in art: the respect for materials and their rela-
tionship in the strongest composition. Schwit-
ters and Schlemmer believed in the imperative
of a universal style to overcome the chaos of
the urban environment, but both he and
Schlemmer insisted upon individuality within
uniformity. Both were committed to the
"cathedral" concept, a unification of the arts as
a prerequisite to a regeneration of human
spiritual harmony. Thus, their respective arts
were open-ended, nuclear models to be built
upon and extended into all forms of life. Their
wit as well as their seriousness gave their efforts
a broader humanity than the efforts of their
Russian counterparts.

When Gabo and Schlemmer, for example,
surveyed the ruins of their cultures after the
war, they turned to new materials without ar-
tistic history to construct a new art of the
present. Schwitters did the reverse.

> At first I tried to construct new art forms out of the
> remains of a former culture. This gave rise to the Merz
> painting, a new kind of painting that makes use of
> every kind of material, manufactured pigments no less
> than junk from junk piles. In this way I rode out to the
> revolution enjoying myself thoroughly, and passed as a
> Dadaist without being one.[20]

Far from being a cynical commentary on his
country's collapse, the early *Merz* reliefs were
evocations of personal joy:

> I felt myself freed and had to shout my jubilation out to
> the world. Out of parsimony I took whatever I found
> to do this, because we were now a poor country. One
> can even shout out through refuse, and this is what I
> did, nailing and gluing it together. I called it "Merz," it
> was a prayer about the victorious end of the war,
> victorious as once again peace had won in the end;
> everything had broken down in any case and new
> things had to be made out of fragments: and this is
> Merz. I painted, nailed, glued, composed poems, and
> experienced the world in Berlin.[21]

In continuing traditions and revitalizing art
with new forms, Schwitters has acknowledged
his debt to Picasso for helping him to "enlarge
the domain of art." *Merz Construction* of 1921
(fig. 111) is the filial descendant of the layered
rectilinear assemblages of studio detritus and
synthetic Cubist paintings by Picasso without
the still-life reference usually found in his con-
structions. Schwitters even emulated the
compositional transcendance of the closed
frame that implies continuity with the envi-
ronment: the intimate irrational and textured
spaces and perforations as well as overhanging
planes that permitted space to move unin-
terrupted throughout the whole. The
more completely abstract nature of the relief
also permitted its reorientation. From Picasso
and Mondrian, Schwitters derived the convic-
tion that in his paintings and reliefs there was
to be no separation of figure and ground, no
privileged area, but rather a democratized col-
lective whole, in which all parts were to be
emphasized. The warm and colorful aspect of
his materials, more marked than in Cubist as-
semblages, conveys the artist's predilection for
objects "steeped in humanity."

Schwitters's reliefs of the twenties group
themselves into the early richly coloristic,

heterogeneous types, those of the mid-twenties, in which unpainted or natural found wooden objects are nailed to a plane, and his more Constructivist, formal geometries, in which white is the predominant color. The last group reflects his sympathies with De Stijl, the Constructivists and the Purists, all of whom favored an impersonal and somewhat rigid "architectural" designing of clean-cut elements, which in Schwitters's case were as far removed from prewar German Expressionism and its expression of "soured souls" as he could get. The same organizing rigor, whether slanting the assembled objects on a diagonal or posting them in vertical phrasings, was tempered by unpainted, natural-grained and weather- or sea-worn surfaces. Schwitters had probably seen Arp's reliefs of found unpainted objects from 1920. It is in these usually untitled and unpainted reliefs that Schwitters came in spirit closest to Tatlin. *Cathedral* of 1926, however, shows a personal symbolism and whimsy alien to the Russian. The multicolored "contraption" and almost abstract narrative reliefs, such as *Little Sailors' Home*, 1926, suggest Schwitters's divided thinking about serious formalism and playful nonsense. In a curious way, he was to resolve his conflicting allegiances in a staggeringly bold and surprising enterprise, the creation of this first and most important *Merzbau*, begun in Hanover in 1923. It was abandoned when he fled the Nazis in 1936 and destroyed in a World War II bombing raid. (See fig. 112.)

Schwitters's "cathedral" of *Merz* was his own home and began when his assemblages outgrew the rooms which he used as studios. He extended them by tearing down walls, tunneling through his own constructions, and cutting through floors until the entire house was occupied. Electric and natural lighting illuminated his personal theater. The fruitful nucleus of the unplanned enterprise was a one-time, freestanding accumulation of objects (or four-sided relief) that he called "Cathedral of Erotic Misery." To this personal kiosk Schwitters affixed urban detritus and objects he associated with friends and others he admired in ways that suggested miniature chapels. He appears, in addition, to have gradually joined together his various assemblages and "paint-

111. Kurt Schwitters, *Merz Construction*, 1921.

ings" that hung or stood in his studio, like a baroque cabinet of curiosities, so that they became a continuous though often submerged part of a structure evolving in depth and extension, like the pyramiding of cities on an ancient site.

As Peter Gay has pointed out, many intellectuals in the Weimar Republic compartmentalized their minds and lives to accommodate the contradictions of their existence, but Schwitters also did it literally in his art.[22] To miniaturize his encounters with the culture of the street and art world and to exteriorize the private obsessions and torments of an erotic and aggressive nature, for years this instinctive *bricoleur* daily improvised with painting, sculpture and architecture. He had found in the principle of disjunctive assemblage and rigorous geometric abstraction the means of wedding art to the life of his mind and spirit. Others recognized the self-psychoanalytical nature of Schwitters's work,

112. Kurt Schwitters, *Merzbau*, Hanover (destroyed).

113. César Domela, *Collage*, 1930. [cat. no. 15]

for not the least purpose of the *Merzbau* was to cope with the past by burying it beneath the present. In 1930, Schwitters wrote:

> . . . I have a corpse on my hands—relics of a movement in art that is now passé. . . . I cover them up either wholly or partly with other things, making clear that they are being downgraded. As the structure grows bigger and bigger, valleys, hollows, caves appear, and these lead a life of their own within the over-all structure. . . . An arrangement of the most strictly geometrical cubes covers the whole, underneath which shapes are curiously bent or otherwise twisted until their complete dissolution is achieved. . . . [It] is the development into pure form of almost everything that has struck me as either important or unimportant over the past seven years.[23]

The *Merzbau* survives only in photographs and descriptions by the artist and a few friends. It is clear that Schwitters arrogated to the service of his most intimate and deeply felt experiences of self and culture the artistic systems developed by Constructivists, Purists and De Stijl artists to accomplish just the reverse of their public purpose. In effect, Schwitters "Merzed" rationalistic abstraction and the new architecture. Duchamp-Villon, before the war, had prophesied that sculptors would have to be their own architects, but he would have been startled by Schwitters's "Merzing" of Cubist

architecture. While it is often compared with the 1919 Expressionist film, *The Cabinet of Dr. Caligari*, with its subjective settings and Romantic grottos, it is questionable that Schwitters had such models consciously in mind, for he worked without a system. He, in fact, subtracted from the existing cubicular architectural spaces, not in order to create a setting generated by vision tormented by fear, as in *Caligari*, but to create, as he put it, a work that had a life of its own, a fantastic city unhampered by zoning laws but afflicted with imaginative urban sprawl. For Schwitters, the "total art" necessary to realize his private being meant dissolving distinctions between media and means.

Though united in the ultimately personal and unparaphrasable meaning of their projects, Schlemmer's reliefs for the Bauhaus and the Zwenkau mural and Schwitters's *Merzbau* are dazzling polarities in German interwar artistic achievement. The Bauhaus master demonstrated to students and faculty how to accept the prescribed fields of a congenial architecture and the way to extend the painted mural concept to relief sculpture. His imaginative primary figures were hopeful expressions of

man's adaptability to the present and future. Schwitters's diaristic epic of his relationship with himself and Weimar culture (and then his experiences under repressive Nazi rule) was enacted in a playground or special place of his own devising, meant only for the contemplation of family and a select few.

Geometric Reliefs

Since a chronology and full inventory of Tatlin's reliefs after 1913 has not been published, it is hard to tell just how formalized his reliefs became after 1917, and to what degree he succumbed in this medium to the Constructivist evolution toward a doctrinaire art. An old photograph of a largely metallic vertical relief, marked by a series of diagonally placed strips which contrast with the rectilinearity of the adjacent motifs, has been dated 1922, but is probably from c. 1917.[24] While the materials are roughly textured, evoking their prior use, their Cubist-derived composition combines the two abstract modes of placement, strict vertical-horizontal rectilinearity and the diagonal. Tatlin combined that which divided Mondrian and van Doesburg in the twenties, for Mondrian believed that the diagonal was too emotionally provocative a form and, therefore, heretical to his theology of objectivity. It is in the reliefs of their sympathizers, Jean Gorin and César Domela (fig. 113), that the mutual inventions of these powerful painters were translated. In 1932, Mondrian commended them for moving away from painting toward an art more integrated with life. With only brief success, he encouraged them to show their reliefs horizontally. When Domela's reliefs are contrasted with those of Tatlin, they seem unpolished and tentative. Gorin's are still less robust but more fastidious in construction within a rectangular format. Their use of painted as well as new, unblemished materials derives from the De Stijl and Purist movements, which prevailed during the twenties in Paris, where Domela had met Mondrian.[25]

Gorin's painted wood reliefs of the thirties look very much at home with similar abstraction practiced after World War II in England and the United States, whereas those of Domela, which have more of a machine aesthetic and draw attention to the materials of modern technology, have no comparable

114. Naum Gabo, *Circular Relief*, 1925.

postwar resonance. Domela's evolution in the thirties included going to exotic and somewhat precious materials, such as alligator skin and ivory, along with plastic curved forms, freed from the Mondrian grid to float on textured wooden backgrounds. With his early use of plastic and shiny, perforated metal forms (such as used by Moholy-Nagy in *Light-Space Modulator*), Domela entered into the newly opened territory of reflectivity, but did not extend its implications, as did Brancusi and Gabo. He was alert to new possibilities, but could not rise above his talent. These artists must be credited with the initiative of taking ideas developed in painting into reliefs. Domela even hung his early square reliefs so that, like some of the paintings of Mondrian and van Doesburg, they were forty-five degrees from vertical or diamond-shaped in appearance. Neither artist, however, had the genius or artistic authority to transcend his sources substantially. Their best work is translatory or art by substitution rather than genuine invention. Domela's art of the thirties seems more interesting today in terms of the history of taste, rather than artistic inventiveness. Their early years of making reliefs join them historically with the utopian hopes of the period. Domela, like his friend Moholy-Nagy, seems to have wanted humanity to feel at home with the new materials of the time, and both artists sought to show that individual sensibility could operate in what to many was an increasingly impersonal era.

The Reliefs of Gabo and Pevsner[26]

One can trace Gabo's departure from a stereometric representation of persons to

abstraction by means of his reliefs. By 1920, they were no longer translatable into the figure or bust form of the reliefs from 1917, but consisted of clear and semi-opaque planes cut from flat sheets of plastic whose combination was not dictated by the memory of the human form. Lacking a detailed history of Gabo's evolution during the crucial years he was in Russia from 1917 to 1922, it is difficult to say whether or not the abstract painting of Malevich, especially his monochromatic white on white paintings, helped to influence or encourage his evolution. Gabo's more regularized planar forms reflect Constructivist painting in general, and certainly he was responsive to the renunciation of the figure by the Russian avant-garde in favor of monochromatic planes suspended in space. In 1920 and 1921 Gabo continued the 1917 idea of building cells for light and space in several plastic reliefs. *Construction en creux* of 1921 has a crystalline aspect; for, no longer constrained to evoke facial features or bodily parts, Gabo could engage in a kind of arcane geometry and games of optical illusions to challenge the viewer to calculate what generated the forms and how much depth or space is involved. Critical in these plastic reliefs is not only their transparency and thinness but also the way the curved and straight edges of the planes pick up the light, giving the configuration an active, radiant armature.

Presumably by 1920, Gabo began to think of and exhibit the same reliefs either horizontally or vertically. This versatility of orientation was possible because of the Constructivist break with fixed viewing perspectives and frontality and the absence of references to gravity or horizon lines, and it also reflected the sculptor's continuing interest in structures that were possible as vertical monuments.

By 1921 Gabo had brought symmetry into his reliefs, thereby uncomplicating his previous, more Cubist-inspired forms and irregular compositions. Rather than perfect bilateral symmetry, Gabo preferred to invert one side and then skew the orientation of the whole in relation to its square base or back plane. (Malevich had used bilateral symmetry before 1920 in his cruciform paintings.) Because the four sides of the reliefs could be rotated on the

wall or the viewer could move around the horizontally disposed composition, the symmetry is not always apparent. When the reliefs are mounted against dark bases, there are prospects, especially from above, which add to the invisibility of the planes, leaving only their light-limned boundaries to evidence their presence and suggest the trajectory of some moving force against black space. The reliefs, thus, seem to project forward into our space and back into depth. By 1925, Gabo's reliefs incorporated more extensively curving and spiraling forms rising from the supporting plane. This rotary configuration was always elegantly worked so as not to distract our optical absorption and gave the reliefs a new rhythmic pulse in and out, upward and downward. In *Circular Relief* of 1925 (fig. 114), Gabo constructed a cantilevered, curving arm that projects over the center of the spiraling concave forms; attached to it was a plastic tube that initiated or completed the curving movements below. Whether in his freestanding works at the time or in the reliefs, Gabo retains what can only be described as a reference to scientific apparatus.

In the thirties, Gabo made relief and freestanding configurations that were very close in character and which tended to fuse rather than reinforce differences in modes of sculpture: *Construction on a Plane*, *Construction on a Line*, and *Base Relief on a Circular Surface*, semispheric, all of 1937. Even his freestanding *Construction with Alabaster Carving*, 1938–39, which was symmetrical front and back, could be halved to make a pair of reliefs. Alabaster gave Gabo the translucency he required to bring his constructions to light. Their luminosity minimized mass or density and evoked depth rather than a sharp cleavage with the surrounding space.

Gabo's reliefs brought to the medium a beauty, optical complexity and elegance that, like his freestanding sculptures, permitted a new tangibility of light and space.

Pevsner's reliefs follow by a few years the evolution of Gabo's work. Among the earliest were the *Portrait of Marcel Duchamp*, 1926 (see fig. 87) and the more abstract *Bust* of 1924–25, in the Museum of Modern Art. Pevsner had a strong background as a painter in Cubism, and when he shifted to celluloid planes, for exam-

ple, it was as if they were tilted up or outward from the surface of his paintings. One has the impression that Pevsner's reliefs are far more impressive than the few paintings that are reproduced, perhaps because the more obdurate materials called for greater incisiveness and clarity of design. Going from painting's surface plane to space was a liberation of Pevsner's imagination. A natural aptitude for geometry may have helped in their design, but the reliefs were derived from artistic intuition. That his bust reliefs tended to depersonalize the human being may have been why one was dedicated to Duchamp; it was, in fact, a portrait whose resemblance to the subject, admittedly vestigial, was as close as stereometry and celluloid permitted.

Pevsner's gift, unlike Duchamp's, was not for parody, and he came into his own with his 1927 brass relief, *Abstraction* (fig. 115). Because he found plastic too fragile, he departed from the aesthetic of translucency and courtship of special colors from light that he shared with Gabo. There remained their joint fascination with various forms of symmetry and the double life of the sculpture, when seen on either a wall or table top. By using sheet metal planes, often folded along an axis, in *Abstraction*, Pevsner continued the tradition of absorbing light and shadow and holding them within the reliefs, a tradition Gabo had abandoned. He set some of his later reliefs on white plastic bases, which served not only as support but as infinite space against which the perforated configuration could be seen when the relief was hung on a wall. In his use of symmetry, Pevsner also avoided bilaterally identical compositions with central, vertical axes. He preferred the top and bottom halves of the relief to be identical, so that there was an implied longitudinal or, occasionally, diagonal axis. (Why this was so is not clear, and perhaps Pevsner was avoiding reference to hieratic figural imagery of the Middle Ages.)

In 1938, he abandoned flat and sheet metal planes when he discovered his "developable" surfaces, which were built entirely out of *straight* metal rods welded together and sometimes patinated. At this moment Pevsner considered himself simultaneously painter, engineer and sculptor.[27]

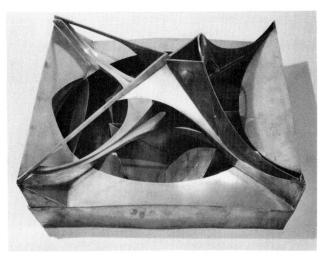

115. Antoine Pevsner, *Abstraction (Bas-relief en creux)*, 1927. [cat. no. 50]

Pevsner occasionally used his developable surfaces in reliefs before 1945. His *Fresco* of 1944 was one of his most complex compositions to that date, consisting of a four-branched star shape emerging out of a conical form, within and against which were smaller conical and triangular shapes. One can read the composition as a triangular shape or force at the left, breaking out of the "X" barred cellular nucleus. Given the fact that the work was made in 1944, the year of the liberation of Paris, where, as a naturalized French citizen, Pevsner had endured the German occupation since 1939, one is led to speculate that the relief may have conveyed the artist's sense of spiritual release from what was a virtual prison. That his abstract sculpture could impart for Pevsner abstract political ideas was shown in his *Developable Column of Victory* of 1946, his *Monument to the Liberation of the Spirit*, 1952, and his entry for the international competition for a Monument to the Unknown Political Prisoner in 1954.

The Reliefs of Ben Nicholson[28]

The spartan reliefs of the English painter Ben Nicholson that he began in 1933 are an example not of the artist transforming the conditions of art to accommodate a new vision, but just the reverse. They began by accident. As the artist was etching a line on a gesso-covered board, a chip fell out, leaving a hollow that the artist then decided to excavate

115

into a circular depression. This came at a time when Nicholson was just beginning to move his painting into abstraction and reduce his motifs to circles and rectangles, partly under the influence of Miró. The first reliefs were carved free-hand in soft board, so that there were irregularities in the shapes. The circular motif had a prior history in his still life paintings, in the holes of sound boxes of guitars and the shape of plates. By 1934, he had trued and regularized his vocabulary of circles and rectangles, developed a form of stepped relief, and increasingly painted the architectural compositions a white color (fig. 116). As Steven Nash described it, "White had become the color of modernism and was omnipresent in architecture, painting, sculpture and interiors as part of the new esthetics of purity."[29] The "poetry" Nicholson found in this mode of work, which he saw as a natural and welcome literal extension of his painting, was expressed thusly:

> You can take a rectangular surface and cut a section of it one plane lower and then in the higher plane cut a circle deeper than, but without touching, the lower plane. *One is immediately conscious that this circle has pierced the lower plane without having touched it . . .* and this creates space. The awareness of this is felt subconsciously and it is useless to approach it intellectually as this, so far from helping, acts as a barrier.[30]

Within this highly restricted and limited art form, optical paradox counts for much. Its observance is accompanied by demands for subtle seeing in terms of the drawing action made by shadow projected from the thin relief edges. Nicholson presupposes an audience with this kind of special aesthetic, just as Renaissance painters such as Piero and Uccello presupposed a public whose tuition had been in plane geometry and algebraic relationships and which was adept at judging volumes and proportions.

One of the paradoxes of Nicholson's reliefs is that he arrived at a purified form of Synthetic Cubist collage indirectly and through a variety of influences, many of which were unrelated to Cubism. He and Barbara Hepworth had seen Arp's studio filled with his white plasters and some of his constructed pictures during a visit in 1932. Perhaps as a way of deflating Arp's influence, Nicholson always pointed to their differences, saying that Arp cut out his shapes, while he carved his. (This is the least of their

differences.) Arp did show him, however, a way of giving pictorial ideas more tangible form. On a visit to Mondrian's studio in 1934, he was moved by the artist's intellectual rigor and the sight of colored rectangles attached to white walls. As with Mondrian's art, that of Nicholson was not a homage to geometry. His layered and irrationally penetrated rectangles held private associations for Nicholson as well, perhaps, as the dream of monumental self-sufficient walls that served no practical purpose, but which resulted from the pure love and joy of their making. He did, in fact, carve small freestanding, one-sided reliefs in 1936. Nicholson not only knew the approving support of important architects such as Gropius, Breuer, and Mendelsohn in London, but he was in constant contact with the white carved world of Hepworth and Moore, who had optimistic views of sculpture's purpose as giving serious pleasure. (Moore himself tried his hand at geometric reliefs in some of his mid-thirties sculptures, but found them unrelated to his experiences of life and, hence, not authentic inspiration for his art.) Hepworth and Nicholson were mutually supportive professionally as well as being husband and wife: for both, abstract form had become integral to their consciousness and influenced their views of nature.

After 1936, Nicholson began to bring strong colors from his paintings together with his white or natural board reliefs. This admixture of colors and planes in varying depths suggests Nicholson's earlier exposure to the ideas of De Stijl as well as Mondrian. By at times deviating from a straight grid arrangement, drawing lines or circles on the rectangles, and introducing textured surfaces to vary surface rhythm and the relief's reception of light, Nicholson had found by 1945 sufficient variables and compositional problems to solve down to the present day. For all of their formal rigor, Nicholson's reliefs stand in relation to Cubism as a farmer to a pioneer. To the interwar period he contributed several beautiful purist reliefs, in which sensibility was free of Constructivist concern for application to technology and new materials. Although he sold but a few, he showed that an abstract mode developed earlier among socialist- and communist-minded

116. Ben Nicholson, *White Relief*, c. 1937–38. [cat. no. 49]

artists was congenial to an artist working in a capitalist society who was content with making beautiful aesthetic objects for contemplation. Like Mondrian, he believed that although appreciated at first by a few, in time his harmonies would become "a force" in the lives of the public.

Calder's Constellations

Calder rivaled Picasso in sculptural inventiveness and, like his older colleague, would sometimes hit upon an idea that another artist might build an entire art upon. With both artists, the variety of their ways of working, if seen in chronological sequence and in the context of their whole art, usually reveals connecting elements, so that a given idea transcends any one medium. Picasso's Boisgeloup *Heads* interconnect with his paintings, drawings and prints of Marie-Thérèse Walter, for example, and before that, his portraits of the late twenties. Picasso was not consciously grappling with the problem of how to revive modeled portrait sculpture or the art of relief, but rather doing what was necessary at a given moment to extend ideas that had temporarily reached a limit in two dimensions. In 1943, Calder, who was as much a *bricoleur* as Picasso, was confronted with the problem that:

> aluminum was being all used up in airplanes, and becoming scarce. I cut up my aluminum boat . . . and I used it for several objects. I also devised a new form of

art consisting of small bits of hardwood carved into shapes and sometimes painted, between which a definite relation was established and maintained by fixing them on the ends of steel wires. After some consultation with [James Johnson] Sweeney and [Marcel] Duchamp . . . I decided these objects were to be called "constellations."[31]

The *Constellations* (fig. 117), made between 1943 and 1945, were a kind of stationary mobile, related to his use of found objects (as seen in *Gibraltar*) and harkening back to his carving of wood and drawings of tight-rope walkers. Thematically, they "had for me a specific relationship to the *Universes* I had done in the early 1930s. They had a suggestion of some kind of cosmic nuclear gases. . . . I was interested in the extremely delicate, open composition."[32] What Calder recalled in 1951 about the *Universe* series seems apt as well for the *Constellations*:

> When I have used spheres and discs, I have intended that they should represent more than what they just are. More or less as the earth is a sphere, but also has some miles of gas about it . . . and the moon making circles around it. . . . A ball of wood or a disc of metal is rather a dull object without the sense of something emanating from it.[33]

The *Constellations* began as table-top pieces in 1943, and soon were rising not only from the floor but projecting from walls. The tripod stance of some and the use of straight wires to connect the wooden shapes to one another in the horizontal and vertical compositions may

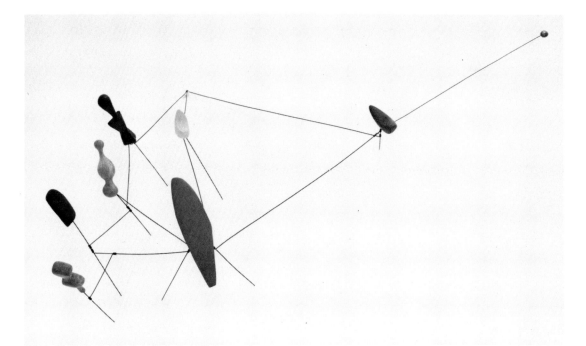

117. Alexander Calder, *Constellations*, 1943.

also have been a recollection of the eighteenth century armilleries that Joan Harter has shown Calder knew. They offered the precedent or model for planetary forms being connected by rods. As she describes it, "Inside the globe the sun would be attached to the two poles by a rod, and the earth and moon are carried on a subsidiary arm from the same rod."

As is so often the case with Calder's art, traditional categories do not apply, and for lack of a better reference, the vertical *Constellations* come closest to reliefs. Schlemmer's wire reliefs at Zwenkau that were projected out from the walls were unknown to Calder, but he probably saw Miró's *Relief Construction* of 1930 (fig. 118), in which, in the manner of Arp, a torso-like form was precisely cut from wood, but then raised off of the back plane. Calder credited Miró's series of oil and gouache "Constellations" done in 1940 – 41 with the inspiration for his work. The linear connectives between the amorphic, figure-eight shapes and oval forms, all of which seem to float above a background rubbed to look atmospheric as well as terrain-like, do make Miró's paintings seem the logical source. Calder, however, could not have seen Miró's "Constellations" until they were exhibited at Pierre Matisse's gallery in 1945. (The first ten had been done in Paris

before the Germans occupied it, and the rest in Spain.) With typical self-effacement and generosity toward Miró, Calder may have forgotten the sequence of things, but his indebtedness to Miró in the mobiles was incontestable. It is also doubtful that Calder could have seen Arp's *Constellation* reliefs made in southern France during the war years of 1941 – 42. Curiously and uncharacteristically, Calder makes no mention of the art his friend, Yves Tanguy, did in Connecticut at this time when in exile from Paris. He, Miró and Arp were models for Calder of how modern artists should respond to Fascism—by continuing with their art! The carved and, at times, painted wooden shapes in Calder's *Constellations* and their wire armatures seem kin to Tanguy's inscapes, such as *Slowly to the North* and *The Palace of the Windowed Rock*, exhibited in the Pierre Matisse Gallery at the same time as the *Constellations* in 1943. In these paintings Tanguy uses luminous lines in a kind of geometric web to connect his rocky shapes. They are seen in a setting where earth and sky dissolve into one another, so that the foreground configurations are seen against the same ground. Calder's vertical *Constellations* are seen against white walls, that, as with Arp's painted reliefs, can seem all surface one moment and all depth the

118

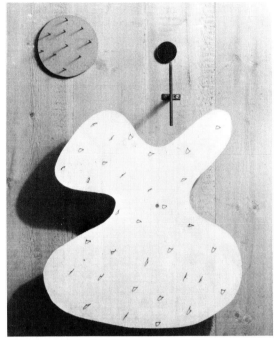

118. Joan Miró, *Relief Construction*, 1930.

next. For an earlier precedent for linear constructions, one could go back to Picasso's abstract drawings for the *Chef d'Oeuvre Inconnu*, in which solid black dots or circles are connected by straight lines that either form abstract patterns or suggest objects, and his 1928 *Abstract Construction,* which derived from imaginary perspective studies and was made of straight and curved bars soldered together. Such a cursory exegesis of the Constellations brings home that these artists, in whom imagination was the center of their being, thought in terms of art rather than medium, while reacting at times to certain properties of the material in terms of form.

The *Constellations* came about as wall reliefs perhaps as insouciantly as Calder would tack his jewelry or wire portraits to a gallery wall for display. They are easily overlooked against the more dramatic and prolific mobiles and stabiles, but they show a delicacy, elegance and audacity of open-form composition of shapes and space that are reminders to take this good-natured, fun-loving artist seriously. The *Constellations* work brilliantly as reliefs, taking the wall, space and light of a room into their service. The shapes are inventive and surprising, playing with and against planetary references, giving the whole an unsteady scale of

reference. The shadow patterns enhance illusions of depth and subvert the solidity of the wall. With no frame, no commitment to or compression between frontal and back planes, these spidery compositions imply movement in all directions. Vertically, they evoke other realities, cosmic and landscape; horizontally, as in *Red and Blue Personages*, they conjure unknown beings, depending, as Calder once put it, upon what the viewer has in mind.

Freestanding "Reliefs"

In 1934, Calder made his very large *White Frame* motorized mobile, which to all intents and purposes was a freestanding relief. The frame, seven feet, six inches by nine feet, allowed him to suspend his moving elements in space. (*Dancing Torpedo Shape* of 1932, though unframed, had a configuration that makes the sculpture seem to function between two parallel planes and be freestanding.) This planar alignment of shapes, it has been suggested, was an intermediary step in the evolution of Calder's imagery from painting to free movement in space. Calder, as was his custom, did not work in such a logical or predictable way. The much-reproduced photograph of Calder's first major exhibition in Paris at the Galerie Percier in 1931 shows that the spherical freestanding universe series preceded the foregoing works and that Calder did not hesitate to go from planetary paintings into sculpture in the round. Unlike certain pre-World War I sculptors in Germany, interwar artists were not obsessed with problems of making sculpture interesting in the round. Traditional definitions were not inhibiting, and if a sculptor such as Calder wanted to have certain shapes moving simultaneously in space but seen as if revolving on the same plane, there was no hesitancy about whether or not the work would show to advantage from its left and right sides.

For a variety of reasons, Giacometti and Lipchitz had recourse to relief-like compositions in space. What they had in common is, obviously, frontality. In Giacometti's case, his plaques that served for heads or a field with an embedded torso, as well as his *Man* (see figs. 31 and 69), may have resulted from a visionary source, as well as the knowledge of Cycladic idols. We know that between 1925 – 1935, he

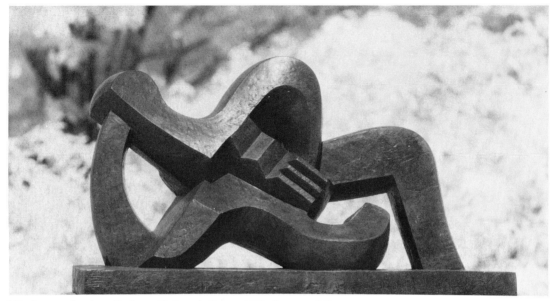

119. Jacques Lipchitz, *Reclining Nude with Guitar*, 1928, [cat. no. 36]

thought out his compositions in advance, and the sharp graphic relief character of *Man* implies that the artist was not inclined to visualize his ideas from all angles. Lipchitz has spoken of certain images done in the twenties, such as the *Harpist*, as having a visionary origin. On the other hand, his *Pierrot Escapes* looks as if it could have come out of a Synthetic Cubist painting. *Ploumanach* came about as the recollection of seeing stones balancing one on top of the other off the Brittany coast. It was not memory alone that accounts for the frontality of this image, for it is possible that Lipchitz had become interested in the power of frontality in primitive art. Lipchitz, as well as Picasso, was very much aware of the taboos of academic art, as when both artists made still lifes the subject of reliefs. They may have felt a kind of perverse incentive to explore, as in *Reclining Nude With Guitar* of 1928 (fig. 119), a work so frontal as to suggest its appropriateness for a relief.

Picasso's *Head* of 1928 (see fig. 61) consists of flat, painted metal sheets held to a ring mounted on a tripod base. It makes sense only from the front and came right out of his drawings. While interesting as an abstract construction from the sides and back, *Woman in a Garden* (see fig. 130) makes thematic sense only from the front. Despite the staggered depth of the flat, cut-out iron planes, the over-

all design looks as if it could have been lifted out of one of the *Artist in His Studio* paintings of the late twenties. Picasso once commented that his ideal of sculpture was that from any angle it should appear *flat*. Picasso's interest at times in achieving the tangibility of sculpture did not convince him to give up the graphic immediacy of a theme to be seen from one point of view.

Arp's transition from his painted reliefs to sculpture in the round, which he had not made since student days, was helped by freestanding reliefs, notably *Handfruit* and *Shell Profiles* of 1930. All that separates these from the 1920 *Birds in an Aquarium* was the use of biomorphic machine-cut shapes placed on their sides to serve as a sculptural base. In 1931, Arp combined two small "figures" in the round with a large, flat key-hole "figure" in a table-top composition, *Figures, One Large and Two Small*, but, thereafter, this combination was seldom used. Arp kept open his option of an essentially two-sided sculpture.

It is likely that Barbara Hepworth shared Henry Moore's aversion to reliefs in the interwar period on the grounds that this medium did not permit the full realization of sculpture's power. In 1936, however, Hepworth carved in stone her now lost, monumental stela, entitled simply *Sculpture* (fig. 120) a large freestanding relief that looks as one would imagine a free-

120

standing relief by Nicholson to have appeared. Less elegant than the work of her husband, Hepworth's form in photographs seems more rugged. She felt compelled to use a large, curving form to lock the vertical planes in place, giving the whole the appearance of a primitive device for bolting a door. Despite its destruction, the piece was fruitful for some of Hepworth's postwar outdoor monumental works.

Only briefly summarized here, the whole question of this interwar phenomenon of what we are calling freestanding relief sculpture in European art merits further inquiry. Suffice it to say that this genre, temporally both old and new, was an interesting option for artists whose imaginations trespassed posted limits for painters and sculptors.

Summary

The ancient purpose of sculptural relief to mediate between sculpture, painting and architecture continued, at least in theory, during the period 1918 – 1945, although with surprising variations. To the Constructivists, Schlemmer and Nicholson, reliefs symbolized the hoped-for reunification of the arts, but in the minds of Arp and Picasso, the relief was a self-sufficient unity that, if anything, signified the irreconcilability of sculpture and architecture. For idealists such as Gabo and Pevsner, reliefs were models for a brave new world in which art and science were in fraternal alliance, whereas Arp's reliefs were viewed by him as "monstrous home furnishing for practical-minded bourgeois." What destroyed the dream of a fusion of reliefs with architecture was the conviction of modern architects that they had already achieved in form what sculpture aspired to. On the practical level of economics, there were few commissions for the artists in this chapter. Tatlin, Schwitters and Brancusi achieved the perfect marriage by designing their own architecture.

For Matisse, Picasso and Manzù, the tradition of the modeled relief was not exhausted, but susceptible to new possibilities. These involved various twentieth century notions of what monumental decorative form would look like as a result of stricter unities between figure and ground, unified surface texture, freer modeling and "drawing" of profiles, or work with new optical effects based on inverting concave-convex relationships. Their audacities came about as a result of modernism's assertive building of the relief forward, from the back plane into the viewer's space, or creating an ambiguous relationship between the motif and the back plane.

Cubist collage put a large crack in the barrier that separated painting and relief, and interwar artists poured through the breach. Whether for artists who worked with the figure or abstractly, in collage or assemblage, the relief was a viable way to go beyond painting, to become more involved with tangible form that reacted to actual rather than painting's depicted light. With reliefs, painters did not have to become full-time sculptors. Reliefs allowed painters to get from surface to space while continuing to work with imagery that was to be seen at eye level. In principle, reliefs were now no longer restricted to the confines of either an implied surface plane (which made the relief a kind of sandwich, as in Maillol) or a prescribed rectangular frame. Schwitters showed how they were extensible until they took over walls, ceiling and most of the floor in his *Merzbau*. Calder's *Constellations* seem to climb like spiders, and he used the wall to suggest deep space. Arp, Pevsner and Gabo employed monochromatic support planes to evoke infinite depth. Reliefs could enjoy a double life, on tabletops, where they resembled architectural models, as well as on walls, where they competed with paintings. New industrial or old vernacular materials, non-descriptive and monochromatic color, the continuity of space inside and outside the relief as well as abstract form, all give a pioneering, modern imprint to work done in relief prior to World War II.

120. Barbara Hepworth, *Sculpture*, 1936.

5. Monuments and the Monumental in Modern Interwar Sculpture

Rare was the modern sculptor between the two wars who did not dream of what Lipchitz called "monumental expression" in sculpture. Lipchitz himself, however, was a rarity among the leading sculptors, for he actually realized a few works in a large size, such as the *Joie de Vivre* and *Prometheus Strangling the Vulture* (see figs. 20 and 136), one sponsored by a wealthy private patron and the other by the French government. As others have observed, much of abstract sculpture is really a proposal for monumental treatment. Despite the lack of opportunities for big works, the study of scale or the spiritual size of sculpture, as Henry Moore defines it, was as important as that of shape and space and went with the pervasive re-examination of the elements of sculpture. What may have encouraged dreams of monumentality was the modern imperative to achieve conceptual largeness of form, largeness in an aesthetic and not physical sense. Academic admonitions to simplify details of the figure as it was increased in size were surpassed by emphasis on the relation of the total configuration to detail. The works of Brancusi and Henry Moore, while for the most part small in size, are large in scale. Moore liked to cite the Albert Memorial in London's Hyde Park as an example of a compostion of great size that did not achieve true scale because it did not add up to more than its accumulated and distracting detail.

Following World War I, it was not the modern sculptors who received the commissions to commemorate the dead on the battlefields and in the military cemeteries of Europe. These assignments went to conservative sculptors, like Bourdelle, who accepted conventional symbols of heroism in styles which modernists felt were sterile falsifications of experience and consciousness. Two of the most moving sculptures associated with World War I were made by Lehmbrück, who suffered through the death of his generation. After the artist's suicide in 1919, *Seated Youth* (fig. 121) became a

monument in a German military cemetery. *The Fallen* of 1915–1916 which was appropriately intended as a war memorial, stands in the artist's museum in Duisburg. Both works are exemplary of the modern phenomenon, begun with Rodin, of the pathetic hero. Their attenuated bodies, slack and broken, bear the burden of Lehmbrück's disillusion. Their intimate relation to the sculptor-poet was expressed by Reinhold Heller, who wrote that "Lehmbrück's *Fallen Man* is a dying genius and the *Seated Youth* is the despairing artist."[1] These personal memorials are in both theme and form the artist expressing himself in the first person.

It was left to Lehmbrück's older countryman and one of the pioneering modern sculptors, Ernst Barlach, to realize fitting memorials to the dead of World War I. Thanks to a few enlightened churchmen, in 1927 Barlach was given the "sacred room" he had dreamed of in the Cathedral of Güstrow. Until that time, as he put it, he "lacked the great opportunities." For years he had also thought of releasing his figures from the ground, which was possible only in reliefs where he sometimes showed a figure floating above those who dreamed. The Güstrow commission gave him the opportunity to suspend horizontally from the ceiling of a chapel his large bronze *Angel of Death* (fig. 122). Having never seen an angel, as Barlach would have said, he invented his own wingless being. Arms folded across the breast, eyes closed, the angel floats above the symbolic tombs of the war dead below. He gave the angel the face of his friend the artist Käthe Kollwitz (fig. 123), a pacifist who had used art as a protest against injustice and the war in which she lost her son. Barlach was moved by both her grief and inner strength. Barlach's "modern" vision, his mute offering of peace in death, made church officials uncomfortable, and it was easy prey for the Nazis, who melted it down, presumably for weapons.

Even more controversial was Barlach's Mag-

121. Wilhelm Lehmbrück, *Seated Youth*, 1917.

deburg memorial to the dead of the Great War, in which he showed two rows of grim figures, frontally carved (fig. 124). The standing soldiers frame a cross, on which are the dates of the war's duration, while below two figures, perhaps of a grieving mother and a father, or an old man suffering the agony of being gassed, flank a helmeted skeleton. The figure of the mother is like a medieval *pleurante*, a mourner whose face is concealed by a cowl that descends to her clenched hands. Like Rodin at the reception of his *Burghers of Calais* in 1895, Barlach knew the disappointment of a public that expected a more traditional and heroic monument of defiance in defeat rather than one that proclaimed citizen-warriors as victims. Barlach responded, "The long and the short of all this is that you want victory monu-

ments, surreptitiously if it can't be done openly and directly, sops to your vanity which can't help the dead . . . It begins with underestimating others and ends with self-delusion."[2] A deeply compassionate but also pessimistic man, Barlach could not accept false symbols or a Christianity that did not re-examine the need to change artistic expressions of belief. In his memorials to his age, Barlach offered a sincere and blunt image of the tragic side of humanity, a pessimism confirmed by the fate of the Magdeburg memorial and the artist himself at the hands of the Nazis.

A third sculptor to come from the German Expressionist movement was Rudolf Belling. Where Lehmbrück and Barlach sought to memorialize the human cost of Germany's defeat in the war, Belling sought to express the

123

122. Ernst Barlach, *The Güstrow Memorial*, 1927, recast after World War II.

perils of postwar liberty, the unimaginable violence that came with founding a new republic on the ashes of the war and the Treaty of Versailles. Behind Belling's proposal for a monument, titled *Gesture of Freedom* (fig. 125), were the bloody counter-revolutions, political murders and instability of the government that shocked Germany in 1919 and 1920.[3] Known to us only in photographs, Belling's image was a warning that in the hands of fanatics, freedom could destroy itself. The sculpture grew out of his Expressionist sympathies for violent emotion, as well as exposure to Archipenko and Cubism which encouraged him to attempt a synthesis of the figure, space and abstraction. During the war, Belling, self-taught as a sculptor, had modeled simplified, gesticulating, wounded figures, whose configurations and movements are remembered in this monument. Belling's barbed forms burst

out of a symbolic spear-framed enclosure, which, though thematically poignant, trivializes the overall sculptural form. The explosive nucleus of the monument is comprised of two fictive forms with spiked, club-like heads, grappling with each other even as they escaped. The monument remains touching in its timeliness, but Belling's limited talents betrayed his ambition.

The aversion of most modern sculptors to monuments in this period was rooted in a distrust of nationalism, which many felt was, in Raymond Sontag's words, "an illusion encouraged by the ruling class; the ruling class profited from preparation for war and from war itself."[4] Like patriotism, the monument had been stigmatized because of its extravagant usage and debasement by the middle class, especially in France. The cult of individuality was attacked by those interested in a classless society for the future. The Russian writer Ilya Ehrenburg expressed views held both inside and outside of postrevolutionary Russia when he wrote, ". . .the personal is dying out, a monument should represent the age, the movement and not any man."[5] Even before 1914, Duchamp-Villon had voiced the view that there were no more heroes worth celebrating. To Arp, monuments to public figures and even public statuary of such innocuous subjects as mythological figures and nudes were "sanctioned lunacy." He wrote:

> No sooner is a building, a monument completed than it begins to decay, fall apart, decompose, crumble. . . . And the buzzing of man does not last much longer than the buzzing of the fly. . . .[6] these naked men, women and children in stone or bronze, exhibited in public squares, gardens and forest clearings, who untiringly dance, chase butterflies, shoot arrows, hold out apples, blow the flute, are the perfect expression of a mad world.[7]

In 1955, Arp wrote of his mock monuments, "The figures of this visible world, which surrounded me and from time to time forced me to erect monuments to neckties, navels, torsos, moustaches, and dolls, formed a bond with my poetry and my friends, the surrealist poets."[8] Although we do not find actual expressions of the idea, perhaps the monument's association with the past and death caused its rejection by artists such as Arp, who sought to celebrate only their optimism about life.

Yet tradition has an amazing survival rate against the slings and arrows of outraged modernists. While the socle and the inscription of *res gestae* or "noble deeds" were rejected along with frock-coated statesmen, bankers and aproned surgeons, the traditional purposes of the monument—to unite the community, give society a self-image, edify by manifesting a commonly held ideal, or be a rallying point for beliefs—still had strong appeal to many modern sculptors and writers. This survival through transformation was important in post-revolutionary Russia; of the numerous plaster statues of revolutionary heroes erected in public, however, we lack both photographs and any record of authorship.

Tatlin's Tower[9]

For sheer intellectual audacity, Tatlin's project for a *Monument to the Third Communist International* still ranks with the wonders of modern art (fig. 126). That the Commissar of Public Education, Lunacharsky, would choose a painter-sculptor without engineering or architectural experience to carry out this assignment is a fascinating part of a story still to be written in full. The two men shared similar ideals of a proletarian culture and the need to unify the arts in the service of the masses. Nonetheless, the commissar's confidence in Tatlin must have been unusual. Seemingly on

124. Ernst Barlach, *The Magdeburg Memorial*, 1929.

his own, Tatlin had begun to think about and make a few drawings of his idea in 1919. On September 7, 1920, Lunacharsky allocated 700,000 rubles to Tatlin to model his conception. This was very little in an inflated currency, but precious coin to the new government faced with staggering domestic problems. This sum barely enabled Tatlin and his assistants to construct the six or seven meter high model during November of 1920, in the mosaic workshop of the government's Academy of Arts in Petrograd. Tatlin taught in this school, and his own workshop was called "Studio for Volume, Materials and Construction." When shown for the first time on December 10, the roughly twenty foot high tower of wood, metal fittings and paper stood for a proposed structure 400 meters high to be made of, in the words of an admirer, "iron, glass and revolution." Tatlin's *Tower* was to soar 100 meters above the Eiffel Tower, which after it acquired its radio transmitter and served a "useful" purpose, became the paradigmatic Constructivist structure.

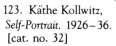

123. Käthe Kollwitz,
Self-Portrait. 1926–36.
[cat. no. 32]

125. Rudolf Belling, *Gesture of Freedom*, 1921.

placed in relation to each other." The spirals are supported by "a series of obliquely placed long thin rods, fitted with horizontal rods placed like rising steps," which carried the spirals upward. From Tatlin's experience with his earlier "*Corner-Reliefs*," as well as the spiral stairway, may have come his ideas of forms held together by tension, in addition to the "stepped" ascension of the spirals. The strut system accorded not only with contemporary engineering practice, but with the interest of Constructivist artists such as Rodchenko in the dynamism of straight lines. Within the external "skeleton" was a tapering conical form, held in place by rings connected to the diagonal girder. Inside the conical area and unattached to it were four vertically staggered geometrical chambers, intended to house various government functions. These chambers were to turn at rates varying from one revolution a year to one a day. The meeting areas were not designed for fixed functions or passive deliberation (there was no place to sit), but rather for "constant agitation." One report of Tatlin's intention had the small spherical chamber destined for the dissemination of news, revolving once a day. To further "inform the proletariat of the world," Tatlin's dream, according to Punin, included sky writing with search lights mounted atop the tower and the projection of movies onto gigantic screens carried by "wings" that could have been added to the tower.[10] Not only did Tatlin want a monument to the Russian Revolution, he wanted his work to inspire creativity; it was his view that the structural logic of a unified art could be derived from the properties of the materials used.

Tatlin's innocence with regard to materials, which he had little chance to study on a large scale, and to the practicality of his design was instantly recognized by such government officials as Lenin and Trotsky. The *Tower* remains as an impressive and imaginative postwar view by a sculptor of what architecture should be. It had to be a form visualized in the round with no sharp distinction between inside and outside. He offered form without mass; with no facade it confronted the world on all sides. It must not show evidence of any architectural history. While it acknowledges a near relative

The original model was later burned in a fire, and the fate of two subsequent versions is not presently known. Along with photographs, recent reconstructions of the first model made in Stockholm and London furnish an idea of its original appearance. Tatlin's conception had to be inspired by Eiffel's tower, its open form systems of struts and girders as well as the arches of the base. The literature on Tatlin is quite right to take lightly the influence on him of Rodin's model for a *Tower of Labor*, a proposed monument in a diagonally spiraling form, and Boccioni's spiraling, unpeeled bottle in space, but it does not mention another possible source much closer to home. It can, in fact, be seen in the workshop where the model was made, in the background of photographs of the model during its December exhibition: the iron spiral staircase.

The main load-bearing elements of the modeled tower consist of a diagonal girder and a pair of spirals, "twisting upward, and dis-

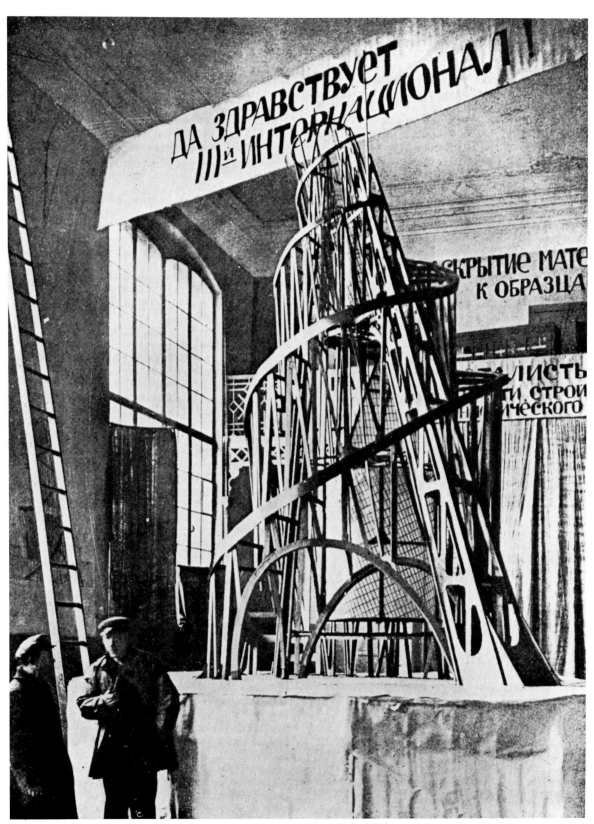

126. Vladimir Tatlin, *Monument to the Third International (model)*, 1919–1920.

in modern engineering, it must have only a future, like the new social order. Having no past and being constantly in movement, the *Tower* was perhaps intended to convey, as well as the Communist revolution, an idea close to Lunacharsky's heart, the triumph of life over death. Tatlin wanted to break new ground by creating a *living* monument. Further advancing its paradigmatic purpose, the *Tower's* form and structure were one. If recent reconstructions are correct and the *Tower* was painted red, Tatlin would have won on the point of uniting painting with sculpture and architecture, but been faulted on his aesthetic of letting the materials speak for themselves.

One of the most interesting and difficult problems he had to resolve was in coordinating the internal geometrical forms, acclaimed as architecture without a memory, with the curving form of the outer skeleton. Perhaps for this reason Tatlin decided to rotate the cylinder, cube, sphere and pyramidal chambers. Without the original it is hard to see if he avoided a confusion of expression. In subsequent models he seems to have altered their number and aligned these internal shapes more vertically. Tatlin was working with interesting visual effects resulting from the interaction of the steel and glass mesh (drawn on paper) of the inner chambers and the pattern of the oblique and vertical struts of the spiral structure. To engage his form more fully in space and time, Tatlin had created a motorized mobile, one whose internal illumination at night must have charged his imagination. At one time he visualized the *Tower* astride the Neva River. Compared to Balla and Depero's 1915 assemblage of a *Futurist Universe*, that Tatlin could not have seen, his conception had greater strength and clarity of design.

To understand the shock the model produced and to appreciate its unrealistic technological demands, one should remember that a small boy had to be concealed inside the model's base to turn a hand crank in order to rotate the core of the piece, which was joined together by ropes and pulleys. When shown in Moscow, most of whose buildings were still of wood, the *Tower* was transported on a horse-drawn cart. Tatlin's attempt to make purely artistic form serve utilitarian purpose on a grandiose scale was a heroic failure. The *Tower* showed more dramatically than his reliefs that he could be a visionary and that he could go beyond Cubism. (Malevich, however, saw the *Tower* as Cubist-inspired.) When exhibited in Paris during a 1925 exposition, if not before, the *Tower* became the symbol of machine art throughout Europe. Its spiral became the logo of modern "dynamism." As Tatlin's fame from this work spread abroad, his prestige within Russia diminished. By those in power his work was credited with being imaginative and interesting, but impractical and a failure in meeting social needs.

Gabo and Pevsner's Proposed Monuments

One of the critics of Tatlin's *Tower* was Naum Gabo, who opposed it as a form of "machine romanticism. . . . It seemed too automatic in machine design. To take forms of the Eiffel Tower on a simple decorative basis was only to begin another academism. . . . I could not follow this path."[11] In rejecting Tatlin's work, Gabo was also renouncing his own designs for a radio station done in 1919–20 that were also based upon the Eiffel Tower. He further argued that what he, Tatlin and others thought was new had been done. He told his colleagues, "Either build functional houses and bridges or create pure art or both." While Gabo would not always be consistent, later designing such architectural projects as a Palace of the Soviets, in the early twenties he conceived of uniting ideas from sculpture and architecture for monuments to modern science. His "towers" seem not to have been intended for habitation and may also have been thought of as monuments. He designed the *Monument for an Observatory* in 1922, and *Monument for an Institute of Physics and Mathematics* in 1925 (fig. 127). Although of small size, the latter has a sense of great scale. It is impressive in its spare beauty and poetic relation to scientific apparatus. In the eighteenth century gifted artisans would decorate scientific instruments such as microscopes to make them tasteful *objets d'art* as well as objects of use for the nobility. Gabo rejected this tradition of applied art, and he instead invented his own sculpture-object, inspired by engineering and what he saw in the laboratories. His sculpture,

although artless by eighteenth century terms and useless for a scientist, has its own elegance to go with its precision and an internal logic for being.

Before the First World War, conventional sculptors sought to memorialize modern flight by creating monuments to fallen aviators or balloonists. These figural compositions, sometimes showing the deceased lying among the wings of his crumpled flying machine, carried the associations, unmistakable to the public at the time, of a fallen Icarus. Antoine Pevsner's 1934 *Construction for an Airport* (fig. 128) epitomizes the modern interwar monument which rejects death or tragic heroism by affirming the inspirational aspect of flight for the creative mind. His thirty inch high model of brass and crystal is a configuration so motivated, thrusting upward from a narrow base and literally spreading out in rhythmic sequences to evoke soaring. Sustained inspection of the piece dissipates momentary associations with the tail assembly of an airplane, and the form assumes its own identity as a kind of strange, winged being. The requirements of symmetry in aeronautical design may not have been lost on Pevsner and sustained him in the violation of one of Western sculpture's taboos.

Pevsner's 1937 *Construction for an Airport*, made of bronze, tin and oxidized brass, joins curving solid and linear planes and evokes the ribbed structures of airplane wings of the time and the graceful curvatures of flight, from takeoff to descent. Space-age sculpture, as exemplified by Pevsner's work, was far in advance of airport architecture, and it is a mark of their growth that these two brothers, Naum and Antoine, did not have to cite architecture as their paradigm after about 1930.

Picasso's Monuments to a Poet

During or shortly before 1928, Picasso was approached by a committee, appointed by the City of Paris, to create a monument to the memory of his late friend the poet and critic Guillaume Apollinaire.[12] His response was to present to the committee at a date not recorded three sculptures, two of which were from his series, *Construction in Wire*, of 1928 (fig. 129). The third was the *Woman in a Garden* (fig. 130), done in 1929 or 1930. Neither these nor

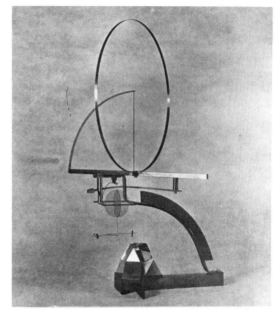

127. Naum Gabo, *Monument for an Institute of Physics and Mathematics*, 1925.

any subsequent proposals were accepted until after World War II, when the committee did accept Picasso's bronze portrait of Dora Maar, done in 1941. It was set up on a pedestal with a dedication to Apollinaire in the small park adjacent to the church of St. Germain-des-Près in Paris.[13] The commission came at about the time Picasso was making drawings and paintings for two lines of colossal figural sculptures to go along the coast at Cannes, a project for monumental sculpture without a monument. Picasso saw no problem in accepting a commission that was unprecedented for him, but the dilemma of the commissioners was that the artist steadfastly insisted upon realizing the monument on his own terms, right to the end of negotiations lasting more than two decades.

It is not clear which of the *Construction in Wire* series constituted the proposals, nor is it a matter of record why Picasso felt his three early proposals were appropriate. Withers argues we should read the early proposals in terms of a statement made by Picasso to the commissioners after 1945 and recorded in Françoise Gilot's book, ". . .I'm going to do something that corresponds to the monument described in [Apollinaire's] *Le Poète assassiné*: that is, a space with a void, of a certain height, covered

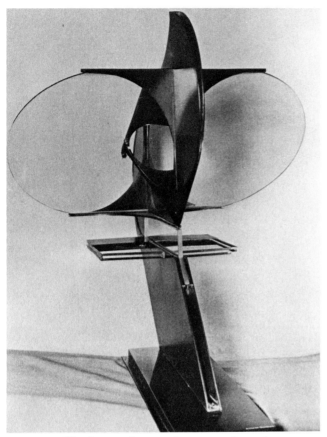

128. Antoine Pevsner, *Construction for an Airport*, 1934.

with a stone."[14] The syntax of this statement, however, does not argue a retrospective view, but, on the contrary, it suggests a futuristic approach.[15]

The *Construction in Wire* has been seen as Picasso's response to Constructivism or as work engendered by his knowledge of Lipchitz's transparent sculptures from 1927 on.[16] These interpretations are conceivable in the absence of definite source; however, they do not take sufficiently into account earlier developments in Picasso's art, specifically his drawings of the twenties which start with imaginative perspective studies and a 1927 series of abstract and still life drawings which were later transposed into woodcuts by Aubert as part of the illustrations for Balzac's *Chef d'Oeuvre Inconnu*. In these and other drawings leading up to the actual constructions in heavy wire or rods, Picasso establishes a series of nodes which are then connected by straight lines. The *Chef d'Oeuvre* drawings, both abstracts and still

lifes, are like the old constellation figures in which the relevant stars are connected on a chart by straight lines to form various entities. (Gonzalez spoke about how, in open-form sculpture, the eye should join together "countless number of points in the infinite."[17] The *Constructions in Wire* may be read abstractly or, in the case of the work illustrated, as interpreted by Rosalind Krauss, as a charioteer.[18] Picasso animated all of the series by placing at the highest point a disk, which bore three circular indentations, signifying a human head. Picasso was reluctant to make purely abstract works; his natural inclination was to animate, to create unknown beings out of elements that are familiar but not always apparent. Apollinaire created whimsical characters in his poems, which Picasso may have felt were a connecting link with his sculptures. At one point it appeared that Picasso thought of using these wire scaffolds as armatures for metal plates, which would have further connected these conceptions to paintings of the late twenties, such as the *Studio* series, with their black linear armatures holding colored planes in place.

Picasso vainly hoped that his sculpture would be accepted and set in the garden near Apollinaire's house. His special involvement in the monument was told by Gonzalez: "This work is made with so much love and tenderness in the memory of his dear friend, at the moment he doesn't want to be separated from it, or to think of its being at Père Lachaise in that collection of monuments where people seldom go."[19] That this assemblage of scrap should have been invested with such feeling is not inconsistent with Picasso's Cubist painting of Eva Humbert, *Ma Jolie*, in which, as Kahnweiler wrote to this author, Picasso "inscribed his love."[20] Conceivably, we have not looked closely enough at the *Woman in the Garden* to see how Picasso's feelings were conveyed.

Picasso's *Woman* is identifiable and separable from the garden only by the head with its open mouth, darting tongue, fashioned of nails like the irises in the enlarged eye, and streaming hair. The whole distressed image of the head is augmented by a tall, neck-like shaft, which it surmounts and is thrust thereby to the highest

point of the composition. This head may be read as that of a screaming woman. It recalls the frenetic agonies and facial contortions of Picasso's painting of 1925, *Three Dancers*, who perform a dance of grief at the death of Ramon Pichot, another close friend of Picasso. This funeral dance takes place in a sedate middle class room presumably overlooking the Mediterranean. It was, thus, no more incongruous for Picasso's disheveled iron *pleurante* to keen among the philodendra. (For years it stood in the tall weeds outside Picasso's house at Boisgeloup; Brassaï catching it once mistook it in the headlights of his car for a stag.)

Brancusi's Monument at Tîrgu Jiu

Brancusi was a rarity among interwar modern sculptors, not the least because he was held in great esteem in his native Rumania. It was because of this esteem that a public subscription enabled him to realize his dream of a major outdoor work. The historical research and analysis of Sidney Geist and William Tucker's thoughtful reading have made Brancusi's three-part ensemble at Tîrgu Jiu well known and understood.[21] According to Geist, the project began as a commission from the Women's League of Gorj to a woman sculptor, Militia Patrascu, who had been a student of Brancusi, but who deferred to her former teacher. The original intent of the commissioners was a monument to those who died in the defense of the town of Gorj, invaded by the Germans in 1916. Presumably, Brancusi accepted this specific commission in 1935, but its details and the history of the ensemble's evolution are not fully known. Although no modern sculptor is more identified with the celebration of life than Brancusi, there were precedents early in his art for making monuments to the dead.[22] Rather than suggesting the overblown rhetoric and titanic figures of a Mestrovič or Bourdelle, Brancusi's ensemble shows how he resolved the demands of the commission on his own terms and made it the culmination of his entire art. Rather than orchestrating the grief of the community, Brancusi proposed a joyful, loving, uplifting celebration of existence that observers such as Tucker report still seems incomprehensible to the local inhabitants. Brancusian simplicity presupposes an urban

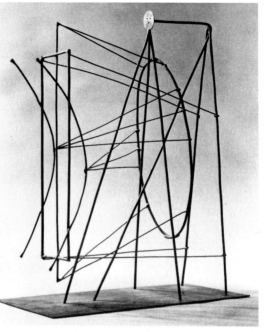

129. Pablo Picasso, *Construction in Wire*, 1928–29.

sophistication more to be found in Paris than Tîrgu Jiu.

The three elements of the complex: the table (fig. 131), the gate and the column, all on axis, are widely dispersed in a space about three-quarters of a mile long. It is an arrangement that Geist argues convincingly Brancusi may have adapted from the axial sequence of the Carousel Arch west of the Louvre, a large circular floral design in the Tuileries and the obelisk in the Place de la Concorde.[23] As one moves from the table through the gate to the column, there is a progression of altitudes in the works that makes the *Endless Column* the physical climax. The whole speaks of unities: fraternal, sexual and spiritual. The table, based on a similar form in the artist's studio, invites social communion. The present uniform spacing of the stools is questionable; and at one time the stools seem to have been paired, an arrangement more appropriate thematically. The table is the element least admired by those who have seen it. In "Object-Sculpture, Base and Assemblage in the Art of Constantin Brancusi," Edith Balas has persuasively claimed not only Brancusi's carved pedestals but also his furniture for sculpture. The stools are bisected spheres with one half inverted and stacked on the other, not

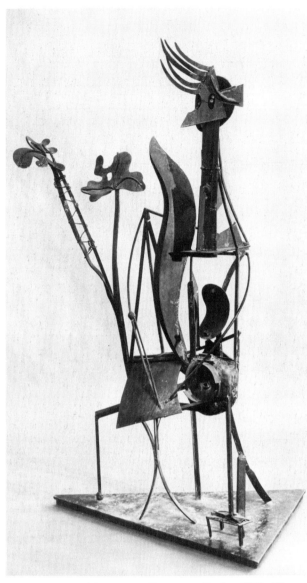

130. Pablo Picasso, *Woman in a Garden*, 1929–30, bronze after a painted iron original.

unlike Bill's sculpture at the time. The table and stools can be looked at as abstract sculpture whose context and relationships evoke human mutuality. Abstract form was to shape and be part of human experience.

If the table was intended to invite sociability and solidarity, "the theme of the Gate," in Geist's incisive phrase, "is love and community, upheld by sexual energy."[24] Geist indicates the freestanding form of the gate (fig. 132) is derived from one of the lateral arched portals of the Carousel Arch in Paris. Its actual appearance, with the repetitive incised motifs above, more resembles in shape if not proportion an Egyptian temple portal, bearing stylized low reliefs of palm forms atop post and lintel. Through reductive thought rather than stylization, Brancusi sustained the motif of *The Kiss* both in the columns and the lintel, giving further equality to the lovers, as Geist points out. Defying the limits of ornament, to which he had reduced what was once a freestanding unique form, Brancusi was making a statement that countered the ancient militaristic tradition of the Roman or Napoleonic triumphal arch: make love, not war. If his ideas were based on Egyptian temple gateways, then there would have been a consonance with the prototypes, which had been known as Gateways to Heaven.

The optimism and taut design of the *Gate of the Kiss* inevitably recalls the pessimism and random anti-architectural ordering of Rodin's *Gates of Hell*, which Brancusi could have studied when he briefly worked for Rodin. Working for the first time on a large scale in relief, Brancusi opted for incising the figures on the ochre-colored travertine of the lintel, while carving more deeply the outlines of the cellular paired eyes and columnar bodies of the lovers. This gave his portal maximal light and shadows that clarified, all resulting in a greater carrying power of the design, but not its subject. Brancusi's *Gate* is, as Tucker says, a beautiful sculpture. Rodin's *Gates* are an expressive sculpture, a distinction well known to academicians as well as to the two sculptors.

The basic design of *The Endless Column* (fig. 133), as Edith Balas has shown, recalls the Rumanian wood carving found in Brancusi's native region on gateposts and, significantly

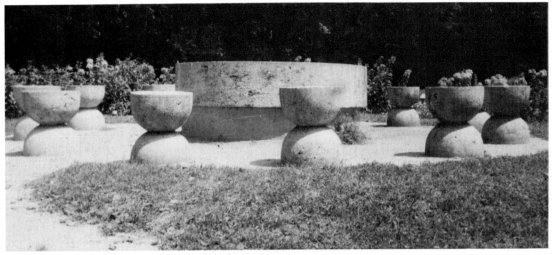

131. Constantin Brancusi, *Table of Silence* at Tîrgu Jiu, 1937–38.

perhaps for this occasion, *grave* posts.[25] The repetition and symmetry, for which Brancusi's columns are so admired by modern sculptors, echo forms of vernacular architecture in his homeland, more dramatic evidence of how, along with tribal art, folk art contributed to uncomplicating Western sculpture while augmenting its symbolic and visual power. The human scale of native Rumanian art and that of Brancusi's art Before Tîrgu Jiu were abandoned for the only time in the artist's life to achieve the inspiring upward flight of *The Endless Column*.

In his keen observance of the sculpture, Tucker points out that:

> *The sculpture starts at eye level*; because of this fundamental principle no two elements can ever be read as exactly identical, and to this fact too the sculpture owes its peculiar presence, appearing to be suspended as if hovering between earth and sky, seeming merely to touch the ground at the base.[26]

As his previous polished surfaces reflected the surroundings of the bronze sculptures, so did the various forms of *The Endless Column* take on meaning from their contexts, as well as their scale. The column had served to support a sculpture in an earlier and shorter manifestation; and it is reported by Geist that the local citizens watching the erection of the fifteen iron units on the central bronze shaft waited to see what would go on top. Given the column's origin in Rumanian grave posts as well as the Egyptian obelisk, an ancient symbol of life, it

may have been that Brancusi was evoking the soul's flight to heaven. At Tîrgu Jiu, the original bronze-sprayed column would have glistened more in the light, giving luster to the poetic linkage of heaven and earth. *The Endless Column*, rather than leading nowhere, is a dramatic manifestation of the interwar credo of "only unify."

Postscript

The primary inhibiting factor in the accomplishment of monumental sculpture in addition to economics was the awareness of sculptors in the thirties that the public did not comprehend what they were doing and that

132. Constantin Brancusi, *Gate of the Kiss* at Tîrgu Jiu, 1938.

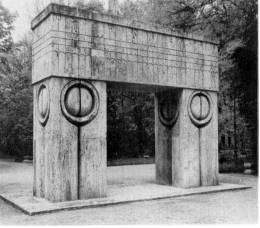

modern sculpture seemed too personal for public spaces. That so many interwar artists such as Gabo, Pevsner, Picasso, Moore, Hepworth, and Arp were able after 1945 to create for public spaces monumental sculptures that were not monuments in the traditional sense testifies to the artists' power to impose their vision on multi-national corporations, federal and municipal governments, universities and banks. Also responsible was the greater sophistication of the public and corporate patrons, as well as their recognition of the durability and quality of these artists and how modern sculpture can serve civic pride and the corporate image. Modern sculpture became Establishment art by 1960.

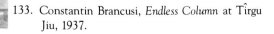

133. Constantin Brancusi, *Endless Column* at Tîrgu Jiu, 1937.

6. The Sculptors' Response to Fascism

Irving Howe, in "The Idea of the Modern," describes one imperative of the modern avant-garde ("a small principled minority in opposition to established values and modes of composition . . .") as "the heroism of patience." For Howe this means that the artist accepts the "confinements of the avant-garde" and does not try to "re-enter the arena of history" by succumbing to the "glamor of ideology or party machines."[1] With few exceptions the leading interwar sculptors either intransigently remained outside history's arena, responding to the rise of Fascism, for example, by ignoring it, or else made limited forays into topical subject matter by means of myth or allegory. They always guarded their flanks by holding to previously developed ideals of form. Until war actually broke out in Spain in 1937, and Europe as a whole in 1939, most modern artists, like other intellectuals, maintained, in Einstein's words, a position "immune from nationalist bias." (During World War I, Einstein had worked on the perfection of his theory of relativity while "ignoring the news from the battlefront.")[2]

Sculptors and painters insulated themselves against political events and the appeal of *"La Patrie."* They had been disillusioned by seeing the work of their predecessors and contemporaries used as a public relations arm of government. Those who were politically non-engaged felt that they had to preserve creative freedom; their greatest contribution would be the revitalization of culture and, thereby, humanity at large. The avant-garde that had been engaged politically in communist countries suffered disillusion, by 1922 in Russia and by 1934 in Poland.

For an artist committed, as Arp put it, to "dreams and freedom," any alliance with political ideologies was inimical to art's purpose. In his collection of essays, *On My Way,* in an undated entry presumably from the thirties, Arp wrote:

Some old friends from the days of the Dada campaign, who always fought for dreams and freedom, are now disgustingly preoccupied with class aims and busy making over the Hegelian dialectic into a hurdygurdy tune. Conscientiously they mix poetry and the Five Year Plan in one pot; but this attempt to lie down while standing up will not succeed. Man will not allow himself to be turned into a scrubbed hygienic numeral, which, in its enthusiasm over a certain portrait, shouts yes like a hypnotized donkey. Man will not permit himself to be standardized. It is hard to explain how the greatest individualists can come out for a termite state I cannot imagine my old friends in a collective Russian ballet.[3]

We can gain a sense of the prevailing apolitical position of some members of the German avant-garde from Oskar Schlemmer's ardent appeal to Joseph Goebbels on April 25, 1933, against the Nazis' confiscation of modern art and its display in exhibitions intended to show its degeneracy:

Please allow me to direct your attention to the period before the war, to the years between 1910 and 1914, when simultaneously all the artistically vital countries like Germany, Russia and France, experienced a spontaneous revolution of consciousness in the arts; the works which grew out of this revolution could not possibly have anything to do with Russian Communism or with Marxism, because these concepts did not yet exist!

It was a period in which the windows of the musty chambers of art were opened wide, when the doors suddenly stood ajar, and the artists were caught up in a delirium of enthusiasm for the new spirit they sensed being born.

It was in this enraptured mood that we young academy students were surprised by the war. We marched off to battle filled with genuine enthusiasm for a noble cause, for the ideals of art! In the name of my fallen comrades I protest against the defamation of their goals.

These days pictures by both living and deceased modern painters are being systematically defamed! They have been branded alien, un-German, unworthy and unnatural. The political motives ascribed to them are in most cases totally inappropriate. Artists are fundamentally unpolitical and must be so, for their kingdom is not of this world. It is always humanity with which they are concerned, always the totality of human existence to which they must pay allegiance.[4]

Shortly after writing this letter, Schlemmer was dismissed from his teaching position and until his death could not support his family working as an artist.

Naum Gabo, probably responding to pressures within the English community to become politically engaged, defended his refusal to deal directly with the evils and horror of war in an eloquent letter to Herbert Read in 1944:

> A world at war, it seems to me, may have the right to reject my work as irrelevant to its immediate needs. I can say but little in my defense. I can only beg to be believed that I suffer with the world in all the misfortunes which are now befallen upon us. Day and night I carry the horror and pain of the human race with me. Will I be allowed to ask the leaders of the masses engaged in a mortal struggle of sheer survival: . . . "Must I, ought I, to keep and carry this horror through my art to the people?"—the people in the burned cities and scorched villages, the people in the trenches, people in the ashes of their homes, the blinded shadows of human beings from the ruins and gibbets of devastated continents . . . What can I tell them about pain and horror that they do not know? . . . The venom of hate has become our daily bread and only nurture. Am I to be blamed when I confess that I cannot find inspiration for my art in that stage of death and desolation. I am offering in my way what comfort I can to alleviate the pains and convulsions of our time. . . . I try to guard in my work the image of the morrow we left behind us in our memories and foregone aspirations and to remind us that the image of the world can be different.[5]

To the end of his life, Gabo belonged to a generation that believed optimistically in "constructive man" as the epitome of civilization and in sculpture's mission to provide humanity with models of harmony which would evoke profound spiritual joy. This ardent Constructivist could never bring himself to interpret destruction of any sort. In this he was not alone.

Early in his career, Calder made the political decision to be non-political as an artist, a resolution which may have been influenced by his friendship with Arp and Miró. He was conscious of criticism of his political non-partisanship and affirmed his position: "They call me a 'playboy,' you know. I want to make things that are fun to look at, that have no propaganda value whatsoever."[6] During World War II, however, he gave a benefit performance of his Circus to help France and did therapy with wounded American soldiers by showing them how to make amusing things out of scrap material or by making caricatures of those who would pose for him.

By contrast with Calder, Gabo and many other leading sculptors of this period, the Italian artist Giacomo Manzù lived and worked at great peril under Fascism, narrowly escaping imprisonment and possibly death on one occasion.[7] Manzù was an artist normally given to steadfast inquiry into the live human figure and aesthetic subjects. In 1938–39, however, he broke off his work on figural sculptures and portraits in Milan and returned to his home city of Bergamo where he produced a series of eight reliefs that began a second life for his art.[8] These reliefs apparently grew out of a personal crisis in which the artist debated how long he could remove his art from the prevailing human tragedies and sought an appropriate artistic form for his thoughts and feelings about inhumanity. Would he use his art to protest against Fascism or to articulate a complex condition with which mankind has lived throughout its history of ongoing victimization when, however, the identity of the villains is not always clear?

The title of his brilliant relief series, Christ in Our Humanity (fig. 134), helps us to understand their somewhat enigmatic character. Although not conceived as a narrative in eight episodes, each relief is a variation on the theme of a crucified man attended by witnesses and a guard or executioner. Without a commentary from the artist, the reliefs appear to come from his meditations on the death of a man who, for reasons unknown, was condemned and put to death by judges and executioners whose identity is likewise unknown. Manzù was both a Catholic and a sympathizer with the Communists in their reaction against Fascism in Italy; he once characterized himself as simply anti-Fascist. Many of his friends were imprisoned or killed under Mussolini, whose rule and violation of human rights was not opposed by the Vatican. If Manzù's reliefs were intended as an indictment, with the accused not specifically named in the reliefs, perhaps it is because of his justifiable concern with censorship. When the reliefs were shown, they were strongly criticized by Fascists and the Church, which supposedly threatened the sculptor with excommunication.

Another reason for the ambiguity of the theme of the reliefs is that they may have represented deeply personal reflections on history; Manzù was self-educated, not given to theorizing, and had fashioned a pragmatic personal art based on working from life. Perhaps he was communizing the crucifixion of Christ. Like Picasso, whose work he knew in the thirties, Manzù may have taken the position that he was on the side of humanity, all men, and the unjust death of innocence was a perpetual reminder of Christ's sacrifice. The representatives of the Church, the cardinals who appear in the reliefs with the naked victim, who often hangs by ropes from the cross, react variously: a naked cardinal, holding his mitre, stares at a hanging skeleton, another cardinal gently assists in the lowering of the corpse, and another stands mutely or impassively. Reminiscent of Picasso's story-telling, Manzù's imaginative variations on a theme include characters in repertorial groups: children appear as indifferent witnesses; dogs bark at a guard; a naked woman, holding a child, looks at the hanging man; another naked woman, seen from the back, grieves, while her counterpart in still another relief diverts her attention from the victim to a pair of naked men, wrestling on the ground. Do these figures recall Mary Magdalene and the soldiers who fought over Christ's cloak? Occasionally, a corpulent guard-executioner-officer, naked except for a German World War I spiked helmet, attends the dead man but is not shown in the act of brutalizing him. The canonical treatment of Christ's Passion is avoided systematically, but there are passages of the reliefs that evoke it. Was not Manzù, like Picasso, creating a situation and leaving its resolution to the beholder, because he himself was unsure of the outcome?

That the series sprang from an inspired and tormented imagination can be seen in its almost visionary quality. At times the cross is absent, and the hanging figure floats in space. Rather than existing in an illusionistic overall space, the forms, beautifully modeled in low relief, seem to hover just in front of it. Consistent perspective is absent, and there is little or no visual contact between participants. Within each relief, logical narrative gives way to a provocative juxtaposition of character as

134. Giacomo Manzù, *Crucifixion with Soldier and Sorrowful Figures* from "Cristo nella nostra umanità" reliefs, 1942, cast executed in 1957. [cat. no. 40]

the artist represents the different degrees of comprehension, indifference and compassion in his fellow man.

Manzù's fresh investigation of the relief was made possible by his lack of academic training. He abandoned his former style to ground his art on the sight and memory of the living body. Drawing and modeling conjoin. He incised lines as second profiles of a leg or knee, seemingly *after* he had modeled the limb, as in late Michelangelo drawings of the Crucifixion, in order to make the figure seem to move or to contradict the illusionary aspect of the softly modulated surface. Even this "conservative" interwar artist rebelled against fixed categories of media, and his fusion of drawing and modeling helps create the special irrational qualities of his theme, at once traditional and deeply personal, synthesizing history and the present, institutions and individuals, pathos and apathy. The reliefs are modern because they

grew from self-questioning and reflect the artist's *processes* of thought, open to the promptings of the irrational and unexpected. Manzù pursued similar themes in two later series of reliefs, which eventually culminated in doors for the Salzburg Cathedral and St. Peter's, confirming that his work represented private parables on the confrontation of past and present and was not just a reaction to Fascism.

One of the rare works by Giacometti that can in any way be interpreted as a reflection of his concern over the implications of the rise of Fascism is his *No More Play* (fig. 135), which Reinhold Hohl sees as a "death-happening," a combination battlefield and graveyard with despairing figures.[9] Hohl writes, "Historically and biographically speaking, *No More Play* was executed at the time the New York Stock Exchange crash had put an end to the golden twenties on Montparnasse and when socialist revolutionary demands faced Fascist reaction on all fronts. Giacometti joined the battle as only an artist can, at first in the Surrealist camp, later under Aragon's spell." As this finest historian of Giacometti's art also points out, however, *No More Play* is part of a life and death cycle the artist created which reflects a broader view of existence than the time in which the works were made.

To designate clearly and accurately certain works of sculpture as specific responses to *les frères ennemis*, as Communism, Fascism and Nazism were termed by the French historian Elie Halévy, is problematic: there was culture-wide fascination with violence, and art was based in the self. This was the era when Frazer's *The Golden Bough* and the Freudianizing of myth created a fertile subject matter for painting and sculpture. No sculptor better exemplified a positive response to this climate nor created more works that suggest an apocalyptic view than did Jacques Lipchitz.

When Lipchitz made the important decision in the late twenties to make his sculpture responsive to the tragic events in his personal life and to seek more human spiritual qualities in his art, the way was prepared for his return to myth and his artistic response to Fascism. Before he had turned to Cubism with its devotion to aesthetic subject matter, Lipchitz had been a student at the École des Beaux-Arts, where he made sculptures based on mythological themes. These early sculptures, since lost, like *Perseus and Andromeda*, were made according to academic interpretations which were highly impersonal in character. When he returned to myths in the late twenties and 1931, it would take the form of "Freudianizing" myth or personalizing the subject according to his own experiences and needs. Lipchitz always rejected the suggestion that he was influenced by Surrealism. No one was more aware than he that in the hands of conservatives, mythical and religious themes had become clichés. As Robert Goldwater pointed out, Lipchitz not only imparted to his mythological themes a new vigor, but "invested them with an unmistakable contemporary significance." In the best short essay written on this sculptor, Goldwater observed that "without exception they are handled through heavy, modelled forms. But they are also forms in motion ('massive construction broken by fluid movement') — and they are something more. In each there is an energy, an activity emanating from within the figures that paralleling the meaning of the themes they express, overcomes the weight of matter by the determination of the spirit."[10]

In *My Life in Sculpture*, Lipchitz recalled the motivations behind this intermittent series of anti-Fascist works:

During 1931 I made a small sketch of *Prometheus*, a reclining figure with arched back and screaming mouth. There was originally a vulture who was tearing at his liver, but this part of the sculpture disappeared or was destroyed, and I preserved only the figure. This, again, was important to me as one of my earlier uses of a theme from classical mythology to illustrate some of my thoughts about the world, in this case specifically about the intellectuals who were moving into a period of darkness and persecution. I was haunted by the spector of fascism in Germany, and this little piece reflected some of my feeling.[11]

In 1932, when my friend the poet Larrea returned from Peru, he told me a story about fiestas where the feet of a condor are sewn into the back of a bull and they are then let loose in an arena. There results a fantastic and horrible battle until one or both are killed. This story moved me deeply. At the moment when Hitler and the Nazis were in power in Germany, I was entering upon a period of profound depression and I felt that the bull and condor, and particularly the human beings who delighted in their struggle, signified the insane brutality of the world. I made two maquettes of the theme in 1932, as well as a relief in 1933, in all of

which I tried to express the horror and the furious struggle of the event. These are modelled with a passion that reflects my emotions in the face of this frightening conflict. The clay is scarred, undercut and torn, like the bodies of the fighters.[12]

In 1933, Lipchitz did a sculpture titled *Rescue of the Child*, one in his long series of the mother and child motif. The mother holds the child aloft to protect it from attacking serpents, while the father struggles to free them. Lipchitz recalls:

> Although this theme may have something to do with my relationship with my own mother, fundamentally the child is ideally my sculpture. This was a time when, with the spread of fascism, I had a terrible fear that everything I had done would be destroyed. There was undoubtedly a confusion in my mind since my mother was ill at this time and died at the beginning of 1934; but all of these things are somehow related.[13]
>
> During 1933 I designed a series of maquettes on the theme of *David and Goliath* that were specifically related to my hatred of fascism and my conviction that the David of freedom would triumph over the Goliath of oppression.[14]

These sculptures showed David killing Goliath, not with the Biblical sling, but rather by twisting a cord around his enemy's neck in order to garrote him. In 1934, he showed this project in the Salon des Surindépendants and dared to place a swastika on Goliath's chest. "The statue caused me considerable difficulty with German agents who in the guise of art critics began to show intense interest in visiting and examining my studio. However, it remained unharmed in the basement of the Musée de l'art moderne during the entire German occupation."[15]

In 1936, the French government commissioned Lipchitz to make a sculpture for one of the gates to the scientific pavilion at the World's Fair of that year (fig. 136).

> Immediately the idea of Prometheus came to me. . . . The Phrygian cap that I placed on Prometheus had a particular significance for me as a symbol of democracy; what I was trying to show was a pattern of human progress that to me involved the democratic ideal. So, in a certain way, this is a political sculpture, propaganda for democracy.[16]

That same year, Lipchitz made a small sculpture, *Scene of a Civil War*, which showed a woman with a child and a man protecting her, firing a gun at an airplane. This was not one of his more imaginative and artistically successful images, but, as he put it, "I was desperately

135. Alberto Giacometti, *No More Play*, 1933.

disturbed by the Spanish Civil War."[17]

In England many young intellectuals were more than disturbed about the Civil War in Spain and went off to fight for the Loyalist cause. Despite the deep interest in the war among those with whom Henry Moore and Barbara Hepworth were in contact, these artists for various reasons could offer but modest artistic expressions of their support of the Loyalists. Lost in the Second World War was Hepworth's seventy inch high project done in 1938 for a monument for the Spanish War that consisted of five forms in plane wood (fig. 137). The meaning of her "family" of forms in this project is not apparent. Like Gabo, she could not bring herself to depict directly death and destruction, and although it is abstract, she may have believed that by working directly in the final material she could evoke her thought.

In the late thirties Henry Moore lived in Hampstead among many progressive and anti-Fascist artists and writers, some of whom were refugees from Fascism and Communism. In 1932, their discussions had focused on artistic problems such as the relative merits of abstraction and Surrealism. By the time of the Spanish Civil War, when some refugees from Nazi Germany had arrived, their attention turned to political subjects. Moore's able biographer, Donald Hall, records:

> Moore considered taking time from his sculpture to devote to politics, but, like most progressives, he found it difficult to act. He was a member of a group that planned to go to Spain during the civil war—a group

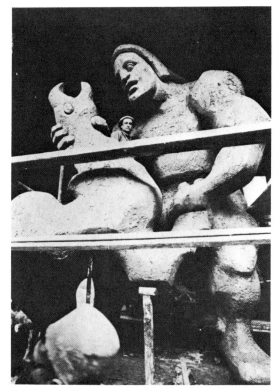

136. Jacques Lipchitz in Paris in 1937 with the clay model of his *Prometheus Strangling the Vulture*.

137. Barbara Hepworth, *Monument to the Spanish War*, 1938–39.

that included W. H. Auden and Stephen Spender. The trip was planned as a propaganda device, its ostensible purpose being to investigate Republican care of Spanish art works. But when the group approached Parliament for permission to make the trip, it was refused. Moore's politics were then—as they are now—inherited, untheoretical English working-class Labour party.[18]

In 1939, Moore made a lithograph titled *Spanish Prisoner* (fig. 138), based on four drawings.[19] The print appeared in a limited edition, which was to be sold to raise funds for defeated Spanish Republican soldiers interned in France. The drawings were inspired by ideas for a figure sculpture, and the one used for the lithograph focused just on the hooded, hollow form of a head in front of which were bars. (It was, thus, related to the *Helmet* series.) In comparison with Lipchitz, Moore's concerns about impending war and Fascism seem to have less demonstrably penetrated his art. One can observe in his drawings more aggressive, pointed shapes, based on shells, and his *Helmet* theme emerges first in drawings of 1930. To the extent that the world "sinister" may be applied to Moore's art, it is in these dark drawings and

small sculptures in metal that one finds a somewhat cage-like figure and the theme of penetration.

When air raids began in London, "the war from being an awful worry became [for me] a real experience." A surprising thing happened, as Moore recalls, "Quite against what I expected, I found myself strangely excited by the bombed buildings, but more still by the unbelievable scenes and life of the underground shelters." In the bomb-hollowed structures and subway refuges, "I saw hundreds of Henry Moore reclining figures stretched along the platforms. I was fascinated, visually. I went back again and again."[20]

Moore's *Shelter Drawings*, which went far to change popular opinion about his work and to establish his reputation with the British public, were a rare opportunity for an avant-garde artist to involve himself directly with life around him and to have an interested national audience as well as government support. Moore has said, "It's from that moment that I didn't need to teach for a living." The drawings and his experiences with their subjects meant many

things to Moore, and one of them was his rediscovery of the draped human form and the recognition of how much he had been touched by his earlier exposure to Italian Renaissance art. In 1943, when he reluctantly and for the only time in his life accepted a commission with a specific subject from the Canon of the Church of St. Matthew's in Northampton, it was partly out of a sense of contributing to the war effort and doing something for the public and also to take up the challenge of religious art, which he saw as having fallen into affected and sentimental prettiness. The resulting subdued style (fig. 139) was undoubtedly dictated by a self-consciousness about the need for the work to be legible and acceptable to the congregation. Intellectually, the challenge was to find

> . . . in what ways a "Madonna and Child" differs from a carving of just a Mother and Child—that is . . . how in my opinion religious art differs from secular art. . . . The "Madonna and Child" should have an austerity and a nobility, and some touch of grandeur. . . . I have tried to give a sense of complete easiness and repose, as though the Madonna could stay in that position forever. . . .[21]

The final work grew out of his earlier themes of maternity, and his first carved drapery was inspired by the *Shelter Drawings.* Perhaps as part of his concern for its reception, but also perhaps because of the more representational mode, Moore makes maternal tenderness more explicit than in his previous work. Although in retrospect Moore does not consider the work one of his finest artistic achievements, and despite its more objective discipline or restraint, it was important for breaking down certain self-imposed restrictions with regard to the treatment of drapery. The sculptor admitted what he considers the Mediterranean tradition of an art (more humane than that of tribal cultures) into active partnership with what he had previously synthesized in his sculpture. Looking at the end of the interwar period, it is interesting that four great sculptors, Moore, Gonzalez, Lipchitz and Picasso, used similar parental motifs to achieve for themselves and mankind what might be called humanistically comforting images.

Although more deeply touched by the Civil War in his own country than Moore, the Spaniard Gonzalez also had to come to terms

138. Henry Moore, *Spanish Prisoner,* c. 1939.

with war in ways that were consistent with an art dedicated to transforming iron's historically murderous connotations. The challenge came when he was asked by the Republican government to contribute a sculpture to the 1937 Paris World's Fair. It was hoped the art of Miró, Dali, Picasso and Gonzalez would reverse the public disfavor into which the Spanish Popular Front had fallen. Gonzalez's *Montserrat* (fig. 140) came out of previous maternity images; the occasion demanded intelligibility of form and motif, hence its more representational style. (Picasso is reported to have urged Gonzalez to replace his "too realistic" entry with the more abstract *Woman with a Mirror.*) The simple and majestic forged-iron *Montserrat,* one of the least appreciated modern sculptures of high quality and clarity of thought, is a marvel of execution.[22] The title spoke to Spaniards of the sacred mountain of the Basques; the motif reminded Loyalists that the Church (which backed Franco) had declared the Virgin and Christ Child the patron saints of Catalonia. Gonzalez created a secular symbol of his homeland as well as of the dignity of the people's defiance of death from the air. Like Picasso with *Guernica,* Gonzalez was filled with the theme and subsequently made several explo-

139. Henry Moore, *Madonna and Child*, 1943–44.

sive heads and masks showing the Montserrat woman crying, none of which would have been so effective on the body of the full figure (see fig. 68).

Cactus Man I and *II* of 1938 and 1939 are more enigmatic figures, *Cactus Man I* having been interpreted as a demonic-pulpy-cactus entity and *Cactus Man II* (fig. 141) as a Loyalist soldier gesturing in defiant rage.[23] Their similarity to drawings of *Terribles Personnages*, as the artist called them, and their intrinsic aggressiveness argue that they are the artist's inspired realizations of the malevolent transformation of men in wartime. As effective as the cactus-like nails in evoking strong response were Gonzalez's ragged-edged iron masks and *Torso* of 1936, conjuring images of war-torn faces and bodies.

During the Second World War few sculptors were able to continue working. As a refugee in New York City Lipchitz continued his art, which reflected a mingling of personal and world crises. He made a large number of sculptures and drawings that mirrored his response to the dark years of the war as well as his hopes while in "exile" in the United States. Three major sculptures forever testify to the artist's paradoxical anguish and optimism: *Mother and Child II* (fig. 142), 1941–42, *Benediction I*, 1942, and *The Prayer*, 1943. Regarding the first, Lipchitz later recalled that it "has to do with the Second World War. There is despair involved in the sculpture but also, I feel, a kind of hope and optimism and even a form of aggression."[24] Unlike Moore in his later Northampton *Madonna*, Lipschitz was uninhibited by the need to make any concessions to a congregation. From his subconscious had come the memory of seeing a legless beggar woman on a rainy night during his trip to Russia in 1935: "[She] was singing, her hair all loose and her arms outstretched." The child clinging to the mother's neck has a body that seems to metamorphose into her hair, although the sculptor read the protruding forms seen from the front and below the mother's upraised arms as the child's legs. "For some curious reason, the child's projecting legs and the woman's breasts seem to form themselves into the head of a bull, something that gave a quality of aggressiveness to the sculpture."[25]

Drawings show the work's evolution and the uncontrived origin of this evocative double image. Lipchitz had also conjoined the maternity theme with that of Europa and the bull, and in contemporary small sculptures he showed Europa driving a stake into the bull's chest.

Benediction was the artist's sensuous "lullaby" for Paris during her "sleep" of the German Occupation. Shortly after his flight from Paris, he conceived this highly erotic figure as "a woman who is in a sense playing on a harp which is part of herself."[26] *Benediction* also recalls his Cubist musicians of the twenties who sit or recline and pluck instruments that likewise seem part of themselves. The sculpture was intended as a full figure, but Lipchitz finally decided on the torso, relocating the buttocks on the same side of the body as the breasts. Added to the frontalizing of the feminine sexual features is the phallic shape of the head, making the form bisexual. Lipchitz felt the form was never resolved.

In *Prayer*, inspired by the infamy of the concentration camps, Lipchitz may have come closest to answering his own question of whether it was possible to make a Jewish art. Of this sculpture which grew out of his flowering *Pilgrim* piece, Lipchitz wrote:

> It was done at the most terrible moment of the war; it was a prayer, a Jewish prayer of expiation; you sacrifice the cock which has to take all your sins. In the left hand the man holds a book, in the right hand the cock; the man wears the Jewish prayer shawl. . . . it is Everyman. . . . the figure is completely disemboweled; in the open stomach are heads of goats, and the innocent victim, a lamb. The entire subject is the Jewish people, whom I thought of as the innocent victims in this horrible war.[27]

These moving works transmit the sculptor's deeply felt empathy and complex feelings of guilt, despair and hope. His largest work until then, made directly in wax, *Prayer* strained the artist's technical competence as well and, as he put it, caused him "terrible suffering" through the forming and casting process. The extreme contrast in mode between *Prayer* and *Benediction* testifies to the still developing range of the sculptor's voice, as he began a new life in this country.

Contributing to Henri Laurens's reputation among his countrymen as one of France's

140. Julio Gonzalez, *Montserrat*, 1937.

141. Julio Gonzalez, *Cactus Man II*, 1939, bronze cast executed after iron original. [cat. no. 27]

greatest modern sculptors is that he remained and worked in Paris during the Occupation from 1939 to 1944. Even in peacetime, this modest and gentle man found supporting himself and his wife so difficult that he was often obliged to make small terra cottas rather than bronzes for his dealer to sell. Life under the Occupation was even more difficult, and he did not have Picasso's international fame to shield him from possible imprisonment. Like Picasso, he and his work were violently attacked by the French Occupation press, and he could not exhibit. While he was not forbidden to work, Laurens could not bring himself to continue the joyful and serene innocence of his prewar art. Although his humanizing of Cubism by restoring sensual volumes and graceful movement to the human form did not take him as far as Lipchitz in the interpretation of violent myth, Laurens had developed a personal and somewhat mythical or allegorical image of fertility. More animated than their Cubist parents, Laurens's figures could evoke simple states of being and, as he was to discover in 1939, allow the artist to convey in simple terms his response to major contemporary events. His upright seated figure of 1939, titled *The Flag*, carried his hopes for French victory.[28] In 1940, without changing his style, this man, credited by Giacometti with reinventing the figure, transformed its mood. In *The Farewell* (fig. 143), as if enacting the collapse of France, a fulsome nude folds in upon herself. A year later he enlarged this sculpture, which in 1955 would be placed on his grave in the Montparnasse Cemetery. In this, the most moving and pessimistic of all his works done under the Occupation, once buoyant volumes are now deadweights. It recalls Lehmbrück's *Man Flung Down*, which had memorialized the artist's tragic disillusion with Germany's defeat in World War I. *The Farewell* also speaks of the disintegration of the human spirit and perpetual mourning for those killed and imprisoned and the France that once was. *Woman-Flower* of 1942 could just as easily be titled *Frightened Woman*; the spiky, extended fingers that protect her face evoke terror more than vegetative growth. A series of prints on *Les Fusillés* (*The Executed*) and the 1942 illustration of Eluard's *The Last Night* illustrate

episodes of physical violence and terror rare in Laurens's art. As late as 1946, Laurens did *Archangel*, a tormented reclining figure as a model for a monument to his friend Max Jacob, who had died in a concentration camp. During the war his figures of *Morning* kneel with heads bowed and eyes closed, as if unable to wake from a disturbing dream. Only in 1944, with the liberation of Paris and France, does his *Dawn* regain prewar ebullience, and the heads of his figures are again unbowed. Laurens's historians have sought to claim an element of optimism in these figures done in the dark years, based on their continued full-ness of form, but *Farewell*, studied from all sides, shows no defiant spirit. Spirit and com-passion were manifested by the sculptor him-self only in making the work and, like Picasso, in continuing sculpture when there seemed no incentive to do so.

In the same year that Lipchitz was giving form to his heartfelt identification with inno-cent victims of the war and Laurens's *Night* symbolized civilization's darkest hours, Picasso was making his most important figure sculpture, *Man with a Sheep* (fig. 144), that, arguably, portrays the self and society in crisis.[29] Customarily seen as a reworking of the ancient Greek Calf Bearer or the early Christ-ian Good Shepherd and interpreted as a sym-bol of Picasso's hope for mankind during the grimmest days of the war, the sculpture actually betrays Picasso's personal, perverse way of defy-ing the obvious. Unlike its ancient predeces-

142. Jacques Lipchitz, *Mother and Child II*, 1941-45.

145

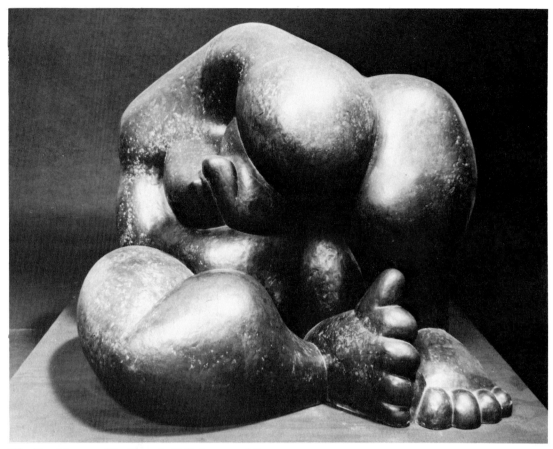

143. Henri Laurens, *The Farewell*, 1940. [cat. no. 34]

sors, Picasso's *Man* gives no indication of what he will do with the struggling sheep, whether he will kill or care for the animal. The work reflects Picasso's own ambivalence toward those he loves, his amorality when it comes to making sacrifices for his art, and his own indecision as to what will be the outcome of a situation that is real or that he has contrived. In the "closed years" of his life during the Occupation of Paris, Picasso came to feel an imperative for a more objective mode of presentation and greater self-discipline. He felt the challenge to keep art alive and to give comfort to all mankind on the "brink of the abyss." His reassurance was to convey a self-knowledge through sculpture, admitting that in crisis, when art and existence are threatened, he would, like mankind, sacrifice innocents, even the women who loved him. The choice of the personalized parable is understandable in view of his close scrutiny by

the Gestapo. Forbidden to exhibit or publish his work, Picasso was also suspected of aiding members of the French Resistance. When Nazi interrogators came to his studio, often insisting that Jacques Lipchitz was living there, they were confronted by *L'Homme au Mouton*, a mute *mouton*, French slang for informer.

No issue so tried the humanity and courage of modern European sculptors as how to respond to Fascism and the Second World War. That there were artists who were numbed into inactivity reminds us of the magnitude and horror of the situation after 1939, suggesting that, for some, their despairing humanity dominated artistic instincts. For others, notably Lipchitz and Picasso, there may have been a curious mingling of psychological responses in which the artists' own aggressive inclinations consciously or unconsciously were identified with those of the military aggressors. One of the values of the art briefly examined in this

section is that it tells us what it felt like to experience Fascism and war as civilians in peril. The artistic as well as thematic violence and anti-nationalism that formed so much of the sculpture and painting of the thirties, while paling before that on the battlefield and in the bombed cities, prepared Lipchitz and Picasso for coping with the challenge.

Measured against the magnitude of the rise of Fascism and World War II, the efforts of sculptors to respond have seemed unworthy of mention by cultural and art historians and seem to be viewed as regressive or failures of nerve.[30] Because there were no radical formal revolutions comparable to those of Cubism and abstraction and because of the artists' recourse to myth, allegory and maternity themes, these works previously discussed are quickly passed over by critics and historians hungry for the portentous.

Until the war turned in favor of the Allies in 1944, both freedom and art appeared to be coming to an end. Yet those artists, notably Picasso, who stayed in Paris after 1939 and continued to work under the eyes of the Gestapo, expressed the deeply felt sense of new and perilous responsibilities toward art and society that the modern artist must assume. Where Picasso, Lipchitz, Gabo and their fellow artists were at their finest was in what Raymond Sontag said of the Irish poet W. B. Yeats: they had "persistent confidence that the spirit of man would prevail over the destructive forces of [their] age."[31] The sculptors may never have read Auden's elegy to Yeats, but many lived the lines:

In the nightmare of the dark
All the dogs of Europe bark
And the living nations wait,
Each sequestered in its hate;

Follow poet, follow right
To the bottom of the night,
With your unconstraining voice
Still persuade us to rejoice;

In the deserts of the heart
Let the healing fountain start
In the prison of his days
Teach the free man how to praise.[32]

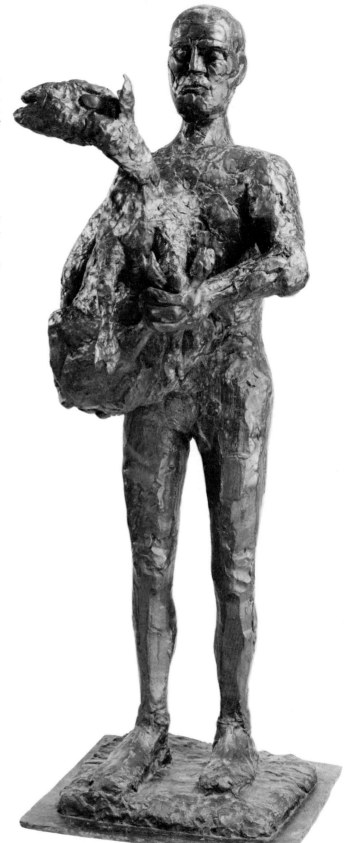

144. Pablo Picasso, *Man with a Sheep*, 1944.
[cat. no. 53]

Postscript: The Artist as Victim and Villain

Fascism, Communism and war took a greater toll on modern artists than did World War I. In 1921, after the defeat of the White Army by the Red Army in Russia, many prerevolutionary academic artists returned to cities like Moscow and were put back into power by the Communist government, which preferred their art to that of the revolutionaries. Pevsner lost his job running a government art school when politicians sided with academic artists, and finding his studio padlocked in 1923, he decided to join his brother in Berlin. Gabo wrote that he did not leave as an exile in 1922:

> I did not go as a refugee. I went away on an open declaration to Lunacharsky that since we are now not any more recognized and there is no possibility either for us to teach or to appear in discussions or even to make exhibitions (which I foresaw would be the case soon), he should give me a permission to leave the country at least temporarily — and that he did.

Both brothers were victims of art politics in their battle with the Productivists, who were favored by Lunacharsky. Gabo also wrote on the fate of other artists who stayed in Russia:

> Malevich was totally deprived of every possibility to teach, even in the provinces . . . he died, completely rejected by the government as well as by his fellow artists then in power. Tatlin . . . was living in an old monastery . . . he was there doing literally nothing. . . . The government succeeded in erasing all traces of the persons and artists who were so active in the first five years of the revolution in Russia.[1]

The monastery to which Gabo referred was in Moscow and placed at Tatlin's disposal by the government to work on his proposal for a glider, which the artist called *Letatlin*. Ironically, in 1933, the glider was exhibited in a special department for Formalism. During 1933, Tatlin experienced severe criticism, and thereafter he returned to traditional painting. He obtained little in the way of commissions for the theater or illustrations and lived from various small jobs, residing in a collective house for artists in Moscow. He died in 1953.

Katarzyna Kobro saw her hopes for a constructive art collapse in the mid-thirties, when the Polish Communist regime, following that of Russia, adopted social realism. Her own work suffered and became less frequent. During the war, she and her husband had to flee, and much of her work was destroyed by the Nazis. Following the war, ill health forced her to cease work, and she died in 1951.

In Germany, Barlach (fig. 145) knew intense persecution and denunciations by the Nazis and lived to see his memorial at Güstrow attacked by the clergy and that at Magdeburg removed by the Nazis. They called Barlach "eastern" and "alien" because of his 1906 trip to Russia and encouraged rumors that he was Jewish and of Slavic descent. He saw his works removed from all German museums and his plays banned, and in 1936, a volume of his drawings was among the two hundred works confiscated by the Nazis. He could no longer exhibit even privately after 1936 and was threatened with a ban on working at all. Barlach refused to emigrate and died of poor health in 1938. His good friend Kollwitz saw her sculpture *Pyramid of Mothers* (fig. 146) removed from an exhibition on the grounds that "in the Third Reich, mothers had no need to defend their children. The State does that for them."[2]

Rudolf Belling was in disfavor with the Nazis not only for the style of his art, but also because he had made many portraits of the leaders of the Weimar Republic. In 1937, the Nazis showed some of his works as decadent and Bolshevik, and many others were removed from exhibition and destroyed. He left Germany for Turkey in 1937 and did not return for thirty years. Moholy-Nagy lost his post at the Bauhaus in 1928 because of political pressures and in 1934 left Germany for good. Because he was overtly anti-Nazi, Hans Bellmer was in great peril. When France was overrun, Bellmer, who had been in Paris, took refuge in southern France and made a meager living by doing portraits of officers of a French Army regiment in Castres. The Vichy police wanted

to turn him over to the Gestapo on the grounds that he was "an idle Jew," but Bellmer took refuge with Resistance forces and did not rejoin his family until after the liberation of France.[3] Schwitters had to flee Hanover for England in 1937 out of fear of imprisonment by the Nazis and then learned of the destruction of his *Merzbau* during an Allied bombing raid in the war. In 1933, Schlemmer lost his post as a government-employed teacher and had to retire with his family to the country. Economic necessity made it impossible to concentrate on his art. Only the sympathy of an industrialist who gave him work in a ceramics factory allowed the artist to support himself. His widow wrote that Schlemmer "felt acutely the discrepancy between his artistic interests and the economic pressures which forced him to sacrifice all that had made life worthwhile to him."[4] He died of poor health in 1943. Freundlich, because he was a Jew and his art had been shown in the infamous 1937 Nazi exhibition of Degenerate Art, with one of his sculptures featured on the catalogue cover, was several times interned during the war and finally, in 1943, arrested in the Pyrenees. He was then deported to Poland to the terrible concentration camp at Lublin, where he died nobly under the most appalling conditions.[5]

The fate of these German artists contrasts with that of three of the many Nazi sculptors, Arno Breker, Josef Thorak and Kurt Schmid-Ehmen, who not only prospered financially by illustrating Hitler's Nordic models of physical culture for government projects (fig. 147) but were exempted from military service. After World War II, it was discovered, however, that Breker had been responsible for saving several French artists from conscription in labor camps. He was subsequently honored by the French government and his work exhibited in a New York City art gallery in 1978. It was a painter and teacher, Adolf Ziegler, president of the Chamber of Art founded by Goebbels, who carried out Hitler's proscription of modern art, directing the organization of the 1937 exhibition of Degenerate Art and removing artists from teaching posts and their art from museums. The artist Georg Kolbe, who had been a leading modern sculptor in Germany

145. Ernst Barlach, 1938.

before 1930, while protesting some Nazi views on art and architecture, did work for Hitler and altered the proportions of his figures to conform to the Führer's Nordic ideals of strength through joy. In the words of Helmut Lehmann-Haupt, "All in all, the Nazis had an easy time in enlisting sculptors for their purposes. They not only found fanatic apostles for their creed among ambitious second-rate talents but they were able to utilize well-established and broadly recognized artists with very little direct pressure."[6]

In France, Laurens, Picasso, Brancusi and Pevsner refused to leave Paris, and all were forbidden to show their art. Laurens and Picasso lived under great tension caused by constant Gestapo surveillance all during the Occupation. Both Pevsner and Laurens lived in seclusion, and the latter, suffering from ill health, found it difficult to work. As he was Rumanian, hence a citizen of an ally of Germany, Brancusi may not have come under the same pressures and scrutiny as Laurens and Picasso, but we lack biographical information on his life during the Occupation. He did

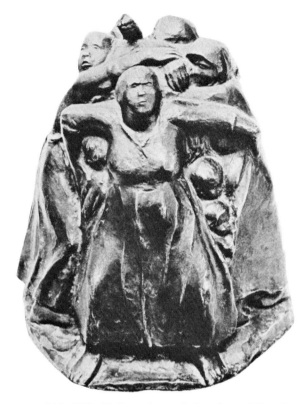

146. Käthe Kollwitz, *Pyramid of Mothers*, 1937–38.

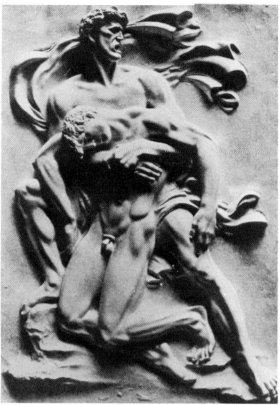

147. Arno Breker, *Comrades*, c. 1939.

continue to refine earlier works, and Geist indicates that Brancusi, "disturbed by the loss of Rumanian territory during the war, . . . carved *Boundary Marker*, calling into service again *The Kiss*. . . ."[7] Geist also interprets the diagonal, "earth-hugging" form of the *Flying Turtle* as representing his thought and the state of his spirit. Picasso defied the ban on metal casting by somehow obtaining the bronze necessary to cast some of his sculptures. Some of the bitterest denunciations of Picasso came from artists who were German sympathizers. He was denounced as a Jew and as a collaborator with the Resistance and was suspected of helping downed Allied flyers to escape. His studio was inspected weekly by the Gestapo, who always announced themselves by asking if his was the studio of Jacques Lipchitz. Lipchitz had fled Paris just before the Occupation, leaving behind all of his art and his library, arriving in New York penniless but safe, thanks to the efforts of Alfred Barr and other American art historians, who were able

to get several artists out of France before its fall. Gonzalez died of a heart attack in 1943, but those who knew him were aware of his fear and despair over what had happened, and some of his friends thought that he died a beaten man. Despite the absence of materials with which to make sculpture, Gonzalez had continued to make some drawings and projected monumental works for the future. Matisse and Arp survived the war by staying in southern France. Maillol spent the war years in Banyuls, near the Spanish border. He died there in 1944, the result of injuries sustained in an automobile accident, but there were rumors afterwards that he had been a collaborator and was killed by the Maquis. After the liberation of Paris, he had not been invited to exhibit in the Salon d'Automne of 1944, unlike Picasso and Laurens, because it was charged that he had exhibited work for the Nazis.

In England, Barbara Hepworth lost several sculptures in the bombing of her studio in Hampstead. Her life in Cornwall during the

war years was very difficult. Moore stopped making sculpture for a few years and instead did his series of shelters and coal miners that brought him national recognition and popularity. In Italy, Manzù experienced constant danger from not only the state, but the Church. In 1941, he had shown his reliefs, *Christ in Our Humanity*, in a Milan gallery, and his friends feared that their subject matter would provoke reprisals. He was branded an enemy of the regime by a Fascist newspaper, and he was labeled an "international Jew." Manzù was also told that the Vatican was considering excommunicating him.[8] In 1944, the Nazis told Manzù to quit his studio. After concealing his work with a friend, he escaped and hid out in Bergamo until the war was over. He was at the Brera Academy to welcome Allied soldiers in 1944. Marini tried to work at the Brera, where he was teaching during the war, but bombs destroyed his studio and his art. He then fled to Switzerland and lived near Locarno with other sculptors who were refugees, Germaine Richier and Fritz Wotruba. The Swiss would not let an alien work in cast materials nor accept commissions. Marini was able to work only in clay and plaster, making portraits of Swiss friends. Giacometti, who was Swiss, spent the war years in Geneva.

148. Alexander Calder, *Black Spot on Gimbals*, 1942. [cat. no. 13]

Conclusion

Looking back at the turn of the century, Gabo wrote in 1937, "The death of sculpture seemed to everybody inevitable. It is not so any more. Sculpture is entering on a period of renaissance."[1] What made this period distinctive and gave sculpture new life was an unprecedented and excited awareness among artists that they had the opportunity to move sculpture into areas previously unknown to imagination and form. There were new realities for the imagining which were available only through art. The single greatest influence of World War I on modern sculptors may have been to turn their thought and art from death to life, from service to the dead to service to the living. What made the medium not only possible but also desirable for many in the postwar era was its noble purpose and the promise of a spiritually healing art. For various artists this took the form of evoking a new poetic wholeness between man and nature or science, technology and the machine. The Great War seems to have been partly responsible for the development, rather than the demise, of a new innocence among sculptors such as Arp. The uninhibited giving of form to the invisible was intended to be comforting to mankind in the sense that it would show that one could live happily in a universe that was not man-centered. (The "Black Hole" was not yet discovered by astronomers and thought of as mankind's future.) While artists were leaders in showing man's reduced role in the cosmic order, they were still celebrants of life. Hepworth wrote that art expresses "the desire to live."[2]

Throughout the period, the seriousness of the artist's role prevailed: he was a model of the *constructive* individual who, by thought and courage, was showing what a better world could be and whose purpose was to unify rather than divide; through art, society could be offered a model of civilized order in place of chaos, one of harmony rather than destruction. Constructivist sculptors as well as painters and writers saw themselves among the secular saviors of mankind and prophets of its future. Moore and Hepworth saw their roles as making their society form-conscious and understanding of the world of relationships, for as Hepworth wrote, "A world without form consciousness would scarcely be alive at all."[3] During the rise of Fascism, modern sculptors felt they were demonstrating what freedom meant by continuing with peaceful, creative work.

In his *Struggle of the Modern*, Stephen Spender, who knew Moore and Hepworth in the thirties, writes about what modernism in this period meant for writers, but much of what he says is appropriate to artists as well, particularly his idea that modern art might bring men together, transform the contemporary environment, and hence, by pacifying and ennobling the inhabitants, revolutionize the world. "The basic reason for hope is that art might re-connect the life which has been driven inwards into the isolated being of the artist, with the external world by accomplishing a revolution in the lives of people to share the visions of modern creation." As Spender also points out, the converse of this last activity "is the idea that the images of the materialist world can be 'interpreted,' made to become symbols of inner life where they are reconciled with older things. . . ."[4] Even World War II could not extinguish these hopes for the artists who survived.

What helped to make the modern world possible for sculpture were abstraction and the symbolic intensity of the new metaphor which made sculpture more poetic through disjunction and formerly impossible connections. The sculptors' optimism about humanity's future, including utopia, gave metaphor a solid base. The creation of unknown beings depended upon the unhinging of anatomy and customary logic and the compacting of imagery prophesied in Duchamp-Villon's *Horse* and his statement about creation. Stylistically, except

for a few sculptors, Cubism did not map the future of interwar art beyond the twenties; but when the prewar criterion of probability by which the artist was constrained to reproduce the imaginable or verifiable was conceptually shattered by Cubism, it was as crucial for many as the impact of the Great War. Cubism helped open the door to richer meaning and greater mystery. Paul Fussell observed that "the drift of modern history domesticated the fantastic and normalized the unspeakable." He then added "And the catastrophe that begins it is the Great War."[5] This may be true for writers, but it does not take into account prewar developments in art.

Fussell cites the injunction on the title page of E.M. Forster's *Howard's End* of 1910, "Only connect," as having had an influence on certain English writers between the two world wars. In sculpture Arp enacted the imperative of "only connect" starting in 1915, and thereafter for the rest of his life.[6] For all of the interwar artists, an appropriate equivalent to Forster's injunction would have been: "only create" or "only imagine." Abstraction resulted in part from the realization that the root of the word "reality" meant the thing thought. If one imagined something, it was real. Interwar sculpture was open wide to "other" realities intuited by artists who claimed for artistic truth parity with that of science, and many scientists have agreed with them, then and now. The universe was there for Gabo and Calder (fig. 148) to reimagine. Heaven and earth could be linked in the sculpture of Brancusi. In all, sculpture was made more responsive to thought and speculation as well as feeling and intuition. The artist was uninhibited about what he could make and thus changed art to accommodate inspiration. What was previously thought or done in private could now be made visible and public.

It was during the interwar period that modernism in sculpture filled out its identity and morality. The first tenet was to recognize and accept the challenges of the pioneers who had opened important new premises for sculpture. The second imperative was an awareness of living in a modern age, one that was post-Darwin and Marx and continued to be influenced by Freud and Einstein. This meant an

149. Constantin Brancusi, *Golden Bird*, 1919 (?). [cat. no. 10]

awareness of living in a moment of history with an unprecedented perspective on both the present and the past. One of the myths propagated in the late fifties and the sixties was that before that time there was a "gap between art and life," as if the former was possible without the latter. Interwar modernism meant sincere expression of authentic life experiences: art in the first person. Modernism opposed nationalistic, edifying and escapist art, such as that of the Nazis and Communists after 1925, because of its falsification of consciousness and experience. The "literary" and the moralizing were inimical to the search for truth in a world that increasingly seemed a strange place. In order to be faithful to one's own lived experience and to preserve its unique qualities (the new spacings between the stepping stones of logic), the artist could now transform the conditions of art if necessary. He was enjoined to create, invent, and discover. For those whose creativity depended on them, spontaneity, impulse, and the irrational had to be preserved even if it meant defying conventions of the artist's decorum before his work and the public. Impersonality as a mode of artistic speech was just as acceptable to modernism. In either mode there was a demand for stricter unity of thought and image, content and form, so that each work was unique in its structure and expressiveness. Crypticism and undecipherability were accepted as a guarantee of authenticity, and modern sculptors learned to live with the recognition that their art was not meeting the public's needs. By the time the public after World War II understood and accepted this art and the values it represented, they were a spent force for younger artists.

Although one is accustomed to modernism meaning the search for a personal style, in artists' statements there is an interesting absence of self-consciousness about style, partly because of the new unity of form and content and also because sculptors often tended to adapt their way of working to their imagery and materials. Like the word "nude," the word "style" may have had unfavorable connotations (such as artificiality), deriving from the older pre-World War I order in art and culture.

The desire for authenticity of experience, more poetic imagery, and for greater intensity of formal expression was coupled with the interest of many artists in engendering fresh inquiry into the elements of sculpture through new materials and processes. Questions were posed, the answers to which had not been rehearsed. In traditional mediums, Moore, for example, restudied, as John Russell puts it, with both innocence and awareness the meaning of shape, scale, rhythm, surface and volume. There was a general desire to pare away traditional associations with the elements of art, to wipe the slate clean, so that they would be made responsive to new ideas. (Moore, however, knew this was impossible and counted on the persistence of psychological associations with shapes.) This was one reason why new materials for sculpture, such as iron, steel and plastics, were sought out and used along with shapes from geometry: they lacked art history and cultural memory. Space was the most inspiring new element to gain full partnership with materials. For artists such as the Constructivists, space made the expression of the modern era possible and audacities with form imperative. What stimulated sculptors were the problems of how to get space into their forms (and the reverse, as well) thereby making space tangible and expressive. Space became a symbol and value as well as a formal element. Brancusi pioneered the surface of high polish and an aesthetic of reflectivity (fig. 149). Light and actual movement came into modern sculpture along with a new space consciousness. These developments made useless the search for any aesthetic value in the classical sense in the work of Gabo and others in the twenties.

Contrary to the views of formalist critics, modernism in this period meant rejecting tidy categories that had separated the arts. Painting and sculpture became extensions of one another in reliefs. It was the delight of Picasso, Arp and Calder to make the unclassifiable. Not only were distinctions pulverized or blurred between painting and sculpture, but even between sculpture and engineering, as well as architecture. The dream of total unity in the arts did not make categories compelling. Art was at the service of vision rather than craft and materials. For these and other reasons there was a vast reduction of what was not art.

150. Henry Moore, *Reclining Figure*, 1935–36. [cat. no. 48]

Modern sculpture between 1918 and 1945 presents even less of a logical, unified development than the previous one hundred years in that medium. This was largely due to the successful challenge of the figure's dominance. From 1900 to 1914, for example, one could trace in the work of several artists, most of whom were in Paris, an evolution away from the imitation of nature and the excesses of Salon art towards a simplification of the figure, an uncomplicating of sculpture. Jacques Lipchitz remembered, "The atmosphere of Paris during the 1920s was very different than it had been during the war. At that time we were all working together and sharing ideas. But after the war even artists who had earlier been very close began to drift apart, each pursuing his own way."[7] Sculptors tended to be loners. Perhaps one day we will detect a truly communal interwar style in sculpture. For now, we can only say that the most venturesome sculpture of the period presented the appearance of having been acted on by the intuitive power and lively intelligence of exceptional minds dedicated to creation in the fullest sense. To paraphrase Picasso, it was an art that challenged the mind and aesthetic sensibility rather than deceiving the eye and exacting tribute for "miracles of the hand." The classical, pre-1914 definition of sculpture was that it should be the selective and palpable imitation of nature. By 1945, even in the most dematerialized manifestations of Gabo and Calder, sculpture was the expression of ideas in palpable form.[8]

Between the two world wars modernism recognized a variety of contradictions and often a cross-fertilization of opposites. Most importantly, rather than representing "freedom from everything," modernism was itself filled with taboos, of which "realism" or descriptive art ranked at the top. As the old barriers and rules were broken, new ones took their place. Matisse argued for the personalizing of rules, but rules nonetheless. Moore warned against overthrowing rules merely for the sake of change. Picasso pointed out that freedom was a matter of the artist choosing his own chains. One of the tyrannies to which the artist submitted was that of *art*: the belief that art has its own inherent demands, logic and spirit, which the artist had to observe. Interwar sculpture continued the dream of the self-sufficient work of art, the work that seemed to have been

self-generated, which had its own reason for being and referred only to itself. No artist truly achieved this ideal, not even Tatlin. The sculptures always bore the stamp of the maker's artistic authority, his thought and aesthetic judgement and, as we see today, his time in history. Abstract sculpture turns out, in fact, to have been about something. The resolution of these paradoxes is that the artist drew inspiration from his self-imposed limitations. They permitted a crucial focusing of thought and energy by eliminating constant choice.

Modernism in sculpture knew a love/hate relationship between art and science and technology. The machine was a paradigm for Moholy-Nagy, but it was the subject of parody for Calder and pessimism for Kobro, who wrote that "imitating the machine was as detrimental as imitating the animal world."9 Vantongerloo and Bill drew freely on mathematics as tools for inspiration, but Moore thought geometrical shapes inimical to the expression of life. Gabo and Pevsner were trained in mathematics, but believed that science could not achieve what was possible through artistic intuition, and they later resented even the attempt to compliment them on their knowledgeability in science. Picasso scorned new objects of advanced industrial design and brought to his art "humble" objects made "impure" by previous human association. Constructivist sculptors were advocates of either pure or applied art, but Calder did both all of his life. Modernism knew personal and impersonal ways of working: Lipchitz in self-expression and Moholy-Nagy as the anonymous agent of society.

If we had only modern sculpture to tell us of the period 1918 – 1945, we would have no understanding, for example, of the great political events of the period, for only Belling and Epstein portrayed the political leaders of society. For historians of art and culture, interwar sculpture is related to its time not so much iconographically as iconologically. A perplexing question is just how much artists were intellectually aware of what was going on around them and how much they were caught up in their own sensations. The detachment of the modern sculptor from historical events was occasionally contradicted by Picasso, Lipchitz and Gonzalez, for example. The art that re-

sulted, however, was a powerful joining of lived experience and the pressures of the time. One of the ironies of the period that does reflect the times is that pacifistic, gentle art of wit and joy coexisted with cruel and violent aggression. In many diverse ways sculptors were spokesmen of the unspeakable.

One of the most interesting paradoxes of the period was the relation of modern sculpture to the past. Modernism's credo was to reject tradition and begin anew. Modern sculpture did, in fact, do both, but also the reverse. The imperative of unity extended for some to collapsing temporal distinctions between selected art of the past and the present. This did not mean eclecticism or revivalist styles, as practiced by those on the edges of modernism, such as Bourdelle and Mestrovic̆. For Matisse, Picasso, Lipchitz and Moore, critically selected traditions were often present in their consciousness as they worked. Pre-1918 art was heroic in opening new options to tradition and showing where it had become exhausted. Interwar art was important in transforming many aspects of tradition. Sculptors rejected the concept of historical progress in the quality and imaginative aspect of art and intersected with older art wherever they chose, whether that of the Cyclades, the Stone Age, Pre-Columbia, Africa or the Middle Ages.10 Thanks to the pioneers of modern sculpture, the precedent was established to expand "tradition" to include world art, folk art and automata, and all were there to admire and plunder, but not prescribe. Picasso and Moore showed a new interest in and comprehension of "pagan" thought and, through their formal analysis rather than comprehension of themes, achieved a sense of unity with artists of many cultures previously unrecognized as having artistic merit. Much of our appreciation of form in world art we owe to our experience of interwar sculpture, both figural and abstract.

The persistence of tradition in modernism can be seen in the overwhelming belief that sculpture should be *about* something, principally something in nature. There was also an interest among certain artists like Lipchitz and Ernst in revitalizing myth, because of its universal appeal; but it had to be personalized myth, retold in a contemporary idiom to avoid

violating the taboo against the literary or archaic. For all of the competition from abstraction, engineering, the machine, and world-centered views, the human figure not only continued but thrived. Modernizing Venus was still a viable challenge, not only for Maillol, Archipenko and Marini, but for Arp, Picasso and Gonzalez. The figure lost its autonomy, nobility, beauty, rhetoric, mobility, its skin and privacy, but it survived and even kept its poise and pride of spirit in Moore (fig. 150) and Gonzalez. Even when the figure was absent or not explicit, human mutuality or relationships were expressed in abstractions, such as those by Hepworth. We may miss the humanism of Rodin, the evidence in sculpture of what makes a being human, but interwar sculpture saw both more and fewer ways by which the artist could express his humanity. Portraits, for example, survived the challenge of the evocative head and made a comeback in the art of Giacometti, Manzù and Marini after 1935.

For all the talk about the machine age, all modern sculpture was handmade, and more work was done in the oldest materials, stone and bronze, and by carving and modeling than in the new materials and processes. The traditional practice of the master and his assistant continued. Despite the interwar flirtation with impermanence, the artists showed a great respect for and interest in permanence. (Picasso saw to it that many of his most fragile works were bronze-cast, even during the Occupation.) Old academicians must have smiled to learn that architecture was the paradigm for many abstract artists because of its intelligent and impersonal order. First lesson for an academic student even between the wars was that architecture was the mother of the arts.

Modern sculptors had a bittersweet relationship with museums, but most dreamed of their art being both in museums and public places, where it could reach the community and be a force in people's lives. (Actually, it was night clubs that allowed Tatlin, Arp and Belling to display their large-scale work where it could be seen by the public.) There were more museums of modern art in Russia before 1925 than in the rest of Europe. As they had since the nineteenth century, many sculptors relied on art dealers to effect a bridge to the public. If it could be on their terms and if they approved of the system, some artists were willing to serve governments, as Barlach, Tatlin, Brancusi, Moore and Gonzalez showed. Schwitters and Bellmer knew an adversary society all their lives, but before the end of the second war, Brancusi and Moore became their countries' most admired artists.

The richest achievement of this period that makes it a genuinely second heroic age of modern sculpture may turn out to be the giving of palpable form, often of superb quality, to the previously unimaginable. More than in previous periods, imagination became the creative center of the artist's being. The artists who survived the Second World War went on to realize much of Europe's finest sculpture to the present time. American sculpture, from the thirties through the early sixties, this country's great period of modern sculpture, is unthinkable without the European model. This model also sowed the seeds of its future rejection. Modernism established the imperative of questioning the past, while itself becoming a tradition. It is because of this legacy and, ironically, in the name of freedom, that so many sculptors since the sixties oppose the necessity of modernism.

Notes

Chapter 1: The Figure in Interwar Modern Sculpture

1. Hans Wingler, *The Bauhaus: Weimar, Dessau, Berlin, Chicago*, ed. Joseph Stein, trans. Wolfgang Jabs and Basil Gilbert (Cambridge, Mass.: M.I.T. Press, 1969), p. 64. See also the section on "The Exemplary Figure" in Albert Elsen, *Origins of Modern Sculpture: Pioneers and Premises* (New York: Braziller, 1974) for the pre-1914 background of the modern sculptor's search.

2. There are a number of reproductions in Wingler and also in Karin von Maur's *Oscar Schlemmer Sculpture* (New York: Abrams, 1972) which show Schlemmer's costumed figures. For the writing of this section, von Maur's work has been indispensable. Except where otherwise indicated, the quotations in this section are from von Maur.

3. For an extensive discussion of automata and their relation to modern sculpture see especially the chapter "Sculpture and Automata," in Jack Burnham's *Beyond Modern Sculpture* (New York: Braziller, 1968). See also John Cohen, *Human Robots in Myth and Science* (London: Allen & Unwin, 1966).

4. For more on these works see Alfred Chapuis and Edmond Droz, *Automata. A Historical and Technological Study*, trans. Alec Reid (Neuchatel: Editions du Griffon, 1958), pp. 298–299.

5. Lincoln Kirstein, *Elie Nadelman* (New York: Eakins Press, 1973), esp. pp. 226–227, 240. On Alexandra Exter see John Myers, "Alexandra Exter: Spirals and Revolution," *Arts Magazine* (New York), vol. 50, no. 5, Jan. 1976, pp. 84–85. For the Surrealists' use of mannequins see William Rubin, *Dada and Surrealist Art* (New York: Abrams, 1968).

6. Siegfried Kracauer, *From Caligari to Hitler* (New York: Princeton University Press, 1947), p. 32. This is a valuable book for giving the background of films in this period, particularly those that would have been seen by Schlemmer and Bellmer.

7. Wingler, *Bauhaus*, p. 66.

8. For the background analysis and reproductions of Bellmer's work see especially Marielle Crete, "Hans Bellmer" in Blaise Gautier, ed., *Hans Bellmer* (Paris: Centre National d'Art Contemporain, 1972), exhib. cat.; Alain Jouffroy, *Hans Bellmer*, trans. Bernard Frechtman (Chicago: William and Norma Copley Foundation, 1961); and Constantin Jelenski, *Hans Bellmer*, trans. Alex Grall (London: Academy Editions, 1972 and New York: St. Martin's Press, 1973).

9. Bellmer published these photographs in 1934 under the title *Die Puppe* (Carlsruhe/Oberschlesien: Selbstverlag, 1934).

10. Alain Jouffroy (in *Hans Bellmer*, n.p.) writes about this work made in Karlsruhe in 1937, "'The Machine Gunneress in a State of Grace,' which remains invisibly aimed at all his enemies, of whom the German fascists were the prototypes. . . . The threat which this object suspends over the external world is that of desire. The grace of a woman's body which is coupled with the mechanism of its support, exposes and ridicules the inhuman and falsely scientific character of this mechanism . . . the mechanism placed . . . in the service of his imagination and desire"

11. Peter Gay, *Weimar Culture* (New York, Harper & Row, 1968), chapter IV, "The Hunger for Wholeness: Trials of Modernity."

11a. See Gerald Nordland, *Gaston Lachaise: The Man and His Work* (New York: Braziller, 1974), pp. 140–171.

12. Sidney Geist, *Constantin Brancusi, 1876–1957, A Retrospective Exhibition* (New York: Solomon R. Guggenheim Museum, 1969), exhib. cat., p. 107. For Rodin's influence through the partial figure on Brancusi and other interwar artists see Albert Elsen, *The Partial Figure in Modern Sculpture: From Rodin to 1969* (Baltimore: Baltimore Museum of Art, 1969), exhib. cat.

13. Edith Balas, "Objective-Assemblage, Base and Assemblage in the Art of Constantin Brancusi," *Art Journal* (New York), vol. 38, no. 1, Fall 1978, pp. 36–46. Of all the arguments involving whether or not Brancusi's bases and furniture were or were not sculpture, I find those of Balas most persuasive.

14. For the best reading of this piece, see Geist, *Brancusi, Retrospective*, p. 80.

15. Ibid., p. 102.

16. Balas, "Object-Assemblage," p. 45.

17. The work's meaning may never be known, lacking the artist's own testimony, for the source seems not to have had a public base. We know Brancusi was interested in the occult and in philosophical as well as mystical matters. The Maharajah's commission gave him the opportunity, unique for a modern sculptor in this period, to create an image from his private culture that was destined to have its own supporting cult. If the temple had been built, some of Brancusi's *Birds in Flight* would have accompanied *The Spirit of Buddha*. For the transformation of the motif of the bird in Brancusi, see not only Geist's book but especially the outstanding study by Athena Spear, *Brancusi's Birds* (New York: New York University Press for the College Art Association of America, 1969).

18. For Arp's relation to Dadaism, see especially William S. Rubin's *Dada and Surrealist Art* (New York: Abrams, 1968) with its section on this artist.

19. Richard Huelsenbeck, "Arp and the Dada Movement," in James T. Soby, ed., *Arp* (New York: Museum of Modern Art, 1958), exhib. cat., p. 18.

19a. The war confirmed for Arp that "only in the monstr-ous is man creative," and "whatever he can achieve, he covers with blood and mud." He saw Surrealism as giving rise to "madness in all its forms, notably in the works of Ernst and Dali." Arp, *On My Way,* p. 50.

20. All quotations from Arp are taken from Hans Arp, *On My Way: Poetry and Essays 1912 . . . 1947* (New York: Wittenborn, Schultz, 1948). For this particular passage, see p. 35.

21. Ibid., p. 123.

22. Ibid., p. 47.

23. Ibid., pp. 70, 72.

24. Ibid.

25. Ibid., pp. 50 – 51.

26. Ibid., p. 70.

27. Ibid.

28. For a reproduction of *Automatic Sculpture (Homage to Rodin)* see Soby, *Arp,* p. 68.

29. Ibid., pp. 14 – 15.

30. Ibid.

31. Arp, had in fact, looked at a legendary past before classical antiquity:

 When the personality, the intellect, philosophy arose from the legendary depths of mythical humanity, when nature was discovered by man, "when the earth, the wavy sea, the moist air . . ." were solemnly sung, beauty dwelt naked among men. . . . In every century, beauty changed. Beauty did not vanish beneath the ruins of the centuries, it vanished into the Maya. . . . So many rare and priceless garments had been showered upon her, she no longer knew in which to show herself. Which is the original image of beauty? . . . Is it the naked corporeality of the Greeks . . . is it the love and the harmony of which Empedocles said: "There were no two arms extending from a trunk, nor were there feet or swift knees or organs of procreation; there was a sphairos [sphere] the same in all its aspects"? Arp, *On My Way,* p. 35.

32. For an interesting though brief discussion of Arp's interest in pre-Socratic forms see the essay by Robert Melville, "On Some of Arp's Reliefs" in Soby, *Arp,* pp. 32 – 33.

33. All quotations are from Jacques Lipchitz, *My Life in Sculpture,* Documents of 20th Century Art (New York: Viking Press, 1972). For this quotation see p. 77.

34. Ibid., p. 95.

35. Ibid., p. 85.

36. Ibid., p. 86.

37. Ibid., p. 140.

38. For a discussion of *Figure* by the artist see Lipchitz, *My Life,* p. 90.

39. Speaking about his search for a new subject matter in the early twenties, Lipchitz said, "I did not deliber-ately set out to develop a new subject matter. I was, in fact, strongly against what I consider the excesses of fantastic subject that the surrealists were begin-ning to explore. To me, fantasy has a particular and somewhat disagreeable connotation, that of uncon-trolled Freudian experience. I oppose to it what I think of as imagination or content, which I was seeking . . . but imagination with a human base and control of my hard-earned formal vocabulary." Lip-chitz, *My Life,* p. 77.

40. Lipchitz, *My Life,* p. 113.

41. For photographs of Lipchitz's important small sketches from this period see H. Harvard Arnason, *Jacques Lipchitz: Sketches in Bronze* (New York: Praeger, 1969). The first study for the *Prometheus* is pl. 68.

42. Picasso told Françoise Gilot, "God is really only another artist. He invented the giraffe, the elephant, and the cat. He has no real style. He just keeps on trying other things. The same with the sculptor. First he works from nature; then he tries abstraction. Finally he winds up lying around cares-sing his models." Françoise Gilot and Carleton Lake, *Life With Picasso* (New York: Signet, 1966), p. 44.

43. Dore Ashton, ed., *Picasso on Art: A Selection of Views,* Documents of 20th Century Art (New York: Viking Press, 1972), p. 73.

44. "Reality must be torn apart in every sense of the word. What people forget is that everything is unique. Nature never produces the same thing twice. Hence my stress on seeking the *rapports de grand écart*: a small head on a large body; a large head on a small body. I want to draw the mind in a direction it's not used to and wake it up. I want to help the viewer discover something he wouldn't have discovered without me." Gilot and Lake, *Life With Picasso,* p. 54.

45. Werner Spies, *Sculpture by Picasso,* trans. J. Maxwell Brownjohn (New York: Abrams, 1971), p. 69.

46. William Rubin and Carolyn Lanchner, *André Mas-son* (New York: Museum of Modern Art, 1976), exhib. cat., p. 124. (Masson's *Metamorphosis* is re-produced on p. 126). Rubin's book on *Dada and Surrealism* has an important chapter on Picasso's art in this period that relates the sculpture to his paint-ing and Surrealism.

47. Spies, *Sculpture by Picasso,* pl. 103.

48. Ashton, *Picasso on Art,* p. 19.

49. On Picasso's view concerning not showing respect to art see William Fifield, "Pablo Picasso: A Composite Interview," *The Paris Review* (Paris), no. 32, 1964, p. 66.

50. For a reproduction of this superb piece see Spies, *Sculpture by Picasso,* pl. 151.

51. For reproductions of *Reclining Figure* and *Woman with a Vase* see Spies, pls. 109, 135.

52. I am indebted to my colleague at the University of California, Berkeley, Professor Herschel Chipp, for this information. What is not known is whether Picasso or his widow made the decision to place this work by the artist's grave. In a conversation with Françoise Gilot, Picasso made the following observa-

tion about a sculpture made with one pure line that evokes comparison with *Woman With a Vase*: "If sculpture is well done — if the forms are perfect and volumes full — and you pour water from a pitcher held over the head, after it's run down, the whole sculpture ought to be wet." Gilot and Lake, *Life with Picasso*, p. 45.

53. I have discussed Picasso's relation to tradition in sculpture in my article, "The Many Faces of Picasso's Sculpture," *Art International* (Lugano), vol. 13, no. 6, Summer 1969, pp. 24 – 34.

54. Josephine Withers, *Julio Gonzalez: Sculpture in Iron* (New York: New York University Press, 1977), p. 72.

55. For the finest reading of body imagery in Gonzalez, see Leo Steinberg's "Gonzalez," in *Other Criteria: Confrontation With Twentieth Century Art* (New York: Oxford University Press, 1972), pp. 241 – 250.

56. Withers, *Julio Gonzalez*, p. 135.

57. Reinhold Hohl, *Alberto Giacometti* (New York: Abrams, 1972), p. 30. Hohl's reading of the 1925 – 35 pieces is very important as is that of William Rubin in *Dada*.

58. Hohl, *Giacometti*, p. 78.

59. Peter Selz, *Alberto Giacometti* (New York: Museum of Modern Art, 1965), exhib. cat., pp. 18, 20.

60. "Giacometti used his 'cages' to dramatize themes and forms (a ball for a head, probably masculine; a pointed shape or spindle for the phallus; a spherical segment, squat cone, and oval plates for the female body, zig-zags for the backbone, rib cage or skeleton) which he and other sculptors and painters, even non-Surrealists, used . . . so that the work becomes a showcase, a private theater of revelation and mystery; this is the Surrealist conception of art and Giacometti's contribution to the art of Surrealism." Hohl, *Giacometti*, p. 81.

61. Selz, *Giacometti*, p. 21.

62. Ibid.

63. Ibid., p. 27.

64. Ibid., p. 28.

65. For an interesting interpretation and recounting of Ernst's sculpture during this period, see Lucy R. Lippard, "The Sculpture," in *Max Ernst, Sculpture and Recent Painting* (New York: The Jewish Museum, 1966), exhib. cat. See also the section on Ernst in Rubin, *Dada*.

66. Alain Bosquet, *Max Ernst, Oeuvre Sculpté, 1913 – 1961* (Paris: Point Cardinal, 1961), opp. cat. nos. 16 and 17.

67. Rubin, *Dada*, p. 262.

68. The anthology *Henry Moore on Sculpture* edited by Philip James (New York: Viking Press, 1967) is the best and most convenient access to the sculptor's statements on his sources.

69. Arthur Koestler, *The Act of Creation* (New York: Dell, 1966), p. 120.

70. One of the best studies of Moore's evolution in this period is that by John Russell, *Henry Moore* (New York: Putnam, 1968). Although done thematically, David Sylvester's *Henry Moore* (New York: Praeger, 1968) is also valuable for its insights into this period.

71. See Sylvester, *Moore*, figs. 71 and 72.

72. James, *Moore*, p. 68.

73. It has been suggested that his burrowing activity as a carver related to his childhood experiences in the mines, where his father was supposed to have worked. Moore's father was not a miner, however, and he does not seem literally to have gone down into the mines until 1943.

74. All quotations from Hepworth are taken from Herbert Read, ed., *Barbara Hepworth* (London: Lund Humphries, 1952). The artist's statements are unpaginated.

Chapter 2: Portraits and the Evocative Head

1. In his *Epstein: An Autobiography* (New York: Dutton, 1955), the artist discoursed on his method: "In my portraits it is assumed that I start out with a definite conception of my sitter's character. On the contrary, I have no conception whatever in the beginning. The sitter arrives in the studio, mounts the stand, and I begin my study. My aim, to start with, is entirely constructive. With scientific precision I make a quite coldly thought out construction of the form, giving the bony formation around the eyes, the ridge of the nose, mouth and cheek-bones, and defining the relation of the different parts of the skull to each other. As the work proceeds, I note the expression and the changes of expression, and the character of the model begins to impress itself on me. In the end by a natural process of observation the mental and psychological characteristics of the sitter impose themselves on the clay. . . . With close and intensive study come subtleties and fine shades. From turning the work round so as to catch every light, comes that solidity that makes the work light proof. . . . For in a work of sculpture the forms actually alter with the change of light, not as in painting or drawing where the forms only become more or less visible." p. 69. For those who are interested in portraiture from life consult Rodin's account of how he works, which is possibly the source of Epstein's method. This is given in my anthology, *Auguste Rodin: Readings on His Life and Work* (Englewood Cliffs, N.J.: Prentice-Hall, 1965), pp. 154 – 58, 164, 167 – 168. The most extensive reproduction of Epstein's portraits can be found in Richard Buckle's *Jacob Epstein, Sculptor* (Cleveland and New York: World, 1963).

2. For reproductions of Manzù's portraits and a biographical account of the artist see John Rewald, *Giacomo Manzù* (London: Thames and Hudson, 1967).

3. For reproductions of Marini's work see Abraham M.

Hammacher, *Marino Marini, Sculpture, Painting, and Drawing* (New York: Abrams, 1970).

4. For a more extensive discussion of Matisse's portraits see this author's *The Sculpture of Henri Matisse* (New York: Abrams, 1972).

5. Lipchitz, *My Life*, p. 7. All portraits referred to in this section can be found in this book.

6. Ibid., pp. 151 – 152.

7. In her *Calder's Universe* (New York: Viking Press in cooperation with the Whitney Museum of American Art, 1976) Jean Lipman reproduces many of these wire portraits.

8. For more on Rosso and his way of working, see Margaret S. Barr, *Medardo Rosso* (New York: Museum of Modern Art, 1963).

9. Hohl, *Giacometti*, p. 80.

10. Ibid., p. 106.

11. Discussion of the beginnings of this subject in Elsen, *Origins*, pp. 49 – 52.

12. For more reproductions of Belling's work and a more sympathetic reading of them than hereafter given, see J.A. Schmoll Gen. Eisenwerth, *Rudolf Belling* (St. Gallen: Erker-Verlag, 1971).

13. The Olex station is reproduced in the Karl Einstein and Paul Westheim book *Rudolf Belling: Skulpturen* (Potsdam: Gustav Kiepenheuer Verlag, 1924), p. 24.

14. Peter Gay, *Weimar Culture* (New York: Harper & Row, 1968), p. 117.

15. For a more extensive discussion of heads and faces in Picasso's sculpture, see Elsen, "The Many Faces of Picasso's Sculpture," *Art International*, Summer 1969.

16. This was first observed by John Berger in his *Success and Failure of Picasso* (Harmondsworth, England: Penguin, 1965), p. 160. "Its secret is a metaphor. It represents a face. Yet this face is reduced to two features: the nose, rounded and powerful, which thrusts forward and is simultaneously heavy and bouyant; and below it, the mouth, soft, open, and very deeply modelled. . . . The scale of the work is what first offers a clue to the metaphor. It is very much larger than a head—one stands looking at it as at a figure, a torso. Then one sees. The nose and mouth are metaphors for the male and female sexual organs; the rounded forms for buttocks and thighs. This face, or head, embodies the sexual experience of two lovers, its eyes engraved upon their legs. What image could better express the shared subjectivity which sex allows than the smile of such a face?" Berger was writing about a different work in the series and which he reproduces on p. 159. Quite apart from his discovery, I had found the same theme in the version here reproduced and discussed in my article first cited in fn. 53, chapter I.

17. Leo Steinberg, "The Skulls of Picasso," in *Other Criteria*, p. 121. Writing of this sculpture Steinberg says, "The bronze Skull survived. It is probably the most powerful single-mass sculpture in twentieth century art . . . it constitutes a landmark in Picasso's artistic history, the most determined attack of his sculptor's career on the problem of giving new life to the monolith." (p. 120).

18. For a reproduction of the paper skull, see Spies, *Sculpture by Picasso*, pl. 257, p. 280.

19. Withers, *Julio Gonzalez*, pp. 42 – 49, for an extensive discussion of these early masks and sheet iron heads. The most extensive reproductions of heads are also in this book.

20. Hohl, *Giacometti*, p. 105.

21. See Read, *Hepworth*, for full coverage of heads in this period.

22. See David Sylvester, ed., *Henry Moore*, 4th ed., vol. I (London: Lund Humphries, Zwemmer, 1957), for reproductions of the heads and in this instance pl. 88.

23. See Sylvester, *Henry Moore*, 1957, pl. 177.

24. Alan Wilkinson, *The Drawings of Henry Moore* (London: The Tate Gallery in collaboration with the Art Gallery of Ontario, 1977), exhib. cat., p. 100, under no. 128.

25. Wilkinson, *Drawings of Moore*, p. 100, no. 128.

Chapter 3: The Other Realities of Abstract Sculpture

1. The literature on which the author drew for the section on Russian Constructivism included: Camilla Gray, *The Great Experiment: Russian Art 1863 – 1922* (New York: Abrams, 1962); John Bowlt et al., *From Surface to Space: Russia 1916 – 1924* (Cologne: Galerie Gmurzynska, 1974), an important exhibition catalogue with several essays; Alla Povelikhina, *The Isms of Art in Russia*, trans. John Bowlt (Cologne: Galerie Gmurzynska, 1972), exhib. cat.; Andrei B. Nakov, *Russian Pioneers: At the Origins of Non-Objective Art* (London: Annely Juda Fine Art, 1976); Andrei B. Nakov, *Malevich, Suetin, Chasnik, Lissitzky* (London: Annely Juda Fine Art, 1977); Troels Andersen et al., *Vladimir Tatlin* (Stockholm: Moderna Museet, 1968), exhib. cat.; Steven Bann, ed., *The Tradition of Constructivism*, Documents of 20th Century Art (New York: Viking Press, 1974); John E. Bowlt, ed. and trans., *Russian Art of the Avant-Garde*, Documents of 20th Century Art (New York: Viking, 1976); Robert C. Williams, *Artists in Revolution, Portraits of the Russian Avant-Garde, 1905 – 1925* (Bloomington: Indiana University Press, 1977); Herbert Read and Leslie Martin, *Gabo: Constructions, Sculpture, Paintings, Drawings, Engravings* (London: Lund Humphries; Cambridge, Mass.: Harvard University Press, 1957).

2. Williams, *Artists in Revolution*, pp. 157, 224.

3. Read and Martin, *Gabo*, pp. 151 – 152. This was from "The Realistic Manifesto, 1920."

4. See Jennifer Licht, "Rodchenko, Practicing Constructivist," *Art News* (New York), vol. 70, no. 2,

April 1971, and its illustrations from the Alfred Barr Archives at The Museum of Modern Art, pp. 61 – 62.

5. For illustrations of sculptures by Ermilov, see *Russische Avantgarde 1910 – 1930, Bilder und Konstruktionen* (Cologne: Galerie Bargera, 1978), exhib. cat.

6. Bowlt, *From Surface to Space*, pp. 136, 138 and Andrei B. Nakov, *2 Stenberg 2* (Paris: Galerie Jean Chauvelin, 1975), exhib. cat., *passim*.

7. Writing in *Circle* in 1937, Gabo made the point, "We consider space from an entirely different point of view. We consider it as an absolute sculptural element, released from any closed volume, and we represent it from inside with its own specific properties." (J.L. Martin, Ben Nicholson and Naum Gabo, eds., *Circle International Survey of Constructive Art* [New York: Praeger, 1971].) Also in Read and Martin, *Gabo*, p. 168. The 1962 quote is from Naum Gabo, *Of Divers Arts*, Bollingen Series 35, The Mellon Lectures in the Fine Arts 8 (New York: Pantheon Books, 1962), p. 100.

8. What is here referred to are the Sacra Monti shrines with their sculptural *tableau vivant* in the region of Varallo in Varese. Dr. Peter Cannon Brooks is doing an extensive study of these works. Some of the Italian sculptors involved were Gaudenzio Ferrari, Morrazzone and Tanzio de Varallo.

9. Bann, *Tradition of Constructivism*, pp. 18 – 19.

10. Read and Martin, *Gabo*, p. 177.

11. Jack Burnham, *Beyond Modern Sculpture*, p. 231.

12. For reproduction of the plans for a Palace of the Soviets and the production of *La Chatte*, see the catalogue *Naum Gabo, Antoine Pevsner*, intro. Herbert Read, text Ruth Oslon and Abraham Chanin (New York: Museum of Modern Art, 1946). Issued in connection with exhibition held in 1948.

13. Burnham, *Beyond Modern Sculpture*, p. 139.

14. See Ryszard Stanislawski, ed., *Constructivism in Poland, 1923 – 1936* (Lodz: Museum Stuki, 1973), exhib. cat.

15. A photograph on page 23 of the Polish Constructivism catalogue cited above shows a structure made by Kobro in 1920 which is a massing of found objects of an industrial nature

16. Ibid., pp. 55 – 56.

17. Ibid., p. 107.

18. Three good sources on Moholy-Nagy are his own *The New Vision* (1928) and *Abstract of an Artist*, trans., Daphne M. Hoffman, Documents of Modern Art, vol. 3 (New York: Wittenborn, 1946. Revised, 1947); Richard Kostelanetz, ed., *Moholy-Nagy* (New York: Praeger, 1920) and the observations by Jack Burnham in *Beyond Modern Sculpture*.

19. The quotations in this paragraph are from Moholy-Nagy, *Abstract of an Artist*, pp. 72, 79.

20. Moholy-Nagy, *Abstract of an Artist*, p. 80. In her 1970 catalogue for the Howard Wise Gallery, *Moholy Nagy: Light Space Modulator*, Nan Piene wrote: "Moholy regarded the metal, glass and plastic light machine which he titled 'Light Prop for an Electric Stage' on its completion in 1930, both as a Constructivist sculpture in its own right and as an instrument for articulating light in motion—what he called 'architecture of light' and what we might today call a light environment." As Professor Piene points out, in the June 7, 1930 issue of Deutscher Werkbund magazine, *Die Form*, Moholy published photostats of working drawings for the machine. She points out that the original in the Busch Reisinger Museum today "differs considerably from its appearance in 1930" and the present chromed surfaces were done during a 1966 restoration. Professor Piene, who assisted in the building of two replicas, goes on to say, "Moholy's article reveals how he first used light with the work: a white painted plywood box, about four feet high, wide and deep, formed a kind of housing for the turning sculpture which reaches 35½ inches from the revolving circular platform above the gear system to the top of the central shaft. Multi-colored light bulbs ringed the inner sides of circular openings cut into the front and rear walls of the plywood box. There were about 20 yellow, red, blue, green and white 15 watt bulbs on each panel, timed to flash in a cycle of two minutes and 31 seconds. Moholy thought of the box as both a model of a room-sized space, its walls catching reflections and shadows on a stagecloth of any size. When Moholy left Berlin for London as a political exile in 1935, the light box had to be junked for lack of shipping space, and he never rebuilt it."

21. Still indispensable to the understanding of his art and intentions is Georges Vantongerloo, *Paintings, Sculptures, Reflections*, trans. Dollie Pierre Chareau and Ralph Manheim, Problems of Contemporary Art, no. 5 (New York: Wittenborn, Schultz, 1948).

22. Ibid., p. 9.

23. Ibid., p. 4.

24. A valuable recent publication with good interpretive essays and the artist's own statements is James Wood and Lawrence Alloway, *Max Bill* (Buffalo: Albright-Knox Art Gallery, 1974), exhib. cat.

25. Ibid., p. 96.

26. The best collection of statements on Calder is that by H.H. Arnason and Ugo Mulas, *Calder* (New York: Viking Press, 1971); Lipman's *Calder's Universe* has a wonderful collection of photographs and the most extensive bibliography. See also Albert Elsen, "Calder on Balance," in *Alexander Calder, A Retrospective Exhibition* (Chicago: Museum of Contemporary Art, 1974), exhib. cat. Burnham gives an excellent analysis of Calder's achievement in *Beyond Modern Sculpture*.

27. Katharine Kuh, *The Artist's Voice: Talks with Seventeen Artists* (New York: Harper & Row, 1962), p. 50.

28. Ibid., p. 42.

29. Joan Marter, "Alexander Calder: Cosmic Imagery and the Use of Scientific Instruments," *Arts Magazine* (New York), vol. 53, no. 2, Oct. 1978, pp. 108 – 113.

30. Jacob Bronowski, *The Ascent of Man* (Waltham, Mass.: Little Brown & Co., 1974), p. 334.

31. This statement was made in 1933 when Calder wrote the introduction to a catalogue of his work for the Berkshire Museum. (Arnason and Mulas, *Calder*, p. 29.)

32. This statement was made in an interview in 1950 with Yvon Taillandier. See Arnason and Mulas, *Calder*, p. 68.

33. The literature on Freundlich's sculpture is slim—one of the few sources is *Deux Sculptures Monumentales de Otto Freundlich*, text Rene Drouin, Georges Charles, Maurice Raynal and the artist (Paris: Galerie Claude Bernard, 1962), exhib. cat. As this book went to press, *Otto Freundlich: Monographie mit Dokumentation und Werkzeichnis*, with essays by several authors, published in 1978 by Rheinland Verlag, Cologne, came to the author's attention. See especially the essay by A.B. Nakov.

34. Gabo, *Of Diverse Arts*, p. 58. This comes at the end of a chapter on art and science and is an eloquent discourse on how they complement one another.

Chapter 4: Interwar Relief Sculpture

1. I have discussed these developments in a section of *Origins of Modern Sculpture*, pp. 130 – 152.

2. Nakov, *Russian Pioneers*, pp. 85 – 91.

3. I have written on the development of the reliefs of the *Backs* in *Sculpture of Henri Matisse*, pp. 174 – 197.

4. Spies, in *Sculpture by Picasso*, reproduces all these reliefs.

5. Ibid., pl. 116, p. 91; pl. 78, p. 274.

6. Rubin, *Dada*, p. 284.

7. Spies, *Sculpture by Picasso*, pl. 145, p. 124.

8. Ibid., pl. 142, p. 125.

9. Soby, *Arp*, p. 18.

10. Arp, "Looking," in Soby, *Arp*, p. 12.

11. Ibid.

12. For these reliefs mentioned in the text but not reproduced see von Maur, *Oskar Schlemmer*.

13. Ibid., p. 27.

14. Ibid., p. 29.

15. For a number of reproductions of this project see Wingler, *Bauhaus* and von Maur, *Oskar Schlemmer*.

16. Von Maur, *Oskar Schlemmer*, p. 29.

17. Ibid., p. 74.

18. Oskar Schlemmer, *Man. Teaching Notes from the Bauhaus*, Heino Kuchling, ed. (Cambridge, Mass.: M.I.T. Press, 1971), p. 23.

19. For source material, photographs and a good interpretive text, see Werner Schmalenbach, *Kurt Schwitters* (New York: Abrams, 1970). An excellent article on Schwitters's sculpture is that of John Elderfield, "The Private Objects: The Sculpture of Kurt Schwitters," *Artforum* (New York), vol. XII, no. 1, Sept. 1973, pp. 45 – 54.

20. Schmalenbach, *Kurt Schwitters*, p. 96.

21. Ibid.

22. Gay, *Weimar Culture*, p. 65.

23. Schmalenbach, *Kurt Schwitters*, p. 130.

24. Andersen, *Vladimir Tatlin*, p. 48.

25. Jan van der Marck, in *Domela* (Paris: Galerie Roger d'Amécourt, 1978), exhib. cat., writes a spirited essay on this artist in which he credits him with inventing the geometric relief. Since Domela didn't start making reliefs until after those cited by Schwitters, which were probably known to the former, the argument isn't convincing.

26. For reproductions of the reliefs by Gabo and Pevsner not shown with this text, see Read, Olson and Chanin, *Gabo and Pevsner* and Read and Martin, *Gabo*.

27. Rosamond Bernier, "Propos d'un Sculpteur," *L'Oeil* (Paris), no. 23, Nov. 1956, p. 34. This article contains much of the most interesting material available on the sculptor's own views of his work.

28. The most extensive treatment of Nicholson's reliefs can be found in John Russell, *Ben Nicholson: Drawings, Paintings and Reliefs 1911 – 68* (London: Thames and Hudson, 1969; Bern: Benteli, 1969; New York: Abrams, 1969; Stuttgart: Belser, 1969) and Steven A. Nash, *Ben Nicholson: Fifty Years of His Art* (Buffalo: Albright-Knox Art Gallery, 1978), exhib. cat.

29. Nash, *Nicholson*, p. 22.

30. From Ben Nicholson, "Notes on Abstract Art," *Horizon* (London), Oct. 1941; reprinted in *Ben Nicholson*, special edition of *Studio International* (London), 1969, p. 34.

31. Alexander Calder, *An Autobiography with Pictures* (New York: Pantheon Books, 1966), p. 179.

32. Lipman, *Calder's Universe*, p. 222.

33. Arnason and Mulas, *Calder*, p. 60.

Chapter 5: Monuments and the Monumental in Interwar Sculpture

1. Reinhold Heller, *The Art of Wilhelm Lehmbrück* (Washington, D C.: National Gallery of Art, 1972), exhib. cat., p. 31.

2. Carl D. Carls, *Ernst Barlach*, rev. enl. ed. (New York: Praeger, 1969), p. 121.

3. Gay, *Weimar Culture*, pp. 147 – 155.

4. Raymond J. Sontag, *A Broken World, 1919 – 1939* (New York: Harper and Row, 1971).

5. Andersen, *Vladimir Tatlin*, p. 58.

6. Arp, *On My Way*, p. 48.

7. Ibid., p. 69.

8. Hans Arp, *Arp on Arp: Poems, Essays, Memoirs*, ed. Marcel Jean, trans. Joachim Neugroschel, Documents of 20th Century Art (New York: Viking Press, 1972), p. 329.

9. The best accounts of Tatlin's *Tower* and the fascinating process of its reconstruction are found in Andersen, *Vladimir Tatlin*. Williams's *Artists in Revolution* adds little on the *Tower* but has an interesting section on Tatlin. The quotations in this section on the *Tower* are from Andersen.

10. The original conception by the architects Piano and Rogers for the Centre Pompidou in Paris called for films to be projected on its western wall. Just as Tatlin's *Tower*, the Centre Pompidou has an external skeleton. There are many other interesting points of comparison between the two structures.

11. Read, Olson and Chanin, *Gabo and Pevsner*, p. 18.

12. Josephine Withers, "The Artistic Collaboration of Pablo Picasso and Julio Gonzalez," *Art Journal* (New York), vol. XXXV, no. 2, Winter 1975/6, pp. 108 – 109.

13. For the history of the *Dora Maar* portrait see Gilot and Lake, *Life with Picasso*, p. 299.

14. Withers, "The Artistic Collaboration," p. 112. The poem is synopsized as well.

15. Withers's interpretations are interesting but not persuasive in terms of her reading of the sculpture *Woman in the Garden* against the poem.

16. This is the view of Withers in "The Artistic Collaboration" and Alan Bowness in his long and interesting essay, "Picasso's Sculpture," in *Picasso in Retrospect*, ed. Sir Roland Penrose and John Golding (New York: Praeger, 1973), p. 139. Jacques Lipchitz also believed this was true.

17. Withers, "The Artistic Collaboration," p. 112.

18. Rosalind E. Krauss, *Passages in Modern Sculpture* (New York: Viking Press, 1977), p. 134.

19. Withers, "The Artistic Collaboration," p. 112.

20. Letter to the author, Aug. 2, 1950.

21. Sidney Geist, "Brancusi: The Centrality of the Gate," *Art Forum* (New York), vol. XII, no. 2, Oct. 1973, pp. 70 – 78 and William Tucker, "Brancusi at Tirgu Jiu," in *Early Modern Sculpture* (New York: Oxford University Press, 1974). See also Sidney Geist, *Brancusi: The Kiss* (New York: Harper, 1978).

22. See Sidney Geist, *Brancusi: A Study of the Sculpture* for a posthumous portrait of the doctor in 1903 (pp. 15 – 17), the graveside figure of *Prayer* and bust of the deceased, pp. 25 – 27, and *The Kiss* in the Montparnasse Cemetery, p. 36.

23. Geist, "Brancusi: The Centrality of the Gate."

24. Geist, *Brancusi: The Kiss*, p. 76.

25. Edith Balas, "The Sculpture of Brancusi in Light of His Rumanian Heritage," *Art Journal* (New York), vol. XXXV, no. 2, Winter 1975/6, pp. 94 – 95.

26. Tucker, *Early Modern Sculpture*, p. 138.

Chapter 6: The Sculptors' Response to Fascism

1. Irving Howe, ed., *The Idea of the Modern In Literature and the Arts* (New York: Horizon Press, 1968), pp. 24 – 25.

2. Sontag, *A Broken World*, p. 181.

3. Arp, *On My Way*, p. 51.

4. Tut Schlemmer, ed., *The Letters and Diaries of Oskar Schlemmer* trans. Krishna Winston, (Middletown, Conn.: University of Wesleyan Press, 1972), pp. 310 – 311.

5. Read and Martin, *Gabo*, p. 172.

6. Arnason and Mulas, *Calder*, p. 183.

7. Rewald, *Manzù*, pp. 44 – 45.

8. All of these are reproduced in Rewald, *Manzù*, but their dating and sequence are not clear.

9. Hohl, *Giacometti*, pp. 82, 299.

10. Robert Goldwater, *Lipchitz* (New York: Universe Books, 1959), n.p.

11. Lipchitz, *My Life*, p. 127.

12. Ibid., pp. 127 – 128.

13. Ibid., p. 131.

14. Ibid., pp. 131 – 132.

15. Ibid. pp. 132.

16. Ibid., pp. 139 – 140.

17. Ibid., p. 136.

18. Donald Hall, "Profiles: Henry Moore—The Experience," *The New Yorker* (New York), pt. II, Dec. 25, 1965, p. 70.

19. Wilkinson, *Drawings of Henry Moore*, p. 100, no. 129.

20. James, *Henry Moore*, pp. 212 – 216. There is an excellent section in John Russell's book, *Henry Moore*, that deals with the Shelter Drawings.

21. James, *Henry Moore*, p. 220.

22. For more on the *Montserrat*, its studies and later versions see Withers, *Julio Gonzalez*, pp. 87 – 91, 94.

23. Ibid., pp. 87, 89, 96 – 97. Withers gives her and Carmean's interpretations. Carmean sees *Cactus Man II* as an "armed Spanish peasant."

24. Lipchitz, *My Life*, p. 148.

25. Ibid., p. 151.

26. Ibid., p. 156.

27. Ibid., pp. 160, 163.

28. For reproductions of the works by Laurens not shown in this text see Werner Hofmann, *The Sculpture of Henri Laurens* (New York: Abrams, 1970).

29. For a recounting of the history of this major sculpture and its interpretation see Albert Elsen, "Picasso's Man with a Sheep: Beyond Good and Evil." *Art International* (Lugano), vol. XXI, no. 2, Mar. – Apr. 1977, pp. 8 – 15.

30. Regarding the weakness of the artist and poet as critic, Spender writes, "The weakness is that of any voice which speaks against power on human or personal grounds." Stephen Spender, *The Struggle of the Modern* (London: H. Hamilton, 1963), p. 149.

31. Sontag, *A Broken World*, p. 234.

32. W. H. Auden, *Collected Shorter Poems 1927 – 1957* (London: Faber, 1966), pp. 142 – 143.

Postscript: The Artist as Victim and Villian

1. Read and Martin, *Gabo*, p. 159.

2. Françoise Forster-Hahn, Dirk de Gooyer, et al., *Käthe Kollwitz, 1867 – 1945, Prints, Drawings, Sculpture* (Riverside, Calif.: University of California, 1978), p. 58. (The quotation is from Kaethe Kollwitz, *The Diary and Letters of Kaethe Kollwitz*, ed. Hans Kollwitz, trans. Richard and Clara Winston [Chicago: Henry Regenery Co., 1955], p. 126.)

3. Jelenski, *Bellmer*, n.p.

4. Schlemmer, *Letters and Diaries of Oskar Schlemmer*, p. xiii.

5. Carola Giedion-Welcker, *Contemporary Sculpture*, Documents of Modern Art 12 (New York: Wittenborn, 1955), p. 266. "In 1939 – 40 his sculpture *Homme Nouveau* was used by the Nazis as the cover illustration for the catalog of their Decadent Art Exhibition; it was also reproduced in the Nazi journal, *Der Stürmer*. He was twice interned and compelled to interrupt his lecture courses. From 1940 – 43 he lived with his wife in the Pyrenees area. On February 21, 1943, he was arrested and on March 4 deported to Lublin where he died. The last news of him was contained in a letter written by a nurse to his wife: 'We are face to face with such unspeakable misery that our spirt is numbed. But the composure of your husband, Madam, is so magnificent that I must write to you about it.' "

6. Hellmut Lehmann-Haupt, *Art Under a Dictatorship* (New York: Oxford University Press, 1954).

7. Geist, *Brancusi: A Study of the Sculpture*, p. 133.

8. Rewald, *Manzù*, p. 43.

CONCLUSION

1. This was published in Martin, Nicholson and Gabo, *Circle*, p. 110.

2. Ibid., p. 116.

3. Ibid., p. 115.

4. Spender, *The Struggle for the Modern*, p. 53.

5. Paul Fussell, *The Great War and Modern Memory* (New York: Oxford University Press, 1975), p. 74.

6. Ibid., p. 106.

7. Lipchitz, *My Life*, p. 95.

8. Gabo resisted the idea that his intention was to dematerialize sculpture. In 1937 he wrote, "We are not at all intending to dematerialize a sculptural work, making it non-existent; we are realists, bound to earthy matters. . . . adding Space perception to the perception of Masses, emphasizing it and forming it, we enrich the expression of Mass making it more essential through the contrast between them whereby Mass retains its solidity and Space its extension." Read and Martin, *Gabo*, pp. 168 – 169.

9. This was written in an article for *abstraction, création, art nonfiguratif* (Paris), vol. II, 1933, p. 27.

10. There was one area in which Lipchitz believed in progress: "I do believe in progress in art. Every generation has greater assets, greater means of expression at its disposal than its predecessor. Among great names Cézanne for me is greater as an artist than Rembrandt, because Cézanne is nearer: the character of his problems is closer to mine, his solutions are therefore more helpful to me in the solution of my problems, the problems of my time. For the same reason Rodin is for me greater than Michelangelo." James Johnson Sweeney, "Art Chronicle, An Interview with Jacques Lipchitz," *Partisan Review* (New York), vol. 12, no. 1, Winter 1945, p. 84.

List of Illustrations

1. Raymond Duchamp-Villon, *The Horse*, 1914, plaster, h. 17".

2. Jacques Lipchitz, *Man with a Guitar*, 1915, limestone, h. 38¼". The Museum of Modern Art, New York. Mrs. Simon Guggenheim Fund.

3. Aristide Maillol, *Torso of the "Ile de France,"* 1921, bronze, 47½ x 13 x 20". The Fine Arts Museum of San Francisco, Gift of the Mildred Anna Williams Fund. [cat. no. 38]

4. Marino Marini, *Susanna*, 1943, bronze, 28⅞ x 21⅛ x 10⅝". Hirshhorn Museum and Sculpture Garden, Smithsonian Institution, Washington, D.C. [cat. no. 41]

5. Oskar Schlemmer, *Abstract Figure*, 1921, cast executed 1962, nickeled bronze, 41½ x 24⅝ x 8½". The Baltimore Museum of Art, Janet and Alan Wurtzburger Collection. [cat. no. 56]

6. Oskar Schlemmer, *Grotesque*, 1923, wood, 22 x 11". Staatsgalerie Stuttgart. Photo Oskar Schlemmer Archiv.

7. Oskar Schlemmer, *Glass Dance,* from Schlemmer's *Triadic Ballet,* 1929. Photo Oskar Schlemmer Archiv.

8. Hans Bellmer, *La Poupée*, 1934.

9. Hans Bellmer, *La Poupée*, 1936, cast executed 1965, painted aluminum, 18¼". William N. Copley Collection. [cat. no. 8]

10. Hans Bellmer, *The Machine Gunneress in a State of Grace*, 1937, wood and metal, 30⅞ x 29¾ x 13⅝". The Museum of Modern Art, New York. Advisory Committee Fund.

11. Constantin Brancusi, *Torso of a Young Man*, 1916(?), wood, 19". Philadelphia Museum of Art, The Louise and Walter Arensberg Collection.

12. Constantin Brancusi, *King of Kings*, 1920, wood, 118⅛". The Solomon R. Guggenheim Museum, New York. Photo Robert E. Mates.

13. Jean Arp, *Torso*, 1925, wood, 9½ x 6¾". Private Collection. Photo Seuphor, Vanves.

14. Jean Arp, *Torso*, 1931, cast executed 1957, bronze, 36". The Baltimore Museum of Art, Janet and Alan Wurtzburger Collection.

15. Jean Arp, *Concrétion Humaine Sans Coupe*, 1933, bronze with gold patina, 22½ x 21 x 17". San Francisco Museum of Modern Art, William L. Gerstle Collection. [cat. no. 3]

16. Jean Arp, *Pre-Adamic Torso*, 1938, limestone, 18⅞". Private Collection. Photo Dietrich Widmer, Basel.

17. Jean Arp, *Growth*, 1938, bronze, 40". Sidney Janis Gallery. Photo Geoffrey Clements. [cat. no. 4]

18. Jacques Lipchitz, *Pierrot Escapes*, 1926, bronze, 18¼". Kunsthaus Zurich.

19. Jacques Lipchitz, *Figure*, 1926–30, bronze, 87½ x 38½ x 28½". The Hirshhorn Museum and Sculpture Garden, Smithsonian Institution, Washington, D.C.

20. Jacques Lipchitz, *Joie de Vivre*, 1927, bronze, 89¼". Marlborough Gallery, New York. Photo Otto E. Nelson.

21. Jacques Lipshitz, *The Couple (The Cry)*, 1928–29, bronze, 28 x 58". Marlborough Gallery, New York. Photo Otto E. Nelson. [cat. no. 37]

22. Pablo Picasso, *Figure of a Woman*, 1928, bronze, 8⅝". Estate of the artist. Photo Brassaï, Paris.

23. Pablo Picasso, *Figure*, 1935, wood, string and metal, 44⅛ x 23⅝ x 13¾". Estate of the artist. Photo courtesy Fine Arts Council of Great Britain.

24. Pablo Picasso, *Woman with Leaves*, 1934, bronze, 15 x 7⅞ x 10⅝". Estate of the artist. Photo courtesy Courtauld Institute of Art.

25. Pablo Picasso, *Woman*, 1933, plaster, 27½". Estate of the artist. Photo Brassai, Paris.

26. Pablo Picasso, *Woman*, 1932, bronze, 27⅞ x 12⅝ x 15¾". Estate of the artist. Photo courtesy Courtauld Institute of Art.

27. Julio Gonzalez, *Woman Combing Her Hair*, 1936, wrought iron, 52 x 23½ x 24⅝". The Museum of Modern Art, New York. Mrs. Simon Guggenheim Fund.

28. Julio Gonzalez, *Grande faucille*, 1936–37, bronze, 20⅛". Collection M. Prévot-Douatte, Paris.

29. Julio Gonzalez, *Torso*, c. 1936, iron, 24½". The Museum of Modern Art, New York. Gift of Mr. and Mrs. Samuel A. Marx.

30. Alberto Giacometti, *Spoon Woman*, 1926, cast executed 1954, bronze, 57". The Solomon R. Guggenheim Museum, New York. Photo Robert E. Mates. [cat. no. 21]

31. Alberto Giacometti, *Man (Apollo)*, 1929, bronze, 15¾ x 13¾ x 3¾". Private Collection, California. Photo Gene's Studio. [cat. no. 23]

32. Alberto Giacometti, *Suspended Ball*, 1930–31, plaster and metal, 24 x 14⅛ x 13¼". The Alberto Giacometti Foundation, Kunsthaus Zurich.

33. Alberto Giacometti, *Woman with her Throat Cut*, 1932, bronze, cast 1949, 8 x 34½ x 25". The Museum of Modern Art, New York. Purchase.

34. Alberto Giacometti, *Invisible Object (Hands Holding the Void)*, 1934, bronze, cast 1935, 60⅝ x 12¾ x 11″. Albright-Knox Art Gallery, Buffalo, New York, Edmund Hayes Fund. Photo Phototech, Buffalo. [cat. no. 24]

35. Alberto Giacometti, *Woman with Chariot I*, 1942–43, bronze, 65¾″. Pierre Matisse Gallery. Photo Eric Pollitzer.

36. Max Ernst, *Oedipus II*, 1934, bronze, cast 1960, 24⁷/₁₆″. Menil Foundation Collection, Houston. Photo Hickey and Robertson. [cat. no. 17]

37. Max Ernst, *Lunar Asparagus*, 1935, plaster, h. 65¼″. The Museum of Modern Art, New York. Purchase.

38. Incomplete Sculptures, Max Ernst's studio, Paris, 1935.

39. Max Ernst, *An Anxious Friend*, 1944, bronze, 26⅜ x 14 x 16″. Collection Mr. and Mrs. Harry W. Anderson. [cat. no. 18]

40. Henry Moore, *Composition*, 1931, blue horton stone, 19″. Collection Mary Moore. Photo Archives Photographiques.

41. Henry Moore, *Two Forms*, 1934, pynkado wood, l. 21″. The Museum of Modern Art, New York. Sir Michael Sadler Fund.

42. Henry Moore, *Four Piece Composition*, 1934, alabaster, 11 x 21 x 11″. Photo O.E. Nelson.

43. Henry Moore, *Stringed Figure*, 1937, cherry wood and string, 20″. Collection Mrs. Irina Moore. Photo Errol Jackson.

44. Henry Moore, *Reclining Figure*, 1939, elmwood, l. 79″. The Detroit Institute of Arts, Gift of Dexter M. Ferry Jr. Trustee Corporation.

45. Barbara Hepworth, *Pierced Form*, 1931, alabaster, 10″. (Destroyed in World War II). Photo courtesy Barbara Hepworth Museum, St. Ives.

46. Barbara Hepworth, *Two Segments and a Sphere*, 1935–36, marble, 12″. Lillian H. Florsheim Foundation for Fine Arts. Photo James Marchael.

47. Barbara Hepworth, *Elegy*, 1945, wood with paint, 15″. McCrory Corporation, New York. Photo courtesy Barbara Hepworth Museum, St. Ives. [cat. no. 30]

48. Barbara Hepworth, *Pendour*, 1947, wood with paint, 10⅜ x 27¼ x 9″. Hirshhorn Museum and Sculpture Garden, Smithsonian Institution, Washington, D.C.

49. Jacob Epstein, *Joseph Conrad*, 1924–25, bronze, 16½ x 11¾ x 10″. Hirshhorn Museum and Sculpture Garden, Smithsonian Institution, Washington, D.C.

50. Giacomo Manzù, *Bust of a Girl at a Window*, 1943, bronze, 13¾″. Private Collection. Photo courtesy of the artist.

51. Marino Marini, *Portrait of the Artist*, 1942, plaster, dimensions unknown. Private Collection.

52. Henri Matisse, *Henriette II*, 1927, bronze, 12⅝ x 8½ x 10¾″. San Francisco Museum of Modern Art. Bequest of Harriet Lane Levy. [cat. no. 43]

53. Henri Matisse, *Henriette III*, 1929, bronze, 16″. Hirshhorn Museum and Sculpture Garden, Smithsonian Institution, Washington, D.C. Photo O.E. Nelson.

54. Henri Matisse, *Tiaré*, 1930 (?), marble, 7⅞″. Músée Matisse, Nice-Cimiez. Photo Claude Frossard.

55. Jacques Lipchitz, *Portrait of Gertrude Stein*, 1920, bronze, 13½″. Photo Archives Photographiques.

56. Alexander Calder, *Josephine Baker*, 1927–29, iron wire, 39 x 22⅜ x 9¾″. The Museum of Modern Art, New York. Gift of the artist.

57. Alberto Giacometti, *Portrait of the Artist's Father*, 1927, bronze, 10⅞ x 8½ x 5⅜″. Private Collection, California. Photo Gene's Studio. [cat. no. 22]

58. Rudolf Belling, *Organic Form*, 1921, bronze, 21½″. The St. Louis Art Museum. Gift of Mr. and Mrs. Morton D. May. [cat. no. 6]

59. Rudolf Belling, *Sculpture 23*, 1923, bronze, partly silvered, 18⅞ x 7¾ x 8½″. The Museum of Modern Art, New York. A. Conger Goodyear Fund.

60. Rudolf Belling, *Head (Fragment of a Group: Madonna and Child)* 1925, brass, 15⅛ x 8⅞ x 10⅜″. Walker Art Center, Minneapolis. Gift of the T. B. Walker Foundation. Photo Eric Sutherland. [cat. no. 7]

61. Pablo Picasso, *Head*, 1928, painted metal, 10″. Estate of the artist. Photo Jean Debout, Paris.

62. Pablo Picasso, *Head of a Woman*, 1931, painted iron, 39⅜ x 14½ x 24″. Estate of the artist. Photo courtesy Galerie Louise Leiris.

63. Pablo Picasso, *Head*, 1931, iron, 33 x 15¾ x 14¼″. Estate of the artist. Photo courtesy Galerie Louise Leiris.

64. Pablo Picasso, *Bust of a Woman*, 1932, bronze, 25⅛″. Estate of the artist. Photo courtesy the Museum of Modern Art, New York.

65. Pablo Picasso, *Death's Head*, 1943, bronze, 11⅜ x 8⅜ x 10¼″. Estate of the artist.

66. Julio Gonzalez, *Head called "The Tunnel,"* 1933–34, iron, 18⅛″. The Tate Gallery, London.

67. Julio Gonzalez, *Head*, 1935, iron, 17¾ x 15¼″. The Museum of Modern Art, New York. Purchase, 1937. [cat. no. 26]

68. Julio Gonzalez, *Head of the Montserrat Crying II*, 1942, bronze, 12¾ x 6⅛ x 10¼″. Indiana University Art Museum. William Lowe Bryan Memorial. [cat. no. 28]

69. Alberto Giacometti, *Observing Head*, 1927–29, marble, 16⅛ x 14½ x 3⅛″. The Alberto Giacometti Foundation, Kunsthaus Zurich. Photo Robert E. Mates.

70. Henry Moore, *Carving*, 1936, marble, 18". Collection the artist. Photo Errol Jackson.

71. Henry Moore, *The Helmet*, 1939–40, lead, 11½". Collection of Roland Penrose. Photo Archives Photographiques.

72. Jacques Lipchitz, *The Helmet*, 1932, bronze, 9". Stedelijk Museum, Amsterdam.

73. Vladimir Tatlin, *Construction*, 1914, iron, stucco, glass, asphalt. Dimensions and present location unknown.

74. Third Obmokhu Exhibition, Moscow, 1921.

75. Kasimir Medunetsky, *Construction No. 557*, 1919, tin, brass, iron, 17¾". Yale University Art Gallery. Gift of Collection Société Anonyme. Photo Joseph Szaszfai. [cat. no. 44]

76. Alexander Rodchenko, *Suspended Composition*, 1920–21, reconstructed 1973, aluminum, 33½ x 21⅝ x 18½". Indiana University Art Museum. [cat. no. 54]

77. Alexander Rodchenko, *Construction in Space*, 1919, wood. Probably destroyed. Photograph from Alfred H. Barr, Jr. Archive, courtesy of the Museum of Modern Art, New York.

78. Naum Gabo, *Linear Construction No. 1, Variation*, 1942–43, plastic, 24½". Collection Nina Gabo. Photo Roger Franklin. [cat. no. 20]

79. Georgii Stenberg, *Construction in Space: KPS 13*, 1919, reconstructed 1974, iron, glass, wood and steel stays, 94⅞". Galerie Jean Chauvelin, Paris. [cat. no. 58]

80. Kasimir Malevich, *Suprematist Architecton*, 1922, painted wood, 3¼ x 9⅝ x 5¾". Galerie Jean Chauvelin, Paris. [cat. no. 39]

81. Vassily Ermilov, *Architectonic Construction*, 1930, painted wood, 60⅝ x 16⅛ x 12¼". Galerie Bargera, Cologne.

82. Naum Gabo, *Head of a Woman*, c. 1917–20 after a work of 1916, celluloid and metal, 24½ x 19¼". The Museum of Modern Art, New York. Purchase.

83. Naum Gabo, *Column*, 1923, plexiglass, wood, metal, glass, 41½ x 29 x 29". The Solomon R. Guggenheim Museum, New York. Photo Robert E. Mates.

84. Naum Gabo, *Spiral Theme*, 1941, plastic, 5½ x 13¼ x 9⅜". The Museum of Modern Art, New York. Advisory Committee Fund.

85. Naum Gabo, *Construction (Stone with Collar)*, 1933, stone and plastic, 16 x 27". Collection of Miriam Gabo. Photo Faber Studio. [cat. no. 19]

86. Antoine Pevsner, *Torso*, 1924–26, plastic, 29½ x 11⅜". The Museum of Modern Art, New York. Katherine S. Dreier Bequest.

87. Antoine Pevsner, *Portrait of Marcel Duchamp*, 1926, celluloid on copper, formerly zinc, 37⅛ x 25⅝". Yale University Art Gallery. Gift of Collection Société Anonyme. Photo Joseph Szaszfai.

88. Antoine Pevsner, *The Dancer* (side view), 1927–29, brass and celluloid, 31¼". Yale University Art Gallery. Gift of Collection Société Anonyme.

89. Antoine Pevsner, *Developable Column*, 1942, brass and oxidized bronze, 20¾". The Museum of Modern Art, New York. Purchase, 1950. [cat. no. 51]

90. Katarzyna Kobro, *Space Composition 5*, 1929–30, painted steel, 9⅞ x 25¼ x 15¾". Muzeum Sztuki, Lodz, Poland. [cat. no. 31]

91. László Moholy-Nagy, *Nickel Construction*, 1921, nickel-plated iron, welded, 14⅛" high, base 6⅞ x 9⅜". The Museum of Modern Art, New York. Gift of Mrs. Sibyl Moholy-Nagy.

92. László Moholy-Nagy, *Light-Space Modulator*, 1930, motorized construction with steel, plastic and wood, 59½". Busch-Reisinger Museum, Harvard University.

93. László Moholy-Nagy, *Dual Form with Chromium rods*, 1946, plexiglass and chrome rods, 36½ x 47½ x 48". The Solomon R. Guggenheim Museum, New York. Photo Robert E. Mates. [cat. no. 45]

94. Georges Vantongerloo, *Construction of Volume Relations*, 1921, mahogany, 16⅛ x 4¾ x 4⅛". The Museum of Modern Art, New York. Gift of Silvia Pizitz.

95. Max Bill, *Construction from a Ring*, 1940–41, gilt bronze, 29½ x 27½ x 32¼". Collection of the artist. Photo Fotostudio Herbert Michel.

96. Max Bill, *Endless Ribbon*, 1935, executed in diorite 1965, 60 x 40 x 48".

97. Alexander Calder, *A Universe*, 1934, motor-driven mobile: painted iron pipe, wire and wood with string, 40½" high. The Museum of Modern Art, New York. Gift of Abby Aldrich Rockefeller.

98. Alexander Calder, *Calderberry Bush*, 1932, painted sheet metal, wood, wire and rod, 84 x 56". Collection Mr. and Mrs. James Johnson Sweeney. Photo Geoffrey Clements.

99. Alexander Calder, *Whale*, 1937, standing stabile: painted sheet steel, supported by a log of wood, 68 x 69½ x 45⅜". The Museum of Modern Art, New York. Gift of the artist.

100. Otto Freundlich, *Ascension*, 1929, bronze, 78¾". Private Collection.

101. Vladimir Tatlin, *Counter Relief*, 1915, reconstructed 1966–70 by Martyn Chalk, iron, aluminum and paint, 27 x 32¾ x 31". Annely Juda Fine Art, London.

102. Henri Matisse, *Back IV*, 1930, bronze, 74 x 44¼ x 6". Photo Patricia M. Elsen.

103. Pablo Picasso, *Construction with a Glove*, 1930, cardboard, plaster, and wood on canvas, covered with sand, 10⅝ x 14". Estate of the artist. Photo courtesy The Museum of Modern Art, New York.

104. Pablo Picasso, *Face of a Woman*, 1934, bronze, 11 x 9⅞". Estate of the artist. Photo John Webb.

105. Giacomo Manzù, *Self Portrait with Model at Bergamo*, 1942, bronze, 50 x 37 x 10″. Hirshhorn Museum and Sculpture Garden, Smithsonian Institution, Washington, D.C.

106. Jean Arp, *Torso, Navel, Head with Moustache*, 1930, painted wood, 31½ x 39¼″. Collection of Muriel Kallis Newman.

107. Jean Arp, *Constellation of Leaves on Oval Form*, 1930, painted wood, 19 x 23¾″. Private Collection, New York. Photo Marc Vaux, Paris. [cat. no. 2]

108. Oskar Schlemmer, *Constructive Sculpture "R,"* 1919, cast executed after 1959, aluminum, 39⅛ x 9⅞ x 4¾″. Fischer Fine Art, Ltd. [cat. no. 5]

109. Oskar Schlemmer, Wall Reliefs in Workshop Building, Weimar Bauhaus, 1923 (destroyed). Photo Oskar Schlemmer Archiv.

110. Oskar Schlemmer, *Wire Relief Mural* in home of Dr. Rabe in Zwenkau, 1931. Photo Staatsgalerie Stuttgart.

111. Kurt Schwitters, *Merz Construction*, 1921, wood, paint, nails, wire, cardboard, 15 x 8¼ x 2½″. Philadelphia Museum of Art. A.E. Gallatin Collection.

112. Kurt Schwitters, *Merzbau*, Hanover (destroyed). Courtesy Kunstmuseum Hanover.

113. César Domela, *Collage*, 1930, painted wood, metal, and glass, 19⅝ x 15⅞. Smith College Museum of Art, Northampton, Massachusetts. Purchased 1935. Photo David Stansbury. [cat. no. 15]

114. Naum Gabo, *Circular Relief*, 1925, plastic on wood, 19½″ diam. Estate of the artist.

115. Antoine Pevsner, *Abstraction (Bas-relief en creux)*, 1927, brass, 23¾ x 24⅝″. Washington University Gallery of Art, St. Louis. [cat. no. 50]

116. Ben Nicholson, *White Relief*, c. 1937–38, painted wood, 25¼ x 49½″. Albright-Knox Art Gallery, Buffalo. Gift of Seymour H. Knox. Photo Phototech, Buffalo. [cat. no. 49]

117. Alexander Calder, *Constellation*, 1943, painted wood and wire, 22 x 44½″. The Solomon R. Guggenheim Museum, New York. Photo Robert E. Mates.

118. Joan Miró, *Relief Construction*, 1930, wood and metal, 35⅞ x 27⅝″. The Museum of Modern Art, New York. Purchase.

119. Jacques Lipchitz, *Reclining Nude with Guitar*, 1928, bronze, 16 x 29¾ x 13″. Hirshhorn Museum and Sculpture Garden, Smithsonian Institution, Wash., D.C.. [cat. no. 36]

120. Barbara Hepworth, *Sculpture*, 1936, stone, 72″ (destroyed).

121. Wilhelm Lehmbrück, *Seated Youth*, 1917, tinted plaster, 40⅝ x 30 x 45½″. National Gallery of Art, Washington D.C. Andrew W. Mellon Fund.

122. Ernst Barlach, *The Güstrow Memorial*, 1927, recast after World War II, bronze, 28 x 29⅜ x 83½″. Güstrow Cathedral, Germany.

123. Käthe Kollwitz, *Self Portrait*, 1926–36, bronze, 14⅛ x 9⅛ x 11⅜″. Hirshhorn Museum and Sculpture Garden, Smithsonian Institution, Wash., D.C.. [cat. no. 32]

124. Ernst Barlach, *The Magdeburg Memorial*, 1929, wood, 255 x 154 x 75 cm. Magdeburg Cathedral, Germany. Photo Beyer.

125. Rudolf Belling, *Gesture of Freedom*, 1921, plaster (probably destroyed.)

126. Vladimir Tatlin, *Monument to the Third International* (model), 1919–20, wood, iron and glass (destroyed).

127. Naum Gabo, *Monument for an Institute of Physics and Mathematics*, 1925, rlass and bronze, 24″. Collection in the U.S.S.R.

128. Antoine Pevsner, *Construction for an Airport*, 1934, brass and crystal on marble base, 30⅞″.

129. Pablo Picasso, *Construction in Wire*, 1928–29, iron wire, 19⅝ x 16⅛ x 6¾″. Estate of the artist. Photo John Webb.

130. Pablo Picasso, *Woman in a Garden*, 1929–30, bronze after a painted iron original, 82¾ x 46 x 32¼″. Estate of the artist.

131. Constantin Brancusi, *Table of Silence* at Tîrgu Jiu, 1937–38, stone, diameter of installation c. 18′3″. Photo F. B. Florescu.

132. Constantin Brancusi, *Gate of the Kiss* at Tîrgu Jiu, 1938, stone, 17′3½″ x 21′7⅛″ x 6′½″.

133. Constantin Brancusi, *Endless Column* at Tîrgu Jiu, 1937, cast iron, 96′ 2⅞″ x 35⅜″ x 35⅜″. Photo F. B. Florescu.

134. Giacomo Manzù, *Crucifixion with Soldier and Sorrowful Figures* from "Cristo nella nostra umanità" reliefs, 1942, cast executed in 1957, bronze, 30½ x 22″. Paul Rosenberg & Co., New York. Photo Taylor & Dull, Inc. [cat. no. 40]

135. Alberto Giacometti, *No More Play*, 1933, marble, 15¾ x 11⅞ x 2″. Collection Mr. and Mrs. Julien Levy.

136. Jacques Lipchitz in Paris in 1937 with the clay model of his *Prometheus Strangling the Vulture*.

137. Barbara Hepworth, *Monument to the Spanish War*, 1938–39, wood, 70″ (destroyed in World War II). Photo courtesy Barbara Hepworth Museum, St. Ives.

138. Henry Moore, *Spanish Prisoner*, c. 1939, lithograph, 14⅜ x 12″. Art Gallery of Ontario, Toronto, Gift of Henry Moore, 1976.

139. Henry Moore, *Madonna and Child*, 1943–44, horton stone, 59″. Church of St. Matthew, Northampton. Photo courtesy of the artist.

140. Julio Gonzalez, *Montserrat*, 1937, iron, 64″. Stedelijk Museum, Amsterdam.

141. Julio Gonzalez, *Cactus Man II*, 1939, bronze cast executed after iron original, 30¾". Munson-Williams-Proctor Institute, Utica, New York. [cat. no. 27]

142. Jacques Lipchitz, *Mother and Child II*, 1941–45, bronze, 50". The Museum of Modern Art, New York. Mrs. Simon Guggenheim Fund. Photo Soichi Sunami.

143. Henri Laurens, *The Farewell*, 1940, bronze, 9⅛ x 11⅞ x 9⅞". Musée National d'Art Moderne, Paris. Photo SPADEM–ADAGP, Paris. [cat. no. 34]

144. Pablo Picasso, *Man with a Sheep*, 1944, bronze, 79½ x 29¾ x 29". Philadelphia Museum of Art. Gift of R. Sturgis and Marion B. F. Ingersoll. [cat. no. 53]

145. Ernst Barlach, 1938.

146. Käthe Kollwitz, *Pyramid of Mothers*, 1937–38, bronze, 10⅝ x 10⅞ x 11".

147. Arno Breker, *Comrades*, c. 1939, stone.

148. Alexander Calder, *Black Spot on Gimbals*, 1942, wire, 16 x 19 x 9¾". Private Collection, New York. [cat. no. 13]

149. Constantin Brancusi, *Golden Bird*, 1919 (?), polished bronze, 37¾ x 6½". The Minneapolis Institute of Arts, The John R. Van Derlip Fund.

150. Henry Moore, *Reclining Figure*, 1935–36, elmwood, 19 x 35 x 15". Albright-Knox Art Gallery, Buffalo, New York. Room of Contemporary Art Fund. [cat. no. 48]

Catalogue of the Exhibition/Biographies

Dimensions are given in inches, with height preceding width and depth. Information on casts, signatures and inscriptions have been provided by the lenders.

ALEXANDER ARCHIPENKO

Archipenko was born on May 30, 1887 in Kiev, the son of a mechanical engineer and inventor. Intrigued by relationships between art and science, he entered art school in Kiev in 1902, studying both painting and sculpture, but soon became discontented with the old-fashioned curriculum. In 1906 he went to Moscow, where he participated in various group shows, and at the age of twenty he moved to Paris. There Archipenko attended classes for a brief period at the École des Beaux-Arts. His work at this time consisted primarily of treatments of the female nude in either a simplified, stylish mode or a more primitivizing manner, but about 1910 he learned of Cubism through Léger and began adapting Cubist fragmentation to his own purposes. A series of highly innovative works soon followed, including *Walking*, the first *Médrano* of 1912, and *Boxers* of 1913. Characteristic are the use of discontinuous, geometrized shapes to assert a strong sense of movement and the substitution of concave for convex parts of the body; Archipenko's exploration of voids to imply volume was the earliest instance of this device in modern sculpture. His series of "Sculpto-Painting" assemblages beginning in 1912 pioneered new combinations of materials and the use of painted surfaces. He exhibited regularly at the Paris Salons, beginning in 1910 at the Salon des Indépendants and 1912 at the Salon d'Automne, and had his first one-man exhibition in Germany at the Folkwang Museum, Hagen, in 1912. Archipenko spent the war years at Cimiez, near Nice, and in 1919 began extensive travels throughout Europe, settling first in Berlin where he opened an art school and then in 1923 in the United States. The following year he opened a summer art school in Woodstock and invented a variable image system known as the "Peinture Changeante" or "Archipentura." He taught at numerous institutions throughout the United States while continuing to make sculpture, but his repeated stylizations of the female figure generally lack the strength of his earlier work. In 1960 he completed his book *Archipenko: Fifty Creative Years 1908 – 1958*. The recipient of many exhibitions and honors, Archipenko died in New York in 1964.

1. **Floating Torso, 1935 – 36**
 terra cotta, 4¾ x 20 x 2⅜"
 inscribed under right leg: Archipenko X
 San Francisco Museum of Modern Art, Gift of Mrs. Drew Chidester

JEAN (HANS) ARP

Born in Strasbourg on September 16, 1886, Jean (Hans) Arp showed a precocious talent for both poetry and art, dual and interconnecting interests which he would manage to harmonize throughout his life. He studied first at the Strasbourg School of Applied Art and then at the Weimar Art School (1905 – 07) and at the Académie Julian in Paris (1908). Working mainly during the following years at Weggis, Switzerland, he met Kandinsky and contributed to the second *Blaue Reiter* exhibition (1912) and the 1913 *Herbstsalon* at Der Sturm gallery in Berlin. He met Max Ernst in 1914 and in 1915 Sophie Taeuber, whom he would later marry and with whom he explored chance effects in the making of abstract collages and paintings. They helped found and were moving spirits behind the Dada group in Zurich. Arp's first abstract reliefs in wood, dating from 1916, counter Picasso's roughly constructed assemblages with clean, whimsical forms in harmonious arrangement. Collaborations with Ernst in Cologne and Schwitters in Hanover followed, and in 1925 he helped Lissitzky publish *Kunstismen*. Arp moved to Paris in 1920; he contributed to the International Dada Exhibition at the Montaigne Gallery in 1922 and the first Surrealist exhibition in 1925, maintaining friendly relations with the Surrealists thereafter. In the late twenties Arp's reliefs had increased in size and by 1930 they had developed into sculpture in the round. With Brancusi he shared an interest in reducing natural forms to a magical essence; distinctive to his work, however, are the qualities of undulating growth and organic fertility which are so poetically evoked in his ceaselessly inventive shapes. Working in bronze as well as stone and wood, he handled ideas on both monumental and modest scales, while continuing all the while to produce poetry, collages, book illustrations and tapestry designs. In 1930 he joined the group *Cercle et Carré* and in 1931 helped found *Abstraction-Création*. The important series of *Concrétions humaines* began in 1933. During the war Arp took refuge in Switzerland and afterward returned to his studio at Meudon, outside of Paris. A first trip to America was made in 1949, and in 1958 he had a retrospective exhibition at the Museum of Modern Art. In his later years he traveled a good deal and enjoyed a number of honors and major commissions. Arp died on June 7, 1966, in Basel.

2. Constellation of Leaves on Oval Form, 1930
painted wood, 19 x 23¾"
signed on label on back
Private Collection, New York [fig. 107]

3. Concrétion Humaine Sans Coupe, 1933
bronze with gold patina, 22½ x 21 x 17"
San Francisco Museum of Modern Art, William L.
Gerstle Collection [fig. 15]

4. Growth, 1938
bronze, 40"
Sidney Janis Gallery [fig. 17]

ERNST BARLACH

Also important as an avant-garde dramatist and poet, Ernst Barlach, born in 1870 in the small Holstein town of Wedel, is best known as a sculptor and graphic artist. He first studied at the Hamburg School of Arts and Crafts (1888 – 91) in order to become a drawing teacher and then at the Dresden Academy as the master-pupil of Robert Diez. During two periods in Paris (1895 and 1897) he attended the Académie Julian, and from 1898 to 1902 he illustrated the review *Jugend*. Barlach worked on several memorial designs during this period and from 1904 to 1906 taught at the Hör School of Ceramics in the Westerwald. A trip to Russia in 1906 and the drawings he made there of simple peasant folk provided him with material for the first sculptures characteristic of his mature style, *The Melon Eater* (1907) and *Russian Beggar-Woman* (1906). Informing the simplified stylizations and spirituality of Barlach's work is the tradition of Northern Medieval carving, while the weightiness and compact rhythms with which he endows his figures are a personal signature and help to express his themes of endurance, suffering and loneliness. In peasants and other humble types he found symbols of what he described as "the human condition in its nakedness between Heaven and Earth." Barlach signed a contract with the Berlin dealer Paul Cassirer in 1907 that enabled him to work full time on his art. Cassirer hosted the artist's first major exhibition in 1917 as well as a retrospective in 1926. In 1910 Barlach withdrew to Güstrow, where he lived and worked for most of the rest of his life. He served briefly in the army during World War I and became a member of the Berlin Akademie der Künste in 1919 and the Munich Academy in 1925. During the twenties he completed several commissions: his earliest war memorial was the wood relief *Mater Dolorosa* for the Nikolai Church of Kiel, followed by his Güstrow memorial, a large and solemn suspended angel (1927), the *Champion of the Spirit* for the University Church at Kiel (1928), and a wood memorial for the Cathedral at Magdeburg

(1929). Primarily a wood carver, he also produced plasters and bronzes, although his works in these media have the same bulky contours and rough-hewn look as his carvings. With the rise of the National Socialist party in Germany, Barlach suffered increasing persecution. Two major memorials at Güstrow and Magdeburg were removed under the "Order *Entarte Kunst*," 381 works, including graphics, were confiscated and several were shown in the Degenerate Art exhibition of 1937. Broken in spirit and forbidden any further exhibitions, Barlach died of a long-standing heart ailment on October 24, 1938. He was given a memorial exhibition the following month at the Buchholz Gallery in New York.

5. The Singing Man, 1928
bronze, 19¾ x 18⅛ x 16½"
Indiana University Art Museum, William Lowe
Bryan Memorial

RUDOLF BELLING

Rudolf Belling was born on August 26, 1886, in Berlin. From 1905 to 1907 he worked as assistant to a figurine modeler and then in a theater scenery workshop from 1908 to 1910. Under Prof. Peter Breuer he studied at the Berlin Academy, 1911 – 12. Belling became associated with the group *Der Sturm* in Berlin and his early work, in its expressionistic treatment of the human figure, shows its influence. Beginning in the mid-teens, however, a more formalistic approach reflecting the impact of Cubism and Archipenko is seen, particularly in his abstract *Triple Clang* of 1919. In 1918 Belling helped found the *Novembergruppe*, dedicated to rebuilding German art after the devastations of war, and in the following years he collaborated with architects such as Würzbach, Taut and others, providing fountains, architectural sculptures and interior designs all reflecting a modern Constructivist sensibility. Belling was at the height of his creativity during the twenties and was particularly drawn at this time to polished, precise, machine-like forms, often interpreting the human body or head as a mechanistic assemblage at once playful and sinister in its robot connotations. In later work he reverted to more organic forms. He became a member of the Prussian Academy of Art in 1931 but after Hitler's rise to power his work was branded "degenerate" and in 1937 he emigrated to Turkey. There he taught sculpture at the Istanbul Academy from 1937 to 1951 and then held a professorship at the Istanbul Technical University. In 1966 he returned to Germany and took up residence at Krailling near Munich.

6. Organic Form (Standing Man), 1921
bronze, 21½"

incised on base: Rudolf Belling 21
The St. Louis Art Museum, Gift of Mr. and Mrs.
 Morton D. May [fig. 58]

**7. Head (Fragment of a Group: Madonna and
 Child), 1925**
 brass, 15⅛ x 8⅞ x 10½″
 Walker Art Center, Minneapolis. Gift of the
 T. B. Walker Foundation [fig. 60]

HANS BELLMER

Hans Bellmer was born on March 13, 1902, in
Katowice, Germany. In 1923 he entered the Berlin
Polytechnical School, where he became ac-
quainted with George Grosz and John Heartfield.
There his interests turned to typography and after
one year he abandoned his studies to work with the
publisher Malik-Verlag. He married in 1927 and
established himself in Berlin as an industrial artist.
Between 1930 and 1933 Bellmer traveled widely;
among the experiences most important for his later
development was a visit to Grunewald's expres-
sionistic altarpiece at Colmar. After the Nazi
takeover in 1933 he ceased all productive commer-
cial activity as a personal gesture of defiance and
began work on his "artificial girls" or puppets,
highly erotic fetish objects, the fragments of which
could be assembled in various hallucinatory combi-
nations. The *poupée* theme remained an obsession
for Bellmer and he subsequently made several
sculptures dealing with aggressively truncated and
recombined female forms. Equally unsettling are his
beautifully executed but erotically and sometimes
sadistically charged drawings of pubescent girls. In
1938 after the death of his wife he fled Germany and
settled in Paris, joining the Surrealist group. He was
interned as an enemy alien in 1939 and, at a con-
centration camp in Les Milles, near Aix, ex-
perimented with Max Ernst on decalcomania.
After the French demobilization he resumed in-
tense work in painting, drawing, illustrating, and
writing. He left an imposing graphic oeuvre, much
of it unpublished, when he died in semi-seclusion in
Paris, 1975.

8. La Poupée, 1936, cast 1965
 painted aluminum, 18¼″
 Collection William N. Copley [fig. 9]

MAX BILL

An artist who has successfully fulfilled the Bauhaus
ideal of unification of "fine" and "applied" arts,
Max Bill continues today to pursue diverse interests
as an architect, painter, sculptor, printmaker, and
industrial designer. Born in Winterthur, Switzer-
land in 1908, Bill trained as a silversmith at the
Kunstgewerbeschule in Zurich from 1924 – 27 and

then at the Bauhaus, 1927 – 29, where Albers and
Moholy-Nagy had particularly strong influences on
him. Another important formative experience was
his visit in 1925 to the *Exposition International d'Art
Decoratif* in Paris where he was introduced to the
formally purified, geometrically based work of Le
Corbusier, Josef Hofmann, and Frederick Kiesler.
In 1929 Bill established himself in Zurich, where he
has lived and worked ever since. His early metal-
work shows a distinctive clarity of design which also
informs the abstract sculpture he began making in
1932 and which, from the beginning, was con-
cerned with problems of spatial expression. Bill
joined *Abstraction-Création* in Paris in 1932 and
contributed to their exhibitions and publications
until the group dissolved in 1936. Always interested
in mathematics, he explored during the late thirties
and early forties certain sculptural concepts based
on topological or mathematical principles; these
concepts would remain leitmotifs in his work, with
evolving treatment in numerous repetitions, varia-
tions, and different materials. In 1944 Bill organized
in Basel the first international exhibition of *Con-
crete Art*, a concept of total self-specificity in art
that Bill defined in his theoretical writings. He was
a lecturer at the Kunstgewerbeschule in Zurich in
1944 – 45, taught in the Department of Architec-
ture at the Technische Hochschule in Darmstadt in
1948, and in 1951 helped found the Hochschule für
Gestaltung at Ulm. In 1957 he opened his own
design and architecture office in Zurich. Among
the awards and commissions Bill has received are
the Grand Prix for designing the Swiss Pavilion at
the Milan *Triennale* (1936 and 1951), first interna-
tional prize for sculpture at *I Bienal de São Paulo*
(1951), and third prize in the international compe-
tition for the *Monument to the Unknown Political
Prisoner.*

9. Konstruktion, 1937
 brass, 19¾ x 10¼ x 10¼‴
 Kunstmuseum Basel

CONSTANTIN BRANCUSI

Born to well-to-do farming parents in the small
Rumanian village of Hobita on February 19, 1876,
Brancusi would carry throughout his life a strong
identification with his peasant roots as well as an
innate feeling for the rugged simplicity and direct-
ness of folk art. In 1894 he enrolled at the School of
Arts and Crafts in Craiova; four years later he
entered the School of Fine Arts in Bucharest,
graduating in 1902. The following year he departed
for Paris on foot. There he studied for two years at
the École des Beaux-Arts (1905 – 07) and worked
briefly for Rodin. Rodin's modeling style influenced
Brancusi's early Parisian work but he was also drawn

to primitive and ancient art; by 1907 – 08, when carving had emerged as his primary mode, he was already tending toward the essentialization of form that marks his mature output. This search for inner essences beyond natural appearances frequently led him to work in series, and the earliest versions of *The Kiss* (1907), the *Sleeping Child* (1908) and the *Maiastra* (1910) initiate certain characteristic themes that he would return to periodically, seeking ever more refined solutions. Five of his works were included in the 1913 Armory Show and in 1914 he had his first one-man exhibition at Stieglitz's Photo-Secession Gallery. Although he had a profound influence on such artists as Modigliani, Epstein, and Gaudier-Brzeska, Brancusi was solitary and retiring by nature and his reputation spread quite slowly. The notoriety surrounding the withdrawal of *Princess* X from the Salon des Indépendants in 1920, however, and a special number of *The Little Review* dedicated to him in 1921 brought wider attention. He had his second one-man exhibition at the Wildenstein Gallery in New York in 1926 and subsequently was shown in a great many exhibitions in both Europe and America. The famous trial over the status of *Bird in Space* (was it art work or an object of manufacture?) was held in 1927. In 1935 Brancusi was invited to design a war memorial for Tîrgu Jiu in Rumania, the installation of which began with his *Endless Column* in 1937. A skillful technician and always attentive to the relation of his works to the space around them, Brancusi often made his own bases, playing off the form, material and surface of the support against the sculpture itself. In 1947 V. G. Paleolog's important monograph on Brancusi was published in Bucharest and in 1949 he completed his last work, the *Grand Coq.* Brancusi died in Paris on March 16, 1957, having willed the contents of his studio to the French state. His total lifetime production numbers under 300 sculptures but his contribution to modern art was immense, offering against the formalism of the Cubists and Constructivists a consistent vision of simplified, rethought natural form that, while pursuing an extreme purification, retains a symbolic, poetic and even mystical dimension.

10. **Golden Bird, 1919 (?)**
 polished bronze, 37¾ x 6½"
 signed at base: C. Brancusi
 The Minneapolis Institute of Arts, The John R. Van Derlip Fund [fig. 149]
11. **Mlle. Pogany II, 1920**
 polished bronze, 17¼ x 7"
 signed at right rear: C. Brancusi and stamped: C. Valsuani cire perdue
 Albright-Knox Art Gallery, Buffalo, New York. Charlotte A. Watson Fund [frontispiece]

ALEXANDER CALDER

Born on July 22, 1898 into a family of American sculptors, Calder nevertheless came to his maturity as an artist while living in France and his style is inextricably bound to modern European developments. While his family background laid a foundation for future interests, his earliest proclivities were for mathematics and mechanics and after graduating from the Stevens Institute of Technology in 1919 he held a number of engineering-related jobs. In 1922 in New York he attended drawing classes taught by Clinton Balmer and after several odd jobs enrolled at the Art Students' League, continuing there until his departure for Paris in 1926. He also free-lanced as an artist for the *National Police Gazette* and in 1925 made his first wire sculpture. In Paris Calder attended drawing classes at the Académie de la Grand Chaumière and continued his work with open-form wire sculptures, exhibiting at the Salon des Indépendants in 1926 and making the first figures for his famous miniature *Circus.* He began giving performances of the *Circus* for friends in 1927, and the circus aesthetic, with its play of movement, color, gaiety, and acts of balance and tension, would remain important to his work thereafter. He also made his first wood carving in 1926. Wire sculptures were exhibited in his first one-man show at the Weyhe Gallery in New York and also at the Salon de l'Araignée in Paris in 1928; Calder's first Parisian one-man show was at the Galerie Billiet in 1929. His friendship with Miró and a visit to Mondrian's studio in 1930 encouraged a new departure, the first abstract paintings and sculpture. At this time Calder began to paint his sculpture white and primary colors and started to incorporate movement and sound as well. He joined *Abstraction-Création* in 1931 and an important exhibition at the Galerie Percier in 1931 introduced a series of abstract constructions or "stabiles" (Arp's term). Calder's "mobiles" (thus christened by Duchamp), the art form with which he is most closely associated, were at first mechanized or hand-cranked sculptures but developed almost simultaneously into the longer-lasting form of standing or hanging works with lightly balanced armatures that depend upon the action of hand or wind for movement. His design interests were wide-ranging and took him into many different fields: he designed stage settings (1935, 1936, 1946, 1950, 1963), made jewelry, designed a mercury fountain (1937) and a water ballet (1939), produced a number of large-scale mobiles and stabiles for architectural settings, illustrated books, and constantly made drawings, gouaches, and many prints. *Whale,* his first large-scale stabile, dates from 1937.

A major Calder exhibition was held at the Museum of Modern Art in 1943, and from the same year dates the first of his *Constellations*. Numerous exhibitions and major commissions followed. He died in New York in 1976.

12. **Four Leaves and Three Petals**, c. 1939
 sheet metal and wire, 85 x 67 x 47½"
 inscribed on largest leaf: CA

 Estate of Alexander Calder courtesy of M. Knoedler & Co., Inc., New York

13. **Black Spot on Gimbals**, 1942
 wire, 16 x 19 x 9¾"
 Private Collection, New York [fig. 148]

14. **Constellation**, c. 1943
 wood and wire, 23 x 23 x 8"
 Private Collection, New York

CESAR DOMELA

Although he first emerged in the twenties as a painter in the De Stijl school, Domela is best known for and has left his mark on modern sculpture through his precise geometric reliefs assembled from such "machine-age" materials as aluminum strips, plastic, brass and bakelite. These developed as forward projections of rectilinear elements in paintings starting in 1927 and became increasingly complex through the thirties with the introduction of diverse, somewhat precious materials and curvilinear rhythms. César Domela-Nieuwenhuis was born in Amsterdam on January 15, 1900. His early work dating from c. 1918 shows the influence of Synthetic Cubism and by 1923 he had pushed his simplified, geometric forms into total abstraction. That year he went to Berlin, where he exhibited with the *Novembergrüppe*, and then moved to Paris. In the work of Mondrian and van Doesburg, whom he met in 1924, he encountered concerns similar to his own, and in that same year he joined the De Stijl group. Nineteen twenty-four also brought his first one-man exhibition at the Audretsch Gallery in the Hague. At the end of 1925 Domela moved back to Amsterdam and then in 1927 to Berlin, where he became involved in commercial typography and photomontage. He exhibited in *Die Abstrakten* in Hanover, joined the *Ring der neuen Werbegestatter* founded by Schwitters, and was closely associated with a number of left-wing activities. In 1933 he fled to Paris, where he has lived ever since. His activities as an important advocate of non-figurative art included publishing works in both the *Cercle et Carré* and *Abstraction-Création* folios, exhibiting in *Cubism and Abstract Art* at the Museum of Modern Art in 1936 and *Konstruktivisten* at the Basel Kunsthalle in 1937, and helping Arp and Taeuber-Arp initiate the re-view *Plastique*. Exhibitions at the Galerie Pierre (1934 and 1939) were followed by important shows at the Galerie Denise René in 1947, Galerie Apollinaire in London in 1948, Galerie Cahiers d'Art in 1952, and several retrospectives beginning with the Museum of Modern Art in Rio de Janeiro in 1954 and the Stedelijk Museum in Amsterdam in 1955.

15. **Collage**, 1930
 painted wood, metal, glass, 19⅝ x 15⅞"
 signed lower left: Domela

 Smith College Museum of Art, Northampton, Massachusetts. Purchased 1935 [fig. 113]

JACOB EPSTEIN

Jacob Epstein was born November 10, 1880 on the Lower East Side of New York City to parents of Polish-Jewish heritage. He would later vividly portray this area in illustrations for Hutchins Hopgood's *The Spirit of the Ghetto* (1902). His first ambition was to become a painter and he enrolled c. 1896 in the Art Students' League to study painting and drawing, but work in a bronze foundry helped to arouse his interest in sculpture and in 1902 he went to Paris to immerse himself in the work of Rodin and the European tradition. He studied at the École des Beaux-Arts from 1902 to 1905 and also attended the Académie Julian, receiving occasional instruction from J. P. Laurens. In 1905 he went to England and subsequently became a British citizen. Epstein quickly met a number of leading literary and artistic figures who encouraged his work, and in 1907 he received his first major commission for eighteen large figures on the British Medical Association Building in the Strand. Upon their completion these stark, archaicized figures were greeted by a public outcry, as was also his *Tomb of Oscar Wilde* in the Père Lachaise Cemetery, Paris (1912). A principal member of the Vorticist group, Epstein's machine-age aesthetics are reflected in his famous *Rock Drill* of 1913. This and other works of the period made him the leader of English modern sculpture. He had his first one-man exhibition at the Twenty-One Gallery, Adelphi, 1913, and was to show frequently (mainly portrait busts) at the Leicester Galleries. By the end of World War I, Epstein's work had shifted away from abstract and mechanical forms toward representationalism, although his interest in primitive models continued and occasionally broke through in such allegorical and religious works as the Hudson Memorial (1925), the personification of *Day* and *Night* on the Westminster Underground Headquarters (1929), *Genesis* of 1931, and the huge *Adam* of 1939. He also received a number of public commissions including the so-called *Cavendish Square Madonna and Child*, 1950, a *Christ in Majesty* for Llandoff Cathedral,

1955, and a *St. Michael* for Coventry Cathedral, 1958. Epstein was knighted in 1954. He died in London on August 19, 1959.

16. Portrait of George Bernard Shaw, 1934
bronze, 26 x 19½ x 11″
Collection of Armand J. Castellani, Niagara Falls, New York

MAX ERNST

Max Ernst's bountiful imagination found creative expression in several different media: perhaps best known as a painter and collagist, he also made a number of early carvings and assemblages, produced several Dada reliefs and about 1934 began making free-standing sculpture, an activity that would occupy him recurrently for the rest of his life. Much of the latter work, executed in plaster, remained little known until it was cast in bronze in the fifties. Born on April 2, 1891, in Brühl, Germany, Ernst began to paint as a youth but at the University of Bonn studied philosophy and abnormal psychology. Friendships with Macke, Marc and other of the German Expressionists, however, encouraged his interest in art and in 1913 he participated in the *Erster Deutscher Herbstsalon* at Der Sturm gallery in Berlin. The poetic inventions of de Chirico also had a strong effect on him, as can be clearly seen in his Dadaist work starting in 1919, including his first collages and altered engravings. With Baargeld he founded the Cologne Dada group. At the invitation of Breton he had his first one-man exhibition in Paris in 1921 at the Galerie au sans Pareil and the following year moved to Paris, where he became an instrumental force in the Surrealist movement. His cultivation of automatism as a direct path to the subconscious led to such inventive techniques as decalcomania, frottage and grattage, all exploiting chance occurrences. Always concerned with the mythic and with anti-rational transformations of objects and forms, he created in his sculpture a personal zoography of fantasy creatures, sometimes mysterious and haunting, sometimes whimsical. Ernst showed two sculptures in the important exhibition of *Fantastic Art, Dada, Surrealism* at the Museum of Modern Art in 1936. With the outbreak of war, Ernst was interned as an alien by the French but escaped and fled in 1941 to the United States, eventually settling in Sedona, Arizona. He continued to have contact with several Surrealist artists who had also immigrated to the United States. The first of several retrospectives were held at the Galerie Denise René in Paris in 1945 and at the Schloss Augustusburg in Brühl in 1951. In 1953 Ernst returned to France. He continued to paint and make collages and sculpture until his death in 1976.

17. Oedipus II, 1934, cast 1960
bronze, 24 7/16″
signed on front of base: V/VI max ernst and stamped on back of base: Susse Fondeur Paris
Menil Foundation Collection, Houston [fig. 36]

18. An Anxious Friend, 1944
bronze, 26⅜ x 14 x 16″
signed on base; Max Ernst 1944, and stamped: Modern Art Foundry, N.Y.C.
Collection of Mr. and Mrs. Harry W. Anderson [fig. 39]

NAUM GABO

Naum Neemia Pevsner (he later changed his surname to Gabo to avoid confusion with his brother, the sculptor Antoine Pevsner) was born in Briansk, Russia, in 1890. After graduating from the Gymnasium at Kursk in 1910, he studied at the University of Munich and at the Munich polytechnicum school. In 1913 and again in 1914 he visited his brother Antoine in Paris, where he met Archipenko and became acquainted with Cubist painting; with the outbreak of war in 1914 he went to Copenhagen and then Oslo with his younger brother, Alexei. Antoine joined them, and it was here that Gabo made his first constructions in 1915. Influenced by Cubism and Futurism but also by his scientific training, these works open up sculptural mass through a honeycombing of thin planes that evokes engineering processes and makes for a dynamic unity of interior and exterior space. In 1917 Gabo returned to Moscow; Pevsner was on the faculty of the *Vkhutemas* and Gabo set up his studio nearby. Gabo sought to produce models of harmony and order that draw upon scientific thought, give a new experience of space and depth, and embody certain intuitons about the universe. Alienated, however, by the utilitarian program championed by Tatlin and Rodchenko, Gabo wrote (and Pevsner signed) in 1920 the *Realistic Manifesto* as a defense of pure artistic research, and that year the two also held their first public exhibition along the Tverskoi Boulevard. In 1922 Gabo went to Berlin to help supervise work on the First Russian Art Exhibition and remained in Berlin for most of the next ten years. Gabo was associated with the *Novembergrüppe* in Germany, lectured at the Bauhaus and in major cities in Germany and Holland, and in 1926 exhibited for the first time in America at the Little Review Gallery with van Doesburg and Pevsner. His first one-man exhibition of constructions was at the Kestner-Gesellschaft in Hanover, 1930. In 1932 Gabo left Berlin for Paris, where he joined the *Abstraction-Création* group, and in 1935 he settled in London. With J. L. Martin and Ben Nicholson he published *Circle, International Survey of Con-*

structivist Art. In 1946 Gabo left England for the United States and settled in Connecticut, where he lived and worked until his death in 1977.

19. **Construction (Stone with Collar), 1933**
 Portland stone, slate slab, 14¼"
 Collection of Miriam Gabo [fig. 85]

20. **Linear Construction No. 1, Variation, 1942–43**
 plastic and nylon thread, 24 x 24"
 Collection of Nina Gabo [fig. 78]

ALBERTO GIACOMETTI

Alberto Giacometti was born October 10, 1901 in Stampa, Switzerland. His father, the painter Giovanni Giacometti, encouraged his interest in art, and at the age of fourteen he produced his first sculpture, a bust of his brother Diego. In 1919 he enrolled at the École des Arts et Métiers in Geneva to study sculpture but left the following year to travel in Italy, where he steeped himself in ancient and Renaissance art and also became acquainted with the work of the Futurists. Moving to Paris in January 1922, he entered the Académie de la Grande Chaumière and continued there intermittently for the next five years under Bourdelle. Giacometti's earliest work was from life but about 1925, when he took his first studio, he abandoned the model and started working instead from his imagination. Cubism and the elemental, evocative forms of primitive art helped to shape his ideas but he quickly moved beyond these sources into a personal "vision of reality" in which found objects, sexual symbolism, open skeletal shapes, and dream-like situations are drawn upon. In 1929 he met Ernst, Breton and Dali and joined the Surrealists, although he was never steadfastly committed to their cause. His first one-man show was in 1932 at the Galerie Pierre Collé in Paris, and in 1934 he showed in New York at the Julien Levy Gallery. Giacometti's work from "interior models" culminated in the *Invisible Object* of 1934 – 35, after which he returned to working from life. For approximately the next ten years he produced little, struggling with how to render his own impressions of the human figure and frequently reducing his sculptures to miniscule size. During the forties there emerged the characteristic elongated figures with eroded and scarred surfaces that would remain the basis of his sculptural style and would also be translated into paintings, drawings and prints. After the war, in 1948, Giacometti had his first one-man show in fourteen years at the Pierre Matisse Gallery. Numerous honors and prizes soon accrued and he became one of the most widely recognized and collected modern sculptors. He died January 11, 1966 in Coiro (Grisons), Switzerland.

21. **Spoon Woman, 1926, cast 1954**
 bronze, 57"
 signed on back: Alberto Giacometti and on base: A. Giacometti ³⁄₆
 The Solomon R. Guggenheim Museum, New York [fig. 30]

22. **Portrait of the Artist's Father, 1927**
 bronze, 10⅞ x 8 ½ x 5⅜"
 Private Collection, California [fig. 57]

23. **Man (Apollo), 1929**
 bronze, 15¾ x 12 x 3⅜"
 Private Collection, California [fig. 31]

24. **Invisible Object (Hands Holding the Void), 1934, cast 1935**
 bronze, 60⅝ x 12¾ x 11"
 signed inside of base at back: Alberto Giacometti / 5/6 1935 and stamped: Susse Fondeur Paris
 Albright-Knox Art Gallery, Buffalo. Edmund Hayes Fund Cover [fig. 34]

JULIO GONZALEZ

Julio Gonzalez was born on September 21, 1876 in Barcelona, where his father and grandfather were goldsmiths and metalworkers. With his older brother Juan he was taught metalwork by his father; they also studied painting together at the Escuela de Bellas Artes and became acquainted with Barcelona's avant-garde. During the 1890s Julio exhibited naturalistic metal objects several times at the *Exposición de Bellas Artes* and the *Exposición de Industrias Artísticas*. About 1900 he moved with his family to Paris, where he became closely acquainted with Picasso (whom he had met in Barcelona) and his friends. Gonzalez made his living as a craftsman in metal but centered his artistic efforts chiefly on painting and pastels, working under a variety of influences but showing no exceptional talent. He also made his first masks at this time. The loss of his brother in 1908, however, resulted in about a ten-year period of withdrawal. In 1918 Gonzalez began working at a Renault factory, where he learned oxyacetylene welding. From 1917 to 1926 he gradually increased his productivity — he had one-man shows at the Caméléon in 1921 and at the Galerie Povolovsky in 1922—but only in about 1926 did he resolve a long-standing uncertainty by abandoning painting for sculpture. In 1928 Picasso asked Gonzalez to assist him in welding a series of metal sculptures; Gonzalez's mastery of technique enabled Picasso to realize certain daring sculptural ideas in metal, and from the collaboration Gonzalez gained a liberated sense of the expressive possibilities of the welded iron medium. His own work at the time centered mostly on relatively flat, collage-like heads and masks but he quickly developed his con-

cept of the figure as an open, skeletal, almost entirely abstract configuration. Nineteen thirty-one saw important exhibitions at the Galerie de France in Paris and the Galerie le Centaure in Brussels, and in 1932 Gonzalez joined the Constructivist group *Cercle et Carré*. Naturalistic elements gradually asserted themselves more strongly in his work, culminating in the large figure entitled *Montserrat*, a personal indictment of war that was exhibited in the Spanish pavilion at the Paris World's Fair of 1937. Due to a shortage of oxygen and acetylene during the war Gonzalez was forced to give up working in iron and concentrated instead on drawing and modeling in plaster. He died on March 27, 1942, at Arcueil outside of Paris, leaving a body of work that has been a rich source of inspiration for later generations of sculptors.

25. Reclining Figure, 1934
iron, 17¾ x 37⅜"
The Museum of Modern Art, New York. Bequest of Nelson A. Rockefeller

26. Head, 1935
iron, 17¾ x 15¼"
The Museum of Modern Art, New York. Purchase, 1937 [fig. 67]

27. Cactus Man II, 1939, cast posthumously
bronze, after an iron original, 30¾"
signed on curve of leg: Gonzalez
Munson-Williams-Proctor Institute, Utica, New York [fig. 141]

28. Head of the Montserrat Crying II, 1942
bronze, 12¾ x 6⅛ x 10¼"
stamped lower right side: © by Gonzalez / Susse Fondeur Paris ⁵/₆
Indiana University Art Museum, William Lowe Bryan Memorial [fig. 68]

BARBARA HEPWORTH

Barbara Hepworth was born on January 10, 1903, in Wakefield, Yorkshire. Her formal artistic training began at seventeen when she entered the Leeds School of Art on scholarship, where Henry Moore was a fellow student; this was followed by three years at the Royal College of Art in London studying sculpture. A travel scholarship in 1924 enabled her to go to Italy to study the Renaissance masters. In Florence in 1925 she married the sculptor John Skeaping and together they studied marble carving under the master-carver Ardini; thereafter direct carving was her primary mode of expression. Returning to England, she arranged an exhibition of carvings with Skeaping in their St. John's Wood studio, December 1927. In 1928 she moved to the Mall Studios, Hampstead, where she remained until 1939. This area in the thirties would become a nucleus of fertile artistic activity, with Hepworth,

Moore, Ben Nicholson, Herbert Read, Adrian Stokes, and eventually Gabo and Mondrian living in close proximity and sharing ideas and criticism. Hepworth had her first one-artist exhibition at the Beaux-Arts Gallery in London in 1928, followed by fairly frequent shows at Tooth & Sons and Reid & Lefevre. Strong influences at this time were Epstein and Gaudier-Brzeska, and she shared with Moore an interest in primitive art that translated into carvings of blocky stone and wooden figures with a pointedly totemic or mysterious quality. In 1931 Hepworth joined the 7 & 5 Society, a group with a strong modernist bias, and exhibited with them until their dissolution in 1936. Her exposure to the work of Ben Nicholson at this time encouraged her pursuit of free, abstract sculptural form, a debt she freely acknowledged and which was reversed when Nicholson began carving reliefs. The simplified, organic forms of Arp and Brancusi greatly impressed her and she began her own research into elegantly purified shapes, evocative of natural formations and rhythmic forces of growth, expansion and erosion. Her first pierced sculpture, incorporating the void as a formal element, dates from 1931. In the summer of 1933, Hepworth and Nicholson were invited to join the *Abstraction-Création* group, and both became members of Unit One in 1934. With the outbreak of World War II, she moved with Nicholson, whom she had married, to St. Ives where she lived the rest of her life. Her first retrospective was held at Temple Newsam, Leeds, in 1943. With her expanding reputation in the 1950s came numerous awards and exhibitions, as well as a number of major commissions, including her *Meridian* (1960) for the State House in London and *Single Form* (1964), a memorial to Dag Hammerskjöld. She died on May 20, 1975, the victim of a fire in her studio.

29. Two Forms, 1935
marble, 6¼ x 16 x 8¾"
Collection Jim Edwards

30. Elegy, 1945
wood with paint, 15"
Collection McCrory Corporation, New York [fig. 47]

KATARZYNA KOBRO

Katarzyna Kobro was born in Moscow into a Latvian family on January 26, 1898. Just before and after 1917 she studied at the Moscow Institute of Painting, Sculpture, and Architecture and then at the reorganized *Svomas/Vkhutemas*. There she met the painter and designer Strzeminski, whom she later married. During these years Kobro was closely involved with the Moscow avant-garde, including Medunetsky and Tatlin; their work, as well as that

of Malevich, influenced her earliest sculptural efforts about 1920. In 1920 she moved to Smolensk where her sculptures were shown at exhibitions organized by the Fine Arts Section (IZO); in the years 1920 – 21 she was a member of the group *Unovis* ("Affirmers of the New Art") led by Lissitzky and Malevich in Vitebsk. Her interests turned to problems of spatial assemblage, and following her move to Poland with Strzeminski in 1922 she developed a distinctive Constructivist style in which cleanly cut metallic planes, both curved and flat, are joined in constructions which have an elegant and rhythmic lightness but which suggest volume through their spatial projections. Her aim was to unify space and solid and to systematize the design of her sculpture through the use of mathematical formulas. Visually, these works offer, in their clear, rectilinear composition and use of white and primary colors, a sculptural counterpoint to the paintings of the De Stijl group. In 1924 Kobro joined the Blok group of Polish avant-garde artists and in 1926, the Praesens group. She also taught at various art schools. In 1929 with Strzeminski she developed a theory of the interrelationships of sculptural and architectural form that appeared as a book in 1931. These principles, based on a mathematical calculation of proportion and the idea of sculpture and architecture organizing the environment, are seen in all her sculpture from 1925 on. In 1931 she moved to Lodz, Poland. In 1932 she joined *Abstraction-Création* and had an article and several works published in its folios. Her work on abstract sculpture, typographical design and theoretical writings continued until the war; nearly all the works in her studio, however, were destroyed by the Nazis. After the war a serious illness prevented her from resuming creative work. She remained in Lodz until her death in February 1951.

31. **Space Composition 5, 1929 – 30**
 painted steel, 9⅞ x 25¼ x 15¾"
 inscribed: MS/SN/R/19
 Muzeum Sztuki, Lodz, Poland [fig. 90]

KÄTHE KOLLWITZ

Although best-known for her prints and drawings, Käthe Kollwitz also produced a sizeable body of sculpture, generally dealing, through portraits and figure studies, with the same themes of torment and suffering so powerfully exposed in her graphics. The wife of a physician who treated the poor, and mother of a son who died in World War I, Kollwitz was no stranger to human misery, but managed always in her work to raise it to a level of universal experience. Kollwitz was born in Königsberg, East Prussia (now Kaliningrad) on July 8, 1867. Encouraged by her father, she went to Berlin to study under

Karl Stauffer-Bern at the School for Women Artists (1885 – 86) and then took painting instruction from Ludwig Herterich in Munich (1888 – 89). The etchings of Max Klinger and the social themes of such writers as Ibsen and Tolstoy helped mold her development. In 1891 she married Dr. Karl Kollwitz, a physician who tended to the poor in the slums of North Berlin. Kollwitz's first etchings date from 1890, and in 1893 she participated in the *Freie Kunstausstellung* in Berlin. Kollwitz first tried her hand at sculpture in 1910, although the decisive influence on her work in this medium was not felt until 1917, when she was deeply impressed by a Barlach exhibition at Paul Cassirer's gallery in Berlin. Like Barlach, she used closed, static forms and rather blunt modeling to help suggest the durability of mankind and the psychological weight of constant suffering and turmoil. In 1919 she was made a member of the Prussian Academy of Art and given a professorship. Upon the loss of her son in 1914 she conceived the idea of a monumental memorial, and finally in 1932 her monument *The Parents* was dedicated in the Soldiers' Cemetery near Dixmuiden in Belgium. With Hitlers' rise in 1933, Kollwitz resigned from the Prussian Academy and was stripped of her professorship. Despite increasing restrictions, however, she continued to work, completing her last major print cycle, *Death*, in 1936 and actually achieving in these years her greatest sculptural output. In 1943 she was forced to evacuate Berlin; her apartment and studio were bombed and many prints and plates were destroyed. She died in Moritzburg near Dresden in April 1945.

32. **Self-Portrait, 1926 – 36**
 bronze, 14⅜ x 9⅛ x 11⅜"
 inscribed on back lower right: Kollwitz
 Hirshhorn Museum and Sculpture Garden, Smithsonian Institution [fig. 123]

HENRI LAURENS

Henri Laurens was born in Paris on February 18, 1885. He first served an apprenticeship in an interior decorating studio and worked as an ornamental stone mason. His only formal artistic training was through evening drawing classes with "Le Père Perrin," an academic sculptor. In 1911 Laurens first met Braque, with whom he became good friends, and later Picasso, Gris and Léger, whose art would have an important and lasting, if not immediate, effect on his own, for Laurens developed gradually toward Cubism. In his earliest work is felt the influence of both Rodin and medieval sculpture. Still life and figure constructions in wood and plaster from 1913 – 15 show his familiarity with Braque's and Picasso's experiments in collage and *as-*

semblage, and Laurens's constructions in wood and steel (1915 – 18) and his first reliefs of terra cotta, wood and stone (1919 – 20), along with the *papier collés* and drawings of that period, reveal his affinities with Cubist principles. He was particularly interested in the use of color to control the effects of light and applied polychromy to many of his works throughout the years from 1915 to about 1928. The introduction of curved forms into Laurens's work around 1921 prefigured an important change in his style, and from 1925 he permanently discarded the hard, angular planes of Cubism for a figural manner that was characterized by soft, organic shapes and a concern for serpentine contour akin to that of Matisse. His use of the more traditional materials of stone and bronze conveyed the desired qualities of density, compactness and monumentality. Laurens's first one-man show was in 1916 at the Galerie de l'Effort Moderne. His skills as a designer were manifested in his sets for the Russian ballet of Diaghilev in 1923, his illustrations for *Le Pélican* by R. Radiguet, 1921, followed by several decorative commissions between 1926 and 1931. In 1932 – 33 Laurens lived at Etang-la-ville, near Maillol and the painter Roussel, and completed his first monumental sculptures, *L'Océanide* and *Les Ondines*. He was the recipient of several awards and major exhibitions including those at the Art Club of Chicago (1941), the Palais des Beaux-Arts, Brussels (1949) and the Musée National d'Art Moderne in Paris (1951). He died in Paris on May 8, 1954.

33. **Large Seated Woman**, 1932
 bronze, 27½ x 19½ x 13″
 signed on back: HL 1/6 and stamped: Valsuani cire perdue
 Albright-Knox Art Gallery, Buffalo, New York. Gift of the Seymour H. Knox Foundation

34. **The Farewell**, 1940
 bronze, 9 x 11¾ x 9⅞″
 Musée National d'Art Moderne, Paris [fig. 143]

JACQUES LIPCHITZ

The most prominent sculptor of the Cubist movement, Lipchitz in the twenties and thirties expanded beyond the boundaries of Cubism into his own world of sculptural beings and grand dramatic themes. Jacques (né Chaim Jacob) Lipchitz was born on August 22, 1891, in Druskieniki, Lithuania, to a prosperous Jewish family. Lipchitz showed early artistic promise but his father insisted on a career in engineering so, without his consent, he escaped to Paris in 1909 to study art. In 1909 – 10, he attended classes at the École des Beaux-Arts and also at the Calarossi and Julian Academies. Recalled to Russia in 1912 for military service, he was dismissed for reasons of health and returned to Paris where he took a studio beside Brancusi's. Through his friend Diego Rivera he became acquainted with several artists and writers in the Cubist circle including Max Jacob, Picasso and Gris. At first he resisted the principles of Cubism, his work at the time showing a kind of academic stylishness, but by 1914 and 1915 he was faceting, simplifying, and restructuring the human figure, sometimes to the point of almost complete abstraction. Lipchitz exhibited at the Salon d'Automne in 1912 and with Diego Rivera in Madrid in 1914. In 1920 he had his first one-man exhibition at Léonce Rosenberg's gallery. Maurice Raynal's important early monograph on his work dates from the same year, and indicative of his standing in the art world was a commission in 1922 from Dr. Albert C. Barnes to execute bas-reliefs for the Barnes Foundation. Late 1925 saw the beginning of a new stage in his development with the first "transparents," open assemblages of flat and linear shapes cast into bronze that anticipate the aerated metal figures of Picasso and Gonzalez. His *Prometheus*, commissioned for the 1937 Paris World's Fair and representative of Lipchitz's later style in its dramatic mythological theme and baroque handling, won a gold medal. In May of 1940 Lipchitz was forced to flee Paris and in June of the following year went to New York, taking a studio in Washington Square. During his American years he achieved wide recognition and was the recipient of numerous commissions. In January 1952 a fire destroyed the contents of his 23rd Street studio including several works in progress. His book, *My Life in Sculpture*, was published in 1972. Lipchitz died the following year on the island of Capri.

35. **Mardi Gras**, 1926
 bronze, 11 x 7 x 6″
 signed on top of base: Lipchitz
 Collection of Mr. and Mrs. Walter B. Ford II

36. **Reclining Nude with Guitar**, 1928
 bronze, 16¼ x 29¾ x 13¼″
 signed on back of base at right: J Lipchitz
 Hirshhorn Museum and Sculpture Garden, Smithsonian Institution [fig. 119]

37. **The Couple (The Cry)**, 1928 – 29
 bronze, 28 x 58″
 Marlborough Gallery, New York [fig. 21]

ARISTIDE MAILLOL

Aristide Maillol was born December 8, 1861, in the Mediterranean fishing village of Banyuls. His interest in art led him to Paris in 1887 where he studied painting at the École des Beaux-Arts under Gérôme and Cabanel. Of more lasting influence, however,

was his early exposure to the work of Gauguin and then later his friendships with members of the Nabis group. Maillol's interest in tapestry, encouraged by his study of Gothic tapestries at the Cluny Museum, resulted in his establishing a workshop in 1893 and exhibiting at the Salon de la Société Nationale until the foundation of the Salon d'Automne in 1904. At the age of thirty-nine, when failing eyesight forced him to give up tapestry work, Maillol turned to sculpture, having already made a number of small scale wood carvings and terra cottas. Vollard purchased several works in 1900 and had them cast in bronze, helping to alleviate Maillol's impoverishment. His mature sculptural style, based more on his Nabis-inspired tapestry designs, drawings, and paintings than on any conscious imitation of ancient sculpture, was achieved early and varied little throughout his career. His principal subject was the nude female figure, realized in terms of smooth surfaces, weighty, monumental forms, and attitudes of calm and repose; he was equally at home working on figures the size of a hand or larger than life. A one-man show at Vollard's gallery in 1902 established his reputation and drew the praise of Rodin, and further acclaim soon came through works exhibited at the Salon d'Automne, where he showed regularly from 1904. The following year Maillol received the first of many commissions, a monument in memory of Auguste Blanqui, for which he created *Action in Chains*. He also enjoyed the patronage of the German Count Kessler and the Russian collector Morozoff, both of whom purchased major works (e.g. *Mediterranean*, 1905, and *Pomona*, 1910) and commissioned others. From 1919 to 1920 Maillol worked on a stone memorial monument for the town of Céret, the first of several postwar monument commissions. In 1925 the Albright Art Gallery of Buffalo hosted his first United States exhibition. Maillol's many drawings and book illustrations reveal the same instincts for broad contour and essential form that characterize his sculpture. During the Second World War he lived in seclusion at Banyuls, working on drawings, paintings and his last sculpture, *Harmony*, completed in 1944. He died on September 27, 1944, as a result of injuries sustained in an automobile accident.

38. Torso of the "Ile-de-France," 1921

bronze, 47½ x 13 x 20″
signed on top of base: M 5/6 and stamped at rear of base: Alexis Rudier, Paris

The Fine Arts Museums of San Francisco, Gift of the Mildred Anna Williams Fund to the California Palace of the Legion of Honor [fig. 3]

KASIMIR MALEVICH

Although primarily a painter, Malevich in his *Architecton* of c. 1920 – 30 (most of which unfortunately have been lost) pursued in three-dimensional form his vision of dynamic geometric structure, achieving a visionary marriage of sculpture and architecture. These works were among the most important of his post-Revolution productions, and he showed them in a number of exhibitions during the 1920s and 1930s. Kasimir Malevich was born on February 26, 1878 near Kiev to working-class Polish-Russian parents. He received little formal education as a boy and although he became an avid reader, the sometimes confused nature of his later writings betray his humble background. He began painting on his own and with particular dedication after his family moved to Kursk in the mid-1890s where, in 1898, he had his first public showing. In 1902 Malevich fulfilled a longtime dream by moving to Moscow to attend the School of Painting, Sculpture, and Architecture. His first truly independent works date from 1908 and comprise boldly simplified figure paintings on rural peasant themes. Throughout the teens he contributed to exhibitions such as the *Knave of Diamonds* (1910), *Donkey's Tail* (1912), *Tramway V* (1915), and *0.10* (1915). Malevich's figure style, influenced both by Russian folk art and French Cubism, erupted about 1912 – 13 into a dynamic cubic division of form and a use of sharp, metallic coloration. Among his 1913 designs for Kruchenykh's Futurist opera *Victory over the Sun* was his first totally abstract geometric composition, which marked the birth of Suprematism. This system, which Malevich proclaimed in the historic *0.10* exhibition in 1915, had a profound influence on modern Russian art. His paintings "of pure sensation," as Malevich himself defined Suprematism, culminated in the famous *White on White* of 1918. During the early twenties he taught at Vitebsk and Petrograd and produced many models and porcelain designs but essentially stopped painting. Malevich visited Warsaw and Berlin in 1927, where one-man shows of his work were presented. About 1930 he returned to more representational art, even contributing to social realism. He died in Leningrad on May 15, 1935.

39. Suprematist Architecton, 1922
painted wood, 3⅛ x 9⅝ x 5¾″
Galerie Jean Chauvelin, Paris [fig. 80]

GIACOMO MANZÙ

Giacomo Manzù was born on December 22, 1908, in Bergamo, Italy, into a large and poor family. At

age eleven he was apprenticed to a wood carver and then to a gilder and plasterer, but in his spare time he took up drawing and modeling. Manzù attended briefly the Accademia Cignaroli in Verona in 1927 but was largely self-taught, and by 1928 he was producing his earliest mature work. At first showing a primitivizing tendency, his style from the beginning was based on a realistic but sensitively stylized treatment of the human body, sometimes incorporating polychromy. His first commission, for decorations in a chapel at the Catholic University of Milan, came in 1930; that same year he showed polychromed sculptures in a group exhibition at the Galleria Milano. Although a monograph on Manzù was published in 1932 and he was managing to sell a few works, he could not escape oppressive poverty, and in 1933 decided to move back to Bergamo. His style at this time reflected an enhanced appreciation of Medardo Rosso. He was working mainly in bronze and wax and the themes of much of his later work had already been set: female portraits, full-length men and women in various relaxed, unselfconscious poses, and ecclesiastical figures (seen first in drawings), all possessed of a quiet but dignified presence. On the eve of the outbreak of war in 1939 Manzù occupied himself with a series of reliefs on the theme of *Cristo nella nostra umanità* with a clear political, anti-Fascist thrust; exhibited at the Galleria Barbaroux in Milan in 1941, they aroused much heated criticism. The artist held a professorship at the Brera in Milan from 1941 to 1954 and also taught at the Academy of Turin. In 1947 he entered an international competition for a portal at St. Peter's; finally awarded the commission in 1952, he worked on the project, evolving it through many revisions, until 1964. Manzù taught for several years with Kokoschka at the International Summer Academy in Salzburg and since the early fifties has been given numerous international exhibitions. He now resides in Ardea, outside of Rome. He has been one of the few twentieth century artists to work on a consistently expressive level with figurative and religious themes; characteristically bringing forth an inner sense of spirituality and humanity, he kept alive the modeling tradition when it had lost favor elsewhere.

40. Crucifixion with Soldier and Sorrowful Figures (from "Cristo nella nostra umanità" series), 1942, cast 1957
bronze, 30½ x 22"
stamped lower right: Manzù with foundry mark
Paul Rosenberg & Co., New York [fig. 134]

MARINO MARINI

Marino Marini was born in Pistoia, Italy, on February 27, 1901. Although he studied under the sculptor Domenico Trentacoste at the Accademia di Belle Arti in Florence, he concentrated primarily upon painting and etching until 1928; his first independent sculptural achievements, such as the *Popolo*, would occur in 1929. Marini's preferred mediums are plaster, wood and cast metal and his work, like that of his compatriot Manzù, has always had a figurative, realistic basis and has frequently incorporated color; but what gives his approach modernity is the vigor of his surface handling as well as his free compacting of forms and his psychological insights. In 1929 he succeeded Arturo Martini at the Monza Art School, retaining his chair until 1940, and between 1930 and 1947 he traveled widely, including several visits to Paris, where he met many of the leading modern artists. In 1936 came the first rendition of a theme that has held constant fascination for Marini ever since, that of the Horse and Rider. Perhaps distantly linked to Tang Dynasty figurines or equestrian portraits the artist knew in Italy and Germany, this motif offered rich formal possibilities involving the organization of simplified shapes around strong axial lines but also has received differing interpretive connotations, from the tragic or heroic to the phallic. Another favorite theme has been the standing or seated nude, static and endowed with sensually swollen contours, and also the portrait head, reminiscent of Roman portraits and notable for Marini's frank psychological exploration. During the war years (1942 – 46) he lived in the Ticino in Switzerland and in 1946 he settled permanently in Milan. Marini's first exhibition in the United States was held in 1950 at the Curt Valentin Gallery in New York. In 1952 he was awarded the *Grand Prix* for sculpture at the Venice Biennale, and in 1959 he executed his largest sculpture, a twenty-three foot high monument for The Hague. A large monographic exhibition was organized by the Zurich Kunsthaus in 1962 and several others have followed.

41. Susanna, 1943
bronze, 28⅞ x 21⅛ x 10⅝"
stamped on plinth center right: MM
Hirshhorn Museum and Sculpture Garden, Smithsonian Institution [fig. 4]

HENRI MATISSE

Although his main ambition and greatest achievements were in painting, Henri Matisse, born in December 1869 at Le Cateau-Cambrésis, also produced no less than sixty-eight sculptures, the modeling of which occupied him continually, if sporadically, throughout his career. His work in sculpture was akin to that of Degas — another "painter-sculptor" — in its informality, small scale, and pri-

vate function. Matisse abandoned a law practice in 1891 to study painting in Paris, first briefly under Bouguereau at the Académie Julian and then with the more liberal Gustave Moreau. He spent considerable time copying art works in the Louvre and from about 1897 studied more contemporary masters. His first sculpture (two small portrait medallions) having been made in 1894, Matisse took up modeling seriously in the late 1890s, attending night classes, sketching ancient Greco-Roman works, and consulting Rodin and Bourdelle. Even his early sculptural exercises, such as the *Jaguar Devouring a Hare* (1899 – 1901) and the *Serf* (1900), reveal his characteristic facturing of surface and subordination of detail to an overall harmonious effect. Matisse's sculpture remained from this time almost exclusively concerned with the human form. Time spent at Collioure with Derain and trips to North Africa and Italy produced not only the vividly colored works that generated the term "fauvism" at the 1905 Salon d'Automne and such large-scale decorative paintings as *Le luxe, calme et volupté* (1907 – 08), but also a series of statuettes culminating in the striking *Serpentine* of 1909. As his international reputation grew Matisse was included in several important exhibitions in Europe and the United States. After producing a few minor pieces between the years 1913 and 1924, he resumed concentrated efforts on sculpture with one of his most ambitious works, the *Large Seated Nude* of 1924 – 25. The next five years were especially productive, with execution of the *Reclining Nudes* of 1927 and 1929, the two *Torsos* of 1929, and the Henriette portraits of 1925, 1926 – 27, and 1929. In 1930 he also completed the final version of his monumental relief, the *Back*, remarkable for its radical simplification of form. In the 1930s Matisse received several commissions, particularly for decorative projects, and also traveled to the United States and Tahiti. His first découpages date from this time. Serious surgery in 1941 rendered him a partial invalid and two years later he moved to a villa in Vence. Among his last works were the design and decorations for the Vence chapel, dating from 1948 – 51, which include the elegant, attenuated bronze crucifix, his last complete sculpture and the most nearly abstract of his three-dimensional works. Matisse died November 3, 1954.

42. **Large Seated Nude, 1923 – 25**
bronze, 30⅜ x 25⁹⁄₁₆ x 13⅞"
signed on back lower right: HM 2 and stamped: Cire perdue/ C. Valsuani
The Minneapolis Institute of Arts, Gift of the Dayton Hudson Corporation

43. **Henriette II, 1927**
bronze, 12⅝ x 8½ x 10¾"
signed back of neck: HM 6/10 and stamped Cire Perdue/Valsuani
San Francisco Museum of Modern Art, Bequest of Harriet Lane Levy [fig. 52]

KASIMIR MEDUNETSKY

Along with the Stenberg brothers, Medunetsky was a founder and one of the most prominent members of *Obmokhu* (Association of Young Artists). Very little, however, is now known of his work. Born c. 1899 in Russia, Kasimir Medunetsky studied art at the Moscow *Vkhutemas* (Higher Artistic Technical Studios); it was in this school that a contingent of students formed the *Obmokhu* group in 1919. Medunetsky exhibited at the four *Obmokhu* exhibitions from 1919 to 1921, organized with the Stenbergs an exhibition at *Inkhuk* (Institute of Artistic Culture), and in 1924 with the Stenbergs contributed as a Constructivist group to the First Discussional Exhibition of Associations of Active Revolutionary Art. Like Kobro, whom he came to know through the *Vkhutemas*, Medunetsky seems to have derived the main inspiration for his early sculpture from the pioneering constructions of Tatlin. In his few known works, different "industrial" materials are freely combined in open and dynamic three-dimensional assemblages that bespeak new "engineering" aesthetics through both their materials and method of structuring. Medunetsky participated in the First Russian Exhibition at the Van Dieman Gallery in Berlin in 1922, from which the Société Anonyme purchased his *Construction No. 557* (now in the collection of Yale University, and in this exhibition). Active after 1923 primarily as a theatrical and industrial designer, he worked along with the Stenbergs, Exter, Vesnin and others on sets and costumes for Meyerhold's and Tairov's revolutionary productions at the Kamerny Theater.

44. **Construction No. 557, 1919**
tin, brass and iron, 17¾"
signed at bottom of base: K. Medunetsky [in Russian]
Yale University Art Gallery, Gift of Collection Société Anonyme [fig. 75]

LÁSZLÓ MOHOLY-NAGY

László Moholy-Nagy was born in Bacsbarsod, Hungary, on July 20, 1895. In 1913 he enrolled as a law student at the University of Budapest, where he became involved in avant-garde literary and musical circles. In Szegad in 1917 he helped to organize the art group *Ma* ("today"). Moholy completed his law degree but thereafter devoted himself fully to a career in art, his wide-ranging interests eventually

taking him into such diverse fields as sculpture and painting, photography, stage and graphic design, and film, while he also made contributions as an art theorist. The Constructivist influence of Lissitzky and Malevich was fundamental to his development, as was also his concern for achieving his "own version of machine technology." In 1920 Moholy moved to Berlin, where he became acquainted with the Dadaists and first experimented with photograms. After seeing Moholy's first exhibition at the Galerie Der Sturm in 1922, Walter Gropius invited him to join the staff of the Bauhaus, where he taught first in the metal workshop and foundation course but later involved himself with murals, photography, and book publishing. Under increasing political pressure, he resigned from the Bauhaus along with Gropius in 1928, moving then to Berlin where he had great success as a stage designer. Always inclined toward experimentation, he worked in painting with such new materials as galalith and plexiglass and in 1930 completed his famous *Light-Space Modulator*, a kinetic sculpture and light display on which he based his film *Lichtspiel schwarz-weiss-grau*. In 1934 he moved to Amsterdam and in 1935 to London, where he undertook several design and film projects and began work on three-dimensional paintings called "space modulators." In 1937 he accepted the directorship of the New Bauhaus in Chicago but after one year the school was forced to close for financial reasons and he opened his own School of Design. About 1941 he developed the idea of the space modulator into three-dimensional sculpture, both standing and free-hanging. Moholy died of leukemia in Chicago in November 1946.

45. Dual Form with Chromium Rods, 1946
plexiglass and chrome-plated steel rods, 36½ x 47½ x 48"

The Solomon R. Guggenheim Museum, New York [fig. 93]

HENRY MOORE

Together with Barbara Hepworth and Ben Nicholson, Henry Moore helped to revolutionize modern English art and since the 1930s has greatly expanded through his landscape/body metaphors the language of twentieth century sculpture. Moore was born in Castleford, Yorkshire, on July 30, 1898. His early interest in art was encouraged in grammar school and by Gothic church carvings, and after brief combat service in the army he entered the Leeds School of Art (1919 – 21) and then won a Royal Exhibition Scholarship to study sculpture at the Royal College of Art in London. His knowledge of early Renaissance art together with the strong influence of Egyptian, Mexican and African sculpture, known to him from frequent visits to the British Museum, contributed to a primitivizing manner in his early carvings of heads and figures. One can identify in his early work the emergence of certain iconographic and formal themes that would remain important thereafter: the mother and child group, the reclining figure (first seen in 1924), the linking of external and internal form through voids, the correlation of natural forms such as pebbles, bones and landscape with the human body. Moore taught at the Royal College from 1924 to 1931 and later at the Chelsea School. He had his first one-man exhibition at the Warren Gallery in London in 1928 and that year began work on his first public commission, a relief on the facade of the new Underground Station building, St. James's Park. During the early thirties Moore's forms gradually became more biomorphic and for a period around 1933 – 35 they often verged on complete abstraction. A founding member of the Surrealist group in England, he exhibited in the International Surrealist Exhibition of 1936 but was never deeply committed to the movement's principles. He lived for a while in the Mall Studios in Hampstead near Hepworth, Nicholson and Herbert Read but in 1940 took a house at Much Hadham, Hertfordshire, where he continues to live. He had his first retrospective at Temple Newsam, Leeds, in 1941 and was appointed the same year a Trustee of the Tate Gallery. During the war he made drawings of underground shelter scenes and coal miners for the War Artists Advisory Committee. In the postwar period Moore became one of the most widely recognized modern sculptors, participating in numerous exhibitions and receiving many public commissions. Among these works were a *Madonna and Child* for St. Matthews, Northampton (1943), a reclining figure for the 1951 Festival of Britain, a stone screen for the Time-Life Building in London (1952), a reclining figure for the UNESCO headquarters in Paris (1956), and a two-piece figure for Lincoln Center, New York (1963).

46. Mother and Child, 1931
alabaster, 17½ x 9 x 6⅞"
Hirshhorn Museum and Sculpture Garden, Smithsonian Institution

47. Reclining Figure, 1931
bronze, 17"
Henry Moore Foundation

48. Reclining Figure, 1935–36
elmwood, 19 x 35 x 15"
Albright-Knox Art Gallery, Buffalo, New York. Room of Contemporary Art Fund [fig. 150]

BEN NICHOLSON

Nicholson was born on April 10, 1894 at Denham, England, into a family of artists, the most prominent of whom was his father William Nicholson, the well-known Edwardian painter and graphic designer. Essentially self-taught, Nicholson attended briefly the Slade School in London but left in 1912 after only three and a half terms to travel abroad. Important for his development was his encounter in France with the work of Cézanne, Henri Rousseau and especially the Cubists. During the twenties he experimented with various modernist modes including Cubism and primitivism, but characteristic throughout were a refined, lyrical taste, a tendency toward geometric form and also an interest in the materiality of his media which led to texturing and then actual carving of the surface. Increased contact in the early thirties with such artists in Paris as Mondrian, Miró and Calder, and his close association with Barbara Hepworth whom he would later marry, provided the catalyst for his breakthrough into total abstraction and a rigorously purified style. A cross between painting and sculpture, his famous white reliefs pushed the "less is more" aesthetic, then so current in international circles, to its farthest limits to date. Nicholson had been a member of the 7 & 5 Society since 1924 and in 1933 joined *Abstraction-Création* along with Hepworth. The two of them lived during the thirties in Hampstead where, with Moore, Herbert Read, and later Naum Gabo and Mondrian they formed a vitally productive artistic community. The important monograph *Circle, International Survey of Constructive Art* was published by Nicholson, Gabo and the architect J.L. Martin in 1937. With the outbreak of war Nicholson moved to St. Ives; he would remain there until 1958. The new coastal environment had an immediate impact on his art and he started to paint landscapes again, and shifted his concentration from abstraction to still lifes. This work culminated in the fifties with a series of monumental paintings based on the tabletop theme, which were then followed by a return to painted and carved reliefs. Nicholson showed throughout the thirties and forties at the Lefevre Gallery, London, and his increasing renown in the fifties brought several major awards and a retrospective at the Tate Gallery in 1955. He lived in the Ticino in Switzerland from 1958 to 1971 and now resides in Hampstead.

49. White Relief, c. 1937 – 38
oil on carved board, 25¼ x 49½"
signed and dated on back (now covered)
Albright-Knox Art Gallery, Buffalo, New York. Gift of Seymour H. Knox [fig. 116]

ANTOINE PEVSNER

Elder brother of the sculptor Naum Gabo, Anton (later changed to Antoine) Pevsner was born in January 1886 at Orel, Russia. Deeply impressed by Russian icons, he began painting in 1902 and studied art first at the School of Fine Arts in Kiev (1902 – 09) and then at the St. Petersburg Academy of Fine Arts (1910). In 1911 he visited Paris and remained there, except for a brief trip to Russia in 1913, until the outbreak of war. In Paris he made the acquaintance of a number of artists including Modigliani and Archipenko and began doing abstract paintings much under the influence of Cubism and Futurism. He spent the war years 1915 – 17 in Oslo with Naum Gabo, producing at this time his first sculptures. In April 1917 Pevsner returned to Moscow where he was appointed professor at the *Vkhutemas*, joining such other artist-teachers as Malevich and Kandinsky. Working closely with Gabo and experimenting with both reliefs and freestanding constructions, he helped to develop a radically modern, technologically oriented imagery utilizing such materials as metal sheeting, glass and celluloid in clean, precisely interlocked shapes. In 1920 Pevsner cosigned Gabo's *Realistic Manifesto* and mounted with him a joint exhibition along Tverskoi Boulevard. Their studios were closed by the authorities in 1921, however, because of their opposition to the social productionist movement led by Tatlin and Rodchenko. In 1922 they took part in the First Russian Exhibition in Berlin; Gabo went to Berlin and remained there and Pevsner left Russia in 1923, going first to Germany and then to Paris, where he settled permanently. The 1924 exhibition at Galerie Percier, *Constructivistes Russes: Gabo and Pevsner*, was important in bringing Constructivist ideas to France. Pevsner designed with Gabo in 1926 the sets and costumes for Diaghilev's *La Chatte*. He helped found the group *Abstraction-Création* in 1931 and also, in 1946, the Salon des Réalites Nouvelles, of which he was later made president. In his later work Pevsner generally abandoned the use of transparency and fashioned his spiraling and projecting forms out of metal sheets or frequently out of brass rods joined into a plane. These create a ribbed effect and complicate the optical activity as the shapes unfold and change from different perspectives. He died in Paris, 1962.

50. Abstraction (Bas-relief en creux), 1927
brass, 23¾ x 24⅝"
signed front lower left: Pevsner
Washington University Gallery of Art, St. Louis [fig. 115]

51. Developable Column, 1942
brass and oxidized bronze, 20¾″
signed on base in two places: AP 42
The Museum of Modern Art, New York, Purchase,
1950 [fig. 89]

PABLO PICASSO

From early in his career Picasso worked in sculpture,
a mode complementary to and often closely allied
with his investigations in other mediums. Born on
October 25, 1881, the son of a painter and art
teacher, Picasso showed a precocious talent for
painting and draftsmanship and at age fourteen
passed the entrance examination at the School of
Fine Arts in Barcelona. He also received instruc-
tion at the Royal Academy of San Fernando but by
1898 had returned to Barcelona, experimenting
there with various fin-de-siècle styles. He made his
first visit to Paris in 1900 and returned in 1901,
when he had his first exhibition at Ambroise Vol-
lard's gallery. From these years date the beginnings
of his melancholic and somber Blue Period and also
his first attempts at modeling (Seated Woman, 1901;
Mask of a Picador with Broken Nose, 1903). The
torment of the Blue Period gave way to a classicizing
phase, which led in turn to his interest in primitive
art and his earliest Cubistic experiments, boldly
inaugurated by Les Demoiselles d'Avignon, 1907.
Vollard cast a series of bronzes for him in 1905 and
in 1907 Picasso carved several African-inspired
wooden figures. The Cubist style that he and
Braque developed together in 1908 – 09 found
translation into sculpture in the faceted modeling
of the bronze Woman's Head of 1909, and the
geometric planes and collage effects of his later
Synthetic Cubism gave rise in 1912 – 14 to a series
of three-dimensional constructions of painted
wood, cardboard, paper, and other commonplace
materials. After 1914, except for occasional exper-
iments, Picasso virtually abandoned sculpture until
1928. During this period his work in painting and
drawing was extremely varied, passing through
Neoclassical, Cubist, and Surrealist phases. A
series of drawings in 1927 of grotesquely distorted
bathers led to his biomorphic Metamorphosis, a plas-
ter of 1928. That same year marked the beginning of
a collaboration between Picasso and Julio Gonzalez
in which the latter provided the technical expertise
to realize in welded metal several open form figural
assemblages. In the prodigiously inventive outpour-
ing of work in all media that followed during the
next decades, sculpture had an important place, as
evidenced by the expressively deformed heads of
Picasso's mistress Marie-Thérèse Walter from 1932,
his stick figures of 1935, the witty transformation of
found objects in bronze figures starting in the early

forties, the monumental and moving Man with a
Sheep of 1944, the robust modeling in works like the
Baboon and Young of 1951, and the cut-out metal
heads and plank figures of the mid-fifties. In 1947 a
visit to the Madoura pottery at Vallauris marked the
beginning of an intense interest in ceramics, giving
birth to both sculpture and decorated objects. After
1948 Picasso spent most of his time in southern
France. He died at Mougins, April 8, 1973.

52. Head of a Woman, 1932
bronze, 33½ x 14½ x 17⅞″
Galerie Louise Leiris, Paris

53. Man with a Sheep, 1944
bronze, 79½ x 29¾ x 29″
marked on rear of base: No. 1 Cire Perdue/C. Val-
suani
Philadelphia Museum of Art, Gift of R. Sturgis and
Marion B. F. Ingersoll [fig. 144]

ALEXANDER RODCHENKO

One of the most diverse and creative of Russia's
avant-garde artists, Rodchenko made important
contributions in the fields of photography, graphic
design and set design as well as painting and
sculpture, working initially in a fine arts tradition
but later seeking to expand the boundaries of art
into everyday life. Alexander Mikhailovich Rod-
chenko was born November 23, 1891, in St.
Petersburg, the son of a stage properties craftsman.
He studied at the Kazan Art School in Odessa from
1910 to 1914 and later moved to Moscow, where he
attended briefly the Stroganov School of Applied
Art and more importantly, became associated with
the avant-garde. In 1918 Rodchenko produced his
famous Black on Black painting, a counterpoint to
Malevich's White on White, and from that year he
worked at various levels in IZO Narkompros and
taught (until 1926) at the Moscow Proletcult
School. Although deeply influenced by Malevich
and Tatlin, the spatial constructions which Rod-
chenko began in 1918 mark a truly original innova-
tion involving open repetitions of modular shapes
that interact dynamically with space on all sides.
His hanging constructions represent probably the
first mobiles in modern art. Denouncing "fine arts"
in favor of utilitarian design, Rodchenko, from
1920 to 1930, was professor at the Vkhutemas/
Vkhutein where, in charge of the metalwork de-
partment, he directed his students toward the ideal
of the artist-engineer. Among his later activities
were collaborations with Mayakovsky on posters,
advertisements, kiosks and theater productions,
the design of a workers' club for the Russian pavil-
ion at the 1925 Paris International Exposition of
Decorative Arts, and several collaborations with
filmmakers. During the twenties and early thirties

he concentrated on photography and typography. In the mid-thirties Rodchenko returned to easel painting, producing a series of abstract "drip" compositions in the early forties. He died in Moscow in 1956.

54. **Suspended Composition, 1920-21, reconstructed 1973**
 aluminum, after a wood original, 33½ x 21¾ x 18½"
 Indiana University Art Museum [fig. 76]

OSKAR SCHLEMMER

Perhaps best known as a painter and stage designer, Oskar Schlemmer also made important contributions in sculpture, using idealized, mechanized human forms to explore his conception of the individual as an archetypal but modern being. Schlemmer was born on September 4, 1888 in Stuttgart. After an apprenticeship in an intarsia workshop, he studied first at the School of Applied Arts in Stuttgart (1905) and then at the Stuttgart Academy of Fine Arts under Adolf Hoelzel (from 1906 intermittently for many years) where he met Willi Baumeister and Otto Meyer-Amden. Schlemmer lived during 1910 in Berlin, becoming familiar with the city's avant-garde milieu, and was also influenced in his development by the structural ideas of Cézanne and Seurat. In 1914 he executed three murals at the *Werkbund* exhibition in Cologne before entering the military. His first sculptures date from 1919. He exhibited at the Der Sturm gallery in Berlin and was appointed the same year to the staff of the Bauhaus. Long interested in ballet and the theater, he worked intermittently on his own *Triadic Ballet* and collaborated with other artists such as Kokoschka and Hindemith on stage productions. At the Bauhaus he headed the mural and sculpture workshops and then took over the stage workshop in 1923; with his students he executed the murals for the Workshop Building in 1924 (later destroyed by the Nazis). Schlemmer's mature paintings and sculpture reflect the Bauhaus and Constructivist emphasis on purity and abstract structural logic but always maintain the human figure as their prime subject. In sculpture he moved from the wall reliefs of 1919, which seem an outward projection of his paintings, to freestanding "abstract figures" that share a mechanical vocabulary with the costumed figures in his ballet. In 1929 Schlemmer left the Bauhaus to accept a professorship at the Breslau Academy, and in 1931 he executed an important wire mural in a private house in Zwenkau. Increasing Nazi harassment led to the closing of his exhibition in Stuttgart in 1933, dismissal from a professorship in Berlin, removal of a series of murals at the Folkwang Museum in 1934, and inclusion in the 1937 Degenerate Art exhibition. During the war he worked first as a house painter and then in a lacquer factory. In addition to appearing in several international exhibitions during the thirties, he had a one-man show at the London Gallery in 1937. After a short illness, Schlemmer died in April 1943 at Baden-Baden.

55. **Constructive Sculpture "R," 1919, cast after 1959**
 aluminum, after a plaster original, 39⅛ x 9⅞ x 4¾"
 Fischer Fine Art, Ltd. [fig. 108]

56. **Abstract Figure, 1921, cast 1962**
 nickeled bronze, 41½ x 24⅝ x 8½"
 The Baltimore Museum of Art, Janet and Alan Wurtzburger Collection [fig. 5]

KURT SCHWITTERS

Kurt Schwitters was born on June 20, 1887, in Hanover, Germany, where he continued to live and work for the greater part of his life. At the Dresden Academy and then the Berlin Academy (1909 – 14) he received a solid education in traditional art and theory, but exposure to the work of Kandinsky and the German Expressionists led, about 1917 – 18, to his experiments with expressionist and abstract styles. In 1919 Schwitters developed his concept of the *Merz*-picture, in which all manner of ordinary, discarded materials, such as crumpled cardboard, clippings, bus tickets and scraps of wood, are assembled into dynamic collage compositions. Expanded into a broad view of art, this designation (derived by chance from the word "*kommerz*") was later applied by Schwitters to his poetry, lectures and other art activities and even to himself ("I call myself Merz"). By 1920 he had begun work on what would be a lifetime project, the famous *Merzbau*, located at first in his Hanover house. A grotto-like construction of disparate elements joined together and painted white, the *Merzbau* was Schwitters's idea of a *Gesamtkunstwerk*, a fantastic fusion of sculpture, painting and architecture that eventually grew to two stories. In 1920 Schwitters met Arp and Raoul Hausmann. Although he is traditionally associated with the Dada movement his relationship to the group was equivocal: he took part in various Dada manifestations and activities but was denied membership in the "Club Dada" because of his activities with Der Sturm gallery. Among his many credits as a writer and theorist are the volume of poetry entitled *Anna Blume*, a series of phonetic poems, and the magazine *MERZ* which he published from 1923 to 1932. Contacts established in Holland with the Neo-Plasticists, particularly van Doesburg, led to a more ordered, Constructivist tendency in Schwitters's work of 1923 – 37. That year he left Germany for Norway. His Hanover *Merzbau* was destroyed in

an air-raid, but while in Norway he worked on a second version (destroyed by fire in 1951), and began still another in Little Langdale, England, having moved to London in 1941 and then to the Lake District in 1945. The latter was still unfinished at the time of his death in January 1948.

57. Treble Clef, 1923
painted wood on cardboard, 34¼ x 25⅞"
signed, dated and titled on reverse
Galerie Gmurzynska

GEORGII STENBERG

Georgii Stenberg and his brother Vladimir, with whom he always worked, were among the most important followers of Tatlin to emerge in the years after the October Revolution. Georgii was born in Moscow in 1899, Vladimir in 1900. They studied at the Stroganov School of Applied Art, 1912 – 18, which was reorganized into the Free Studios (*Svomas*), where they continued for two more years. Together with Medunetsky they were founding members of *Obmokhu* and were to identify with the Constructivist group in renouncing "fine art" in favor of industrial design. Responding to the Counter-Reliefs of Tatlin as well as to Rodchenko's investigations of linear dynamics, the Stenberg brothers produced in 1919 – 20 a series of innovative *Spatial Apparatuses* which use non-traditional materials such as iron and glass in free-standing constructions. These works combine architectural and industrial references with a new dematerialization of sculptural mass: skeletal armatures of wood and metal open up the works completely to space, while suspended planes of glass introduce transparency and a confounding of inner and outer, near and distant relationships. Exhibited at the *Obmokhu* group exhibition of 1921, the *Spatial Apparatuses* were apparently all destroyed but have been recreated recently under the supervision of Vladimir Stenberg. Equally important to the Stenbergs' work in sculpture were their achievements in stage and costume design, typographical work, and poster design. From 1929 to 1932 they taught at the Architecture-Construction Institute, Moscow. Georgii Stenberg died in Moscow in 1933; his brother continued to work on poster design after that and still lives in Moscow.

58. Construction in Space: KPS 13, 1919, reconstructed 1974
iron, glass, plastered wood and steel stays, 94⅞"
Galerie Jean Chauvelin, Paris [fig. 79]

SOPHIE TAEUBER-ARP

Painter, sculptor, weaver and teacher, Sophie Taeuber was born in Davos, Switzerland, on January 19, 1889. Her formal training centered on applied arts, first at the technical school at Saint-Gall in the textile section (1908 – 10), then in von Debschitz's experimental workshop in Munich (1911, 1913), and at the Arts and Crafts School in Hamburg (1912); from 1916 to 1929 she taught at the Kunstgewerbeschule, Zurich. In 1915 she met Jean Arp, whom she would later marry, and together they helped found the Dada movement in Zurich. They also began to explore together the laws of chance in making abstract collages and paintings. She and Arp married in 1921 and in 1926 they built a studio at Meudon from plans she had designed. Her abstract, geometric style of painting, formulated in the teens, became increasingly rigorous and severe during the twenties, and by the end of the decade she was applying Constructivist principles to painted wooden reliefs. In 1927 and 1928 she collaborated with Arp and van Doesburg in the painted decorations of l'Aubette, an inn in Strasbourg (later destroyed). She was a member of *Abstraction-Création* in Paris, 1931 – 36, joined *Allianz* in Zurich in 1937, and was editor of the magazine *Plastique* from 1937 to 1939. She and Arp left Paris for Grasse in 1940 and in 1942, to escape the war, they fled to Switzerland. On January 13, 1943, she died an accidental death in Zurich. In addition to participation in several Dada exhibitions, the *Abstraction-Création* exhibitions and such Constructivist shows as *Kunstruktivisten* in Basel in 1937, Taeuber-Arp had retrospectives at the Kunstmuseum in Bern in 1954 and the Musée National d'Art Moderne in Paris in 1964. On the whole, however, her contribution to both Dada and geometric abstraction still remains undervalued.

59. Sculpture, by 1936
wood, 12¾"
Yale University Art Gallery, Gift of Jean Arp in memory of Sophie Taeuber-Arp

Index